SITES OF CONSCIENCE

DISABILITY CULTURE AND POLITICS

Series Editors: Christine Kelly (University of Manitoba)
and Michael Orsini (University of Ottawa)

This series highlights the works of emerging and established authors who are challenging us to think anew about the politics and cultures of disability. Reconceiving disability politics means dismantling the strict divides among culture, art, and politics. It also means appreciating how disability art and culture inform and transform disability politics in Canada and, conversely, how politics shape what counts as art in the name of disability. Drawing from diverse scholarship in feminist and gender studies, political science, social work, sociology, and law, among others, works in this series bring to the fore the implicitly and explicitly political dimensions of disability.

This is the seventh volume in the series. The previous volumes are:

Mobilizing Metaphor: Art, Culture, and Disability Activism in Canada, edited by Christine Kelly and Michael Orsini
Disabling Barriers: Social Movements, Disability History, and the Law, edited by Ravi Malhotra and Benjamin Isitt
The Aging–Disability Nexus, edited by Katie Aubrecht, Christine Kelly, and Carla Rice
Disability Injustice: Confronting Criminalization in Canada, edited by Kelly Fritsch, Jeffrey Monaghan, and Emily van der Meulen
Cripping Intersex, Celeste E. Orr
Dispatches from Disabled Country, Catherine Frazee, edited by Christine Kelly and Michael Orsini

DISABILITY
CULTURE AND
POLITICS

SITES OF CONSCIENCE
Place, Memory, and the Project of Deinstitutionalization

Edited by Elisabeth Punzi and Linda Steele

UBCPress · Vancouver

© UBC Press 2024

All rights reserved. No part of this publication may be reproduced, stored in a retrieval system, or transmitted, in any form or by any means, without prior written permission of the publisher, or, in Canada, in the case of photocopying or other reprographic copying, a licence from Access Copyright, www.accesscopyright.ca.

Printed and bound by CPI Group (UK) Ltd, Croydon, CR0 4YY

UBC Press is a Benetech Global Certified Accessible™ publisher. The epub version of this book meets stringent accessibility standards, ensuring it is available to people with diverse needs.

Library and Archives Canada Cataloguing in Publication

Title: Sites of conscience : place, memory, and the project of deinstitutionalization / edited by Elisabeth Punzi and Linda Steele.
Names: Punzi, Elisabeth, editor. | Steele, Linda, editor.
Series: Disability culture and politics.
Description: Series statement: Disability culture and politics | Includes bibliographical references and index.
Identifiers: Canadiana (print) 20230553176 | Canadiana (ebook) 20230553338 | ISBN 9780774869324 (hardcover) | ISBN 9780774869355 (EPUB) | ISBN 9780774869348 (PDF)
Subjects: LCSH: People with disabilities – Deinstitutionalization. | LCSH: Mentally ill – Deinstitutionalization. | LCSH: Memorialization. | LCSH: Social justice. | LCSH: Psychiatric hospitals.
Classification: LCC HV1552 .S58 2024 | DDC 305.9/08 – dc23

UBC Press gratefully acknowledges the financial support for our publishing program of the Government of Canada and the British Columbia Arts Council.

UBC Press is situated on the traditional, ancestral, and unceded territory of the xʷməθkʷəy̓əm (Musqueam) people. This land has always been a place of learning for the xʷməθkʷəy̓əm, who have passed on their culture, history, and traditions for millennia, from one generation to the next.

UBC Press
The University of British Columbia
www.ubcpress.ca

Contents

Acknowledgments / viii

Introduction: Sites of Conscience, Social Justice, and the Unfinished Project of Deinstitutionalization / 3
LINDA STEELE and ELISABETH PUNZI

Part 1: Centring Survivor Voices and Experiences in the "Afterlives" of Disability and Psychiatric Institutions / 27

1 Historical Memory, Anti-psychiatry, and Mad People's History / 29
GEOFFREY REAUME

2 Contested Memorialization: Filling the "Empty Space" of the T4 Murders / 46
ELENA DEMKE

3 Names on Frosted Glass: From Fetishizing Perpetrator Mindsets to Disability Memorialization of the Victims / 64
DAVID T. MITCHELL and SHARON L. SNYDER

4 Truth, Reconciliation, and Disability Institutionalization in Massachusetts / 80
An interview with ALEX GREEN

5 "I'm Not Really Here": Searching for Traces of Institutional Survivors in Their Records / 91
JEN RINALDI and KATE ROSSITER

6 Listening to Peat Island: Planning, Press Coverage, and Deinstitutional Violence at a Potential Site of Conscience / 109
JUSTINE LLOYD and NICOLE MATTHEWS

7 "The Old Concept of Asylum Has a Valid Place": Patient Experiences of Mental Hospitals as Therapeutic / 126
VERUSCA CALABRIA and ROB ELLIS

Part 2: Learning from Sites of Conscience Practices / 143

8 Benevolent Asylum: Performance Art, Memory, and Decommissioned Psychiatric Institutions / 145
A conversation with BEC DEAN, LILY HIBBERD, and WART

9 Constructing History in the Post-institutional Era: Disability Theatre as a Site of Critique / 166
NIKLAS ALTERMARK and MATILDA SVENSSON CHOWDHURY

10 The Workhouse and Infirmary Southwell: Collaboration with Learning-Disabled Neighbours and Partners / 182
An interview with JANET OVERFIELD-SHAW

11 Intellectual Disability in South Africa: Affirmative Stories and Photographs from the Grahamstown Lunatic Asylum, 1890–1920 / 196
RORY DU PLESSIS

12 Pathways to Disrupt Eugenics in Higher Education / 213
EVADNE KELLY and CARLA RICE

13 "You Just Want to Do What's Right": Staff Collusion in Institutional Abuse of People with Learning Disabilities / 231
NIGEL INGHAM, JAN WALMSLEY, and LIZ TILLEY

Part 3: Social Justice and Place Making in the Absence of Sites of Conscience / 249

14 A Place to Have a Cup of Coffee: Remembering and Returning to a Dismantled Psychiatric Hospital / 251
HELENA LINDBOM and ELISABETH PUNZI

15 A Sense of Community within a Site of Amplified Stigma: The Strange Case of Spookers / 266
ROBIN KEARNS, GRAHAM MOON, and GAVIN ANDREWS

16 Naming Streets in a Post-asylum Landscape: Cultural Heritage Processes and the Politics of Ableism / 283
CECILIA RODÉHN

17 "We Bent the Motorway": Community Action on Exminster Hospital / 298
NICOLE BAUR

List of Contributors / 315

Index / 322

Acknowledgments

Thank you to our editors at UBC Press, James MacNevin and Megan Brand, and to the Disability Culture and Politics series editors, Michael Orsini and Chrissy Kelly, for their support and guidance throughout the publishing process and for their belief in this project.

Thank you to the Centre for Critical Heritage Studies at the University of Gothenberg and to the Faculty of Law at the University of Technology Sydney for their financial support of the collection.

Thank you to the contributors for their engagement with and trust in this project and for their perseverance throughout the 2020 and 2021 pandemic conditions.

SITES OF CONSCIENCE

SITES OF CONSCIENCE

Introduction
Sites of Conscience, Social Justice, and the Unfinished Project of Deinstitutionalization

LINDA STEELE and ELISABETH PUNZI

Despite the closure of many large disability and psychiatric institutions during the past four decades, deinstitutionalization remains an unfinished project. It is a project that includes open-ended failures – transinstitutionalization[1] and the continued operation of many disability and psychiatric institutions – that sustain oppression and undermine the popular assumption that the closure of disability and psychiatric institutions has delivered social justice to disabled people and to people experiencing mental distress. In 2020 and 2021, with the unfolding worldwide events of COVID-19 and their disproportionate and lethal impacts on disabled people and on people experiencing mental distress, we were reminded that although we might think of disability and psychiatric institutions as relics of the past, many disabled people and people experiencing mental distress still live in institutions such as long-term care homes, group homes, disability residential centres, mental health facilities, and prisons. Indeed, it is becoming increasingly apparent that long-term care homes (also known as nursing homes and aged care facilities), which house older and disabled people, are particularly lethal institutions that have largely survived the deinstitutionalization project (Dehm, Loughnan, and Steele 2021; Herron, Kelly, and Aubrecht 2021) and now sit at the margins of social justice activism and critical scholarship on disability and psychiatric institutions. COVID-19 provided an important reminder that the persistent existence of disability and psychiatric institutions presents ongoing challenges to the realization of social justice, that deinstitutionalization

is an ongoing necessity (Knapp et al. 2021; Quinn 2021), and that the disability and Mad[2] communities' institutional experiences of violence and death over decades and centuries demand action and justice (Page and Pandit 2020; Sheldon, Spector, and Wildeman 2020; Wong 2020). It is thus increasingly urgent that we find new ways to understand and engage with the endurance of institutionalization and with the unfinished deinstitutionalization project and its open-ended failures.

This edited collection engages with specific historical moments and sites of deinstitutionalization to consider afresh how disability and psychiatric institutions impact social justice for disabled people and for people experiencing mental distress. This collection explores how memories and places of former disability and psychiatric institutions can provide more intimate, nuanced, and materially grounded insights into the ongoing roles that institutionalization and, indeed, deinstitutionalization play in the oppression of disabled people and of people experiencing mental distress. We propose that it is the ongoing commitment to keeping alive the heritage and memories of these places, the humanity of the individuals who resided there, and the experiences of survivors, rather than the simple closure of these institutions, that holds the greatest potential for community recognition, accountability, and action on institutionalization, institutional violence, and current disability and psychiatric oppression. Ultimately, realizing social justice might in part be connected to the disability and psychiatric institutions themselves and depend on what we as communities, activists, and scholars do with these places and their memories.

Our edited collection uses "sites of conscience" as a concept, analytical framework, and set of practices through which to critically re-engage with the political possibilities of specific historical moments and sites of deinstitutionalization in a context of the endurance of institutionalization and the unfinished project of deinstitutionalization. Sites of conscience practices are activities such as walking tours, survivor-authored social histories, performances, and artistic works situated on or generated from sites of systemic harm, suffering, and injustice (Ashton and Wilson 2019; Brett et al. 2007; Ševčenko 2002). These practices are premised on the persistence of past injustices in the present and are directed toward eliciting within the community greater understanding of and commitment to addressing the continuity of injustice across time and the ongoing perpetration of further harm. These practices connect histories of place to contemporary social issues in order to move the community toward action for social change. Sites of conscience practices are already being used in relation to a number

of former disability and psychiatric institutions, such as in Canada, Australia, England, and the United States, and there is much potential for broader engagement with sites of conscience by the disability and Mad communities, by critical disability, Mad, and critical mental health scholars, and by practitioners in heritage, planning, human rights, law, and policy-making. Moreover, the collection connects sites of conscience with current experiences of eugenics logics and settler colonialism, thereby illuminating how the pressing social justice issues encountered by disabled people and by people experiencing mental distress are interrelated with the political struggles of diverse marginalized populations.

In this introduction to the collection, we first map out where deinstitutionalization and social (in)justice critically intersect with heritage, materiality, and memories of disability and psychiatric institutions. Next, we discuss sites of conscience and then introduce how each chapter engages with the thematic concerns of the book.

Deinstitutionalization, Transinstitutionalization, and Social (In)justice

"Disability and psychiatric institutions" is a term used in this collection to refer specifically to "large-scale residential settings in which disabled people [and people experiencing mental distress] live in circumstances of congregation and confinement and are segregated and isolated from the community, purportedly in order to achieve goals of health, welfare and control" (Steele 2022, 3). Although often associated with a particular architectural form – large, old-fashioned brick buildings – disability and psychiatric institutions are characterized by the power dynamics of coercion, control, violence, and dehumanization (Chapman, Carey, and Ben-Moshe 2014; Rossiter and Rinaldi 2018). The United Nations Committee on the Rights of Persons with Disabilities (2022, 2–3) has offered a definition of institutions and institutionalization:

> There are certain defining elements of an institution, such as obligatory sharing of assistants with others and no or limited influence as to who provides the assistance; isolation and segregation from independent life in the community; lack of control over day-to-day decisions; lack of choice for the individuals concerned over with whom they live; rigidity of routine irrespective of personal will and preferences; identical activities in the same place for a group of individuals under a certain authority; a paternalistic approach in service provision; supervision of living arrangements; and a disproportionate number of persons with disabilities in the same environment.

Institutionalization of persons with disabilities refers to any detention based on disability alone or in conjunction with other grounds such as "care" or "treatment." Disability-specific detention typically occurs in institutions that include, but are not limited to, social care institutions, psychiatric institutions, long-stay hospitals, nursing homes, secure dementia wards, special boarding schools, rehabilitation centres other than community-based centres, half-way homes, group homes, family-type homes for children, sheltered or protected living homes, forensic psychiatric settings, transit homes, albinism hostels, leprosy colonies and other congregated settings. Mental health settings where a person can be deprived of their liberty for purposes such as observation, care or treatment and/or preventive detention are a form of institutionalization.

Since the late twentieth century and continuing through to the present day, many nations have engaged in processes of "deinstitutionalization," which refers to the closure of disability and psychiatric institutions and the movement of former residents into community settings. Deinstitutionalization is frequently hailed as a significant milestone in disability rights during the mid- to late twentieth century, and it is seen as providing an impetus for the introduction of rights-based legislation (such as the Americans with Disabilities Act in the United States) that has impacted the lives of disabled people (Downey and Conroy 2020). However, with regard to social justice, many have questioned the negative impacts and unintended consequences of deinstitutionalization for disabled people and for people experiencing mental distress.

One of the most enduring and popular criticisms of deinstitutionalization is that the closure of disability and psychiatric institutions was not matched by sufficient community-based housing and supports, resulting in many former residents being subjected to inequality, criminalization, and even transinstitutionalization (Topor et al. 2016). Often, this criticism claims that deinstitutionalization has failed, and it calls for a return to the institution model of housing and support. Scholar of critical disability studies Liat Ben-Moshe has criticized this argument. She proposes that this framing attributes the root cause of failure to individual, untreated mental distress, thus overlooking the structural conditions that drive inequality, criminalization, and incarceration, enable state irresponsibility, and justify nonconsensual psychiatric treatment and detention (Ben-Moshe 2017). Building on Ben-Moshe's criticisms, this edited collection is not focused on simplistic and reductive approaches to deinstitutionalization.

Disability activists and critical disability and Mad studies scholars offer more complex and nuanced reflections on how the practice and rhetoric of deinstitutionalization – as an unfinished project with open-ended failures – relates to social justice. One set of criticisms focuses on understanding institutionalization, deinstitutionalization, and transinstitutionalization as parts of a broader range of practices of confinement, control, and violence. Some scholars and activists argue that former disability and psychiatric institutions are parts of a larger "institutional archipelago" of confinement and control (Ben-Moshe, Chapman, and Carey 2014, 14) or parts of a "Medical Industrial Complex" (Mingus 2015) that extends to community-based alternatives. The closure of more obvious and stereotypical brick-and-mortar disability and psychiatric institutions has the rhetorical effect of suggesting justice and progress, thus masking how control and confinement are maintained, including through the continuation of the epistemologies of disability and the models of care that shaped the treatment of disabled people and of people experiencing mental distress in disability and psychiatric institutions (Ben-Moshe 2020; LeFrançois, Menzies, and Reaume 2013). There are also connections between disability and psychiatric institutions since individuals across their life could often end up in multiple sites and systems, despite ideas about scientific and precise diagnoses and about the ability of assessments to provide absolute and singular categorizations, ideas that still prevail (Steele 2020). Moreover, disability and psychiatric institutions are interconnected with a range of welfare and penal institutions – such as child welfare homes and industrial schools, Indigenous residential schools or homes, prisons, immigration detention centres, and juvenile justice detention centres – that target a variety of marginalized populations as part of the broader logics of eugenics (Chapman 2014).

Scholars and activists have also drawn attention to the role that disability and psychiatric institutions play in settler-colonial violence by sustaining what historian Patrick Wolfe (2006, 388) refers to as the "logic of elimination" – that is, the dispossession, displacement, and elimination of First Nations and Indigenous people (Avery 2018; Burch 2016, 2021; Chapman 2014; Whitt 2021). Scholars and activists have also offered critiques of the complexities of the relationships between disability, mental distress, and reckoning with and repairing settler-colonial violence. American Indian studies scholar Dian Million (Tanana Athabascan) (2013) argues that medicalized discourses of trauma and healing that have structured reconciliation processes in Canada, including in relation to institutional violence, can fold back into, rather than disrupt, the very systems and practices of colonial control

that they are purportedly directed toward redressing. Profoundly deaf and Aboriginal scholar of the Worimi people Scott Avery (2020, 15), writing in the context of the Australian Royal Commission into Violence, Abuse, Neglect and Exploitation of People with Disabilities, states that "truth-telling is needed to expose the structural influences on the incidence and impact of violence [against First Nations and Indigenous people with disability] that otherwise remain unspoken of."

Another set of criticisms concerns the relationship between deinstitutionalization – as an unfinished project with open-ended failures – and justice. Some argue that the disability and psychiatric institution (in its brick-and-mortar form) occupies a central position in narratives of disability rights, often positioned as the "dark past" against which a more progressive present and future are understood (Altermark 2018, 156). In this approach, deinstitutionalization – cast as a historical phenomenon – is the moment of justice. Drawing the line of (in)justice at the point of closure of the disability or psychiatric institution not only allows society to move on without reckoning with and redressing the full complexity, scope, and ongoing impacts of that institution but also obscures the continuities of violence in the "progressive" reforms and alternatives that follow closure (Steele 2022). Some critical disability and Mad studies scholars and former residents, using empirical research methods and autoethnography, have explored the ongoing harms and injustices of disability and psychiatric institutions, which have lived on well beyond deinstitutionalization and formal legal and political redress processes (Burghardt 2018; Malacrida 2015; Rinaldi and Rossiter 2021; Rinaldi, Rossiter, and Jackson 2017; Rossiter and Rinaldi 2018). In the aftermath of deinstitutionalization, some critical disability scholars and socio-legal disability scholars have reflected on activist and legal strategies for achieving legal and social justice change that is transformative, situating these objectives in a broader context of prison abolition, anti-racism, and other anti-carceral and anti-oppression struggles (e.g., see Ben-Moshe 2020; and Wildeman 2020).

Former Disability and Psychiatric Institutions and the Erasure of Injustice

Activists and scholars remind us that former disability and psychiatric institutions were places where disabled people and people experiencing mental distress once lived, worked, and learned – sites not only of violence, harm, and death but also of resistance, survival, and the love and friendship of residents. They were places, too, where individuals sometimes experienced concern from compassionate staff members. Their closure is a testament to the survival, leadership, and activism of disability and Mad communities.

Yet many former disability and psychiatric institutions have been repurposed for other uses, including as hotels, spas and wellness facilities, university campuses, residential areas, business parks, community mental health centres, aged care facilities, refugee camps, and even amusement parks and haunted houses (Moon, Kearns, and Joseph 2015; Mussell, Walby, and Piché 2021). The redevelopment of these institutions forms part of the broader neoliberal trajectories of gentrification and privatization. Commonly, the heritage of former disability and psychiatric institutions becomes reduced to architectural and material features, with the oppression and resistance of former residents being sentimentalized, sensationalized, or erased rather than recognized, remembered, and redressed. In the subsequent uses of former psychiatric institutions, two strategies have been identified that reflect the typical limits of remembering the former site: strategic forgetting, achieved by co-opting institutional features such as isolation and seclusion as positive with no explicit recognition of the earlier psychiatric use of these features for repressive ends; and selective remembrance, undertaken through the heritage preservation of "architecturally-distinguished buildings" (Moon, Kearns, and Joseph 2015, 25–26, 129–30).

Planning and heritage processes do not always provide opportunities for former residents and their representative organizations to give input on decisions about the redevelopment and future uses of institutional sites (Yahm 2014). Moreover, former residents' experiences and memories are often not even comprehensible as forming part of the heritage of a site. Here, the insights of scholars of critical heritage studies help us to understand that disability and psychiatric institutions constitute "difficult heritage" (Macdonald 2009) or do not fit within "authorized heritage discourses" (Smith 2006, 4) that present a particular view of history that conforms to nationalist ideals (McAtackney 2020). According to anthropologist and museologist Sharon Macdonald (2016), difficult heritage concerns wrongdoings perpetrated by nations. But there are always memories and counter-narratives that demand recognition. Using the example of Germany, Macdonald shows that it is possible to publicly address the horrible past and to acknowledge difficult parts of the nation's history; it might even be a sign of moral cleanliness and strength to officially admit wrongdoings and to recognize the victims. Such transitions do not occur on their own but are the result of efforts by victims' organizations, committed stakeholders, and pressure groups (Macdonald 2016).

In settler-colonial nations, the redevelopment of disability and psychiatric institutions on unceded lands of Indigenous and First Nations people

needs to be considered in the context of reconciliation and accountability for the institutionalization of First Nations and Indigenous peoples as one part of broader concerns with First Nations and Indigenous truth-telling and self-determination (Avery 2020). Moreover, sites of former disability and psychiatric institutions might be places of oppression and injustice for First Nations and Indigenous people, including where the construction and operation of the disability and psychiatric institutions are connected to the displacement and dispossession of First Nations and Indigenous people. If not acknowledged, these dynamics of oppression and injustice can be further entrenched through any subsequent redevelopment of such sites or through use of the site as a disability site of conscience. The sites of former disability and psychiatric institutions might be places of cultural significance to First Nations and Indigenous people, thus giving rise to questions about how any practices related to disability sites of conscience will support their custodianship of the land and their self-determination regarding the present and future use of that land. In acknowledging some of these complexities of place, scholars have identified a series of considerations at the intersection of disability, Indigeneity, and place (Larkin-Gilmore, Callow, and Burch 2021):

- Place as nourishment for our work as relatives, scholars, and activists.
- Different approaches to place: as the location where things happen; as relational with beings, identities, and systems of power; and as a cross-generational experience that impacts individuals, communities, and nations.
- The many meanings of occupation and accountability – living on other people's lands and how those lands have been used by colonial powers to disable.
- The disablement of land, water, and air, alongside living beings.

These considerations invite a nuanced and multi-layered engagement with place and land in the context of disability and psychiatric institutions and social justice.

Even though there are examples of the official remembrance of disability and psychiatric institutions (Downey and Conroy 2020; Reaume 2016), these accounts often do not recognize and reckon with wrongdoings perpetrated in disability and psychiatric institutions. On the contrary, wrongdoings might be rationalized by presenting them as innovations, or abusive interventions might be deemed necessary, or at least understandable, due to

the lack of effective treatment (Rodéhn 2020). Thereby, violent interventions and the disciplines that promoted and professions that performed them are excused rather than questioned, and oppressive practices are seen as occasional failures on the otherwise exemplary road to justice and humane treatments (Punzi 2022). Such misrecognition is not uncommon in the heritage sector, even though heritage managers and curators might have good intentions (Waterton and Smith 2010). Official acts of remembrance can focus on staff and family members' memories and agency, thus marginalizing the experiences and resistance of survivors/victims and giving rise to ongoing epistemic injustice (Fricker 2007). However, those who have been exposed to oppression in disability and psychiatric institutions are increasingly claiming their rights to remembrance and a place in history, as exemplified by the Museum der wahnsinnigen Schönheit, a "Museum of Mad Beauty," described in the chapter by Elena Demke, which a group of psychiatric survivors proposed in the 1990s to situate at the very place in Berlin where it had been decided during the Nazi era that persons classified as disabled or mentally ill should be murdered (Rotzoll et al. 2006).

Redevelopment can sever any opportunities for former residents or disability and Mad communities to have ownership or custodianship of former disability and psychiatric institutions, to influence how the history and heritage are interpreted or represented, and to access the site for purposes of healing and memorialization. The sale of property and the subsequent financial enrichment of the former owners of disability and psychiatric institutions can overlook the forced labour that contributed to the very existence and economic value of these sites (Downey and Conroy 2020; Reaume 2009).

These challenges of engaging with former disability and psychiatric institutions in ways that realize social justice, rather than erasure and oppression, provide the impetus for this edited collection.

Sites of Conscience, Deinstitutionalization, and Social Justice

Sites of conscience provide opportunities for political engagement with former disability and psychiatric institutions. Sites of conscience practices are centred on "remember[ing] the past to build a better present and future," and organizers of these activities make a "specific commitment to democratic engagement through programs that stimulate dialogue on pressing social issues today and that provide opportunities for public involvement in those issues" (Brett et al. 2007, 1). Maria Tumarkin (2022, 331) defines sites of conscience as "a movement and a methodology of community-led place-making and place-tending around histories of violence, loss, dispossession,

displacement, incarceration – and so, always, in the same breath, around histories of survival, resistance and activism."

Sites of conscience practices have been utilized in a variety of former disability and psychiatric institutions. One example is the Pennhurst Memorial and Preservation Alliance in Pennsylvania, an online museum about the former Pennhurst State School and Hospital (Beitiks 2012; Pennhurst Memorial and Preservation Alliance n.d.). Also, on Staten Island in New York, the Willowbrook Mile is a self-guided walk around former Willowbrook State School – now a campus of the College of Staten Island, City University of New York (College of Staten Island n.d.; Fritz and Iwama 2019). Moreover, the nineteenth-century brick boundary wall of the former Toronto Asylum for the Insane (now the Centre for Addiction and Mental Health), its last remaining structure, has been the epicentre of walking tours, theatre performances, and activist interventions (Reaume 2016). And in Southwell, England, the Workhouse, operated by the National Trust, is a "prototype of the 19th century" and includes the Firbeck Infirmary for poor individuals who were too sick to work in the Workhouse, an infirmary that later became a nursing home after the closure of the Workhouse (National Trust n.d.).

Sites of conscience practices are not only about remembering disability and psychiatric institutions as a historical phenomenon but also about eliciting public reckoning with the injustices of these places in terms of their continuing role in disability and psychiatric oppression, the ongoing trauma done to survivors, and the demand for collective accountability and action from the broader community. Sites of conscience practices can centre the experiences, voices, and leadership of disabled people and of people experiencing mental distress, thus serving as a form of epistemic justice (Fricker 2007). Sites of conscience practices can also involve the custodianship and control of former institutions by disabled people and by people experiencing mental distress. These practices, too, can honour the lives of former residents, can celebrate their resistance, survival, and friendships, and can sustain the ongoing and broader impact of legal or political victories associated with the closure of institutions (Steele 2022). The possibilities for disability social justice through sites of conscience intersect with the broader possibilities for disability activism through artistic practice (Kelly and Orsini 2017).

It is timely to critically engage with the political possibilities of sites of conscience both as a set of practices and as a concept and analytical framework that can enrich our understandings of the role in social justice of

the materialities, temporalities, corporealities, spatialities, and legalities of disability and psychiatric institutions, institutionalization, and deinstitutionalization. An exploration of the intersections of sites of conscience with social justice (and with narrower conceptions of legal justice and human rights) is particularly timely given the increased focus on redress, citizenship, accountability, and justice by means of the litigation and government inquiries related to disability and psychiatric institutions (and to other institutions that target a variety of marginalized populations as part of the broader logics of eugenics) that are currently underway in many jurisdictions worldwide, some of which arose in reaction to the impacts of COVID-19.

An exploration of the intersections of sites of conscience with social justice is also timely given the ongoing engagement of national governments and civil society with the United Nations Convention on the Rights of Persons with Disabilities (CRPD). Article 19 of the CRPD – which concerns the right to live independently and to be included in the community – requires signatory nations to "adopt a strategy and a concrete plan of action for de-institutionalization" (United Nations Committee on the Rights of Persons with Disabilities 2018, 12). To date, signatories have not met this obligation. However, if this obligation is to be met, the United Nations Committee on the Rights of Persons with Disabilities (2022, 7–8) has clarified that signatories must not only close institutions but also introduce legal and policy frameworks that "enable the development of inclusive community support systems and mainstream services and the creation of a reparations mechanism, and guarantee the availability, accessibility and effectiveness of remedies for survivors of institutionalization." The committee has explained that reparations must go beyond financial compensation and extend to forms such as apologies and truth-telling (17–18).

The emerging connection in international human rights norms between deinstitutionalization and reparations suggests that the CRPD might provide openings to explore the role of the memories, geographies, and materialities of former disability and psychiatric institutions in reparations, thus helping to bring about the broader realization of disability human rights. Indeed, survivors and their allies, as well as human rights and transitional justice movements in other contexts – such as after conflict, Apartheid, slavery, and colonialism, and more recently after the closure of Indian Residential Schools and Magdalene Laundries – have engaged with sites of conscience practices as part of structural justice and in efforts aimed at eliciting state and community accountability (Cooper-Bolam 2019; McAtackney 2020; Ševčenko 2011a, 2011b; Toth and Hibberd 2021). However, political

pressures giving rise to the closure of disability and psychiatric institutions might also provide an impetus for states to cleanse these sites of their difficult histories in order to amplify the efficiency of their progress from a "dark past" (Altermark 2018, 156).

Despite their possibilities, sites of conscience practices also give rise to questions and challenges. First, there is little empirical research on how the impacts of disability and psychiatric sites of conscience are experienced by community members and on how these impacts effect social change, as well as little documentation regarding the perspectives of disabled people and of people experiencing mental distress (Steele 2022).

Second, the possibility of utilizing sites of conscience practices in relation to specific former disability and psychiatric institutions depends on the ability to gain access to sites. Access can be challenging when these sites have been sold. Indeed, the issue of access is particularly pertinent if the new use of a site depends on a history that is either cleansed (e.g., through residential gentrification) or exploited (e.g., as a haunted house) (Beitiks 2012; Punzi 2019).

Third, there might be tensions between reclaiming a former disability or psychiatric institution for the disability community and reckoning with First Nations and Indigenous justice related to dispossession of the land on which the institution is situated and with the role of such institutions in settler colonialism. It is unclear the extent to which existing sites of conscience practices related to disability and psychiatric institutions move beyond a singular set of disability injustices to grapple with multiple (intersecting) injustices and with settler colonialism (Steele 2022). Such an approach can result in missed opportunities for public recognition of a broader range of injustices on land that is itself at the core of Indigenous dispossession, displacement, and genocide; sites of conscience practices can unintentionally be implicated in settler-colonial violence (Chalmers 2019). Scholars suggest that the very notion of a "site" of conscience is a settler concept and that a shift is needed if we are to include understandings of First Nations and Indigenous worldviews and approaches to memory (Andrew and Hibberd 2022).

This Collection

This edited collection aims to bring into conversation scholars working across diverse disciplines and jurisdictions to investigate how specific historical moments and sites of deinstitutionalization offer fresh insights into the role that the memories, geographies, and materialities of disability and psychiatric institutions play in realizing social justice for disabled people

and for people experiencing mental distress. In doing so, it uncovers possibilities for heritage, curating, and memorialization to be in transformative relationships with urban redevelopment, human rights, law, and activism aimed at addressing the endurance of institutionalization and the ongoing project of deinstitutionalization. The collection is thematically structured in three parts, each exploring a set of concerns.

Centring Survivor Voices and Experiences in the "Afterlives" of Disability and Psychiatric Institutions

Part 1 explores how the voices and experiences of former residents tend to become silenced when they are centred in what scholars have referred to as the "afterlives" of former institutions (Moon, Kearns, and Joseph 2015), particularly their redevelopment and reuse. The chapters are authored by disabled people and by people experiencing mental distress, and/or they draw on the lived experiences and insights of disabled people and of people experiencing mental distress, as well as the insights of their allies.

In Chapter 1, Geoffrey Reaume writes about historical memory and memorialization, how the histories of people deemed mentally ill or disabled have been allowed to be forgotten and how some academic historians try to marginalize critical interpretations of psychiatry articulated by those who have been in the position of the patient. These historians may marginalize the voices and memories of survivors of psychiatry by portraying them as anti-psychiatry without defining what that means, thereby lumping together critics of psychiatry as belonging to one undefinable type, who are therefore all the easier to dismiss. Another way to marginalize survivors of psychiatry is to use an either/or framework in which people are portrayed either as former patients/activists or as academic historians and to describe the two groups as having different aims. Reaume shows that people may be both activists and historians. He also shows that history is still very present for many activist-historians. Accordingly, memorialization is not just an academic pursuit. On the contrary, survivors' important perspectives and knowledge create a more truthful presentation of history.

In Chapter 2, Elena Demke shares her experiences of being part of a group of activists who strove to honour the victims of the Nazis' campaign of involuntary euthanasia, known as Aktion T4, carried out at psychiatric killing centres. This activism occurred at the very site where Aktion T4 was planned and organized: Tiergartenstraße 4 in Berlin. She describes how survivors of the campaign and survivors of psychiatry who were born after Aktion T4 spent decades struggling for thoughtful remembrance and for

the acknowledgment and termination of oppressive current practices. The efforts were unsuccessful, not least since the memories and narratives of survivors were neglected and silenced. This outcome ultimately shows the importance of a site of conscience perspective.

In Chapter 3, David T. Mitchell and Sharon L. Snyder explore approaches to the memorialization of disabled people who died during the Second World War in Germany and Austria at Nazi psychiatric killing centres operated under Aktion T4. Mitchell and Snyder explore the different ways that disabled people's voices and experiences can be accessed in the context of scant direct testimony from those who died and in the context of a memorialization of killing centres that fetishizes perpetrators' perspectives. Mitchell and Snyder propose the concept of a "stretchier" form of witnessing that tells the story of Aktion T4 from the perspective of disabled people. Stretchy witnessing includes maps of the physical location of the ashes of deceased disabled people as material remnants of disabled lives and the memoirs of family members of deceased disabled people.

Chapter 4 presents an interview with Alex Green. Green introduces the transitional justice framework of truth and reconciliation as one possible way to reckon with the histories of former disability institutions and to make sense of their ongoing impacts in the present. Green focuses on the Walter E. Fernald Developmental Center in Waltham, Massachusetts, a former disability institution with a significant disability history both nationally and internationally. Recognizing that people with intellectual disability have historically been excluded as legitimate knowers – including in the specific context of public history – Green proposes that the truth and reconciliation framework is particularly pertinent because it is premised on centring the voices and perspectives of former residents.

In Chapter 5, Jen Rinaldi and Kate Rossiter explore disabled people's interventions in their institutional records. Rinaldi and Rossiter focus on the case study of Ontario's Huronia Regional Centre in the context of its failure to accurately and comprehensively document the lives of the disabled people who experienced extreme control and violation within its walls for years and decades. Rinaldi and Rossiter discuss their experiences of recording disabled people engaged in reviewing and reflecting on their own records, and they argue that speaking back to the archives can be both a form of resistance to violence and its ongoing impacts and ultimately a mode of restorative justice.

In Chapter 6, Justine Lloyd and Nicole Matthews explore the inclusion of the voices and lived experiences of disabled people in media discourse on

deinstitutionalization. Matthews and Lloyd focus on the case study of the closure in 2010 of a disability institution on Peat Island in Australia, which was operated by the state government for ninety-nine years. They argue that the exclusion of disabled people from media discourse on Peat Island's closure, an exclusion that occurred in the context of the broader erasure of the physical evidence of the institution, reflects what they call "deinstitutional violence." They suggest that a site of conscience might be one way to centre disabled people's experiences of institutionalization and deinstitutionalization and thus a means to counter this violence.

In Chapter 7, Verusca Calabria and Rob Ellis argue that our duty to remember the difficult pasts of mental hospitals needs to be balanced by the memories of victims, survivors, and citizens in the context of the failings of community care. The chapter focuses on an in-depth oral history of a former patient and service user who encountered life as an in-patient at Shenley Hospital in England. The authors highlight the ongoing challenges faced by former patients during the period following deinstitutionalization in the United Kingdom.

Learning from Sites of Conscience Practices
Part 2 explores how engagement with memories and places of former institutions can support social justice for disabled people and for people experiencing mental distress. The chapters present case studies of current practices of sites of conscience, as well as memorialization and artistic practices.

In Chapter 8, Bec Dean, Lily Hibberd, and Wart explore the role of performance art in engaging the public in histories of psychiatric institutions while connecting these histories to a broader range of injustices. They focus on the case studies of two sites in Australia: Callan Park, which is a former psychiatric institution that operated for around 130 years; and Lavender Bay, where a prison-asylum hulk was moored in the early eighteenth century. Dean, Hibberd, and Wart propose that engaging with place provides opportunities for nuanced understandings of the central contradiction of welfare institutions as both caring and violent and for accounts of the embodied experiences of those who have lived in these institutions and who continue to be impacted by them even after they leave.

In Chapter 9, Niklas Altermark and Matilda Svensson Chowdhury provide an analysis of two theatre plays co-created and performed by persons/actors with disability, one staged in Finland and the other in Sweden. Altermark and Svensson Chowdhury relate these performances to institutionalization and to the unfinished process of deinstitutionalization. Through

their analysis, they reveal that despite the dominance of the idea that current disability policies are the opposite of those that characterized the institutional era, this view does not convey the truth.

Chapter 10 presents an interview with Janet Overfield-Shaw, who is chair of the Workhouse Network and of the Workhouse and Infirmary Southwell in England. The interview captures a moment in a process of change for the individual property and for the National Trust as a whole. Many of the elements discussed in the chapter have become embedded in reset programs established by the National Trust following the COVID-19 pandemic, including programs focused on the National Trust's new core activity of forming partnerships with local communities and businesses, which in turn has led to the creation of the new role of program and partnership officers. The chapter refers to an overarching project of reimagining, whose concept is heavily influenced by the memory-to-action approach of the International Coalition of Sites of Conscience. This approach is a force for change that enables inclusive, co-creative work with neurodivergent partners, artists, and participants. This work aims to produce interpretations from lived experience in the presentation of the nineteenth-century historical institution to visitors and seeks to inspire them to move from memory to action.

In Chapter 11, Rory du Plessis explores the potential of photographs contained in institutional files to memorialize and humanize disabled people who lived in disability and psychiatric institutions. Du Plessis focuses on the case study of photographs of some former residents contained in the files of the Grahamstown Lunatic Asylum in South Africa. Du Plessis proposes that even though the photographs and accompanying documentation were produced in an institutional context, they are open to different interpretations that can redress the eugenics history of disability.

In Chapter 12, Evadne Kelly and Carla Rice investigate the role of educators in reproducing the legacies of colonialism and in justifying the oppressive practices of disability and psychiatric institutions. They take the example of the University of Guelph to show how the eugenics and euthenics that were taught at the university's precursor now uncannily emerge in the current slogan of the university: "Improve Life." Kelly and Rice themselves work at the university and accordingly have the possibility to engage with its institutional history of human-betterment ideas and practice and to analyze how mechanisms of not knowing currently operate.

In Chapter 13, Nigel Ingham, Jan Walmsley, and Liz Tilley explore the role of oral history in addressing contemporary institutional violence. Building on their earlier work on the oral history of disabled people who have

lived in disability institutions, they turn their attention to the oral histories of the nursing staff of long-stay disability institutions. They suggest that these oral histories reveal the ethical complexities of working in these contexts and the possibilities of staff members' perpetration of and complicity in violence. Engaging with these oral histories can contribute to a deeper understanding of the causes of disability oppression and violence and in turn can enable staff employed in contemporary disability social care to end these practices.

Social Justice and Place Making in the Absence of Sites of Conscience

Part 3 explores the challenges and possibilities of realizing social justice when places of former disability and psychiatric institutions are used not as sites of conscience or memorialization but for other purposes. The chapters present case studies of current practices of urban planning, heritage management, and reuse/redevelopment in relation to former institutions.

In Chapter 14, Helena Lindbom and Elisabeth Punzi explore the adaptive reuse of former psychiatric institutions as places for community social gathering, such as cafés. Punzi and Lindbom take as their case study the Lillhagen Hospital in Sweden, which operated in the twentieth century as a psychiatric institute for around sixty years. They focus on the concept of a cup of coffee as a little thing that holds much significance in terms of meaningful opportunities for connection, friendship, and community. Challenging our understanding of what a site of conscience can be, the authors shift our attention from the grander ambitions of museums, walking tours, and memorials to the intimate and smaller-scale opportunities of interpersonal interactions, arguing that these interactions restore something that is taken in institutionalization and that they provide a foundation for mending social relations moving forward.

In Chapter 15, Robin Kearns, Graham Moon, and Gavin Andrews explore the reuse of former psychiatric institutions as haunted houses. They focus on the case study of Spookers, an attraction located on the site of Kingseat Hospital in New Zealand, a former psychiatric institution. They argue that this haunted house has a complex and ambivalent relationship to its former use. The attraction provides opportunities to recognize the former hospital, yet it ultimately falls short of meaningful remembrance and critique while offering those who work at Spookers opportunities for community, identity, and belonging.

In Chapter 16, Cecilia Rodéhn discusses the process of giving names to streets in a post-asylum landscape during the 1990s. Focusing on the former

hospital area of Ulleråker in Uppsala, Sweden, Rodéhn investigates the role that naming plays in the production of cultural heritage. The study reveals that street naming works as a way to remember the (predominantly male) staff members at the hospital and the social elite and that, as a result, the heritages of the Mad and the working class are largely forgotten. The chapter investigates how this process is imbued with the politics of ableism and also connects the discussion to social class and gender.

In Chapter 17, Nicole Baur describes how in 1987, almost 150 years after its grand opening, changes in health policy and the erosion of services and support led Exminster Hospital to close its doors. The question about what would become of its remnants had occupied the minds of local authorities, hospital staff, and the wider Exminster community for nearly two decades. Against the backdrop of recent developments in heritage preservation, which give increasing weight to the input of lay people, this chapter traces the conversion of the former psychiatric hospital near the city of Exeter in England into a luxury residential estate, focusing on how its heritage was intentionally and unwittingly preserved through intense discussions between experts and lay people. Based on interview data, oral histories, and material artifacts collated in the two-year participatory project Remembering the Mental Hospital, the chapter illustrates people's efforts, frustrations, successes, and failures in trying to preserve Exminster Hospital. Findings demonstrate a keen interest in preserving the hospital's heritage, rooted in the ties between the hospital and the surrounding community, but they also show that efforts were frequently hampered by the diverging agendas of the groups and actors involved in the process. At the same time, their input regarding the hospital's preservation created a legacy in itself in the form of material and immaterial heritage, including streets named after former hospital staff, hospital buildings and premises now used for community purposes, and a wealth of stories.

Conclusion

In the face of the enduring presence and harmful impacts of disability and psychiatric institutions, this collection responds to the challenge of finding new ways to understand and engage with the unfinished deinstitutionalization project and its open-ended failures. Through diverse sites, lived experiences, and contexts of institutionalization, contributors to this collection offer reflections on the role of the memories, geographies, and materialities of former disability and psychiatric institutions in the realization of social justice for disabled people and for people experiencing mental

distress. The collection offers new paradigms and strategies for building hopeful and just futures that deliver accountability and repair for the harms of disability and psychiatric institutions and that honour the lives and celebrate the activism and resistance of disabled people and of people in mental distress.

NOTES

1 Transinstitutionalization refers to a process in which persons who previously would have been patients or residents in large psychiatric or disability institutions are now placed in other types of institutions that are equally coercive, such as group homes or even prisons.
2 In this book, the terms "Mad community," "Mad people, and "Mad scholars" are used. These terms are connected to the field of Mad studies, which integrates theory, research, activism, artistic expression, and a focus on the lived experiences of those who, currently and throughout history, have identified as Mad, including scholars and practitioners. Lived experiences are seen as forms of knowledge. Biomedical approaches are rejected, and the word "Mad" is deliberately chosen to reclaim its history and to overturn its solely negative interpretations because it has a common meaning and is disconnected from modern biomedical terminology. Mad studies is historically connected to the Mad pride movement and is, just like this movement, a form of radical and disorderly counter-narrative, counter-philosophy, and/or counter-culture – uniting those who challenge or denounce orthodox terminologies and interventions as well as reclaim expertise based on the knowledge of those who have lived these experiences in the past and present (e.g., see Beresford 2020; LeFrançois, Menzies, and Reaume 2013; and Reaume 2019).

REFERENCES

Altermark, Niklas. 2018. *Citizenship, Inclusion and Intellectual Disability.* London and New York: Routledge.

Andrew, Brook, and Lily Hibberd. 2022. "The Blacktown Native Institution as a Living, Embodied Being – Overcoming Trauma through Zones of Creativity at Places of Australian First Nations' Living Memory." *Space and Culture* 25 (2): 168–83.

Ashton, Paul, and Jacqueline Z. Wilson. 2019. "Remembering Dark Pasts and Horrific Places: Sites of Conscience." In *What Is Public History Globally? Working with the Past in the Present,* ed. Paul Ashton and Alex Trapeznik, 281–94. London: Bloomsbury.

Avery, Scott. 2018. *Culture Is Inclusion: A Narrative of Aboriginal and Torres Strait Islander People with Disability.* Sydney: First People's Disability Network Australia.

–. 2020. *Something Stronger: Truth-Telling on Hurt and Loss, Strength and Healing, from First Nations People with Disability.* Sydney: Royal Commission into Violence, Abuse, Neglect and Exploitation of People with Disability.

Beitiks, Emily Smith. 2012. "The Ghosts of Institutionalization at Pennhurst's Haunted Asylum." *Hastings Center Report* 42 (1): 22–24.
Ben-Moshe, Liat. 2017. "Why Prisons Are Not 'the New Asylums.'" *Punishment and Society* 19 (3): 272–89.
–. 2020. *Decarcerating Disability: Deinstitutionalization and Prison Abolition.* Minneapolis: University of Minnesota Press.
Ben-Moshe, Liat, Chris Chapman, and Allison C. Carey, eds. 2014. *Disability Incarcerated: Imprisonment and Disability in the United States and Canada.* New York: Palgrave Macmillan.
Beresford, Peter. 2020. "'Mad,' Mad Studies and Advancing Inclusive Resistance." *Disability and Society* 35 (8): 1337–42.
Brett, Sebastian, Louis Bickford, Liz Ševčenko, and Marcela Rios. 2007. *Memorialization and Democracy: State Policy and Civic Action.* Santiago/New York: Latin American School of Social Sciences/International Center for Transitional Justice/International Coalition of Historic Site Museums of Conscience. https://www.ictj.org/sites/default/files/ICTJ-Global-Memorialization-Democracy-2007-English_0.pdf.
Burch, Susan. 2016. "Disorderly Pasts: Kinship, Diagnoses, and Remembering in American Indian–U.S. Histories." *Journal of Social History* 50 (2): 362–85.
–. 2021. *Committed: Remembering Native Kinship in and beyond Institutions.* Chapel Hill: University of North Carolina Press.
Burghardt, Madeline C. 2018. *Broken: Institutions, Families and the Construction of Intellectual Disability.* Montreal and Kingston: McGill-Queen's University Press.
Chalmers, Jason. 2019. "Settled Memories on Stolen Land: Settler Mythology at Canada's National Holocaust Monument." *American Indian Quarterly* 43 (4): 379–407.
Chapman, Chris. 2014. "Five Centuries' Material Reforms and Ethical Reformulations of Social Elimination." In *Disability Incarcerated: Imprisonment and Disability in the United States and Canada,* ed. Liat Ben-Moshe, Chris Chapman, and Allison C. Carey, 25–44. New York: Palgrave Macmillan.
Chapman, Chris, Allison C. Carey, and Liat Ben-Moshe. 2014. "Reconsidering Confinement: Interlocking Locations and Logics of Incarceration." In *Disability Incarcerated: Imprisonment and Disability in the United States and Canada,* ed. Liat Ben-Moshe, Chris Chapman, and Allison C. Carey, 3–24. New York: Palgrave Macmillan.
College of Staten Island. n.d. "Willowbrook Mile: About Us." https://www.csi.cuny.edu/about-csi/president-leadership/administration/office-vp-economic-development-and-community-partnerships/reporting-units-and-initiatives/willowbrook-mile/about.
Cooper-Bolam, Trina. 2019. "Workhouses and Residential Schools: From Institutional Models to Museums." In *Cybercartography in a Reconciliation Community: Engaging Intersecting Perspectives,* ed. Stephanie Pyne and D.R. Fraser Taylor, 143–66. Amsterdam: Elsevier.
Dehm, Sara, Claire Loughnan, and Linda Steele. 2021. "COVID-19 and Sites of Confinement: Public Health, Disposable Lives and Legal Accountability in

Immigration Detention and Aged Care." *University of New South Wales Law Journal* 44 (1): 60–103.
Downey, Dennis B., and James W. Conroy, eds. 2020. *Pennhurst and the Struggle for Disability Rights.* Houston: Keystone Books.
Fricker, Miranda. 2007. *Epistemic Injustice: Power and the Ethics of Knowing.* Oxford: Oxford University Press.
Fritz, William, and Ken Iwama. 2019. "The Power of Place-Based Legacies in Advancing Reengagement with Community." *Metropolitan Universities* 30 (2): 63–71.
Herron, Rachel, Christine Kelly, and Katie Aubrecht. 2021. "A Conversation about Ageism: Time to Deinstitutionalize Long-Term Care?" *University of Toronto Quarterly* 90 (2): 183–206.
Kelly, Christine, and Michael Orsini, eds. 2017. *Mobilizing Metaphor: Art, Culture, and Disability Activism in Canada.* Vancouver: UBC Press.
Knapp, Martin, Eva Cyhlarova, Adelina Comas-Herrera, and Klara Lorenz-Dant. 2021. *Crystallising the Case for Deinstitutionalisation: COVID-19 and the Experiences of Persons with Disabilities.* London: Care Policy and Evaluation Centre, London School of Economics and Political Science. https://www.lse.ac.uk/cpec/assets/documents/CPEC-Covid-Desinstitutionalisation.pdf.
Larkin-Gilmore, Juliet, Ella Callow, and Susan Burch. 2021. "Section II Introduction: Place." *Disability Studies Quarterly* 41 (4). https://production.ojs.dsq-sds.org/index.php/dsq/article/view/8771/6314.
LeFrançois, Brenda A., Robert Menzies, and Geoffrey Reaume, eds. 2013. *Mad Matters: A Critical Reader in Canadian Mad Studies.* Toronto: Canadian Scholars' Press.
Macdonald, Sharon. 2009. *Difficult Heritage: Negotiating the Nazi Past in Nuremberg and Beyond.* Abingdon, UK: Routledge.
—. 2016. "Is 'Difficult Heritage' Still Difficult? Why Public Acknowledgement of Past Perpetration May No Longer Be So Unsettling to Collective Identities." *Museum International* 67 (1–4): 6–22.
Malacrida, Claudia. 2015. *A Special Hell: Institutional Life in Alberta's Eugenic Years.* Toronto: University of Toronto Press.
McAtackney, Laura. 2020. "Materials and Memory: Archaeology and Heritage as Tools of Transitional Justice at a Former Magdalene Laundry." *Éire-Ireland* 55 (1–2): 223–46.
Million, Dian. 2013. "Trauma, Power, and the Therapeutic: Speaking Psychotherapeutic Narratives in an Era of Indigenous Human Rights." In *Reconciling Canada: Critical Perspectives on the Culture of Redress,* ed. Jennifer Henderson and Pauline Wakeham, 159–77. Toronto: University of Toronto Press.
Mingus, Mia. 2015. "Medical Industrial Complex Visual." *Leaving Evidence,* February 6. https://leavingevidence.wordpress.com/2015/02/.
Moon, Graham, Robin Kearns, and Alun Joseph. 2015. *The Afterlives of the Psychiatric Asylum: Recycling Concepts, Sites and Memories.* Farnham, UK: Ashgate.
Mussell, Linda, Kevin Walby, and Justin Piché. 2021. "'Can You Make It Out Alive?' Investigating Penal Imaginaries at Forts, Sanitaria, Asylums, and Segregated

Schools." *Journal of Qualitative Criminal Justice and Criminology* 10 (3). https://doi.org/10.21428/88de04a1.d3d18f84.

National Trust. n.d. "The Workhouse and Infirmary." https://www.nationaltrust.org.uk/visit/nottinghamshire-lincolnshire/the-workhouse-and-infirmary/index.

Page, Cara, and Eesha Pandit. 2020. "Intersections of Justice in the Time of Coronavirus." Funders for Justice, March 25. https://www.nfg.org/news/intersections-justice-time-coronavirus-cara-page-eesha-pandit.

Pennhurst Memorial and Preservation Alliance. n.d. "The Mission of the Pennhurst Memorial and Preservation Alliance." http://www.preservepennhurst.org/.

Punzi, Elisabeth. 2019. "Ghost Walks or Thoughtful Remembrance: How Should the Heritage of Psychiatry Be Approached?" *Journal of Critical Psychology, Counselling and Psychotherapy* 19 (4): 242–51.

—. 2022. "Långbro Hospital, Sweden – From Psychiatric Institution to Digital Museum: A Critical Discourse Analysis." *Space and Culture* 25 (2): 282–94.

Quinn, Gerard. 2021. "COVID-19 and Disability: A War of Two Paradigms." In *COVID-19 and Human Rights*, ed. Morten Kjaerum, Martha F. Davis, and Amanda Lyons, 116–32. Abingdon, UK: Routledge.

Reaume, Geoffrey. 2009. *Remembrance of Patients' Past: Patient Life at the Toronto Hospital for the Insane, 1870–1940*. Toronto: University of Toronto Press.

—. 2016. "A Wall's Heritage: Making Mad People's History Public." *Public Disability History*, November 21. https://www.public-disabilityhistory.org/2016/11/a-walls-heritage-making-mad-peoples.html.

—. 2019. "Creating Mad People's History as a University Credit Course since 2000." *New Horizons in Adult Education and Human Resource Development* 31 (1): 22–39.

Rinaldi, Jen, and Kate Rossiter. 2021. "Huronia's Double Bind: How Institutionalisation Bears Out on the Body." *Somatechnics* 11 (1): 92–111.

Rinaldi, Jen, Kate Rossiter, and Liza Kim Jackson, eds. 2017. *Canadian Journal of Disability Studies* 6 (3).

Rodéhn, Cecilia. 2020. "Emotions in the Museum of Medicine: An Investigation of How Museum Educators Employ Emotions and What These Emotions Do." *International Journal of Heritage Studies* 26 (2): 201–13.

Rossiter, Kate, and Jen Rinaldi. 2018. *Institutional Violence and Disability: Punishing Conditions*. Abingdon, UK: Routledge.

Rotzoll, Maike, Paul Richter, Petra Fuchs, Annette Hinz-Wessels, Sascha Topp, and Gerrit Hohendorf. 2006. "The First National Socialist Extermination Crime: The T4 Program and Its Victims." *International Journal of Mental Health* 35 (3): 17–29.

Ševčenko, Liz. 2002. "Activating the Past for Civic Action: The International Coalition of Historic Site Museums of Conscience." *George Wright Forum* 19 (4): 55–64.

—. 2011a. "Sites of Conscience: Heritage of and for Human Rights." In *Heritage, Memory and Identity*, ed. Helmut Anheier and Yudhishthir Raj Isar, 114–23. Los Angeles: Sage.

—. 2011b. "Sites of Conscience: Reimagining Reparations." *Change Over Time* 1 (1): 6–33.
Sheldon, Tess, Karen Spector, and Sheila Wildeman. 2020. "Viruses Feed on Exclusion: Psychiatric Detention and the Need for Preventative Deinstitutionalization." *Ricochet*, April 12. https://ricochet.media/en/3038/viruses-feed-on-exclusion-psychiatric-detention-and-the-need-for-preventative-deinstitutionalization.
Smith, Laurajane. 2006. *Uses of Heritage*. London and New York: Routledge.
Steele, Linda. 2020. *Disability, Criminal Justice and Law: Reconsidering Court Diversion*. Abingdon, UK: Routledge.
—. 2022. "Sites of Conscience Redressing Disability Institutional Violence." *Incarceration* 3 (2): 1–19.
Topor, Alain, Gunnel Andersson, Per Bülow, Claes-Göran Stefansson, and Anne Denhov. 2016. "After the Asylum? The New Institutional Landscape." *Community Mental Health Journal* 52 (6): 731–37.
Toth, Naomi, and Lily Hibberd. 2021. "Parragirls Past, Present: Unlocking Memories of Institutional 'Care': Witnessing and Creative Reparation in the Aftermath of Parramatta Girls Home." *Synthesis* (13): 94–114.
Tumarkin, Maria. 2022. "Theorising Otherwise: Sites of Conscience and Gendered Violence." *Space and Culture* 25 (2): 331–40.
United Nations Committee on the Rights of Persons with Disabilities. 2018. "General Comment No. 5 on Article 19: Living Independently and Being Included in the Community." CRPD/C/GC/5.
—. 2022. "Guidelines on Deinstitutionalization, Including in Emergencies." CRPD/C/5.
Waterton, Emma, and Laurajane Smith. 2010. "The Recognition and Misrecognition of Community Heritage." *International Journal of Heritage Studies* 16 (1–2): 4–15.
Whitt, Sarah. 2021. "'Care and Maintenance': Indigeneity, Disability and Settler Colonialism at the Canton Asylum for Insane Indians, 1902–1934." *Disability Studies Quarterly* 41 (4). https://production.ojs.dsq-sds.org/index.php/dsq/article/view/8463/6299.
Wildeman, Sheila. 2020. "Disabling Solitary: An Anti-carceral Critique of Canada's Solitary Confinement Litigation." In *The Legacies of Institutionalisation: Disability, Law and Policy in the 'Deinstitutionalised' Community*, ed. Claire Spivakovsky, Linda Steele, and Penelope Weller, 87–102. Oxford: Hart-Bloomsbury.
Wolfe, Patrick. 2006. "Settler Colonialism and the Elimination of the Indigenous." *Journal of Genocide Research* 8 (4): 387–409.
Wong, Alice. 2020. "Freedom for Some Is Not Freedom for All." Disability Visibility Project, June 7. https://disabilityvisibilityproject.com/2020/06/07/freedom-for-some-is-not-freedom-for-all/.
Yahm, Sarah. 2014. "Oregon State Hospital Museum of Mental Health." *Journal of American History* 101 (1): 203–8.

PART 1

Centring Survivor Voices and Experiences in the "Afterlives" of Disability and Psychiatric Institutions

Part 1 explores how the voices and experiences of former residents can be centred, and the histories and spaces of former disability and psychiatric institutions can be reclaimed, in what Moon and co-authors (2015) refer to as the "afterlives" of former psychiatric institutions, particularly their redevelopment and reuse. Chapters are authored by disabled people and people experiencing mental distress, and/or draw on the lived experiences and insights of disabled people and people experiencing mental distress and their allies. Authors consider the complex role of engagement with the memories and places of former disability and psychiatric institutions in our understandings and practices of social justice and disability human rights. Authors also consider the role of such engagement in contesting current oppression, including that which today often occurs in less-visible institutions, such as smaller scale group homes or private homes. Noting that disabled people and people experiencing mental distress continue to experience segregation, discrimination, and violence beyond the walls of disability and psychiatric institutions, authors also consider how the memories and places of former disability and psychiatric institutions can illuminate and contest current oppression.

PART I

Telling Survivor Voices and Experiences in the "Shadows" of Disability and Psychiatric Institutions

1

Historical Memory, Anti-psychiatry, and Mad People's History

GEOFFREY REAUME

Historical memory refers to how events, places, and people are remembered – whether as real human beings, as caricatures, or as figures to be ignored. It also relates to who gets to interpret these events and to where and how interpretation occurs. This chapter discusses how the histories of Mad people are remembered in public spaces and how some academics seek to construct barriers that restrict whose historical interpretations become accepted as credible.

When referring to historical memory, it is essential to acknowledge that memory is not static or fixed – that how events and people are remembered shifts and evolves over time. Memory also refers to what is not remembered, or perhaps more accurately, to what is allowed to be forgotten as well as to what is allowed to be commemorated. Specifically, in regard to the topic of this chapter, the historical memory of unpaid work by asylum inmates at the Toronto Asylum for the Insane was allowed to be forgotten. Certainly, there were people alive in the late nineteenth and early twentieth centuries who would have remembered the work that patients did, not least the patients themselves, as well as witnesses to the voluminous amounts of work that they did. Their toil was clearly documented in public reports at the time, which I came across in the archives over a century after the reports were first published (Reaume 2000b). Some of the doctors who wrote these reports have been remembered, and their work commemorated, with plaques and public spaces named for them, including Toronto Asylum superintendents Joseph

Workman (1853–75) and Charles Kirk Clarke (1905–11). Workman has had an auditorium and a small park named after him, and from 1966 to 1998 a prominent psychiatric facility was named after Clarke in Toronto. By contrast, until recently, the work done by unpaid patient labourers was not remembered with any public acknowledgment. It was allowed to be forgotten until the efforts of a group of historian-activists brought wider public attention to this history beginning in the late 1990s and continuing well into the first decade of the 2000s through theatre performances, commemorative events, and a plaque campaign.

Historical memory is therefore about who gets to frame whom and about what history is remembered and how. The efforts described in this chapter coincide with the work of critical heritage studies, which is involved in redressing the power imbalances that determine whose histories are told and how. Importantly, "critical heritage scholars and practitioners advocate theoretically and politically informed analyses of processes in society that produce and consume heritage, often from a bottom-up perspective" (Ashley, Terry, and Lapace 2018, 1). As shown by this chapter's discussion of efforts to publicize the history of the Toronto Asylum's inmates, there is an obvious connection between the aims of Mad activist-historians and critical heritage studies. Both seek to provide public awareness of people who have been previously left out of mainstream, public interpretations of history. Cecilia Rodéhn (2020, 211), in her insightful critique of how the guided tours of a former asylum are deliberately oriented to produce empathy for hospital staff at the expense of psychiatric patients, who were stereotyped as violent and dirty, points to a particular problem with how Mad people are depicted in public history: "Attention needs to be turned to how sanism as a norm permeates the entire heritage system ... Inquiries need to be made into how the employment of sanist emotions orient visitors in museums – how visitors are directed to feel certain things about people with mental illness and the heritage thereof." Sanism is a concept whereby people deemed mentally ill are discriminated against and caricatured as the negative other based solely on their real or presumed mental state (Perlin 1992). Sanism has long been present in public interpretations of Mad people's history and is manifested in various ways through historical memory. Elisabeth Punzi (2019) describes this process in recounting how a former asylum site, now run by a private enterprise in Sweden, uses this history for commercial profit by promoting grotesquely stereotyped depictions of Mad people through "ghost walks," among other activities, despite protests from local activists to stop

this othering. Protests have also taken place in Canada over "ghost tours" on the grounds of a former asylum (Mack and Reaume 2021).

These extremely prejudiced depictions of our history relate to a wider concern with the fact that not only Mad people but also disabled people more generally are viewed solely through a negative lens. Into the 2020s, the positive aspects of the lives of even famous disabled individuals like Helen Keller have been discounted as fraudulent simply because some able-bodied people do not believe that people deemed disabled – physically, mentally, or sensorily – have anything to contribute to the world (Gershon 2021). This belief is directly related to the topic of this chapter since it points to how, even when there is public acknowledgment of the abilities of Mad and disabled people, there is also a negative reaction against these efforts, whether on social media, as with Keller, or in the halls of academia, as described below.

Either/Or, Historical Memory, and Mad People's Public History

An essential part of grappling with historical memory is to deal with an either/or framework – either one is Mad/disabled and therefore incapable, or one is able-bodied/able-minded and therefore capable. This simple equation, devoid of both complexity and accuracy, is also manifest in academic accounts of our history that describe critical perspectives in an either/or framework. These accounts set up a simple difference between one side and another without acknowledging that there can be more than two sides or perspectives – in this case, in regard to historical memory as well as our interpretations of the past. History, after all, is messy in ways that an either/or approach does not reflect. This approach is evident, for example, when historians Alexandra Bacopoulos-Viau and Aude Fauvel (2016, 17) write, "Historians, of course, have different aims from those of Mad activists."[1]

Bacopoulos-Viau and Fauvel (2016, 1) consider the writing of patients' perspectives in psychiatric history while also discussing the development of Mad studies as "an imagined space." Their point is to reassure their readers – primarily academic historians of medicine – that they are not trying to give credence to Mad activists by taking them seriously as researchers. Rather, they are referring to the pervasiveness of what they term the "gothic" depiction of Mad people and psychiatrists, the latest example being in Mad studies (1). This dismissal of Mad studies as anachronistic and the claim that historians "of course" are different from Mad activists are just the latest examples of historians seeking to marginalize critical interpretations of

psychiatry as different from, presumably, the interpretations provided by the more conventional and therefore serious scholars with whom they identify.

During the 1990s, both Edward Shorter (1997, 272–82) and Norman Dain (1994) denounced what they very broadly referred to as "anti-psychiatry." It was also in the 1980s and 1990s that Mad activists like myself began to document our own histories and to write about our experiences independently of academic historians. These activists included Judi Chamberlin (1978), Lenny Lapon (1986), and Linda Morrison (2005) in the United States, as well as Mel Starkman (1981) and Irit Shimrat (1997) in Canada.

It is important to note that the term "anti-psychiatry" has been used to categorize critics from within the mental health profession such as Thomas Szasz (1961), David Cooper (1967), and R.D. Laing (1960), as well as academic theorists such as sociologist Erving Goffman (1961) and philosopher Michel Foucault (1965). Anti-psychiatry has also been used to categorize activists engaged in the Mad and psychiatric-survivor communities, such as Judi Chamberlin (1978), Kate Millett (1991), and others who have promoted alternatives to the medical model of mental illness. As there are significant differences between the ideas of such a diverse group of people to whom the term "anti-psychiatry" has been imposed, this label can be a lazy shorthand for lumping critics of psychiatry together as belonging to one undefinable type, who are therefore all the easier to dismiss. For those activists who have identified as anti-psychiatry, their main point is to call for an end to psychiatry (Burstow 2015). It should be obvious to any serious observer, however, that it is inaccurate to identify all activist-researcher critics of the medical model of mental illness as anti-psychiatry. Yet the way that some historians seek to get around this issue is to come up with new formulations that further impose this convenient catch-all term in order to denounce critically informed efforts to commemorate our histories.

Commemoration and Critique

To set the scene of the discussion that follows, it is necessary to provide context about the organization at the centre of commemorative efforts described below and my own involvement in this topic as the author of this chapter. The Psychiatric Survivor Archives of Toronto (PSAT) was founded in January 2001 by four activists – Janet Bruch, Mel Starkman, Don Weitz, and myself – for the purpose of preserving and interpreting the history of people deemed Mad. During the next decade, PSAT, supported by additional members and allies, worked on securing a location to store donated archival material, developed a self-governing structure through measures

such as bylaws and incorporation, consulted professional archivists about how to organize our collection, and raised awareness about the need to preserve and interpret Mad people's history from the perspectives of those who have lived it. One of PSAT's main efforts from 2002 until 2010 was advocating for the preservation and public interpretation of the patient-built nineteenth-century boundary walls surrounding part of the grounds of the former Toronto Asylum, now the Centre for Addiction and Mental Health. My article "Plaques, Politics and Preservation: Publicly Memorialising Mad People's Labour History" (Reaume, forthcoming) provides a more detailed account of this public history campaign. It is sufficient to point out here that those of us who organized this effort with supporters inside and outside the archives did so to ensure that our history, told from the perspectives of those deemed Mad both in the past and in the present, was taken seriously and publicly acknowledged. Central to this interpretation were our own critical analyses aimed at ensuring that this history would not be sugar-coated as a sort of "best intentions" narrative where, in this case, unpaid inmates' work was an extension of benign therapy led by benevolent asylum staff. Some PSAT members ourselves know what it was like to work in mental institutions and sheltered workshops for little or no pay. We do not need researchers who themselves have no first-hand experience of such labour practices to provide us with lessons about how to understand our own history. This history included being deemed too mentally disabled to be properly paid for one's work and thus being legally denied a minimum wage, as has historically been the case for disabled people who toiled in segregated facilities in places like Ontario (Galer 2018; Reaume 2004).[2] These and other personal experiences of the founders and members of PSAT guided our critical perspectives on this specific topic and showed us how important it was to lead this work ourselves. This approach was taken to avoid the sort of interpretations seen in most academic studies about Mad people's labour history, which generally support notions of work as therapy and which downplay or dismiss unpaid work as exploitation (Ernst 2016). The chapter now turns to this latter point.

 Historians Nathan Flis and David Wright (2011) have critiqued the work done by myself and other activists involved with the Psychiatric Survivor Archives of Toronto to assist archivists and administrators at the Centre for Addiction and Mental Health in creating memorial plaques dedicated to psychiatric patients who were labourers at the former Toronto Asylum, as represented by the boundary walls that unpaid inmates built in the nineteenth century. These wall plaques, a series of nine, with one centrally

located plaque describing the history of the exploitation of asylum patients' labour, were installed in 2010. This undertaking was accomplished after an eight-year campaign by the Psychiatric Survivor Archives of Toronto and allies to publicly mark and interpret the history of the patient-built nineteenth-century walls that exist in a highly visible part of the city (Reaume 2016).

There are several seriously flawed claims in the article by Flis and Wright (2011), who discuss Toronto activists' work – and inaccurately record PSAT's name (108) – that are especially relevant to this chapter. One such claim is that the efforts of Mad activists to preserve and interpret our history are motivated by an "anti-psychiatry" agenda. Flis and Wright argue that these efforts are a "subtle new form of anti-psychiatry, where motifs borrowed from memorializations of the Holocaust, the First World War, and American slavery are adapted to the political aspirations of 'psychiatric survivors' organisations. Aided by a sympathetic press ... senior figures of the psychiatric establishment ... have paradoxically embraced problematic narratives of their own profession's past" (102). They further state that those of us who have engaged in commemorative efforts "do so using tropes that do no justice to the incredible complexity of the relationship between society and the mad over the course of the last 200 years" (113).

Flis and Wright (2011) do not rest their argument for these claims on a single piece of evidence in regard to the work done by Toronto activists. As one of the people most directly involved for the better part of a decade in this effort to publicly commemorate Mad people's labour history, I can say unequivocally that these commemorative efforts never, at any time, undertook comparisons with "the Holocaust, the First World War, and American slavery." Flis and Wright's article is notable for the absence of a single story from a supposedly "sympathetic press" willing to publicize commemorative efforts by PSAT regarding this history, including a fundraising event in April 2010 and the actual unveiling of the wall plaques in September 2010, neither of which were covered by a "sympathetic press" outside of articles written and distributed from within the local Mad community. In fact, as one of the main organizers of these events, I was disappointed by the failure of the mainstream press to cover these historical efforts by PSAT and its allies. In 2003, the *Toronto Star* did publish an article about a "Town Hall on the Wall" organized by the archives, which was about efforts to preserve one specific section of the wall on the east side of the property (Sorensen 2003). This article appeared more than seven years before the plaques were installed and does mention PSAT's support for preserving this structure, the only time that mainstream media made any mention of the archives' efforts

in nearly ten years of advocacy. Flis and Wright have effectively set up a straw-man argument that can be easily knocked down by simply pointing out that the mainstream media – television, newspapers, and radio – did not cover the archives-organized commemorative events at all, in spite of efforts to attract their attention by those of us involved.

In 2009, more than a year before the plaques were unveiled, the *Toronto Star* also published an article on the history of the patient-built walls, for which I was interviewed. This article was a helpful and supportive source of publicity about the history of unpaid work by asylum patients, and it does discuss the commemorative efforts in which I engaged by leading historical tours of the wall. However, PSAT's work is not mentioned (Morrow 2009). In 2010, when the campaign to raise funds for the interpretation and installation of the plaques was at its peak, no local mainstream media paid any attention. Bizarrely, the one newspaper story from which I am quoted by Flis and Wright (2011, 111, 115) was published in 2007 and does not discuss PSAT's historical commemoration work. It also needs to be stated that the claim of Flis and Wright that these efforts are a "subtle new form of anti-psychiatry" (102) is not supported by any explanation of what they mean by "anti-psychiatry" or by a clear statement of how these efforts meet this description. For example, they cite no specific theorists like Szasz, Laing, or Bonnie Burstow to show how their ideas relate to the content of what actually transpired in PSAT's work. Related to these points, German activist-historian Elena Demke (2021, 289) writes, "One obstacle to scholarship on the survivor movement in Germany is its conflation with 'antipsychiatry,' which tends to be treated as a terminological bin rather than being analysed in terms of overlapping and contradictory movements questioning mainstream psychiatry – including the particular uses of the term by activists as a self-identifier."

Similarly, given the malleable way that the term "anti-psychiatry" is used without explanation or elaboration, there can be no other conclusion than that Flis and Wright (2011) use this term in a vague way as part of an attempt to dismiss community-based efforts to publicly interpret asylum inmates' history, even though this activist work was based on peer-reviewed archival historical scholarship that I had published in, among other places, a book that Wright himself had co-edited (Reaume 2006). Consequently, their critique becomes a form of medical McCarthyism by branding a particular point of view with a term that is intended to sideline and belittle such efforts. They take this approach most clearly in falsely constructing what they term "an allusion to slave labour ... [which] drives home the point of

exploitation as a central theme in the history of the mental hospital" (Flis and Wright 2011, 108–9). They also state that, when I lead tours of the nineteenth-century boundary walls built by patient labourers, walls that still exist on the site, and that when efforts are made to dedicate these walls to their memory, "the allusions to unpaid patient labour also invoke suggestions of plantation work by slaves prior to emancipation" (109). Such allusions are totally false and have been created by Flis and Wright to undermine critically informed commemorative efforts. I have never made any such comparisons in print or during nearly 150 tours of the patient-built walls conducted between 2000 and 2022 (including online tours since the start of the pandemic in 2020).

Flis and Wright's (2011, 102) claim that PSAT's historical commemorative efforts are a "subtle new form of anti-psychiatry," without any substantiation of what this term actually means, leads to the realization that, ultimately, proving this claim is not their point and that doing so is not even necessary to have the desired effect. Their rhetorical association of such efforts with anti-psychiatry is enough. At one point, they write that "PSAT, once a loosely organized group of former patients often voicing the more extreme versions of anti-psychiatry, has matured over the last two decades to become a well organised advocacy organisation" (109). Leaving aside the historical inaccuracy of this statement – PSAT was only a decade old when these words were written – these efforts are identified as "extreme" without a single example of what this actually meant in practice. It is reasonable to ask which statements, issued in PSAT's name, qualify as anti-psychiatry and how? Instead, Flis and Wright cite one quotation by a US researcher, Gayle Hornstein, who does make a reference to patient narratives as similar to "slave narratives" (109). However, their inexplicable claim that Hornstein was a PSAT member is totally false. She never had anything to do with the archives, and I met her only once at a medical history conference a year before the archives was founded.

It needs to be stated that the term "guilt by association" should be avoided here, as there is nothing to be "guilty" of when it comes to those with whom PSAT members choose to associate. The attempt to make this link by association, however, is in the same dubious category as Cold War red-baiting, which sought to marginalize not only real activists but also supposed members or supporters of the Communist Party, who were thus targeted as politically suspect and as socially discreditable in a capitalist state (Caute 1978; MacKenzie 2018; Schrecker 1986). A similar tactic is employed by Flis and Wright but, obviously, with a less personally devastating impact compared to what people suffered when targeted in the early Cold War. When a historical

organization run by psychiatric survivors is branded as "anti-psychiatry" and therefore "extreme" simply because some – but not all – of the people involved identified with anti-psychiatry, doubt is intentionally sown among historians about the credibility of commemorative efforts that are critical of how Mad people were mistreated and, yes, exploited.

The very word "exploitation" is doubted by Flis and Wright (2011, 108–9), as though it has no place in asylum patients' history. Nineteenth-century social critics like Karl Marx (1977), among many others, used this term to describe the way that capitalism exploits the toil of the labouring classes. Whether or not one subscribes to Marxism, the idea that poor, unpaid, confined inmates were made to work for no pay and were therefore exploited under the guise of therapy is hardly an original idea; some patients themselves denounced their unpaid status based on their own experiences at this very same mental institution in Toronto long before any of us historians arrived on the scene (Reaume 2000b, 160–65).

This discussion leads to another essential point: the use of the word "exploitation" on the main commemorative plaque – one of nine that were unveiled in 2010. Although Flis and Wright (2011) appear to have written their article just before the plaques were publicly unveiled, they were aware of this interpretation of patients' labour, which I have expressed in my own work, as evidenced by their article's indication that they do not believe that patients' labour was exploited. For instance, they put scare quotes around the word "unpaid" (108) when referring to the work of inmate labourers. They also put scare quotes around the term "patient-built" (109) when referring to the boundary walls still in existence. The use of such scare quotes indicates that they are trying to convey to readers some doubt about both of these points, even though the historical evidence for these facts is beyond dispute, as primary-source research indicates (Reaume 2000b, 2006). As noted above, neither I nor PSAT as an organization have made any "allusions," as Flis and Wright (2011, 109) claim, to slave labour or to the Holocaust in our efforts to preserve and publicly interpret the patient-built walls at the former Toronto Asylum. Indeed, I have long been on public record for critiquing such comparisons as inappropriate and inaccurate (Reaume 2000a, 120–21). The question therefore arises of what constitutes exploitation in the context of disability-labour history and, in particular, Mad people's history?

The act of exploitation entails the "use of a person or situation in an unfair way so as to gain advantage for oneself" ("Exploit" 2005, 349). From a Marxist point of view, to live under capitalism as a working-class person, as

did the unpaid inmates who toiled at the Toronto Asylum, is to live under a system where one's labour is automatically exploited (Marx 1977). In disability history, during the nineteenth and twentieth centuries, besides people in insane asylums, people who were confined in various institutions and who worked in the community, ranging from people with intellectual disabilities to people who were blind, were unpaid or underpaid for their work precisely because of their impairment and subsequent devaluation as workers (Galer 2018; Rose 2017). It is extremely narrow and inaccurate to solely equate "exploitation" with slave labour, as do Flis and Wright (2011) in regard to unpaid psychiatric patients' labour. This equation suggests that any criticism of the unpaid work that confined populations were required to do in institutions for people deemed disabled can be dismissed as alluding to another more well-known and horrific injustice – slavery – when what is being criticized are the power relations that existed in the specific context of the requirement for people being held in involuntary confinement to do work for no pay. Toronto Asylum inmates' toil was not slave labour or comparable to the Holocaust, nor has this author ever alluded to it as such. It was, however, exploited labour in relation to the wider society in which disabled people lived at the time.

Flis and Wright (2011) construct a hierarchy of exploitation where the unfounded "allusions" to which they refer imply that it is possible to use the term "exploitation" only when addressing the most heinous atrocities in history – slavery and the Holocaust – and that the unjust treatment of psychiatric patients who were not paid for their work and whose toil until recently went widely unacknowledged was not exploitation since it was not slavery or mass murder. The cultural memory to which Flis and Wright refer is obfuscated and manipulated by false comparisons in order to deter efforts to commemorate lesser-known episodes of historical injustices in psychiatric practice. If discussions of exploitation in reference to episodes of unpaid asylum-inmate labour are automatically perceived as making "allusions" to some of the most well-known examples of economic and social cruelties – slave labour and mass murder – then how can the term "exploitation" ever be used in any context outside of this narrow reading? To regard the term "exploitation" as meaning only slave labour is to dismiss criticism of unpaid labour among Mad people, or among any people anywhere, and thus to avoid seriously grappling with the issues raised by such practices.

Flis and Wright (2011) do not discuss the major ethical and economic issues involved in requiring unpaid work from underprivileged populations confined in large institutions for people defined as Mad. By avoiding

a discussion of the entire reason for the historical commemoration efforts by Mad activists and psychiatric survivors, they avoid acknowledging past injustices that have been publicly ignored for so long. This approach allows them to sidestep "a grave injustice" – their article's title – that took place inside these walls, an injustice that later generations of activist-historians have sought both to publicly acknowledge and to stop from being perpetuated.

Why Does Any of This Debate Matter?

Disinformation that distorts serious efforts to commemorate our history as nothing more than "anti-psychiatry" matters not only for reasons of accuracy but also because of its use for gatekeeping purposes. At stake is not simply the resolution of a dispute between academics in the ivory tower. It is essential that the efforts to interpret, remember, and commemorate our collective history as Mad people, and as disabled people more broadly, be undertaken between historical researchers and the wider community of people who have lived this history. This project is made more difficult when the motives and goals of Mad activists are falsely presented as a "subtle new form of anti-psychiatry," without any serious effort to understand such work from the perspectives of those directly involved in these commemorative efforts. It needs to be stated that neither Flis nor Wright asked me or any other PSAT members involved in these efforts what our motives were for undertaking these public history commemorations.

This omission takes us back to the quotation at the start of this chapter from Bacopoulos-Viau and Fauvel (2016, 17), who insist on an either/or split between historians and Mad activists, as though the two, "of course," could never have the same aims. Like Flis and Wright (2011), Bacopoulos-Viau and Fauvel seek to impose an either/or interpretation on activist efforts to record and interpret this history. The implication is that work done by Mad activists cannot, in itself, be serious scholarship since being an activist and being a historian do not go together. If that is the case, much community-based research conducted by people in various social movements can be dismissed as not "real history" since they have been part of the history about which they have written, involving themselves as activists representing women, disabled people, racialized communities, labourers, 2SLGBTQ+ people, anti-war groups, and so on. Obviously, this conclusion is absurd. Of course, historians and Mad activists can and do have similar aims to record and remember the past and indeed can be one and the same person or one group of people identified as Mad activist-historians. At the same

time, neither historians nor activists are homogenous groups, and there are unquestionably some historians who dislike the sort of activist history that some of us have engaged in over the years. It is, of course, anyone's right to do so. No academic, however, has any business declaring that historians and activists are ipso facto separate entities simply because they do not take the same approach to history, how it is interpreted, and who gets to be involved in these interpretations. To do so is to participate in an extreme form of gatekeeping.

Such a declaration also illustrates the observation made by Tim Winter and Emma Waterton (2013, 530) that "problematic chasms in knowledge production and discourse ... now exist between the academy and those working in the heritage profession." The efforts of Flis and Wright (2011) to marginalize public interpretations of exploited psychiatric patients' labour history by dismissing such activist work as a form of "anti-psychiatry," without explaining what they mean by this term, as well as by making false comparisons and allusions, are not too different from Bacopoulos-Viau and Fauvel's (2016) statement that historians and Mad activists have different objectives, which they likewise do not explain, as though all historians are on the same wavelength and, presumably, will understand the universal application of this statement. The purpose of both articles, moreover, is the same, namely to undermine critically informed knowledge production in the public sphere about Mad people's history, which Winter and Waterton (2013) observe happening more broadly in disputes between heritage professionals and academics.

As regards PSAT's plaque campaign described here, this work was done by taking our collective history seriously from a critical perspective. It is an approach that is accountable to the community from which this history originates rather than an approach that restricts this history to academics who have, as in the cases cited here, tried to act as interpretative gatekeepers of our past. These efforts to interpret our past from the perspectives of people who have lived at least some of this history are by no means unique to the PSAT-organized plaque campaign focused on the Toronto Asylum inmate-built walls. For instance, cemetery-restoration efforts have been organized by Indigenous activists who have preserved, publicly marked, and held memorial services for Indigenous people who were buried in a cemetery between 1902 and 1934 on the grounds of the former Hiawatha Asylum for Insane Indians in Canton, South Dakota (Yellow Bird n.d.). As Carla Joinson (2016, 270) writes, "In 1988 the late Harold Iron Shield, a member of the Lakota Nation's Yankton tribe, initiated memorial services for the dead at

the cemetery"; a decade later, this cemetery "was added to the National Register of Historical Places" and has a plaque with the names of the people buried there (see also Yellow Bird n.d.).

Efforts at cemetery restoration and public marking have been undertaken elsewhere, such as on the grounds of the former Orillia Asylum, which operated in Ontario from 1876 to 2009, where people with intellectual disabilities were confined. People who had themselves been institutionalized there were involved in the interpretation of this site's history, which included plaques, cemetery preservation, and efforts to record all the names of the people who died in this institution, an ongoing endeavour (Rossiter and Rinaldi 2019, 14, 18, 54–55, 69, 75). In Minnesota, beginning in 1994, disability groups organized public efforts to "honor people who lived and died in Minnesota's state institutions" with cemetery-restoration efforts that included proper names being recorded on markers (Ladd-Taylor 2017, 223). These same efforts led to a thirteen-year campaign for a formal state apology "for the whole range of abuses that Minnesotans identified as having developmental disabilities or mental illness had suffered" (223). An apology was finally delivered in 2010, although the qualifying phrases from state officials led to dissatisfaction among disabled activists, who stated afterward that another apology would have to be forthcoming for current developments (Ladd-Taylor, 2017).

Although PSAT's work on commemorating unpaid patients' labour at the former Toronto Asylum site involved support from racialized and Indigenous activists within the Mad community, including Bobbi Nahwegahbow and Kevin Jackson, most of us who were involved were white activists. Class and gender intersections were described on the historical plaques, but race and Indigeneity were not mentioned. These omissions, although discussed during wall tours over the years, should have been recorded in print on the permanent plaques, particularly as the land on which this history took place was stolen by white settlers from Indigenous people, the Mississaugas of the New Credit (Court 2021). Criticisms can be made of the plaque commemorative project described above, with these omissions being the most poignant example of the project's shortcomings. In contrast, the critiques by Flis and Wright (2011) are both inaccurate and misleading as to what actually happened, or did not happen, in this public history project.

As this chapter has sought to underline, the past is still very present for many activist-historians involved in these efforts and is therefore not just an academic pursuit. The relevance of this work is all the more reason to ensure that the simple either/or distinctions that some historians seek to construct

with false allusions and unnecessary gatekeeping are not perpetuated into the future. Interpretations of our past need to be far more engaged with the perspectives of those who have lived the history that is being remembered for future generations. It is indeed "a grave injustice" that some academic historians have for too long sought to marginalize these efforts as being disconnected from what historians should be doing when recording our collective past.

NOTES

1 In early 2015, Alexandra Bacopoulos-Viau and Aude Fauvel invited me to submit an article for the special issue of *Medical History* (2016) that they were editing, in which their above-cited work appeared. My article was rejected for publication by two anonymous peer reviewers. While I appreciated their invitation, my criticism here of the article by Bacopoulos-Viau and Fauvel is based on the content cited herein.
2 To make clear my own personal history in relation to this topic, I was a psychiatric in-patient for a total of six months at two different mental health facilities in Ontario, one in Windsor (1976) and the other in St. Thomas (1979), when I was a teenager. While in St. Thomas Psychiatric Hospital from the end of January to mid-April 1979, I was first sent to occupational therapy and later sent to what was called "industrial therapy," or "IT." Modelled on a factory system, the IT facility was in a building on the grounds of the hospital reached by an underground tunnel from the rest of the wards. Both in-patients and disabled people who lived in the community worked there at various jobs overseen by staff. As an out-patient back home in Windsor from April 1980 to June 1981, I worked at a sheltered workshop run by Goodwill Industries, also modelled on a factory system, called Contract Division. It had punch clocks and bells that regulated the Monday to Friday workday, which began at 7:30 a.m. and ended at 4:00 p.m., with two fifteen-minute snack breaks and one half-hour lunch break. The Windsor sheltered workshop was separate from the main Goodwill store, located in another part of the city, where I worked for a week before being sent to Contract Division to work for over a year on contracts supplied by local industrial and commercial firms. This workshop was comprised exclusively of male workers with various physical and mental disabilities. Ranging in age from their late teens to their sixties, most of them were white (like me), although there was a small minority of racialized workers. Around twenty-five to thirty people worked there at any given time. There was also a manager and foreman, both white males, and for a brief time, a white woman was employed as an assistant to the foreman. Compared to most of my co-workers in 1980–81, I was fortunate to be living comfortably with my parents and siblings, whereas most of the workers whom I came to know lived at or near the poverty line and would have experienced, depending on the individual, various intersecting oppressions related to disability, race, class, and in some cases, older age. In regard to the period covered by this chapter, I was active in Toronto's psychiatric survivor and Mad community from 1990 to 2013, including being involved in PSAT from 2001 to 2013.

REFERENCES

Ashley, Susan L.T., Andrea Terry, and Josée Lapace. 2018. "Introduction: Critical Heritage Studies in Canada." *Journal of Canadian Studies* 52 (1): 1–10.

Bacopoulos-Viau, Alexandra, and Aude Fauvel. 2016. "The Patient's Turn: Roy Porter and Psychiatry's Tales, Thirty Years On." *Medical History* 60 (1): 1–18.

Burstow, Bonnie. 2015. *Psychiatry and the Business of Madness: An Ethical and Epistemological Accounting.* New York: Palgrave Macmillan.

Caute, David. 1978. *The Great Fear: The Anti-Communist Purge under Truman and Eisenhower.* New York: Simon and Schuster.

Chamberlin, Judi. 1978. *On Our Own: Patient Controlled Alternatives to the Mental Health System.* New York: Hawthorn.

Cooper, David. 1967. *Psychiatry and Anti-psychiatry.* London: Tavistock.

Court, John. 2021. "Lands of the Asylum." *Friends of the CAMH Archives Newsletter* 29 (1): 8–12. https://www.camh.ca/-/media/files/archives-newsletters/foa-newsletter-spring2021-pdf.pdf.

Dain, Norman. 1994. "Psychiatry and Anti-psychiatry in the United States." In *Discovering the History of Psychiatry*, ed. Mark S. Micale and Roy Porter, 415–44. Oxford: Oxford University Press.

Demke, Elena. 2021. "Brutal Sanity and Mad Compassion: Tracing the Voice of Dorothea Buck." In *Voices in the History of Madness: Personal and Professional Perspectives on Mental Health and Illness*, ed. Rob Ellis, Sarah Kendal, and Steven Taylor, 287–306. London: Palgrave Macmillan.

Ernst, Waltraud. 2016. "Introduction: Therapy and Empowerment, Coercion and Punishment: Historical and Contemporary Perspectives on Work, Psychiatry and Society." In *Work, Psychiatry and Society, c. 1750–2015*, ed. Waltraud Ernst, 1–30. Manchester, UK: Manchester University Press.

"Exploit." 2005. In *Compact Oxford English Dictionary of Current English*, 3rd ed., ed. Catherine Soanes and Sara Hawker, 349. Oxford: Oxford University Press.

Flis, Nathan, and David Wright. 2011. "'A Grave Injustice': The Mental Hospital and Shifting Sites of Memory." In *Exhibiting Madness in Museums: Remembering Psychiatry through Collections and Display*, ed. Catherine Coleborne and Dolly MacKinnon, 101–15. London and New York: Routledge.

Foucault, Michel. 1965. *Madness and Civilization: A History of Insanity in the Age of Reason.* New York: Pantheon.

Galer, Dustin. 2018. *Working towards Equity: Disability Rights Activism and Employment in Late Twentieth-Century Canada.* Toronto: University of Toronto Press.

Gershon, Livia. 2021. "What Does It Mean to Call Helen Keller a Fraud? A Tik Tok Trend Is Only the Most Recent Example of How People Often Question the Abilities of Marginalized Groups." *JSTOR Daily*, June 19. https://daily.jstor.org/what-does-it-mean-to-call-helen-keller-a-fraud/#:~:text=Writing%20more%20than%20a%20century,of%20people%20could%20be%20literate.

Goffman, Erving. 1961. *Asylums: Essays on the Social Situation of Mental Patients and Other Inmates.* Garden City, NY: Anchor Books.

Joinson, Carla. 2016. *Vanished in Hiawatha: The Story of the Canton Asylum for Insane Indians.* Lincoln: University of Nebraska Press.

Ladd-Taylor, Molly. 2017. *Fixing the Poor: Eugenic Sterilization and Child Welfare in the Twentieth Century.* Baltimore, MD: Johns Hopkins University Press.

Laing, R.D. 1960. *The Divided Self.* London: Tavistock.

Lapon, Lenny. 1986. *Mass Murderers in White Coats: Psychiatric Genocide in Nazi Germany and the United States.* Springfield, MA: Psychiatric Genocide Research Institute.

Mack, Tracy, and Geoffrey Reaume. 2021. "Asylum 'Ghost Tours' are Grotesque Tours." *Public Disability History* website blog journal 6 (3), May 24th. Online at: https://www.public-disabilityhistory.org/2021/05/asylum-ghost-tours-are-grotesque-tours.html.

MacKenzie, David. 2018. *Canada's Red Scare, 1945–1957.* Ottawa: Canadian Historical Association.

Marx, Karl. 1977. "Wage Labour and Capital." In Karl Marx and Frederick Engels, *Karl Marx, Frederick Engels: Collected Works,* vol. 9, 197–228. Moscow: Progress.

Millett, Kate. 1991. *The Loony-Bin Trip.* New York: Touchstone.

Morrison, Linda. 2005. *Talking Back to Psychiatry: The Psychiatric Consumer/Survivor/Ex-patient Movement.* London and New York: Routledge.

Morrow, Adrian. 2009. "If Only the Walls of These Psychiatric Institutions Could Talk." *Toronto Star,* July 13. https://www.thestar.com/life/health_wellness/diseases_cures/2009/07/13/if_only_the_walls_of_these_psychiatric_institutions_could_talk.html.

Perlin, Michael. 1992. "On Sanism." *SMU Law Review* 46 (2): 373–407.

Punzi, Elisabeth. 2019. "Ghost Walks or Thoughtful Remembrance: How Should the Heritage of Psychiatry Be Approached?" *Journal of Critical Psychology, Counselling and Psychotherapy* 19 (4): 242–51.

Reaume, Geoffrey. 2000a. "Portraits of People with Mental Disorders in English Canadian History." *Canadian Bulletin of Medical History* 17 (1–2): 93–125.

–. 2000b. *Remembrance of Patients Past: Patient Life at the Toronto Hospital for the Insane, 1870–1940.* Toronto: Oxford University Press Canada.

–. 2004. "No Profits, Just a Pittance: Work, Compensation and People Defined as Mentally Disabled in Ontario, 1964–1990." In *Mental Retardation in America: A Historical Reader,* ed. Steven Noll and James W. Trent Jr., 466–93. New York: New York University Press.

–. 2006. "Patients at Work: Insane Asylum Inmate Labour in Ontario, 1841–1900." In *Mental Health and Canadian Society: Historical Perspectives,* ed. James Moran and David Wright, 69–96. Montreal and Kingston: McGill-Queen's University Press.

–. 2016. "A Wall's Heritage: Making Mad People's History Public." *Public Disability History,* November 21. https://www.public-disabilityhistory.org/2016/11/a-walls-heritage-making-mad-peoples.html.

–. Forthcoming. "Plaques, Politics and Preservation: Publicly Memorialising Mad People's Labour History." In *Narrating the Heritage of Psychiatry,* ed. Cornelia Wächter, Elisabeth Punzi, and Christoph Singer. Leiden: Brill.

Rodéhn, Cecilia. 2020. "Emotions in the Museum of Medicine. An Investigation of How Museum Educators Employ Emotions and What These Emotions Do." *International Journal of Heritage Studies* 26 (2): 201–13.

Rose, Sarah F. 2017. *No Right to Be Idle: The Invention of Disability, 1840s–1930s.* Chapel Hill: University of North Carolina Press.

Rossiter, Kate, and Jennifer Rinaldi. 2019. *Institutional Violence and Disability: Punishing Conditions.* Abingdon, UK: Routledge.

Schrecker, Ellen. 1986. *No Ivory Tower: McCarthyism and the Universities.* New York: Oxford University Press.

Shimrat, Irit. 1997. *Call Me Crazy: Stories from the Mad Movement.* Vancouver: Press Gang.

Shorter, Edward. 1997. *A History of Psychiatry: From the Era of the Asylum to the Age of Prozac.* New York: John Wiley and Sons.

Sorensen, Chris. 2003. "Future of Shaw Street Wall in Doubt." *Toronto Star,* February 13.

Starkman, Mel. 1981. "The Movement." *Phoenix Rising: The Voice of the Psychiatrized* 2 (3): 2A–15A.

Szasz, Thomas. 1961. *The Myth of Mental Illness: Foundations of a Theory of Mental Illness.* New York: Hoeber Harper.

Winter, Tim, and Emma Waterton. 2013. "Critical Heritage Studies." *International Journal of Heritage Studies* 19 (6): 529–31.

Yellow Bird, Pemina. n.d. "Wild Indians: Native Perspectives on the Hiawatha Asylum for Insane Indians." National Empowerment Center. https://power2u.org/wild-indians-native-perspectives-on-the-hiawatha-asylum-for-insane-indians-by-pemima-yellow-bird/.

2

Contested Memorialization
Filling the "Empty Space" of the T4 Murders

ELENA DEMKE

When I was a school child in East Germany in the 1970s and '80s, my family moved town twice. Adapting to a new environment included learning about the local variation of an otherwise identical insult, to be spoken in a mocking tone: "You will be sent to [add the name of the most notorious mental institution of the region]." The names that I learned this way were Brandenburg/Görden (while living in Potsdam), Herzberge (while living in Berlin), and Uchtspringe (while living in Magdeburg). I'm not sure how many of my peers shared the uneasy feeling that I experienced, vaguely wondering: "What if I ... ?," but I'm sure that, while learning to conform to an ableist and sanist culture, we were unaware that those had been the sites where psychiatrized and disabled children had been murdered (Uchtspringe and Brandenburg) or where they had been selected for killing (Herzberge) just a few decades earlier.

Awareness grew slowly, hesitatingly. It entailed and continues to entail a shifting of concepts of identity. A fellow student at Oxford in the 1990s, about to embark on a career in the history of medicine, insisted on sharing graphic details about the assessments of the first procedures to kill by gassing, tested on mental patients at the onset of the Aktion T4 program. I guess he did not know I was psychotic right then and overwhelmed as I desperately looked for a useful message in information I would rather have avoided at the time.

Perhaps that's why I chose avoidance later on. Although I was working in the field of memorial politics (with respect to a different historical period) at an institute close to the former site of Tiergartenstraße 4, where the Aktion T4 program was headquartered, beyond hearing about a memorial being set up there, I did not process any further information for quite a long time.

As I noticed a transparent wall made of blue glass being set up, I wondered. At my workplace, I glanced at the invitation card for the opening ceremony, again wondering – wondering in the sense of stopping short of spelling out the thought. When I eventually went to see the memorial, the thought became clear: The uneasy sense of "What if I ... ?" had taken on a new meaning; the boundaries of "us" and "them" had been shifted. Given the social, behavioural, diagnostic, and institutional criteria that predicted selection for being murdered in the course of the Aktion T4 program, I realized that by then some of my closest friends met those criteria – diagnoses of schizophrenia together with ascribed and certified unfitness for work, a record of "unruly" behaviour, and so on. Projecting my own parameters back into the Nazi era, I could consider myself one of those "privileged" individuals among the Mad who were likely to be sterilized but not murdered. This did not come as a relief, nor have any of my friends ever expressed gratefulness for not having being exposed to the risk of being murdered.

Instead, we are angry and outraged about the suffering caused by harmful present-day psychiatric concepts and practices, as was the founding figure of the Federal Association of (Ex-) Users and Survivors of Psychiatry, Dorothea Buck, who on the occasion of her hundredth birthday in 2017, soon put the present aside, produced a recent newspaper, keenly asking her visitors what we were going to do about the instances of psychiatric coercion that she had read about.

As laid out by the editors of this collection, the concept of sites of conscience focuses on the relationship between past crimes and today's human rights issues. However, the significance of past crimes is open to interpretation, as are the human rights in question. Alliances are shaped by present-day interests and are formed around shared interpretations of the past or are even brought about by these interpretations. Through such fluid and complex processes, sites of conscience are being negotiated.

My contribution here highlights the complexity of such negotiations by focusing on a seemingly forgotten chapter in the history of the commemoration of crimes committed against psychiatrized and disabled people at Berlin's Tiergartenstraße 4, the former headquarters of the planning and organizing of the so-called T4 murders. On first sight, "chapter" may appear to be too big a word for a failed campaign to put up a memorial and learning centre in the 1990s, which was finally succeeded by a memorial based on different concepts, supported by different agents, and rooted in different decisions regarding the present-day relevance of commemorating the murders. Nonetheless, this chapter in the history of commemorating the T4 crimes at the site of their planning is worth discussing and remembering: it was an initiative by former psychiatric patients that appears exemplary in terms of contesting the significance of past crimes against disabled and psychiatrized people in relation to the current human rights issues in the same field.

This case study is situated in several, overlapping historical contexts: the prosecution, forced sterilization, and murder of disabled and psychiatrized people under Nazi rule; the history of the attempts to redress these crimes and to commemorate their victims; and the history of the actual site of Tiergartenstraße 4.

The Crimes

Tiergartenstraße 4 in Berlin was the address of the central Nazi headquarters that supervised the planning and organizing of the killings of adult disabled and psychiatrized people. These murders were carried out using gas chambers at six extermination facilities, most of which had been set up at psychiatric institutions stretching across the territories of the German Reich and incorporated Austria. They were operated from September 1939 until August 1941, during which period about 70,000 victims were murdered. At the same time and later, mental patients were murdered in the occupied territories through gassings and mass shootings. After protests had shown that the Aktion T4 program could no longer be kept secret, and with the invasion of the Soviet Union imminent, Adolf Hitler ordered the end of the program. But the killings of adults continued at psychiatric institutions by means of medically supervised starving or lethal medication, methods that had been used in the murder of children from 1939 on, with a particular focus on selecting children for the sake of conducting brain research. Estimates state that, including adult and child victims as well as those murdered in Germany and in the occupied territories, 200,000 to

300,000 psychiatrized and disabled people were killed and that 350,000 to 400,000 were forcefully sterilized.[1] The headquarters at Tiergartenstraße 4 supervised the medical, organizational, and administrative apparatus behind the murders, working in up to six specialized divisions (Hinz-Wessels 2015a, 75). Thus the medical division oversaw the decisions on who was to be killed. Among other steps, this process included collecting specific forms on patients (Meldebögen) submitted by hospitals and care institutions and forwarding them to medical experts, who then made decisions on the basis of the forms provided; the transport division organized the deportation of those selected to be killed at the extermination facilities; the administrative division dealt, among other things, with death certificates and information for the families of victims; and along with an economic division, there was one responsible for the staff of the extermination facilities, a significant number of whom were transferred to Holocaust extermination camps after the official end of the T4 program. Nonetheless, the T4 headquarters continued to be involved in what has been termed "wild euthanasia" after 1941 (Hinz-Wessels 2015a).

Redressing and Commemoration

The history of forced sterilizations and the mass murdering of disabled and psychiatrized people under Nazi rule was particularly late to be recognized as a societal responsibility requiring legal redress, financial compensation, and public commemoration. This history of protraction and reluctance is complex in itself. It entails a brief period of focus on disabled and psychiatrized victims during the Nuremberg trials, the conviction of a small number of perpetrators during the immediate post-war years, and the consolidation of professional elites in the Federal Republic of Germany (West Germany), which bolstered the authority of medical experts who had been involved in making possible the crimes and who now became agents of the ongoing degrading of former victims by acting as experts on questions of rehabilitation or compensation (Tümmers 2011; Westermann, Kühl, and Ohnhäuser 2011). The German Democratic Republic (East Germany) dealt strategically with perpetrators, storing relevant documents in the archives of the secret police, ready to use them either to secure internal adherence to the regime or to taint the reputation of West Germany (Leide 2006; Weinke 2002). Survivors and relatives thus faced degrading administrative procedures and routine refusals when trying to gain compensation and rehabilitation.

When the former head of the medical division of the T4 headquarters, Werner Heyde, who had continued to work as a doctor and expert witness

under a false name in West Germany, was exposed in 1959, a major trial against T4 perpetrators seemed feasible. However, his suicide prevented a trial and protected fellow perpetrators. The public silence on the T4 crimes that had followed the Nuremberg trials was thus interrupted but not overcome in the early 1960s.

Historiography usually identifies journalist Ernst Klee and his 1983 study *Euthanasie im NS-Staat: Die Vernichtung lebensunwerten Lebens* (Euthanasia in the Nazi state: The destruction of lives unworthy of life) as the groundbreaking work that brought these crimes into public focus again. However, the fight of survivors – although not publicly acknowledged – had broken ground, too. Notably, during the 1960s, Dorothea Buck, a victim of forced sterilization in 1936 and by the end of the twentieth century one of the most eminent activists of the movement of psychiatric survivors in Germany, was stirred by the news on an impending trial that promised to make the voices of victims heard and the deeds of doctors and their helpers known. After Heyde's suicide had prevented a trial, she wrote a play called *Die Tragödie der Euthanasie* (The tragedy of euthanasia), envisaging theatre as an alternative way to create a public stage for the history of the T4 crimes. She also drew a line to contemporary psychiatry, adding a "satyr play" on the latter, and in numerous of her texts to come, she stated her view that there was an interrelationship between the disrespect for psychotic experience expressed in current psychiatric practice and the disrespect for the lives of Mad people that had led to their extermination. In the late 1970s, she sent parts of her play to Ernst Klee, encouraging him to address the topic of the T4 murders in his work. When, a few years later, he told her that he was going to take up the matter, she urged him to include parts of her text in his publication. He refused to do so and did not even mention Buck in his 1983 book (Demke 2021).

This episode shows that making visible the crimes and making invisible the contributions of survivors could go hand in hand. Such was the case with the interaction of Dorothea Buck and Ernst Klee in the 1980s, and it seems to be have been the case, too, with the trajectory of the memorial at the former site of Tiergartenstraße 4.

As for the strife of legal recognition and compensation, the situation of the victims of forced sterilizations and of survivors of deportations to extermination facilities of the T4-program improved slowly from 1988 onward. They were included in the group of so-called war victims receiving financial aid in cases of social hardships, but they have not been granted the

same legal status and compensations as recognized victims of National Socialist injustice on racial, religious, or political grounds. In 2007, the German Parliament (*Bundestag*) discussed the annulment of the legal basis of forced sterilizations and in this context declared the legislation and practice of forced sterilizations under Nazi rule to have been acts of injustice by the National Socialist regime – a kind of moral victory without financial consequences.[2] Protraction and lack of recognition can be understood as consequences of the continual acceptance of the sanist and ableist assumptions that had been part of the ideological substructure of the crimes and that had persisted throughout the consecutive, differing political systems. At the same time, the story is complex and paradoxical. Notably, it was the murdering of these stigmatized groups that had led to protests on a most unusual scale under the Nazi regime.

The Site

Tiergartenstraße 4 was situated in the centre of Berlin, around the corner from what was considered the busiest traffic junction in Europe in the 1920s – Potsdamer Platz. Under Nazi rule, the area was a hub for the organization of repression and terror: among others, the Gestapo headquarters, the Volksgerichtshof (People's Court), and the headquarters of the T4 murders were all situated within walking distance. The latter was housed in the villa of the dispossessed Jewish family of Hans Liebermann and his sister Eva. Toward the end of the Second World War, the building and the surrounding quarter were heavily damaged in an air raid. Parts of it remained in use but were further damaged and eventually torn down after the war (Hinz-Wessels 2015a; Wehry 2015). The post-war division of the city turned the formerly busy quarter and centre of power into an area at the margin of West Berlin, close to the border with East Berlin. When the Berlin Wall was built in 1961, the area ran the risk of becoming an urban nowhere-land. With the aim of countering this effect, and to compensate for the inaccessibility of the respective original institutions, which happened to stand on East Berlin ground, outstanding West Berlin cultural institutions were built in the area: the New National Gallery; (West) Berlin's central academic library, Staatsbibliothek Preussischer Kulturbesitz (State Library of Prussian Cultural Heritage); and a new house for the Berlin Philharmonic Orchestra. The site of the former villa Tiergartenstraße 4 was incorporated into the new architectural ensemble – as a paved void and bus stop in front of the orchestra house.

Addressing the Void: Social Psychiatry and "Gedenkstättenbewegung" in the 1990s

Compared to its British and Italian counterparts, (West) German psychiatry was late to undergo deinstitutionalization, doing so only in the 1970s (Beyer 2016). Around the same time, the concerns of the British, Italian, and Swedish movements for a democratization of historiography through "histories from below" were taken up in Germany, too, also spurring interest in day-to-day aspects of Nazi rule and persecution. Several local initiatives were undertaken to turn sites associated with Nazi crimes into places of historical learning, and earlier failures to address the difficult past were criticized; historians speak of a "Gedenkstättenbewegung" (memorial movement) when characterizing this period (Knoch 2020, 70–77). These coinciding developments set the scene for renegotiating the rules of discourse concerning the murdering of disabled and psychiatrized people.

In the context of social psychiatry, particularly during the 1980s, comparisons between the murdering of patients under Nazi rule and contemporary psychiatric practice became acceptable and thus no longer confined to the voices of psychiatric survivors. In 1979, the Deutsche Gesellschaft für Soziale Psychiatrie (German Society for Social Psychiatry), founded in 1970, published a memorandum titled "Holocaust und die Psychiatry – oder der Versuch, das Schweigen in der Bundesrepublik zu brechen" (The Holocaust and psychiatry, or The attempt to break the silence in the Federal Republic) (Dörner et al. 1980, 206) based on research and on voices from a discussion group at a congress of the so-called Mannheimer Kreis (Mannheim Circle) of the same year. It gives witness to a radical self-questioning of psychiatric professionals in light of their learning about the T4 murders. Notably, not only were coercive practices interpreted as contemporary versions of traditions of psychiatric violence, but the very idea of changing people through therapy or through medication and other interventions was also questioned for its assumed alignment with the progressive ambitions of some of the major T4 perpetrators. Consequently, prior to discussions on dealing with the actual site of Tiergartenstraße 4, these debates and initiatives had highlighted the potential of the T4-murders to become a *lieu de mémoire* (site of memory, see Nora and Kritzman 1996) that would support historical narratives in the vein of what more recently has been encapsulated in the ethics of a "site of conscience," urging the questioning of present-day psychiatric repression.

However, this potential was not embraced by the addressees of the memorandum. Any connection between the history of psychiatry under

Nazism and present-day psychiatric practices was strictly refuted by the minister of health in response to the memorandum (Dörner et al. 1980, 224). The critical line of thought, connecting the commemoration of past crimes with the questioning of present practices, remained one limited to certain circles of people and, with respect to German social psychiatry, also one of a limited time slot.

In 1987, on the occasion of Berlin's 750th anniversary, activists and professionals subscribing to a "history from below" initiated a so-called *mobiles Museum* (mobile museum), using a converted bus to host temporary exhibits. It criticized the self-acclamatory character of the celebrations by staging historical counter-narratives at sites of Nazi crimes and persecution. Supported, among others, by the Berliner Geschichtswerkstatt (Berlin History Workshop) and the Berliner Ärztekammer (Berlin Medical Association), and based on texts by historian Götz Aly, the first exhibition of the mobile museum was shown at the site of the former Tiergartenstraße 4. Titled *Vergessene Geschichte? Tiergartenstraße 4 – Euthanasie-Aktionen 1939–1945* (Forgotten history? Tiergartenstraße 4 – Euthanasia campaigns, 1939–1945), it ran during September 1987, accompanied by lectures and a film screening (Allen 2015, 132). Aly insisted on the pre-agreed destruction of the exhibition after the showing, but the commitment of Aly and others resulted in the grounds of the former T4 headquarters being marked with a metal plaque in "honour to the forgotten victims." It spoke of 200,000 victims and described them as "poor, despaired, defiant or in need of help" – a wording that avoided the medical framing that is implied in speaking of the "mentally ill." Although the authors used the latter term, too, the overall characterization of the victims was kept broad, making provisions for understanding conditions such as poverty and defiance as reasons for psychiatrization – which was closer to the self-understanding put forward by activists of the (ex-)user and survivor movement (Aly 1989).

The Utopian Haus des Eigensinns/Museum of Mad Beauty of the 1990s

The 1990s saw heightened state involvement in the setting-up or rebuilding of memorial sites addressing Nazi as well as Communist repression in Germany (Knoch 2020). Research on and commemoration of the T4 murders won new momentum, too. The opening of the archives of the former East German Secret Police led to the unexpected finding of thousands of files on T4 victims (Hohendorf et al. 2003). And with the pulling-down of the Berlin Wall, the area around Potsdamer Platz became a huge and busy building site, located once again in Berlin's vibrant centre.

Interested in the resurgence of utopian hopes in the 1980s, Jennifer L. Allen (2015) has analyzed the mobile museum and the Berliner Geschichtswerkstatt as examples of West Berlin movements of the 1980s that combined grassroots democracy, the questioning of established institutions, and the struggle to create enduring alternatives, which turned out to be different from those originally envisioned when "the 1990s rendered confrontations with Germany's Nazi past decidedly mainstream" (182).

With respect to the remembrance of the T4 murders, this periodization has to be modified since developments were "delayed" by more than a decade. In the late 1990s, far from rendered mainstream, commemoration of the former T4 headquarters was addressed by another grassroots project in which (ex-)users and survivors of psychiatry campaigned to set up a museum and memorial site, securing considerable funding and renowned public support.

Its utopian power lay in a double questioning of established institutions. Not only was it a grassroots initiative, but it was also carried out by the kind of people who had actually been victims of Nazi eugenics – such as Dorothea Buck – and by younger, "unruly" Mad folk who had received the kind of diagnostic and institutional labels that had once been decisive for the selection procedures of the T4 program. Collaborating with the Bundesverband Psychiatrie-Erfahrener (Federal Association of Psychiatric Survivors) and with the Bund der Euthanasie-Geschädigten und Zwangssterilisierten (Association of Victims of Euthanasia and Forced Sterilizations), including the relative of a victim killed in the T4 program who was involved as a potential curator, and enjoying the support of a number of well-known writers, historians, and politicians, the Berlin Irrenoffensive envisioned a site at which the supposedly unruly, unfit Mad would take the lead in giving shape to commemoration and historical learning at the former headquarters where the murders were planned. After four years of campaigning and disputes, this initiative finally failed.

This initiative receives only very brief mention in later publications on the history of the memorial site, whose form was decided on in 2011, with the project completed in 2014 (Hinz-Wessels 2015a, 138; 2015b, 42). Documents archived online by the Lunatics' Offensive (Haus des Eigensinns n.d.), the written legacy of Dorothea Buck (archived in the Dorothea-Buck-Haus, DBH), and press coverage by various newspapers from 1998 to 2002 allow for the reconstruction of the visions, agents, and contestations of this campaign in more detail.

Facts, Visions, and Contestations

The plans were rather large in scope: 1,100 square metres for a permanent historical exhibition plus art exhibitions, a café, a library, a film-screening facility, and a lecture room. Transferring the famous collection of art by psychiatric patients, the Prinzhorn Sammlung, from Heidelberg University's psychiatry department to the Haus des Eigensinns/Museum of Mad Beauty was a core element of the plan (Buck to R. Talbot, October 6, 2001, DBH). The design by the Berlin architects Hierholzer and Rudzinski consisted of a circular steel construction, made from segments that would have allowed for a fast erection of the building with an open space underneath, and included taking up plans by the city to replace the bus station on the former grounds of Tiergartenstraße 4 with a small park (Buck to M. Wunder, January 27, 1998, DBH).

Public support was considerable. In January 1998, the Freundeskreis (Association of Friends) of the Haus des Eigensinns/Museum of Mad Beauty was founded, including renowned public figures such as Wolfgang Huber, the bishop of Berlin, Brandenburg, and Upper Silesia; Ellis Huber, the head of the Berlin Medical Association; Norbert Kampe, the director of the memorial site and learning centre House of the Wannsee-Conference; Henry Friedländer, a Holocaust survivor and researcher; and Peter Raue, an internationally renowned lawyer on questions of art and property, who provided an expert statement questioning the righteous ownership of the Prinzhorn collection by Heidelberg University's psychiatry department.[3]

Dorothea Buck used her double identity as a victim of forced sterilization under Nazism and as a psychiatric survivor throughout three political systems in Germany, as well as her involvement in the respective associations, in order to further concerted action. For instance, she wrote to the head of Heidelberg University on behalf of the Bund der Euthanasie-Geschädigten und Zwangssterilisierten (Association of Victims of Forced Sterilizations and Survivors of T4 Crimes) to request that the Prinzhorn collection be handed over to the Federal Association of Psychiatric Survivors. "We, those forcefully sterilized and survivors of psychiatric extermination facilities," she stated, "full heartedly embrace and support the initiative of present-day psychiatric survivors" (Buck to the head of Heidelberg University, January 12, 1998, DBH). Three days later, the board of the Federal Association of Psychiatric Survivors requested that the collection be handed over to a memorial site in Berlin, to be headed by psychiatric survivors, and argued that keeping the collection in Heidelberg University's psychiatry department, which had

had been involved in the T4 crimes, "not only taunts the artists and victims but is also an ongoing insult to present-day psychiatric survivors (B. Siebrasse to the head of Heidelberg University, January 15, 1998, DBH).

A private donator had offered 1.75 million Deutschmark, on the condition that the plans outlined by the survivor initiatives were to be put into practice (Buck to the executive of the German Society for Social Psychiatry, November 20, 2000, DBH).

However, federal funds to complement the private donation would have had to be provided, too, and the Berlin Senate would have had to agree to the property's use. Although the plans enjoyed the support of the Social Democrats, the Green Party, and the Party of Democratic Socialism, they were rejected by the Christian Democrats, then the strongest political force in the Berlin Senate, whose members where skeptical about a potential "inflation of memorials" (*Die Tageszeitung* 1999).

Survivor initiatives continued to campaign for the implementation of their plans, but contestations ensued. Thus, the significance of survivorship was disputed. Although the curator-to-be, Petra S., was the niece of a T4 victim, Buck argued that the voice of "more direct survivors" should be given greater weight (Buck to the board of the Federal Association of Psychiatric Survivors, January 29, 1998, DBH).

Readiness for compromise – such as opting for a loan of pieces from the Prinzhorn collection instead of a transfer of ownership – and matters of respect and appreciation for contributions from outside activism were further points of contestation (Buck to P. Storch and R. Talbot, January 7, 1998, DBH).

Finally, the question of whether present-day psychiatry had fundamentally changed compared to psychiatry under Nazism was disputed. Thus, the initiator of the Haus des Eigensinns/Museum of Mad Beauty, René Talbot, argued that the lack of willingness to hand over the Prinzhorn collection to a survivor-run initiative documented ongoing disrespect for survivors, comparing the potential significance of such an act to the famous gesture of German chancellor Willy Brandt falling to his knees in front of the memorial for victims of the Warsaw Ghetto in 1970 (Buck to R. Talbot, January 8, 1998, DBH).

Information on the involvement of one of the activists with Scientology further damaged the image of the campaigners for the museum and eroded trust in them and among them. The person in question – Elvira Manthey – had been deported to Brandenburg's T4 termination facility as a child but,

unlike her sister, had not been sent to the gas chamber. Buck referred to the lack of support by established authorities for someone like Manthey in order to excuse and explain her dubious allyship with Scientology (see, along with others, the comments in Buck to U. Caberts, July 9, 2001, DBH). However, networks and solidarity crumbled.

While fighting to rescue the plans, Buck invoked their underlying vision by using arguments that gave witness to the urgency that activists felt about connecting the past to the present at the former site of Tiergartenstraße 4 along the lines of what much later became known as "sites of conscience." Writing to the minister of health, Andrea Fischer, she argued that a mere memorial in the sense of a *Denkmal* (monument) would address only the past, whereas a *Gedenkstätte* (in the sense of a memorial site with a learning centre) could "support present-day survivors and their families" (Buck to A. Fischer, September 9, 2000, DBH). In an address to the parliamentary group of the Social Democrats in the German Parliament, she added, "In order to reduce prejudice against ... the mentally distressed, I envisage the contributions of the memorial site planned by us, such as exhibitions of art by former patients ... Just a memorial/monument without a learning site will not change prejudice in our society" (Buck to Dr. Tesch, September 1, 2000). "Us," in this context, refers to the survivor-run character of the memorial as envisaged by Buck, Talbot, and their allies. They insisted that commemoration also required a performative redressing of prejudice and discrimination, which implied to grant those activists carrying the same psychiatric labels as the former victims, authority over the shaping of the memorial site. The case of Henry Friedländer documents that this reasoning could be shared by a professional from outside the Mad community: Friedländer argued that the current activists and ex-patients had a right "to speak for those murdered." He also interpreted the refusal to hand over the art of former patients to the proposed Museum of Mad Beauty in Berlin's Tiergartenstraße as an expression of the ongoing disrespect for psychiatric (ex-)patients (*Die Tageszeitung* 1998). However, this position was not widely shared by the evolving German memorial culture.

Today's Memorial

By November 2011, when the establishing of a memorial at the former site of Tiergartenstraße 4 was discussed and decided in Parliament, the plans for the Haus des Eigensinns/Museum of Mad Beauty and the visions of survivor initiatives had disappeared from the agenda. Although some activists and

members of survivor initiatives had been invited to take part in round-table talks preceding the political decision, their position was far from predominant, and the politics of convening this group seem to have lacked transparency, as stated by the former chairwoman, Margret Hamm (2021). Historians of psychiatry who were involved in writing the concept for the memorial later stressed efforts made in terms of "inclusion," such as discussions of the concept with invited representatives from various survivor groups. However, the authoritative book on today's memorial and its history speaks a different language. Notably, while discussing at length the usefulness of easy language and media stations for purposes of inclusion (even naming the trainers who ran workshops) and while framing inclusion as having the aim of enabling those who would have been killed under Nazism to appropriate their own history, the same chapter of the book leaves out the story of the most dynamic and elaborate attempt at such an appropriation – the campaign of survivor initiatives to create the Haus des Eigensinns/Museum of Mad Beauty (Fuchs and Rotzoll 2015). It gets only brief mentioning in two sentences in a chapter on the history of the memorial in the same book, with the names of the activists omitted and their visions and aims unstated (Hinz-Wessels 2015b, 42). It is also missing from the brief chronicle of today's memorial site, which refers to the metal plaque of 1989 and to the round-table initiatives from 2007 onward (Stiftung Denkmal für die Ermordeten Juden Europas n.d.).

The genealogy of the Memorial and Information Site for the Victims of the National Socialist "Euthanasia" Murders (Stiftung Denkmal für die Ermordeten Juden Europas n.d.), which was finally handed over to the public in September 2014, is complex and cannot be dealt with in any depth for the purposes of this chapter. It includes the evolution of a new memorial landscape in Berlin's city centre, where the Memorial to the Murdered Jews of Europe was handed over to the public in 2005, followed by the Memorial to Homosexuals Persecuted under National Socialism in 2008 and the Memorial to the Sinti and Roma of Europe Murdered under National Socialism in 2012. The Deutsche Gesellschaft für Psychiatrie, Psychotherapie und Nervenheilkunde (German Association for Psychiatry, Psychotherapy, and Neurology), which – unlike the Ärztekammer Berlin (Berlin Medical Association) and the German Society for Social Psychiatry – had been rather silent on the topic during the preceding decades, got involved in an alliance with medical historians of psychiatry who, following the discovery of the patient files of T4 victims in the 1990s, had specialized in the topic.

Their efforts were no longer grassroots nor utopian but instead followed the paths set out by developments that Allen (2015) has characterized as mainstream memorialization. The design was decided on through a competition, which was criticized for not favouring designs aimed at reminding the visitor of "discrimination against psychiatric patients up until now" and for producing a memorial considered to be a "budget version of commemoration" (Nowak 2013).

The winning and finally implemented design combines abstract art – a transparent wall made of blue glass that is 24 metres long and rises higher than people's heads – with information on the historical background, presented on a steel panel that offers an overview of the dynamics, scope, and context of the murders, exemplary biographies of victims, and information on perpetrators.

As for the question of a mere memorial versus a memorial site with a museum and learning centre, the memorial's design constitutes a compromise, as facilities at the nearby Memorial to the Murdered Jews of Europe are used for seminars on the history of the T4 murders, and the neighbouring Berlin Philharmonic Orchestra hosts commemorative events.

A Site of Conscience?

If addressing present-day psychiatric repression and working toward social justice are criteria for a site of conscience, the plans for the Haus des Eigensinns/Museum of Mad Beauty met these criteria very well. The plans highlighted the creativity of former patients and T4 victims by including their art and envisioned to make it also a "centre of our self-help movement" (Buck to the executive of the German Society for Social Psychiatry, R. Suhre, November 20, 2000, DBH), and perhaps most importantly, redressed stigma in a performative way by granting authority to those who might have been killed under Nazism.

While developed and pursued by those whose experience of psychiatric labelling was a fit with that of the largest group of T4 victims, these plans made no provision for including other victims, such as people with learning disabilities or physical handicaps, in terms of shared control of the project. However, it was not the omission of the latter that led to the failure of their project. Rather, the organizers seem to have asked for too much in seeking more control (including control over the artwork of former patients) than the political and academic elites were prepared to grant to (ex-)users and survivors of psychiatry, despite considerable support by individuals.

Although hardly mentioned in the published trajectory of today's memorial, the historical significance of this initiative appears to be considerable: it put the request for a substantial memorial and learning site on the political agenda, and it was a forerunner in spirit to the United Nations Convention on the Rights of Persons with Disabilities.

In 2011, when the German Parliament finally discussed the resolution to set up a memorial, the speaker of the Christian Democrats expressed his thanks for the "various civic initiatives" undertaken to "patiently but also relentlessly" support the cause of commemorating the T4 crimes, but no survivor initiatives were named. Rather, the German Association for Psychiatry, Psychotherapy, and Neurology was identified as a representative example of this civic commitment, and such commemoration was framed as "strengthening democracy, fighting extremism, [and] preventing dictatorial regimes." Any reference to present-day psychiatric repression was absent from this speech and from any others (Deutscher Bundestag 2011, 16635).

Survivors had interpreted history differently and had envisioned a different site. The connection that they made with the present was quite different, too: not a confirmation of the status quo or vague warnings of extremism but demanding a more tolerant society with respect to madness – which entails criticism of the pathologization of mental distress.

In 2017, the Congress of the World Psychiatric Association took place in Berlin. A group of (ex-)users and survivors of psychiatry unrolled a banner at the entrance, branding this conference as convened "in the city of the murderers." Others accepted the invitation to deliver papers, more or less disillusioned about the tokenistic nature of their contribution and yet hoping to move something or someone. Among us was New York sociologist and activist Darby Penney, who asked me to accompany her to the T4 memorial afterward. She did not hold any internalized fear of appearing "too radical" or "too anti-psychiatric" and had no hesitation about understanding the site as one of solidarity with former victims, becoming deeply immersed in the site – and in grief. At that moment, a bus full of psychiatrists from all over the world, guests to the congress, happened to stop by for a rushed visit. A short nod from the German historian who functioned as their tour guide and long gazes from me while I observed the way that they and Darby moved about at the site. It made palpable to me how this site spoke to "us" versus "them" in a different language. And it was clear

that the distribution of power was unequal when it came to making publicly known what "the site had to say." Indeed, there was a wall between us. It was not made of blue glass.

NOTES
Dedication: In memory of Darby Penney, 1952–2021.
1 Research has been extensive since the 1990s, more recently with a special focus on local dynamics and individual biographies. Exemplary are Beyer et al. (2016), Jütte (2011), Rotzoll (2010), and Westermann, Kühl, and Ohnhäuser (2011). For a discussion of the numbers of victims, see Faulstich (2000) and Topp (2013, 35). For overviews in English, see Bailer-Galanda (2019) and Robertson, Ley, and Light (2019).
2 Herrmann and Braun 2010. See also the timeline of the struggle for recognition by the Association of Victims of Forced Sterilizations and Survivors of T4 Crimes: https://www.euthanasiegeschaedigte-zwangssterilisierte.de/themen/entschaedigung/zeittafel-entschaedigungspolitik-fuer-zwangssterilisierte-und-euthanasie-geschaedigte/.
3 See the collection of documents, including open letters and press releases, by the Lunatics' Offensive in Haus des Eigensinns (n.d.). The Berlin newspaper *Die Tageszeitung (Taz)* covered the topic several times, see Andresen and Lutz 1998, Lutz 1998, Nowak 2001, Spannbauer 1999.

ARCHIVE
Dorothea-Buck-Haus (DBH), Diakonisches Werk Gladbeck-Bottrop-Dorsten, written legacy of Dorothea Buck.

REFERENCES
Allen, Jennifer Leigh. 2015. "Searching for Sustainable Utopia: Art, Political Culture, and Historical Practice in Germany, 1980–2000." PhD diss., University of California, Berkeley. https://escholarship.org/uc/item/0j67m8xp.
Aly, Götz. 1989. *Aktion T4: 1939–1945: Die "Euthanasie"-Zentrale in der Tiergartenstrasse 4.* Berlin: Edition Hentrich.
Bailer-Galanda, Brigitte, and Juliane Wetzel. 2019. *Mass Murder of People with Disabilities and the Holocaust.* Berlin: Metropol.
Beyer, Christof. 2016. "'Islands of Reform': Early Transformation of the Mental Health Service in Lower Saxony, Germany in the 1960s." In *Deinstitutionalisation and After: Post-war Psychiatry in the Western World*, ed. Despo Kritsotaki, Matthew Smith, and Vicky Long, 99–114. New York: Springer.
Demke, Elena. 2021. "Brutal Sanity and Mad Compassion: Tracing the Voice of Dorothea Buck." In *Voices in the History of Madness*, ed. Robert Ellis, Sarah Kendal, and Steven J. Taylor, 287–306. New York: Springer.
Deutscher Bundestag. 2011. Plenarprotokoll 17/139, November 10, 16635. https://dserver.bundestag.de/btp/17/17139.pdf.

Die Tageszeitung. 1999. "Kahlschlag im "Wald der Mahnmale," August 10, 1999, 15.

—. 1998. "Sie sprechen für die Ermordeten," April 15.

Dröner, Klaus, Christiane Haerlin, Veronika Rau, Renate Schernus, and Arnd Schwendy. 1980. *Der Krieg gegen die psychisch Kranken. Nach "Holocaust": Erkennen – Trauern – Begegnen.* Rehburg-Loccum: Psychiatrie-Verlag.

Faulstich, Heinz. 2000. "Die Zahl der 'Euthanasie'-Opfer." In *"Euthanasie" und die aktuelle Sterbehilfe-Debatte: Die historischen Hintergründe medizinischer Ethik*, ed. Andreas Frewer and Clemens Eickhoff, 218–34. Frankfurt: Campus.

Fuchs, Petra, and Maike Rotzoll. 2015. "Erinnern heißt gedenken und informieren: Konzeption einer Ausstellung an schwierigem Ort." In *Tiergartenstraße 4: Gedenk- und Informationsort für die Opfer der nationalsozialistischen "Euthanasie"-Morde*, ed. Uwe Neumärker, 44–51. Berlin: Stiftung Denkmal für die Ermordeten Juden Europas.

Hamm, Margret. 2021. Personal communication with author, October 17.

Haus des Eigensinns. n.d. https://www.psychiatrie-erfahren.de/eigensinn/projekt.htm.

Hermann, Svea Luise, and Kathrin Braun. 2010. "Das Gesetz, Das Nicht Aufhebbar Ist: Vom Umgang Mit Den Opfern Der NS-Zwangssterilisation in Der Bundesrepublik." *Kritische Justiz* 43 (3): 338–52.

Hinz-Wessels, Annette. 2015a. *Tiergartenstrasse 4: Schaltzentrale der nationalsozialistischen "Euthanasie"-Morde.* Berlin: Links.

—. 2015b. "Von der Bankiersvilla zum Erinnerungsor." In *Tiergartenstraße 4: Gedenk- und Informationsort für die Opfer der nationalsozialistischen "Euthanasie"-Morde*, ed. Uwe Neumärker, 34–43. Berlin: Stiftung Denkmal für die Ermordeten Juden Europas.

Hohendorf, Gerrit, Maike Rotzoll, Paul Richter, Wolfgang Eckart, and Christoph Mundt. 2003. "The Victims of the National Socialist 'T4' Euthanasia Programme – Preliminary Results from the Analysis and Interpretation of Patient Files Stored in the Federal Archive in Berlin." *B.I.F. Futura* 18 (1): 23–34.

Jütte, Robert. 2011. *Medizin und Nationalsozialismus: Bilanz und Perspektiven der Forschung.* Göttingen: Wallstein.

Knoch, Habbo. 2020. *Geschichte in Gedenkstätten. Theorie – Praxis – Berufsfelder.* Tübingen: dtv.

Leide, Henry. 2006. *NS-Verbrecher und Staatssicherheit: Die geheime Vergan genheitspolitik der DDR.* Gottingen: Vandenhoeck & Ruprecht.

Neumärker, Uwe, ed. 2015. *Tiergartenstraße 4: Gedenk- und Informationsort für die Opfer der nationalsozialistischen "Euthanasie"-Morde.* Berlin: Stiftung Denkmal für die Ermordeten Juden Europas.

Nora, Pierre, and Lawrence D. Kritzman, eds. 1996. *Realms of Memory: The Construction of the French Past.* Translated by Arthur Goldhammer, 3 vols. New York: Columbia University Press.

Nowak, Peter. 2013. "Die vergessenen Toten." *Jungle World*, January 10. https://jungle.world/artikel/2013/02/die-vergessenen-toten.

Robertson, Michael, Astrid Ley, and Edwina Light. 2019. *The First into the Dark: The Nazi Persecution of the Disabled.* Sydney: UTS ePress, University of Technology Sydney.

Spannbauer, Andreas. 1998. "Streit um Gedenken: Mahnmal für Euthanasieopfer in der Tiergartenstraße sorgt für Kontroverse." *Die Tageszeitung (Taz),* August 16, 16. https://taz.de/!1276408/.

Stiftung Denkmal für die Ermordeten Juden Europas. n.d. "Memorial and Information Site for the Victims of the National Socialist 'Euthanasia' Murders." https://www.stiftung-denkmal.de/en/memorials/place-of-remembrance-and-information-for-the-victims-of-the-national-socialist-euthanasia-murders/.

Topp, Sascha. 2013. *Geschichte als Argument in der Nachkriegsmedizin: Formen der Vergegenwärtigung der nationalsozialistischen Euthanasie zwischen Politisierung und Historiographie.* Göttingen: Vandenhoeck and Ruprecht.

Tümmers, Henning. 2011. *Anerkennungskämpfe: Die Nachgeschichte der nationalsozialistischen Zwangssterilisationen in der Bundesrepublik.* Göttingen: Wallstein.

Wehry, Katrin. 2015. *Quer durchs Tiergartenviertel: Das historische Quartier und seine Bewohner.* Ed. Michael Eissenhauer. Berlin: Nicolai.

Westermann, Stefanie, Richard Kühl, and Tim Ohnhäuser, eds. 2011. *NS-"Euthanasie" und Erinnerung: Vergangenheitsaufarbeitung – Gedenkformen – Betroffenenperspektiven.* Münster: Lit.

Weinke, Anette. 2002. *Die Verfolgung von NS-Tätern im geteilten Deutschland: Vergangenheitsbewältigungen 1949–1969, oder, eine deutsch-deutsche Beziehungsgeschichte im Kalten Krieg.* Paderborn: Schöningh.

3

Names on Frosted Glass
From Fetishizing Perpetrator Mindsets to Disability Memorialization of the Victims

DAVID T. MITCHELL and SHARON L. SNYDER

In this chapter, we compile the events that expose the precarity of disabled peoples' lives during the Second World War in Germany through an examination of the transition of Nazi psychiatric killing centres into contemporary "euthanasia" memorial centres. As Judith Butler (2016, 2) points out, recognizing the conditions of vulnerability calls us to a responsibility to alter abuse, suffering, and violence, yet it may also be true that "the apprehension of precariousness leads to a heightening of violence, an insight into the physical vulnerability of some set of others that incites the desire to destroy them." Such is the case with the medical mass murder of psychiatric patients in Nazi Germany, as this slaughter made possible the post-1941 genocide of 5.6 million Jewish people in the death-camp gas chambers of the Holocaust (Snyder 2010, 410). The vulnerability of disabled people held in institutions occurred as acts of homicidal violence that went unchecked in six specially designed killing centres with gas chambers: Brandenburg on the Havel, Grafeneck (near Munsingen), Bernburg (near Halle), Pirna-Sonnenstein (near Dresden), Hartheim Castle (near Linz, Austria), and Hadamar (near Limburg) (Burleigh 1994, 144). After the gas-chamber killings were halted (Lifton 2000, 95), the technology, staff, and knowledge base of mass murder were transferred to remote territories in Poland in the summer of 1941 (Conroy 2017, 204; Friedlander 1995, 284; Müller-Hill 1988, 41) where the state had been destroyed by the convergence of German and Russian armies along the Molotov-Ribbentrop Line (Snyder 2010, 393).

Butler (2016, 14) likewise formulates "precarious lives" alongside the related question of what lives are grievable – "grievability is a presupposition for the life that matters" – in order to make the point that some lives are so devalued that their extermination by the state occurs with impunity. Thus, in addition to the historical events that comprise Nazi medical mass murder and the processes by which they occurred, investigations into the nature of contemporary disability memorialization today serve as an entry point into understanding the extent to which disabled lives have become (un)grievable. This process relies on the recognition of disability as a basis not only for determining precarity to be a foundational condition of the subpopulation in question but also for using grievability as a barometer of attitudes toward any expendable population. Investigations of Adolf Hitler's secret plan (codenamed Aktion T4) show that it was intended to exterminate "nonproductive" children (Conroy 2017, 63–4) and adults viewed as "ballast lives" (Klee 2001, 36–7) and "unproductive eaters" (Lifton 2000, 21). This hyper-eugenics vocabulary travelled across the "Eugenic Atlantic" (Snyder and Mitchell 2006, 101) and serves as a grounding for understanding how disabled people came to be targeted and continue to experience their lives in their ostensibly degraded corporealities in our midst.

Thus, the chapter attempts to answer some critical questions by using Nazi medical mass murder as its historical foundation: What meaning can be derived from the memorialization of disability history in our own contemporary moment? What role do these public acts of recognition and grievability play as part of the preservation of disability history? Why are these medical mass killings, which pre-dated and led to the Holocaust, still primarily unrecognized and forgotten? Finally, what do today's memorialization practices tell us about contemporary attitudes toward disabled people as this largely unaffiliated subpopulation lives in the aftermath of a murderous history?

Over the past fifteen years, the members of our disabled family team – professors David T. Mitchell and Sharon L. Snyder, filmmaker Cameron Mitchell, and Emma Mitchell – have returned to Germany more than two dozen times as guest lecturers and have collaborated with multi-national research groups and study-abroad students to pursue an analysis of the Nazi T4 program. As our family includes two members with significant disabilities and two caregivers with deep disability intimacies, the story of the mass extermination of more than 300,000 disabled people in psychiatric institutions by Nazi-appointed physicians holds both personal and collective interest for us (Knittel 2014, 39; Köbsell 2012, 97). As pointed out by

Timothy Snyder (2015), a Yale historian of the Holocaust, eastern Europe, and Russia (who is also a member of our extended family), to study mass murder is to engage in an act of grieving, commemorating, and memory maintenance: "Yet dead or alive they [i.e., those who perished] cannot save us. Memory cannot save us. Pictures cannot save us. Understanding might." Coming to such an understanding is a difficult objective, as these words suggest, and it is a primary impetus of our chapter.

A "Stretchier" Kind of Witnessing

Robert McRuer (2018, 19) argues that although the "historical connections of crip to cripple seem to tie the [reclamation] term ['crip'] to mobility impairment, it has actually proven to be far stretchier." McRuer's argument surfaces with respect to a wider range of disability, such as "undocumented disabilities" and those who lack a visual correlative that makes them readable as forms of non-normative embodiment (19). Here, we intend to move McRuer's analysis of the stretchier nature of disability to forms of witnessing that have come to comprise the contemporary memorialization of disability in our own time. As for Butler's (2016, 14) key question of which lives are grievable, the kinds of witnessing that we unearthed in this project necessarily differed from the kinds of direct testimony that have traditionally anchored Holocaust studies due to the fact that more than 50 percent of Jewish internees survived the camps.

Since there were effectively no survivors of Aktion T4 – with the exception of a couple of instances discussed below, such as the testimony of Elvira Manthey (1999), who escaped the gas chamber at Brandenburg – one is left to read between the lines of the Holocaust perpetrators' debilitating records. Like the vast majority of research into the T4 program to date, this chapter seeks to expand our understanding of the concept of witnessing – to make it "stretchier," in McRuer's terms (2018, 19), and no less substantive than the first-person observations of the witness who experienced genocide at the site of the killings. Bauman (1989, xi) points out that although memorialization and commemoration ceremonies are important, they fail to offer access to the deeper meanings embedded in our historical public knowledge. Thus this chapter itself assists in promoting its own kind of alternative, stretchier form of witnessing by developing understandings of how today's memorialization and research practices seek to shift the historical practices of narrating the killings away from the point of view of the perpetrators and toward that of the victims.

Primarily, we identify five forms of stretchy witnessing critical to retelling the T4 story from the point of the view of the victims rather than from the fetishized perspective of the perpetrators: (1) the lengthy struggle to include the memorialization of disabled people in the developing thanatourism industry in Germany, the United States, and the formerly occupied territories of the German army; (2) the accessibility of the disability memorial sites for disabled visitors and researchers (not to mention the hiring of disabled staff); (3) the foundations of a stretchier form of "vicarious witnessing" (Knittel 2014, 112) in the absence of direct witnesses of Aktion T4, as formulated by Jewish survivors such as Primo Levi; (4) the wide-scale comparison and contrast of the six killing centres now turned into memorials to the victims of euthanasia; and (5) the open listing of unredacted names of the victims and the cultivation of biographical databases about the lives of disabled victims. Our argument is that together these five alternative practices of memorialization provide a foundation for the stretchier form of witnessing that we advocate. The transformation of T4 memorials – from ones that fetishize the perspectives of the perpetrators into ones that tell this disability history from the point of view of the victims to the greatest extent possible – requires that we honour indirect witnessing, for it reveals the *longue durée* of generational investments in disposable humanity. Because the Nazis sought to effectively eradicate the evidence of some forms of disability from the human record, these key alternative, stretchy pursuits of witnessing offer us a developed body of tools for reaccessing the lost lives of disabled people.

Accessing the Killing Centres

Germany, unlike many modern nations, has actively taken up practices of memorialization with respect to its own traumatic history of state-sponsored violence. These memorialization practices have often gone the route of spectacle in that the Holocaust-based tourism industry (or thanatourism) now serves as a key anchor of the German tourist economy. In the city of Berlin, one can tour the Memorial to the Murdered Jews of Europe, created by American artist Peter Eisenman; visit a large block of angular stone at the boundary of Tiergarten Park that serves as the Memorial to Homosexuals Persecuted under National Socialism, created by 2SLGBTQ+ activists Michael Elmgreen and Ingar Dragset, and view a videotape of gay, lesbian, and trans people perpetually kissing; take a tour of the remains of the bombed-out shell of the former Gestapo headquarters and interrogation

cells while visiting the outdoor exhibits at the Topography of Terror historical museum; visit deportation sites where Jewish people were ousted from their homes and shipped off to work camps and death camps around the city; pay homage at the gravesite of the philosopher Moses Mendelssohn in the Old Jewish Cemetery on Grosse Burger Strasse, which was desecrated by the German army in 1943–44; contemplate the names of those selected for "relocation," which are now displayed in gold *stolpersteine* (stumbling stones) inlaid variously among the sidewalk cobblestones; stand at a glass window embedded below the sidewalk of Bebelplatz and peer into an all-white room populated by empty bookcases at the spot where Magnus Hirschfeld's (1868–1935) sexology library and 20,000 other books found their destruction for indecency on May 10, 1935, in the Nazi book burnings; and enter the granite walls of the Memorial to the Sinti and Roma of Europe Murdered under National Socialism and witness the daily blossoming of a flower in the pool that memorializes the sterilizations and deaths of Sinti and Roma people by the Nazis in the shadow of the Reichstag Building. In fact, until September 2014, there was no Berlin memorial to those disabled people murdered in the T4 program. As disabled educator and T4 historian Petra Fuchs (2017) explains, "T4 was the last memorial because disabled people are still excluded from German society."

Finally, in the most literal sense, accessibility involves removing barriers at memorial sites and gaining access to historical archives despite the myriad obstacles that such places situate before disabled people. One irony that we encountered almost immediately during our visits to memorial centres prior to 2012 was ongoing public inaccessibility at the memorials themselves. Public transportation continues to be defined by a lack of ramps, working lifts, Braille signage and guide books, visual signals for deaf people, simple text for people with cognitive disabilities, and effective support services in general. Many of the memorials are situated in inaccessible buildings constructed in earlier centuries, and the German memorials governing board has participated in more than thirty years of reluctance to make them accessible. Public attitudes remain, at best, skeptical about the wisdom of travelling with a disability; facilities such as restrooms and cafeterias often fail to accommodate disabled visitors, and thus these public spaces anticipate what kinds of bodies will be allowed to participate in the memorialization of disability by the very nature of their architecture.

Consequently, the tangible barriers for disabled researchers in pursuing information about disability collective history are a central part of this story. In other words, our investigations address a palpable marginalization of the

medical mass murder of disabled people within the larger commemoration of the Holocaust and the lives of 23 million people killed in the "bloodlands" between Russia and Germany (Snyder 2010). We argue that even at today's more accessible memorials, cultural ambivalence about the value of disabled lives is still on exhibit; their physical and historical lack of centrality results from the marginalized spectre of these killings and from the non-integrated livelihoods of disabled people in general. In Judith Butler and Athena Athanasiou's (2013, 20) terms, their dispossession from the category of the "human" reduced them to forms of "non-being" and confined them to ghostly wards, yet, ironically, they were overdetermined by their ontological status as inferior bodies. This ontological depreciation exposes memorialization as a practice largely addressed to nondisabled participants, and thus the erasure of disabled people envisioned by the Nazis threatens to become realized. A more proactive disability commemoration practice that anticipates disabled people as participants effectively begins to roll back the promised erasures of Aktion T4.

Absence of Direct Witnessing

Scholar of Holocaust public memory Susanne C. Knittel (2017) comments that "there are two components to a story becoming tellable," one of which – survivors – is completely missing, as there were no survivors of the T4 program. This circumstance has necessitated the creative approach of drawing on the later generational findings of dedicated relatives who stumble on these pasts, much like one stumbles on a T4 memorial site or one of the aptly named stumbling stones that commemorate the victims of the Holocaust and some T4 victims. This creative approach completely engulfs viewers in the history of a place, as well as invoking the fragile balance that can erase or preserve something visceral in our cultural memory about those groups targeted during the Second World War.

A wide-scale comparison and contrast of the locales and architecture of the killing centres that have been turned into memorial sites allows for the revelation of new findings. For instance, few works of T4 research have delved into the meaning of the fact that these psychiatric killing centres exist in widely variable locations: in the middle of bustling cities, on the rural outskirts of towns, and in castle-like structures, converted city jails, and repurposed military armories. New conversations gathered during research reconnaissance visits to Germany in the summer of 2017 revealed that in Bernburg, Hartheim, and Pirna-Sonnenstein, the crematoria ashes of victims were wantonly carted to city dumps and discarded with other trash. At

Bernburg, for example, the human ash pit is now a football field, and its excavation/preservation as a memorial site is under contest in the courts (Hanzig 2017; Hoffmann 2017; Schwanninger 2017). Few have discussed the yearly struggles to keep these memorial sites open in the face of public opposition to the tainted history that they represent amid the ongoing budget cuts of the austerity state. Consequently, our research reveals that a wide-scale comparison of all the killing sites leads to a depth of understanding, with the remaining physical architecture providing a glimpse both into disabled lives and into perpetrator processes in Nazi Germany during the Second World War.

Medical Files and Grievable Lives

Although our examinations strive, like Claude Lanzmann's (1985) documentary film *Shoah*, to primarily utilize the active killing-centre memorial spaces as they are currently preserved, there are a few moments when deviation from this striking and original presentation of the history can be doubly impactful. Select photos, letters, and institutional documents bring to mind the everyday lives of T4 perpetrators as they committed these mass murders in their institutions. At Hartheim, the lead physician, Rudolf Lonauer, kept a photo album of his family's vacations, meals, portraits, and modestly appointed home. The same cannot be said for the disabled people on whom Lonauer preyed. Most of the remaining photos of institutionalized residents are, typically, medical in nature and thus do not fully capture the breadth and complex humanity of each individual life. For example, the curator of Jewish Museum Berlin, Jorg Waßmer (2017), recalls that one of his great uncles, Alois Zähringer, was eventually selected and transported to a gas chamber after years of internment in institutional care facilities on the Upper Rhine River. The one existing photo of Alois shows the vague outline of his head and upper body in a heavily shadowed, chiaroscuro-like image of a disabled boy hidden in the wood pile while members of his family get their photographic portrait taken without him (Waßmer 2017). Alois is in the picture, but the family either did not care or could not take the time to include him in the finished photograph.

Similar findings occur in the stories of victims Elvira Manthey (birth name Hempel) and Ernst Putsky, whose lives are portrayed in the archival medical files at the Brandenburg and Hadamar Euthanasia Memorial Centres (Marx 2017; Schaaf 2017). Their medical files, which identify their diagnoses and the reasons for their institutionalization as "asocials," include

not only their detention papers, photos, personal letters, and notes from medical personnel but also hand drawings of their experiences. In the case of Elvira, who later wrote a memoir of her experiences and escape from the gas chamber (Manthey 1999), she and her younger sister were forcibly removed from their family for being poor and were detained in the old prison that was converted into the Brandenburg killing centre in late 1939 or early 1940. Her younger sister was killed first, and then Elvira was sent to the gas chamber with a group of young children (Manthey 2003). Once the group arrived at the killing centre's barn, which was located in the compound across from the old prison, the children's medical files were checked against their identities, and they were instructed by a nurse to undress. Elvira tells of her fear of a deadly outcome and recalls undressing as slowly as possible (Manthey 2003). The other children, now naked, their clothes in piles off to their right, filed into the gas chamber. Dr. Heinrich Bunke stopped Elvira from following the lineup by taking her wrist, drawing her aside, and asking for her name and age (Marx 2017). Elvira responded without hesitancy, and Bunke told her to get dressed and return to her cell (Manthey 2003).

Later, after Elvira was released from Brandenburg and was writing her memoir, the illustrator Elli Koll worked with her to make line drawings of the pivotal scenes of her memory. The illustrations show her eating at a table with the other children, a Nazi guard patrolling the perimeter of the killing centre with a German shepherd, the three children who occupied her cell using a chair to look through the barred windows at unfolding events outside, and, most hauntingly, an overhead point of view that shows the children disrobing, the nurses at a table performing intake paperwork, the piles of clothing lying to the right of each child, and a view of the gas-chamber door (Manthey 1999). Elvira's memoir is perhaps the closest document to a direct eyewitness account of what life was like at the killing centres. There were 5,000 disabled children murdered in the T4 children's killing program (Czech 2012, 59).

In the case of Ernst Putsky, who died at the Hadamar Euthanasia Memorial Centre in 1943, likely from neglect and starvation, we have a voluminous file that represents one of the most densely documented lives unearthed in the possession of the Russian Stasi after the fall of the Berlin Wall. Putsky was a caustic critic of Hitler's government and was arrested for handing out leaflets denouncing the Nazi Party. He also had multiple disabilities, including blindness and a limp from an injury sustained working as a farmhand. Putsky drew multiple cartoons that provided pointed social

commentaries on Hitler's deranged practices. Two compelling sketches populate the file: in one, Hitler stands at a podium talking to a mass assembly of people about the greatness of the German nation while being prodded in the back by the devil, who prompts him with propaganda to sell his Aryan ideals; in the other, Hitler sits before a cornucopia of food at a table with a checkered tablecloth. In a speech bubble, he asks: "Who is eating all of my food?" Hauntingly, in the background is a train full of sheep transported in open train cars to the slaughter. The T4 content of the cartoon comes through in Hitler's suspicion of those he believed were "useless eaters" and in his system for transporting psychiatric patients – the sheep – to die in the killing centres in order to increase the German abundance for nondisabled Aryans.

Accompanied by photos and letters, the sketches in Putsky's file help us to overcome one of the most difficult aspects of T4 research, namely the paucity of victim testimonies. These sketches offer the most complete representation to date of a T4 victim's perspectives on the killings and their legacies (Schaaf 2017). Whereas victim testimonies of direct witnessing serve as the backbone of Holocaust studies and of our knowledge concerning life in the labour and death camps, the accounts above foreground the stretchier form of witnessing that the T4 program necessitates by offering momentary views of the victims sent to the killing centres.

Names in Frosted Glass: From Fetishizing Perpetrators to Disability Memorials

Most of the materials gleaned from the T4 program come from files dominated by the views of the perpetrators. Patients' personal stories and drawings are rare, and one must read between the lines of pathologizing medical files full of falsified information meant to deflect people's investigations into the fates of their relatives. Thus, as we have argued, the concept of witnessing has to be stretchier in the reconstruction of T4 histories, hence our opening question about how many ways there are to view a tragedy that has no survivors in order to further develop the history of disability in Germany during the Second World War under the Aktion T4 program.

One of the most significant developments on display at key euthanasia memorial sites such as Hartheim Castle and Pirna-Sonnenstein is the installation of frosted glass walls that identify as many names as possible of those who were murdered in these facilities. At Grafeneck, there is an outdoor chapel constructed for commemoration and a laminated death book that contains the names of those exterminated at the first operatational killing

centre. The open display of names has a history of controversy because the German government decided that the identities of those killed at the facility should be concealed, as the records came from medical files that were to be protected due to worries about the stigmatization of the victims' future generations of relatives.

At Pirna-Sonnenstein, memorial staff openly publish the names of the more than 13,000 victims without permission from their families (Hanzig 2017). The staff decided not to seek permission because they believe that there should be no shame in publicizing the names of those killed in the T4 dragnet and no shame about needing treatment for mental health disorders and other disabilities at psychiatric facilities. This emphasis on removing shame is a critical part of the transition of the memorial centres away from telling the story of Aktion T4 from the point of view of the perpetrators and toward an approach to memorialization that privileges the point of view of the victims. Like the recorded names of those murdered in the Holocaust, the names etched on glass walls are an open claim that those who died in these medical mass murders should not be forgotten.

Of course, a list of names does not in and of itself tell us anything specific about the identities of the victims. The act of listing names serves primarily as a simple compilation of the victims for those who enter the memorial centres. However, families come to identify relatives who may have been killed, and they may then turn to the memorial staff for access to digital records that contain more specific information (Eigelsberger 2017). These digital records contain key information such as falsified death certificates, notifications to next of kin about the death of an institutionalized relative, and medical records kept during institutionalization, among other materials.

Perhaps the most important development of the transition from perpetrator to victim perspectives – from killing centres to memorials – has been the creation of the memorial website Gedenkort-T4.eu, which not only provides in-depth information about the T4 killings but also has a rapidly evolving library of victim biographies, many of them written by disabled authors (Parzer 2017). Documenting the constantly evolving digital archives of victims, this digital memorial site moves beyond the display of names to provide biographical details that further flesh out the lives of T4 victims. Although the Nazis intended to erase not only the people but also their diagnostic categories, the tripartite mug shots taken of individuals just before their gassing were intended to supply proof of the beneficence of the euthanasia killings. T4 memorialization, at its core, is what Knittel (2014, 112) refers to as "vicarious witnessing" – a practice that does not patronizingly

speak for those who cannot speak for themselves but instead represents a form of stretchy witnessing that "engenders identification with rather than distancing from the victims." Knittel argues that, as an effort to reclaim these lives and to ensure that they never disappear from the human record, vicarious witnessing describes a "specifically 'elective' relationship ... an act of reclaiming the memory and identify of these victims from the impersonal, bureaucratic, and dehumanizing language of the perpetrators" (115).

Follow the Ash: Material Remnants of Disabled Lives

A further research methodology employed by our investigative team examined evidence regarding the disposal of human ash, which is key to mapping the handling of bodies and their appropriate burial to honour lives criminally destroyed. Each T4 facility faced the problem of what to do with the mountains of ash and bone produced by cremation, and the facilities handled the disposal in various ways. It is believed that at Brandenburg the ashes were dumped into the nearby river Havel and that at Grafeneck the ashes were dumped in the woods in mass graves. At Hartheim Castle, ash was shovelled into garbage bags and stored in the attic and basement. One of the most important empirical pieces of evidence for disposal practices was traced out at Bernburg, where the director of the Bernburg Euthanasia Memorial Centre, Ute Hoffmann (2017), was told by a witness to the killings that a man with a horse-drawn cart came to the facility and transported the human remains to the nearby town dump. Hoffmann and her research team found the employment record of the horse-drawn cart's driver during the T4 phase. Today, that dump is the site of controversy, as it is currently covered over by a soccer field where athletes train, and there is a movement to turn the site into a memorial facility.

At Pirna-Sonnenstein, an exhumation of the hill behind the gas chamber's building revealed that there were up to 3 metres of human remains under the trees and on the downhill slope (Hanzig 2017). Workers took loads of human ash from the crematoria in wheelbarrows and dumped the ash down the hill toward the quiet town of Pirna below. The ash lay on the ground in piles and billowed up in the wind across the river Elbe. Today, the hillside has been converted into a memorial burial site, and a massive stone cross overlooks the hill and the post-war town.

Hartheim's killing pits were discovered in the garden area immediately beyond the gas chamber. When heating pipes were being reinstalled in the early 2000s, human remains, personal keepsakes, and parts of the crematoria oven were discovered lying in eight pits dug to bury the evidence.

Today, a room of archival cabinetry exists where all of the items found in the pits related to the T4 program and other killings in the Hartheim killing facility are stored. The cabinets hold hundreds of items that belonged to the victims, including tea cups, toys, hair combs, barrettes, glasses, and prosthetic limbs. At both the Pirna-Sonnenstein and Hartheim Castle memorials, a display cabinet exhibits the curated items of victims so that viewers might imagine the lives of those who owned them. During our visit to Hartheim, we met two architects who had been hired by the German government to excavate and map the crematoria areas of several killing centres. At Hartheim, they had already discovered that one crematoria oven and chimney were replaced by another more substantial set-up in an attempt to address the recurrent fires in the stacks of the crematoria ovens due to the constant burning of bodies 2-3 or more at a time. This billowing smoke caused a perpetual exhaust over the town to gather and collect (Drechsler 2017). Grafeneck residents mounted one of the few successful protests against the killings, forcing the closure of the killing centre and, ultimately, the return of the institution to the Sisters of Mercy, an organization that continues to oversee the institution and its disability-provisioned lodging today. The display of human artifacts speaks to the minimalist existences of life in German psychiatric institutions and also reveals the personal items to which individuals clung even as they were divested of all clothing and personal items prior to their gassing.

Further, the exhumation of remnants of the T4 killing apparatus at Jewish death camps in Poland shows that the closure of the killing centres was followed by the transfer of crematoria ovens and staff from the psychiatric institutions in Germany proper to the Polish "nowhere." Not only did the German euthanasia administration develop the killing techniques of genocide in the killing centres, but Nazi administrators also learned that you could not kill hundreds of thousands of people within your own borders and keep the mass slaughter a secret (Parzer 2017). Thus one of the key "lessons" taken away by the perpetrators was a recognition that performing genocide outside the boundaries of the German state would better allow the perpetrators of the Holocaust to take advantage of what Timothy Snyder (2010, 451) refers to as the "lawless zones" taken over and occupied by the German army. This critical comparison and contrast of the six killing centres (plus the first site of psychiatric patient gassings in Posen, Poland) enables us to understand not only the fast-paced acceleration of the process of mass killings but also the reasons behind the removal of Jewish death camps to locations outside of the formal state.

Vicarious Witnessing

Finally, there are also many instances of stretchy witnessing in the post-war period, such as that narrated by Ute Hoffmann (2017) about the time her mother showed her the gas chamber at Bernburg. Hoffmann tells a story of begging her mother, who worked at Bernburg as a nurse in the late 1970s, for one of the baskets woven by the patients as work therapy. Ultimately, her mother gave in to the request and brought Hoffman to the building of the former killing center. Leading her down the concrete stairs to the basement, her mother stopped to open the door to the gas chamber. Ute, fifteen years old at the time, peered into the room and saw what looked like a large, tiled shower room full of boxes of supplies such as toilet paper. Her mother asked: "Do you know what this is?" When Ute responded with uncertainty, her mother told her about the gassing of psychiatric patients killed by the Nazis at Bernburg. Ute, following her mother's command, resolved at this point to go to college, major in history, and return to create a memorial to the victims of the crimes committed on this site.

Finally, as with Ute's story, there is an educational role – yet to be uncovered – that these memorial sites are serving for public schools, medical and psychiatry professionals-in-training, and patients treated at the facilities. Indeed, no existing scholarship discusses the uncomfortable fact that a majority of these memorial sites are situated on active psychiatric campuses. The importance of this function is, of course, to educate the next generation of aspiring medical professionals with reference to a cautionary history of medical murder. However, for our team, the long-standing practice of offering this cautionary tale of medical overreach exposes a key characteristic of the conversion of killing centres into memorials: the T4 memorials all originated as exhibitions that largely anticipated a primary audience of non-disabled medical persons-in-training. Disabled people were not anticipated as a potential audience, hence the irony of more than twenty years of inaccessibility at disability memorials. Although the history of T4 killings became more available, disabled people themselves continued to be erased from the forms of public memory that the memorials represent.

Conclusion: Aktion T4 as the Hinge to the Holocaust

One of the key arguments of Black feminist materialism (BFM) developed by critical race theorists such as Sylvia Wynter (McKittrick 2015), Alexander Weheliye (2014), and Asma Abbas (2010) is that we need to junk the exclusionary category of the "human." Although the human appears on its surface to serve as the most elastic classification of belonging, BFM theorists

have argued that the classification excludes the majority of bodies that occupy the earth: women, racialized people, 2SLGBTQ+ individuals, labourers, and the like. Contemporary research on Aktion T4 and on the shifting nature of victims' perspectives allows for the addition of disabled people to the BFM catalogue of dispossessed forms of nonbeing based on ontological properties of biological inferiority. Nearly all of the euthanasia memorial centres exist on active psychiatric campuses. The T4 program was expanded to Jewish labour camps during the Aktion 14f13 phase and then to the capillary sites of medical power, becoming established in nearly every hospital, clinic, and psychiatric institution in Germany and the German-occupied territories. Such an expansion of medical mass murder leads Ute Hoffmann (2017) to conclude that turning former T4 sites into memorial sites by closing all active psychiatric institutions where murders were committed would entail the closure of nearly every psychiatric institution in Germany.

NOTE

Acknowledgment: A different version of this chapter originally appeared as "A 'Stretchier' Kind of Witnessing: Turning Nazi Psychiatric Killing Centers into Memorials," by David T. Mitchell and Sharon L. Snyder, in the *Journal of Literary & Cultural Disability Studies* 16 (3) (2022): 317–37. Reproduced with permission from Liverpool University Press through PLSclear.

REFERENCES

Abbas, Asma. 2010. *Liberalism and Human Suffering: Materialist Reflections on Politics, Ethics, and Aesthetics.* New York: Palgrave Macmillan.
Bauman, Zygmunt. 2002. *Modernity and the Holocaust.* New York: Cornell University Press.
Burleigh, Michael. 1994. *Death and Deliverance: "Euthanasia" in Germany, 1900–1945.* Cambridge, UK: Cambridge University Press.
Butler, Judith. 2016. *Frames of War: When Is Life Grievable?* London: Verso.
Butler, Judith, and Athena Athanasiou. 2013. *Dispossession: The Performative in the Political.* New York: Polity.
Conroy, Melvyn. 2017. *Nazi Eugenics: Precursors, Policy, Aftermath.* Stuttgart: Ibidem-Verlag.
Czech, Herwig. 2012. "Nazi Euthanasia Crimes in Second-World-War Austria." In *The Holocaust in History and Memory,* vol. 5, *Euthanasia Killings: The Treatment of Disabled People in Nazi Germany and Disability since 1945,* ed. Rainer Schulze, 51–74. Colchester, UK: Department of History, University of Essex.
Drechsler, Franziska. 2017. Interview with author, Otto Weidt Blindenwerkstat Memorial, June 22, 2017.
Eigelsberger, Peter. 2017. Interview with author, Pirna-Sonnenstein T4 Memorial, June 6, 2017.

Friedlander, Henry. 1995. *The Origins of Nazi Genocide: From Euthanasia to the Final Solution.* Chapel Hill: University of North Carolina Press.

Fuchs, Petra. 2017. Interview with author, Topography of Terror, Berlin, Germany, August 3.

Hanzig, Christoph. 2017. Interview with author, Pirna-Sonnenstein Euthanasia Memorial Centre, Pirna, Germany, June 12.

Hoffmann, Ute. 2017. Interview with author, Bernburg Euthanasia Memorial Centre, Bernburg, Germany, June 15.

Klee, Ernst. 2001. *Dokumente zur "Euthanasie."* Berlin: Fischer Taschenbuch.

Knittel, Susanne C. 2014. *The Historical Uncanny: Disability, Ethnicity, and the Politics of Holocaust Memory.* New York: Fordham University Press.

–. 2017. Interview with author, Grafeneck Euthanasia Memorial Centre, Gomadingen, Germany, July 27.

Köbsell, Swantje. 2012. "Towards Self-Determination and Equalisation: A Short History of the German Disability Rights Movement." In *The Holocaust in History and Memory*, vol. 5, *Euthanasia Killings: The Treatment of Disabled People in Nazi Germany and Disability since 1945*, ed. Rainer Schulze, 85–102. Colchester, UK: Department of History, University of Essex.

Lanzmann, Claude, dir. 1985. *Shoah.* BBC/Historia/Les Films Aleph.

Lifton, Robert J. 1986. *The Nazi Doctors: Medical Killing and the Psychology of Genocide.* New York: Basic Books.

Manthey, Elvira. 1999. *Die Hempelsche: Das Schicksal eines deutschen Kindes, das 1940 vor der Gaskammer umkehren durfte.* Lübeck: Hempel-Verlag Heinz Manthey.

–. 2003. Interview with Stephen Stept, January 13.

Marx, Christian. 2017. Interview with author, Brandenburg T4 Memorial Center, June 6, 2021.

McKittrick, Katherine, ed. 2015. *Sylvia Wynter: On Being Human as Praxis.* Durham, NC: Duke University Press.

McRuer, Robert. 2018. *Crip Times: Disability, Globalization, and Resistance.* New York: New York University Press.

Müller-Hill, Benno. 1998. *Murderous Science: The Elimination by Scientific Selection of Jews, Gypsies, and Others in Germany, 1933–1945.* Trans. George R. Fraser. Planview, NY: Cold Spring Harbor Laboratory Press.

Parzer, Robert. 2017. Interview with author, Topography of Terror, April 24, 2017.

Schaaf, Claudia. 2017. Interview with author, Hadamar T4 Memorial Centre, July 14, 2017.

Schulze, Rainer, ed. 2008. *The Holocaust in History and Memory: Euthanasia Killings: The Treatment of Disabled People in Nazi Germany and Disability in Germany Since 1945.* Colchester, UK: Department of History, University of Essex.

Schwanninger, Florian. 2017. Interview with author, Hartheim Euthanasia Memorial Centre, Linz, Austria, June 7.

Snyder, Sharon L., and David T. Mitchell. 2006. *Cultural Locations of Disability.* Ann Arbor: University of Michigan Press.

Snyder, Timothy. 2010. *Bloodlands: Europe between Hitler and Stalin.* New York: Basic Books.
–. 2015. "The Ghetto Is Here." *Tablet,* October 11. https://www.tabletmag.com/sections/arts-letters/articles/the-ghetto-is-here.
Waßmer, Jorge. 2017. Interview with David T. Mitchell and Cameron S. Snyder. Jewish History Museum Archives, Berlin, Germany, June 30.
Weheliye, Alexander. 2014. *Habeas Viscus: Racializing Assemblages, Biopolitics, and Black Feminist Theories of the Human.* Durham, NC: Duke University Press.

4
Truth, Reconciliation, and Disability Institutionalization in Massachusetts

An interview with ALEX GREEN

Alex Green is a widely recognized advocate, writer, and scholar on the history of disability institutions in the United States. He is on the faculty of the Harvard Kennedy School and is a Fellow at the Harvard Law School Project on Disability, and a visiting scholar at the Brandeis University Lurie Institute for Disability Policy. The following is an interview with Green conducted by Elisabeth Punzi and Linda Steele.

Linda Steele: I first encountered your work, Alex, in the context of the 2020 protests against the light show in Waltham, Massachusetts. Can you please tell us a bit about that light show, what was so problematic about it, and the bigger problems around disability history that the light show surfaced?

Alex Green: Waltham, Massachusetts, is located 9 miles west of Boston. The 128 highway corridor that passes through Waltham is often referred to as the Silicon Valley of the East, but Waltham is still much more of an eastern post-industrial mill town with an urban centre and a suburban periphery. On the city's northeastern edge, there is a massive, 196-acre parcel of land that was sold by the state to the city in 2014 for a pittance. That land, which could have been developed for a multi-billion-dollar housing development, was instead dedicated for open space and historic preservation, meaning

that it has limited uses in perpetuity. Its historical importance stems from the fact that it was home to the Walter E. Fernald Developmental Center, once known as the Massachusetts School for the Feeble-Minded, the first public educational institution for people with intellectual disabilities in the western hemisphere. It is a designated National Register historic site and has foundational ties to disability history in America, including a dark human rights history as well as a major disability civil rights history.

Thousands of citizens of the Commonwealth were incarcerated here, often from childhood, from 1887 to 2015. The institution's superintendent from 1887 to 1924, Walter E. Fernald, was a major figure in education, psychology, medicine, and eugenics. Significant aspects of his approach to managing the institution were emulated globally from Canada and the United Kingdom to Japan and China.

Following Fernald's death, from the Great Depression through the Second World War, conditions at the institution went into steep decline, and abuses were rampant. Studies were done on children using radioactive isotope tracers, which later became a national scandal. In the 1970s, a major civil rights movement led by parents resulted in the reform of the institution, which was overhauled entirely. Hundreds of millions of dollars were spent on the institution before political leaders abandoned the project, and ultimately the centre was shut down.

Within the first few years of the site being purchased, it became clear that the city was not going to fulfill even the most basic regulatory obligations stipulated, to which it had committed. Abandoned, the site's hundreds of millions of dollars' worth of facilities were swiftly destroyed by vandals, ranging from ghost hunters to neo-Nazis. Copper thieves stripped the buildings. As the volunteer chairperson of the city's historical commission, I negotiated the purchase and terms of the sale along with our mayor. After seeing how the city handled the site, I stepped down from the commission.

In subsequent years, it has been used for pet projects and political giveaways. A large parcel of abandoned land can be used for a lot of things. One of those giveaways was to a local chapter of the Lions Club, which was allowed to contract out a carnival fundraiser on the grounds of the school. The president of the club also happened to have close connections to the mayor and held

numerous municipal positions on boards and agencies, some of which were directly related to the handling of the site's future.

With the pandemic, the club was given a permit to use the site for a drive-through holiday light show in the winter of 2020. At the time, those of us involved in disability history and disability rights advocacy were seeing first-hand that any optimism we'd had about disability rights prior to the pandemic was unwarranted. COVID-19 measures were disproportionately impacting our communities for reasons that were completely consistent with long-standing discrimination and abuse of disabled people. This outcome was perhaps reflected best by the fact that Waltham was not alone. Two other former institutional sites in Massachusetts were also being used for light shows.

A colleague at the Disability Law Center in Boston wrote to me and asked if I would consider taking up an objection to the light show with the city, and I agreed. I wrote to our mayor, asking that she rescind the permit, and she responded with threats rather than an answer. At that point, I brought together a large group of disability organizations statewide, objecting to and protesting the show. We launched a petition, which quickly garnered hundreds of signatures, and we held a protest at City Hall. Our efforts received national and international media attention. Our protests were not successful in stopping the show. The city's mayor refused to meet with disabled people, and the following year, the show was repeated, although there have been some political consequences due to the publicness of the city government's rebuke of us.

For many of us, the light show was emblematic of the ways that society has tried to paper over its historic, consistent, and persistent abuse of disabled folks. The unresolved, abandoned, underexplored, and shameful silence that hangs around many of these sites – and especially this one – seems to represent something that disabled people have known for a long time.

Elisabeth Punzi: Wow, that speaks to so many of the tensions we are exploring in our edited collection. Alex, so it sounds like you have a much longer background in disability history in Massachusetts. Can you tell us a bit about your work with local communities in relation to the Metropolitan State Hospital, Walter E. Fernald Developmental Center, and MetFern Cemetery?

Alex: In the mid-2010s, I was asked to develop a disability-history high school course for 11th graders at Gann Academy, a private Jewish day school adjacent to the site of the Fernald. At that point, I had been researching the history of what was once called hospital row – a string of six asylums, hospitals, and state schools – of which the Fernald was once part. All but one of those institutions was closed by 2014, but they left behind an unsettled legacy. The place where this was most profoundly distilled was the MetFern Cemetery, an institutional cemetery shared by the Fernald School and an asylum, the Metropolitan State Hospital, from 1947 to 1979. In that cemetery, 296 inmates were buried under gravestones marked only with a letter for their religion – C for Catholic or P for Protestant – and a number. Arguments about privacy had prevented simple adherence to the law, which says that vital records should be public, and so names of the people buried there had been withheld by the state. The cemetery is located on the grounds of Met State and was overgrown, with the stones toppled and hidden away in the woods. I obtained the names of the people buried there, and with my students, we built a website where we told the stories of every single person identified. With regard to those impacted by the state's institutional system, this work is part of a broader effort that I've undertaken at Harvard, Brandeis, and Gann to work with communities and individuals in ways that offer them a chance to tell their stories, be heard, be seen, and be understood.

Elisabeth: Your public disability-history work related to the MetFern Cemetery is fascinating. Can you explain the significance of engaging with cemeteries in terms of disability social justice?

Alex: All of the work I have done at MetFern follows a path set by Pat Deegan, a rights advocate who led the restoration of the Danvers State Hospital cemetery in Danvers, Massachusetts, in the 1990s. Deegan and other institutional survivors demanded substantial accountability for the nameless graves at Danvers, and they got it. They did significant research to uncover the names of the deceased and erected a memorial plaque. They also pushed for legislation to maintain former state institutional cemeteries.

But more broadly, these cemeteries have a kind of kinship of disregard that they share with cemeteries the world over, from Indigenous schools in the United States and Canada to the Magdalen

Laundries in Ireland. Whatever common funeral and burial practice was provided for honouring life and reckoning with loss in their part of the world, the people in these burial grounds were denied it, and the reason was a distilled disregard for their lives by those who exerted power over them.

There is a kind of archaeological memorialization that can occur if we go into these spaces and turn these burials back on themselves by finding names, telling stories, and reconnecting the relatives of survivors with their loved ones and their ancestors. Each step of this work reverses the core tenets of disregard that led these people to be treated in life and buried in death in such a fashion, and although we cannot undo those indignities, we can engage in a kind of retributive act that denies the people in power the very things they thought they controlled into finality. They believed these burials were an end because their thinking was eugenically linear and evolutionary. But we can bend that history into a loop and refuse the finality of what they did. That's at least some of the thinking behind this work.

In a practical sense, this work involves enormous archival effort, public education, significant research, and patience. When I began working on MetFern, the work was incredibly lonely, and the psychological burden of carrying so many stories of abuse and cruelty and sadness and loss was becoming too much for me to bear. I embraced the idea that this loneliness was the world telling me I needed community, and I think my sense that these places can be reckoned with in ways that dignify the past into the present has only grown. As people with disabilities, for the very first time, we can control our own reckoning with the past, and much of my work has centred on that idea and on finding ways for nondisabled people to be good allies.

I do not believe, as others do, that reckoning with such places is certain to help us avoid a dark path in the future, but I do believe that doing so forces us to accept the past to which we are connected and denies us the ability to sever those connections into a present-history dynamic that is constructed around an us-them framing. I'm after us-us.

Linda: Recently, your work on public disability history has taken a legal turn, and you are involved in leading a movement for truth and reconciliation legislation in Massachusetts. Can you tell us a bit about

what prompted your turn to law and what the legislation will achieve if passed?

Alex: Through the protests and my other work involving institutionalization, it has been clear that the idea of disabled people having a history is foreign to many people, let alone a history of relevance and significance. The result is that some were asking the genuine question, regarding the light show: "Why is this important?" Others who had ties to the institution's history could not make sense of what it was when they went looking for relatives and discovered that they had been incarcerated there.

For years, other issues had lingered. It was clear that crucial elements of the recommendations made by the commission that studied the use of radiation on boys at the Fernald Centre and the Wrentham State School were never taken up, nor was the bill on perpetual cemetery upkeep that resulted from Pat Deegan's work. Most of all, there was a mistaken belief that many survivors of the institutions were no longer alive.

It seemed that what was needed was a larger reckoning with all of these loose ends and that it could be done collaboratively in ways that would compel the state to lead and to claim ownership of its mistakes and successes. This view was encouraged by two legislators, senator Mike Barrett and representative Sean Garballey, who hoped that a commission could lead to a memorial or museum of some kind. But it was particularly important to ensure that disabled people, for once, led these efforts.

All of this is to say that the light show is a symptom of a series of pervasive and prevailing mindsets that could not be shifted solely through confrontation with the most morally bankrupt individuals. For that, we needed to go after the causes, and the causes are profoundly important to address. Simply saying that disabled people are human and deserving of a human rights commission – let alone saying that we should have a majority of the seats on such a commission and can lead this work – is still considered radical, unfortunately, even if the idea of truth and reconciliation or human rights commissions is frankly somewhat conservative.

The job of the commission will be to investigate major remaining issues that reckon with questions about whether deinstitutionalization was a success for disabled people or simply, as you've said in this book's Introduction, a form of transinstitutionalization, as well

as with questions about where unmarked graves might be, where survivors are, how people can access records, and what the history of the institutional systems for intellectual/developmental and mental health disabilities were here. The commission's job will be to make a report with recommendations.

There is some historical resonance for this, too. This entire system is the result of similar legislative efforts in the 1840s by Dorothea Dix and Samuel Gridley Howe. It seems to me, on a spiritual or existential level, that this is a place to return to – a method of action, legislatively – in order to do this reckoning.

Linda: Can you explain why truth is so central to disability social justice?

Alex: Truth is important because, without it, people will protect themselves reflexively from reckoning with the continued society-wide devaluation of disabled lives. But it's also important to say whose truth matters. With few exceptions, truth in disability history is the province of nondisabled people. Although many have made major contributions, the truth is necessarily incomplete without the truths represented by the historiographic lens that survivors and contemporary disabled people can bring to the reckoning with this history.

Lately, I've been thinking quite a bit about the idea of history as an intellectual pursuit, and it seems that the key belief in an ableist society is that people with intellectual/developmental or mental illness or with other disabilities cannot inherently pursue something intellectual. By this, I mean that society does not believe we can pursue intellectualism or engage in the discipline of historical work, which means that, at some level, there is a belief that we do not possess intellect. Part of the meaning of possessing intellect is that an individual can possess common sense, which includes the making of meaning and can include the assertion of that meaning as truth or fact.

This idea is something that occupied the earliest reformers involved in work with folks with intellectual/developmental disabilities, and the radical notion put forward by folks like Howe was that common sense could be learned, developed, and possessed by those who nobody believed. The extension of this understanding into the possession and assertion of truth in the present day means that our charge – our radical act, of sorts – is to relentlessly push the notion that disabled people have a right to these things, and I think that

gets a bit at why truth is so important here, although frankly, an entire chapter could be written just about this notion writ large.

Elisabeth: Your observation about the exclusion of disabled people from public history on the basis of assumptions about their cognitive incapacity is so important to be mindful of when engaging in memorial and conscience scholarship and practice. Can you explain the specific role of people with disability in the truth and reconciliation legislation?

Alex: The legislation states that the majority of members of the commission must identify as having a disability. It is certainly my hope that we come to understand, through this deeply archive-focused work, the limits of the archives – limits that can be addressed and overcome only by listening to people with disabilities. And we have learned over time that, largely speaking, the only way for people with disabilities to truly have a way to speak and be heard is if disabled people are leading the creation of those opportunities and spaces in some way.

Linda: Can you speak a bit more about the importance of the government and the community hearing the direct testimony of people with disability?

Alex: The government remains, even in this era, the arbiter of legitimacy, the source of institutional coherence for the violence that was done to disabled people, and the forum for resolution. It is vital that the government acknowledge the experiences of those who testify, the absences created by the eradication of those who cannot, and the responsibility to present those experiences without mediation as a recognition of their inherent truth.

Elisabeth: There is a long history of disability rights activism in the United States, and some of it emerged out of deinstitutionalization. I wonder if your proposed legislation will explore some of the histories of resistance, survival, and activism?

Alex: It must. The era of reform has been largely overlooked in regard to institutionalization and deinstitutionalization, especially in Massachusetts. Stories from this era are invaluable, with subjects ranging from those who sought major institutional reform to those who sought the wholesale dismantling of institutions. People fought hard. In a spirit of understanding, we owe them our ears and the space to share what they did and why they did it.

Elisabeth: What is the role of former institution staff and family members in the proposed truth and reconciliation process?

Alex: Staff and family members are often overlooked for their small and radical acts against a system that could respond with violence and cruelty. Some upheld a system. Many others entered during the reform era, bore witness to the previous system, and tried to transform it. Many have been demonized by the simple fact of their proximity to these places without a nuanced understanding of the seriousness with which they approached their work and the vehemence of the old system as it was forcibly strangled in the 1970s through federal court action.

We have a twofold obligation in this work. In the past, these folks have spoken, but their words have been twisted against them. They deserve to be heard and understood. At the same time, they have often been surrogates for people who do not speak with former institutional residents directly. This role leads to a disturbing form of disability ventriloquism, in which we risk supplanting the experiences of disabled people with those of the people around them. So our second obligation is to elevate the disabled voices to the paramount place, which is the only way to do this work correctly, while not continuing a practice of devaluing, silencing, or altering the words of former employees and family members.

Linda: Archives seem to have a key role in the proposed truth and reconciliation process. Can you explain the role of archives and how it relates to the role of direct testimony from people with disability?

Alex: Archives tell the story of the perpetrators, not the victims, but they are a crucial window onto the ways that these systems were constructed, rationalized, weaponized, and inflicted on people with disabilities. They often include stories of resistance from nondisabled people working within institutions and from disabled people within and outside of institutions, as demonstrated by a system that was largely intent on self-preservation and socio-ideological purity. In addition, they include accounts of an era when that finally broke down and document a time when people confronted this system and attempted to reform it. It is both essential and limited.

Linda: We are really interested in exploring the role that the places of former disability institutions play in contemporary social justice. What role does place have in your proposed legislation?

Alex: We are still in a stage of large-scale disbelief and othering of the idea that the United States and its people, at all levels of government and society, for a sustained period of time, prosecuted a eugenic campaign against the existence of disability. That means that people need places where they can reckon with this history, places whose truth in this story cannot be easily refuted, and places where we take up the heretofore somewhat paltry amount of serious investigation of these places. Not only does the legislation attempt to reckon with what people have done with these former institutional sites in order to understand how much they have actually engaged with their history, but it also pursues the matter of open questions like the possible and likely presence of unmarked graves at these former institutional sites.

Linda: There is increasing advocacy in North America related to redressing the legacies of eugenics – redress schemes in relation to sterilization being a key example. Will the proposed truth and reconciliation legislation engage with histories of eugenics?

Alex: It will, although I am concerned about the potential ways that our reckoning with eugenics in the United States are narrow, brittle, incomplete, and often fetishizing. Because Massachusetts never had a large-scale sterilization scheme in place, with its institutional leaders by and large vehemently rejecting sterilization as a means of deploying eugenics, I am hopeful that we can get at the nuance of these ideas, which go far beyond sterilization.

Linda: There are some sites of conscience that grapple with intersecting and overlapping histories and memories of place. I am thinking here of Dorothea Dix Park, which explores First Nations, slavery, mental health institutionalization, and environmental degradation. How do you connect your work on place-based, public disability history to other experiences and histories of oppression?

Alex: Carefully and with a somewhat resistant mindset around the value of comparison. If I am asking for our communities to be heard and seen for the distinct and nuanced aspects of our experiences, I must respect the same with regard to the experiences of others and start from that position. Do these areas overlap? Certainly. There is no way to fully understand any of these issues, ranging from Indigenous communities to African American ones, 2SLGBTQ+ people, Jews, immigrants, and others without seeing those areas of overlap

for what they were and what they are. At the same time, I think there is a potential for a blurring of reckonings that is at cross-purposes with the notion that this work is, in part, about enshrining the dignity of individuals and ensuring that they are seen and heard through the ages as much as they were silenced in their lives.

So I am a student of others doing remarkable work elsewhere, in awe of their ideas, perseverance, creativity, resilience, and wisdom. But I am also doing my best to be cautious about crossing from admiration and affinity into areas that can quickly become appropriation and, as such, inappropriate.

Elisabeth: Sites of conscience are characterized by moving from memory (of place) to action (on contemporary social justice concerns). Even though you do not explicitly frame your work on public disability history and (now) on law reform in this paradigm, do you have any thoughts on the possibilities or limitations of sites of conscience?

Alex: It think this is an incredibly valuable framework. I am perhaps an odd person in this work because I am deeply skeptical about the overvaluation of place. In old-school, Old Testament terms, you could say that I'm worried about false idolatry, which is an inherently reductive act, at best, and a violently deceptive one at worst. Any emphasis on place has this risk if the demands for action – including thought – do not keep pace. In modern terms, I'm worried about fetish. There is the risk that, much as circus promoter P.T. Barnum pitched a mixture of thrill and education, we could be pitching education and thrill. Something is always sacrificed. Poet and activist Lawrence Ferlinghetti once said something like, "I too was a tourist of revolutions," and I worry about sites of any kind appealing to that idea. At the same time, these are places of connection, and their obliteration disturbs me.

Perhaps all of this is rambling, but it's to say that I find this attention to sites of conscience useful as a process – as a means – but my sense of the ends is not entirely wedded to the need to preserve such sites. If we got to the end of a reckoning with a state institution, and all of the former inmates said, "Tear it down and forget about it," I would listen, follow, and find some other way to study and learn and gather community around the history of the place.

Linda: Alex, thank you so much for speaking with us about your important work.

5

"I'm Not Really Here"
Searching for Traces of Institutional Survivors in Their Records

JEN RINALDI and KATE ROSSITER

The Huronia Regional Centre was a notoriously violent Canadian institution that warehoused intellectually disabled children and youth. In 2013, Huronia survivors[1] settled a class action lawsuit with the Government of Ontario for its negligent operation of the facility, which had resulted in physical and sexual injury to residents (*Dolmage v Ontario* 2013). In order to submit claims for settlement funds, members of the injured class requested access to their institutional files. Ontario's Ministry of Children, Community and Social Services sent claimants binders containing copies of admission, medical, clinical, educational, and discharge records, along with family notes, photographs, and financial receipts. These files provide a detailed administrative timeline of residency at Huronia. Even as many of the brick-and-mortar buildings on the grounds now stand empty, these records sustain and extend institutional memory.

Survivors of the institution have expressed frustration with file contents that sanitize experiences of violence and that absolve perpetrators of this violence.[2] This failure to properly document survivors' experiences of the Huronia site constituted for them a deep injustice. So we sat down with five Huronia survivors in order to review their records. In unstructured interviews, they corrected, contradicted, and contextualized what they found in their files. They filled in gaps and shared memories that they prioritized over the words on the page. They also reacted to what they read and reflected on the impacts of staff perception and treatment. In sum, survivors

claimed ownership over Huronia's history and co-constructed a new public account of their time institutionalized.

The Huronia Regional Centre records that we reviewed constitute an archive and should be critically analyzed as such. In this chapter, we draw from postmodern archival theory[3] to show that the work done in these interviews recovers truths that were missed or misconstrued in the original archive. Postmodern theorizations of archives posit that archives are not passive presentations of history but are actively engaged in making meaning and memory. In the Huronia context, gatekeepers of public memory deselected or discounted traces of survivors' lived experience and in so doing constructed a history that was unrecognizable. Survivors' responses to this archive call their own experiences and perspectives into collective memory and in so doing resist another kind of violence following their institutionalization: the violence of being forgotten. Survivors engage in this resistance work by filling in administrative gaps, challenging official interpretations, and inserting themselves into their narrative. In what follows, we unpack each of these three strategies in order to show that those administrative gaps signal that archives are designed to facilitate forgetting, that the contradictions in interpretation point to how records are constituted through power and must be reconstituted by heeding the powerless, and that the ephemeral traces of survivor narratives can still be found in an official archive if one knows where to look.

Background

The Huronia Regional Centre was located in the small town of Orillia, Ontario, off the shore of Lake Simcoe. Originally called the Orillia Asylum, the facility was established in 1876, at a time when the province was solidifying its role in managing populations marked by disability diagnosis (Abbas and Voronka 2014; Park and Radford 1999). At the asylum, in a large Victorian-style building, and eventually a network of on-site "cottages," Ontario provided long-term custodial care for intellectually disabled children and youth sent from around the province. It came to be both the largest facility in Canada to offer these services and the longest one standing – shut down in 2009 (McLaren 1990; Rossiter and Clarkson 2013). Today, the buildings on Huronia's campus still stand, but many are not open to the public.[4]

Huronia was what Canadian sociologist Erving Goffman (1961, xiii) calls a "total institution" – a state-operated facility that provided its isolated population with social assistance in the form of around-the-clock, centralized

service support. Total institutions have a dark legacy, and Huronia was no exception. Watchdog investigations and provincially commissioned reports documented that residents' quality of life was impacted by chronic systemic failures, including overcrowding, understaffing, and poor living conditions (Berton 1960; Welch 1973; Willard 1976; Williston 1971). Following Huronia's closure, survivors Patricia Seth and Marie Slark filed a class action lawsuit[5] against the Government of Ontario for failing in its obligations to fund, operate, and supervise facility practices, resulting in the physical and sexual abuse of residents (*Dolmage v Ontario* 2010). Seth and Slark's legal advocacy thus brought public attention to the violence that was endemic to life at Huronia.

The class action ended in a settlement in 2013, marking a legal victory for survivors and serving as a model for settling future lawsuits (Rinaldi and Rossiter 2019; Rossiter and Rinaldi 2019).[6] A $35-million settlement fund was arranged for survivors who claimed to have experienced abuse while at Huronia. Each claimant potentially received up to $42,000, depending on the level of detail in the claim package submitted. Nonmonetary benefits included commemorative initiatives meant to preserve Huronia's history, such as a plaque on the grounds, maintenance of the cemetery, six open tours of the facility across the span of one year, and an opportunity for scholars to archive artifacts (*Dolmage v Ontario* 2013). Despite all these gains, when the dust settled, there were survivors who expressed dissatisfaction with the settlement (The Doc Project 2016). The financial reward that individual survivors could claim was not enough to substantively improve their lives in the long term. Further, despite painstaking efforts to construct a kind of archive as embodied in commemorative monuments and the preservation of artifacts, there were survivors who did not see enough of themselves in the work.

In an effort to document Huronia in a way that survivors might find more restorative, the Recounting Huronia Collective was formed in 2014. The collective comprised scholars (including this chapter's authors), students, artists, and institutional survivors. The survivors involved in the project were credited as co-researchers and were involved in shaping the collective's goals and methods. In 2017, we received a grant from the Strategic Program Investment Fund, a one-time funding program that was an outcome of the aforementioned lawsuit's settlement. The collective used these funds to construct the Recounting Huronia Community Archive, an open-access platform that presents Huronia's history from the perspective of survivors.[7]

The Recounting Huronia Archive features an interview series that also served as the data source for this chapter. In each interview (five in total),[8] a chapter author sat with a survivor, and together they reviewed the institutional records that the survivor had received from the Ontario Ministry of Children, Community and Social Services in order to claim settlement funds.[9] In two cases, those records comprehensively encompassed everything written about an institutional resident across their confinement at Huronia. In the other three instances, records had been streamlined to serve as evidence in support of settlement claims. The most prevalent records documented a resident's admission to the centre, medical and clinical history, education, and discharge from the institution. Also included were letters from family members, photographs of institutional residents, and invoices for goods and services that residents received. These records provide detailed portraits of institutional life, yet as survivors noted, there were significant gaps and points of contention.

The interview series offered a platform for survivors to review and respond to the files that had been kept on them. In doing so, they deconstructed Huronia's documented history. This deconstructive work was accomplished through dialogue and support given that survivors were neurodivergent in varied ways and that their memories were traumatic. For these reasons, the data presented in this chapter come in the form of exchanges between the interviewer – chapter author Jen Rinaldi – and the survivor being interviewed. Also, in the analysis, we provide the affective dimensions of those exchanges (referencing Rinaldi's observations during interviews).[10] In what follows, we use postmodern archival theory to show that institutional memory hinges on forgetting through silence and interpretation but cannot entirely stamp out all traces of survivor experiences.

"They Blacked That Out": On the Facilitation of Forgetting

The documents that survivors reviewed in our interviews comprised a kind of archive, here understood as a "collection of documents and a repository of preserving, housing, organizing and making accessible documentary materials ... maintained for information of continuing value" (Gracy 1988, 98–99). Huronia staff, superintendents, medical professionals, and social workers contributed to the development of this archive and accessed it in order to inform their work at the institution. A provincial ministry retained the files, circulated them for legal purposes (i.e., so that survivors and their families could provide evidence in their claims for settlement funds), and

uploaded many documents to a public repository in order to satisfy a non-monetary settlement directive.[11] The value of the records shifted over time – first supporting the goings-on at the facility and then constituting a history of the province's involvement in the running of "total institutions" (Goffman 1961, xiii).

Our collective was dedicated to developing our own archive in response to the inadequacies of the ministry archive. There are ways that these limitations can be read through a postmodern critical lens. The term *archive* is etymologically rooted in commencement, as though the archive marks the start of a story; but the term also derives from commandment, meaning that it operates according to rules (Derrida 1995). This double meaning enables the archive to do more than preserve history, for it also necessarily determines what is worth preserving (Boshoff 2012; Calano 2012; Vismann 2008). There are absences in archived history, experiences that fall outside the archival frame. Put another way, in the privileging of some information and the failure to acknowledge other information, archives facilitate forgetting (Lothian 2012; Matthews 2016).

That archives facilitate forgetting was certainly clear in our collective's work, where every survivor who reviewed their records with us referenced significant gaps in the paperwork. Anna could not find her memories of mistreatment reflected back to her in what was meant to be comprehensive documentation of her residency at Huronia. She was not surprised, and she noted that mistreatment of residents would not be recorded. When considering staff abuse, Emmett, too, was certain that "they blacked that out" of his record, a phrase referencing redaction. These lacunae in their files served as extensions of violence because the archive as commandment constitutes a value determination. In other words, the failure in their records to explicitly identify the ways that they were degraded further signalled to survivors that they did not matter, and this diminishment is itself violent (Stauffer 2015).

Gaps in the records also did work to isolate residents, which had a lasting traumatic impact. As an example, we found a letter in Alice's file from her mother, addressed to Huronia's superintendent. In the letter, Alice's mother asked about missing correspondences and declared her intention to visit:

Jen Rinaldi reading from Alice's file: "I've been writing my daughter but I failed to receive an answer in reply. As she's said she's been writing a letter a week, my husband and I would very much like to talk to you and to get things straightened out. I'll be up to see Alice on

> May 10. We're hoping very much to take her to town and show her a good time ... All Alice wants is love and affection." [Addressing Alice:] Do you think you would have known that staff were keeping residents from seeing family?
>
> **Alice:** I was in a room. I was drugged ... with Largactil.[12] I didn't even know if they were there or not. I was in another world.
>
> **Jen:** And it doesn't seem like your letters would have gotten to them.
>
> **Alice:** I don't remember.

Only this letter from her mother referenced Alice's attempts to correspond with family. Those correspondences themselves did not reach their intended end points and were not enclosed in Alice's records. Although the practice was not explicitly identified here, institutional obstruction of residents' communication with the outside world was an established strategy employed at Huronia to induce behavioural compliance. Residents who received visits or letters tended to act out or had trouble adjusting to institutional life – because reminders of life outside Huronia made them homesick – so families were discouraged from frequent contact.[13] This strategy was only hinted at in Alice's file, creating a significant gap in the record, and it had the profound impact of isolating Alice from her loved ones. Throughout her interview, she spoke about how her relationship with her mother was estranged and how she had presumed throughout her life that her mother had not cared about her. That Alice reached this conclusion is certainly reasonable given that her mother was largely absent from her life once Alice was institutionalized. Yet, around the edges of these absences, it appears that her mother tried, only to encounter barriers. Due to these barriers, Alice was denied opportunities to make meaningful, happy memories of her family.

Some silences only poorly erase or eclipse violent incidents. This effect is evident in Dorothy's experience of solitary confinement at a young age, a discovery made through careful reading:

> **Jen reading from Dorothy's file:** "This little girl has been isolated on April 23, 1965." [Addressing Dorothy:] And you were released on May 1, 1965. So that means you were potentially isolated from April 23 to May 1. Does that sound like something that would have happened? You would have been put in isolation for lengths of time? [Dorothy nods.] When you were six and a half years old? [Dorothy nods.]

This memory was particularly difficult to surface in our interview. I paused to run the calculations in my head and then to second-guess my conclusions given the cruelty that they implied: professionals leaving a six-year-old girl in isolation as punishment over the span of a full week. Dorothy had no words to articulate what her experience was like, only the capacity to confirm. Even in our efforts to build a better archive that fills in key gaps, this story still sits in silences because it is rather horrific to remember.

Joseph had a comparable encounter with traumatic memory related to coerced electroshock treatment, a kind of medical violence (Burstow 2015) that was documented in his records as therapy. In the excerpt below, he grapples with medical files that highlight in diagrams of brains the part of his own brain that this procedure targeted:

Jen: You have evidence.
Joseph: But I'm not really here.
Jen: You're still not in these files, is what you're saying? Why do you think that? What's missing?
Joseph: I don't want to remember. I know when I was in that room. I broke down when I was in that place. I remember. And I was angry. Angrier than I think you could ever believe. So I just tell myself it doesn't exist.

For Joseph, the affect of his experience exceeded words. The emotional weight was so heavy for him that he found dissociation an effective survival strategy. Years later, the memories were so painful that he preferred to forget them. Joseph and Dorothy show in these exchanges that survivors themselves are not always well positioned to recover forgotten histories.

"That's the Way of Life": On Contrasting Interpretations

If the archive constitutes a commandment, it is critical to know who has the power to issue commands. Postmodern approaches to archival theory reference archons, defined as "keepers or guardians of all official documents" (Boshoff 2012, 635). These archons are vested with the authority to determine the contents of an archive and to interpret its items. They shape the story told (Vismann 2008). Their methods of archiving, then, not only record historical events but also produce these events (Devine 2019). This is what renders the archive a political artifact marked by and made through power (Derrida 1995; Lothian 2012).

In Huronia's context, the archons might have been ministry officials, medical professionals, and institutional staff – any author of a contribution to a resident's file. That their contributions were coloured with their own interpretation of events was clear in moments of sharp contrast with survivors' memories. This contrast was especially evident in behavioural records. For three survivors, their behavioural charts identified that they were *angry, aggressive,* or *saucy,* among other comparable terms – all behaviours that called for disciplinary action or medical intervention. In their respective interviews, these survivors responded to the descriptions that we read together by arguing that they had learned anger at Huronia and that their outbursts while residents were reactions to indignities and were modelled after staff hostility. After we read several accounts of Emmett acting out against staff or fighting with fellow residents, he described how he had learned anger:

Jen: There's a lot of anger in these stories. Do you think you learned anger at Huronia?
Emmett: Yes, I do.
Jen: Why do you think that?
Emmett: I didn't want to do that. I'm a person, kind and cool ... I didn't know what the staff do. And I found out in a hurry. So, I was angry.

Reflecting on her own learned anger, Dorothy offered that anger can be "good if you channel it properly." Rage even fuels her advocacy against institutionalization. The records themselves are devoid of all the motivations driving resident behaviours and of all the more nuanced valuations of these affects because residents themselves had no power to contribute to the archive. The meanings embedded in the files, then, convey not some value-neutral truth but instead the institution's power imbalance.

As an example, Alice's records were especially preoccupied with her alleged promiscuity. We read the following staff account of a conversation with a police constable who had returned Alice to the institution:

Jen reading from Alice's file: "[Alice's] family is well known to the police and were called in on numerous occasions. Alice has told them that she has been raped by her father. The constable feels that Alice is promiscuous herself and has reports of Alice involving younger boys in the area of sexual activity."

Alice: That's not true. The constable I remember ... He was the one who took me back to Orillia.
Jen: It ends here by saying that "when one of the boys named by Alice was questioned over a February 18 incident the lad was insistent that Alice asked for intercourse."
Alice: No! I don't like sex.

Throughout this accounting, those in positions of authority – facility staff and police officers – were dismissive of Alice's allegations of sexual violation despite a record of two pregnancies that took place when she was unable to give consent: one when she was underage and the other while she was institutionalized, which most likely occurred at the hands of a staff member. That she experienced sexual abuse is clear enough in her timeline, which stands in sharp contrast with the presumptions about her involvement that can be found in statements like "The constable feels that Alice is promiscuous herself" and "The lad was insistent that Alice asked for intercourse." Alice has had such a painful and unrelenting history of sexual abuse – remarking, "my whole life has pretty much been a rape fest" – that she was clear and firm about her distaste for sexual activity altogether.

We also found dissonances in what constituted privilege at the institution. The institutional conditions missing from the records are not just absences, for their reintroduction into the narrative changes the record itself. The work that survivors did to respond to their files, then, not only filled in gaps but also contradicted what they found. For instance, Anna and Joseph encountered repeated assertions that they were obedient or suggestible framed in their files as a mark of progress. Both survivors were clear that their compliance came from a place of fear and that both complied as a tactic to avoid violent retaliation.

To elaborate, Joseph's file contained receipts documenting when his aunt purchased snack foods for him to enjoy. He provided context:

Jen: Your aunt bought you food.
Joseph: They had a canteen, as they do in jail. But my canteen never came up. Mine never came. Always gave mine to the bigger kids. I didn't have a choice.
Jen: Why not?
Joseph: I was in there with them. So what I did was protection. I gave them whatever I got given. And that's the way of life.

Joseph, then, understood the canteen as a survival mechanism. That he needed to trade canteen items for protection or to avoid resident violence was so natural to him that it was "the way of life" – not even just a way of life but the only way to live that was available to him.

Similarly, Anna shared an abrupt, brutal memory associated with a record referencing her "privilege card," a tool that enabled her to leave the institution for brief stretches of time:

> **Anna reading from her own file:** "She is a trustworthy girl and she is going to be granted a privilege card to run errands, take walks and so on throughout the grounds. She has been instructed as to her behaviour: not hanging around boys ... and made to realize she can lose her privileges by carelessness."
> **Jen:** Do you remember privileges?
> **Anna:** Yeah, I remember having a privilege card.
> **Jen:** What sort of errands would they have you run?
> **Anna:** Well, one time a whole ward was sick with people, and I volunteered to go get something to eat for somebody. So I did that. And a guy tried to put his thingamabobber up my ass ... Because I was by myself.

Like Joseph's experience of the canteen, Anna's memories of the privilege card – a supposed advantage – carried only adverse attachments. The privileges granted to Anna both positioned her to conduct more labour on behalf of the institution and rendered her more vulnerable when she was in town by herself. Her account threw into sharp relief the words in her file referencing staff instruction – no "hanging around boys" and no "carelessness" – as though she could be made complicit in the sexual abuse that she endured.

These moments of contrast challenge the archive on record and in so doing reconstitute that archive. The act of reconstitution "means to iterate the same while introducing a difference" (Praeg 2010, 112). There was definitely a canteen, and there were certainly day passes, and some residents were indeed angry. The presentation of these moments, however, can be reconstituted if survivors are able to introduce their own interpretations. If archiving is a political project, a just approach to archiving would be to commit to the perspectives of the powerless so that what matters to them gets caught in the archival frame.

"I Just Want to Show People": On Recovering Traces

In our work together, survivors searched for evidence of themselves. In archival theory, these fragments and residues are called ephemera, defined as "traces of lived experience ... maintaining experiential politics and urgencies long after those experiences have been lived" (Muñoz 1996, 10). The ephemeral is the unstable flickering of truths that bely the solid, established contributions to the archive (Ahmed 2019; Halberstam 2006). All that is cut out of the archive, deemed unimportant to the archons, still leaves impressions if one looks closely enough. Finding these traces destabilizes, deconstructs, and reconstitutes the history that the archive was built to remember. Memory, then, can be transformed.

As an example, Dorothy had a difficult time reading about herself in her file, reflecting throughout her interview that her keepers at Huronia were harsh in their characterizations of her. But there was one well-earned moment of joy in our interview. At the outset, she expressed interest in finding a page that contained scanned photographs of her, and we set ourselves the goal of finding these photographs during our visit. When we finally located them two-thirds of our way into her thick binder of materials, we clapped and whooped in celebration. There were four photographs, each depicting Dorothy at a different age. The first was a photograph taken for her admission record, when she first entered the facility. The last was from her final year at Huronia. Here are excerpts from our exchange:

> **Dorothy:** There they are!
> **Jen:** I'm so glad we found them! This is you?
> **Dorothy:** As a little girl, when I first got admitted [in 1964].
> **Jen:** Okay. So you were six? [Dorothy nods.] How long were you there?
> **Dorothy:** Until 1979.
> **Jen:** That's so long. You can see it across the photographs that you grew up there.
> **Dorothy:** I felt like I was never going to get out.

Through visual markers of time, it was possible to trace Dorothy's history at Huronia from child to adolescent to young woman. The passage of time evident when the pictures were arranged altogether led to Dorothy expressing the potentially ephemeral truth that institutionalization restricted her freedom and kept her contained without a clear end in sight. In her words, "I felt like I was never going to get out." Whereas staff carefully marked dates and

charted her progress, their own sense of time rigorously observed, Dorothy understood her time at Huronia to be interminable.

Feeling no such affinity when reviewing his admission photograph, Joseph remarked, "That ain't me. I don't know him." He did not see himself in his file, particularly in his photographs, because the pictures captured him in a generic uniform and standard buzz cut. For him, the pictures that we encountered showed how Huronia stamped out traces of his individuality. He did, however, introduce new evidence of his experience. He pointed to scars on his temple and forearm when recounting physical abuse. One scar came from an injury never recorded in his files, and the other was documented without reference to staff abuse. The physical assaults that he endured only flickered on the page, whereas his own body maintained a solid, indisputable record of events.

He also thought that the facility itself could contain evidence of him, as though the architecture at Huronia could be scarred like skin. A carpenter by trade, Joseph's memories of Huronia – how the beds in dormitories or the showers and sinks in common washrooms were physically arranged – were structured like a blueprint. He could vividly describe the layout of the small room that he was locked in as punishment. He reflected on a desire to return to Huronia's grounds in order to recover the door to that room:

Jen: What do you think you'd do with the door?
Joseph: I don't know until I get a hold of it. But I just want to show people, "Hey, if you think there's any doubt. You take a look at the other side of that door." There'll be no doubt whatsoever. None. None whatsoever.
Jen: What's on the other side?
Joseph: My nails. And the scratch marks going down that door.

Joseph's institutional records failed to capture his experience of Huronia, but he could find confirmation of his memories elsewhere. The scratch marks on the door – a very solid marker and also just a memory for him as long as his access to the facility grounds was restricted – represented a trace of what he had lived. His desire to have and to work with that door felt earnest and urgent, as though the collection of this evidence would change how his residency was remembered, leaving "no doubt whatsoever." Joseph's counter-narrative is archaeological, found in material, on-site remnants that have the power to transform institutional memory (Djuric and Hibberd 2019; McAtackney 2020).

Conclusion

This chapter presents how public memory of the Huronia Regional Centre materializes in the institution's records and to date how it has done so in incredibly fraught and egregiously unjust ways. The archive that we reviewed for this project commanded, or dictated, which stories would be told, with much survivor experience relegated to the silences and absences of the text. Also, the stories preserved in Huronia's archive were told from the vantage point of the archons, or those at Huronia who held power, so survivor accounts that contradict canon have the power to entirely reconstitute collective memory of the Huronia site. Finally, the work of challenging the official record entails chasing down the ephemera of survivor experience, and doing this work is a key step toward deconstructing an archive's established "truths" in order to make way for a more just accounting.

Survivors participating in this project shared this common intention of "setting the record straight," or responding to accounts of themselves that had been historically privileged despite being inadequate and inaccurate. However, there may be no such thing as a straight record. Even our collective efforts to co-construct a new archive run the risk of leaving out key details. The population at the heart of this history are not traditionally entrusted with history-making work because their diagnosed neurodivergence potentially affects their capacity to recall, to cognitively process, and to articulate experience. Moreover, their lived experience was touched by trauma, which affects memory. Traumatic memory is sharp in some places and blunted in others. Traumatic memory can be fragmentary, cyclical, and too intense to fully convey. Yet the lived experience of this population is palpable, and deserves recognition after being long discounted from a historical record that was already fallible anyway.

If collective forgetting extends historical injustices, the documentation of survivor stories generates restoration. Our project of building a digital archive has been political and intentional work. This archive is open-access, and thus available to the broader public, in an effort to centre survivor accounts in the collective memory. Huronia's brutal legacy of enacting violence in physical space carries through to the physical record. When left uncontested, this record showcases only the perspective of abusers. Our efforts toward building our own archive position survivors as custodians of their own history and actively involve survivors in deciding how this history is told.

NOTES

1 "Survivor" is the term that many former Huronia residents use to self-identify as a way of highlighting the injustice of their institutionalization. "Resident" is a non-medical term found in institutional records to reference individuals during their time institutionalized (used alongside the less encompassing, medically specific term "patient").
2 Huronia survivors share these frustrations in common with other deeply wounded institutionalized populations in Canada, including (and especially) residential school survivors. Indigenous people who survived Canada's residential school system and families who lost children to this system lack full access to their records, particularly day-to-day staff logs, because the Catholic Church, which operated many of the schools, refuses to release its archive. This refusal became a matter of public interest with the identification of suspected unmarked graves on residential school sites, located using ground-penetrating radar, starting in Kamloops, British Columbia, in 2021. Without a fulsome accounting, Canadian settler-colonial governments have failed in their commitments to truth and reconciliation because they have denied First Nations, Inuit, and Métis peoples the ability to act as custodians of their own history (Clarkson forthcoming; Rinaldi and Rossiter 2021; Rossiter and Rinaldi 2021).
3 For more on the foundations of postmodern archival theory, see Cook and Schwartz (2002), Ketelaar (2001), and Nesmith (2002). Archival theory is postmodern when rooted in philosophical traditions that are critical of totalizing and value-neutral understandings of the world. The postmodernist scholar endeavours to deconstruct ideas mistaken for universal truths by revealing their historical roots, particularly in relation to power (Lyotard 1984).
4 Since the institution shut down, some of the buildings on Huronia's 260-acre campus have been used as a courthouse, a public health laboratory, and training facilities and trainee residences of the Ontario Provincial Police. An office for the Ontario Disability Support Program used to exist on the grounds but was relocated so that former Huronia residents now on the income-support program were not forced to revisit the site (Faught 2021). The Huronia Cultural Campus Foundation, including visual artist Charles Pachter and novelist Margaret Atwood, formed to propose a revitalization project that would have converted the empty buildings into artist residences and art galleries. Defending this proposal, Pachter claimed, "the land and the site itself is magnificent" (Battersby 2016). Institutional survivors advocated against this project (and the project was ultimately unsuccessful), arguing that they deserve a say in what happens to the site.
5 A class action is a kind of civil lawsuit that can be brought by litigants representing people who share a legal claim in common. Seth and Slark, along with their litigation guardians, Marilyn Dolmage and Jim Dolmage, who helped them to understand legal proceedings and to make decisions about the case, represented in court a class that included persons who had resided at Huronia from 1945 until 2009 and close living relatives of people who had died while residents at Huronia during this time frame (*Dolmage v Ontario* 2010). The class was successfully certified in 2010, which meant that the litigants could proceed to sue the Government of Ontario for negligence (or a failure in its duties causing injury to the class). The lawsuit ended when the two

parties reached a settlement in 2013, meaning that they arrived at a resolution without needing a ruling.
6 Civil suits in Ontario that directly followed the *Dolmage* class action formula and settlement model include David McKillop's suit on behalf of residents of the Rideau Regional Centre in Smith Falls and Mary Ellen Fox's suit on behalf of residents of the Southwestern Regional Centre in Blenheim (settled together in *Dolmage, McKillop and Bechard v Ontario* 2014); Marlene McIntyre's suit on behalf of residents of the Adult Occupational Centre in Edgar (*McIntyre v Ontario* 2016); Robert Seed's suit on behalf of residents of the W. Ross MacDonald School for the Blind in Brantford (*Seed v Ontario* 2017); and Christopher Welsh's suit on behalf of residents of the Ernest C. Drury School for the Deaf in Milton (*Welsh v Ontario* 2019).
7 The Recounting Huronia Community Archive can be found here: https://exhibits.wlu.ca/s/huronia.
8 All five participants had been diagnosed with an intellectual disability and institutionalized at the Huronia Regional Centre as children sometime between 1950 and 1975. At least two survivors have mobility-related disabilities. Everyone involved is approaching or has entered senior citizenship. Three are cisgender women, and two are cis men. All five are white and self-identify as straight. With the exception of one high-income earner, the interview subjects are low-income, to the point of needing government income support. For more on the project, see, https://exhibits.wlu.ca/s/huronia/page/speaking-back-to-the-institutional-record.
9 For this project, we sought approval from our universities' research ethics boards. We intended interviews to last one hour, although in two cases the survivor was interested in speaking for longer. Interviews were unstructured and were centred on reading and reacting to survivors' records. Interviews were recorded and transcribed. In this chapter, we attribute excerpts to pseudonyms. We engaged in discourse analysis to find common themes.
10 In the sections that follow, the first-person pronouns used in data analysis are based on Rinaldi's observations.
11 For more information on the online repository, see https://news.ontario.ca/en/release/27646/ontario-helping-former-residents-of-huronia-regional-centre-access-personal-files.
12 Largactil is a brand name for chlorpromazine, the first anti-psychotic drug. This medication was typically overused on Huronia residents (by which we mean too frequently and despite the absence of a plausible psychiatric diagnosis), particularly in cases where a resident was identified as having behavioural outbursts.
13 This strategy is outlined in the 1960 informational video about Ontario institutions titled *One on Every Street*.

CASELAW

Dolmage v Ontario, 2010 ONSC 6131
Dolmage v Ontario, 2013 ONSC 6686
Dolmage, McKillop and Bechard v Ontario, 2014 ONSC 1283
McIntyre v Ontario, 2016 OJ No. 2205
Seed v Ontario, 2017 ONSC 3534
Welsh v Ontario, 2019 ONCA 41

REFERENCES

Abbas, Jihan, and Jijian Voronka. 2014. "Remembering Institutional Erasures: The Meaning of Histories of Disability Incarceration in Ontario." In *Disability Incarcerated: Imprisonment and Disability in the United States and Canada*, ed. Liat Ben-Moshe, Chris Chapman, and Allison C. Carey, 121–38. London: Palgrave Macmillan.

Ahmed, Sara. 2019. *What's the Use? On the Uses of Use*. Durham, NC: Duke University Press.

Battersby, Sarah-Joyce. 2016. "Former Residents Feel Walled Out of Huronia's Future." *Toronto Star*, May 2. https://www.thestar.com/news/ichmo/2016/05/02/former-residents-feel-walled-out-of-huronias-future.html.

Berton, Pierre. 1960. "What's Wrong at Orillia: Out of Sight, Out of Mind." Reprint, *Toronto Star*, September 20, 2013. https://www.thestar.com/news/insight/2013/09/20/ichmon_pierre_berton_warned_us_50_years_ago.html.

Boshoff, Anel. 2012. "Archive Fever: Order Is No Longer Assured." *South African Journal of Philosophy* 31 (4): 632–45.

Burstow, Bonnie. 2015. *Psychiatry and the Business of Madness: An Ethical and Epistemological Accounting*. New York: Palgrave Macmillan.

Calano, Mark Joseph. 2012. "Archiving Bodies: Kalinga Batek and the Im/Possibility of an Archive." *Thesis Eleven* 112 (1): 98–112.

Clarkson, Annalise. 2023. "The Societal Underpinnings of Institutionalizing Othered Bodies: A Typology of Institutional Violence at the Huronia Regional Centre and the Mohawk Institute." In *Population Control: Theorizing Institutional Violence*, ed. Jen Rinaldi and Kate Rossiter, 92-112. Montreal and Kingston: McGill-Queen's University Press.

Cook, Terry, and Joan M. Schwartz. 2002. "Archives, Records, and Power: From (Postmodern) Theory to (Archival) Performance." *Archival Science* 2 (3–4): 171–85.

Derrida, Jacques. 1995. "Archive Fever: A Freudian Impression." *Diacritics* 25 (2): 9–63.

Devine, Nesta. 2019. "The Perils of the Archive, or Songs My Father Sang to Me." *Educational Philosophy and Theory* 51 (10): 1014–19.

Djuric, Bonny, and Lily Hibberd. 2019. *Parragirls: Reimagining Parramatta Girls Home through Art and Memory*. Sydney: NewSouth.

The Doc Project. 2016. "The Gristle in the Stew: Revisiting the Horrors of Huronia." *CBC News*, July 11. https://www.cbc.ca/radio/docproject/the-gristle-in-the-stew-revisiting-the-horrors-of-huronia-1.3673553.

Faught, Jim. 2021. "Consultation Summary: Huronia Regional Centre Campus Land." Infrastructure Ontario, September 17. https://www.ontario.ca/page/consultation-summary-huronia-regional-centre-campus-land#ref-3.

Goffman, Erving. 1961. *Asylums: Essays on the Social Situation of Mental Patients and Other Inmates*. New York: Anchor Books.

Gracy, David B. 1988. "What Every Researcher Should Know about the Archives." In *Researcher's Guide to Archives and Regional History Sources*, ed. John C. Larsen, 18–33. Hamden, CT: Shoe String.

Halberstam, Jack. 2006. *In a Queer Time and Place: Transgender Bodies, Subcultural Lives.* New York: New York University Press.

Ketelaar, Eric. 2001. "Tacit Narratives: The Meanings of Archives." *Archival Science* 1 (2): 131–41.

Lothian, Alexis. 2012. "Archival Anarchies: Online Fandom, Subcultural Conservation, and the Transformative Work of Digital Ephemera." *International Journal of Cultural Studies* 16 (6): 541–56.

Lyotard, Jean-François. 1984. *The Postmodern Condition.* Minneapolis: University of Minnesota Press.

Matthews, Richard J. 2016. "Is the Archivist a 'Radical Atheist' Now? Deconstruction, Its *New Wave,* and Archival Activism." *Archival Science* 16 (3): 213–60.

McAtackney, Laura. 2020. "Materials and Memory: Archaeology and Heritage as Tools of Transitional Justice at a Former Magdalen Laundry." *Éire-Ireland* 55 (1–2): 223–46.

McLaren, Angus. 1990. *Our Own Master Race: Eugenics in Canada, 1885–1945.* Toronto: University of Toronto Press.

Muñoz, José Esteban. 1996. "Ephemera as Evidence: Introductory Notes to Queer Acts." *Women and Performance: A Journal of Feminist Theory* 8 (2): 5–16.

Nesmith, Tom. 2002. "Seeing Archives: Postmodernism and the Changing Intellectual Place of Archives." *American Archivist* 65 (1): 24–41.

Park, Deborah C., and John P. Radford. 1999. "Rhetoric and Place in the 'Mental Deficiency' Asylum." In *Mind and Body Spaces: Geographies of Illness, Impairment and Disability,* ed. Ruth Butler and Hester Parr, 70–97. London and New York: Routledge.

Praeg, Leonhard. 2010. "Of Evil and Other Figures of the Liminal." *Theory, Culture and Society* 27 (5): 107–34.

Rinaldi, Jen, and Kate Rossiter. 2019. "Recounting Huronia: A Reflection on Legal Discourse and the Weight of Injustice." In *Madness, Violence and Power: A Critical Collection,* ed. Andrea Daley, Lucy Costa, and Peter Beresford, 221–36. Toronto: University of Toronto Press.

–. 2021. "Releasing Residential School Records Is a Crucial Step toward Documenting Canada's Genocidal Legacy – but the Effort Will Face Considerable Challenges." *Toronto Star,* July 4. https://www.thestar.com/opinion/contributors/2021/07/04/releasing-residential-school-records-is-a-crucial-step-toward-documenting-canadas-genocidal-legacy-but-the-effort-will-face-considerable-challenges.html.

Rossiter, Kate, and Annalise Clarkson. 2013. "Opening Ontario's 'Saddest Chapter': A Social History of Huronia Regional Centre." *Canadian Journal of Disability Studies,* 2 (3): 1–30.

Rossiter, Kate, and Jen Rinaldi. 2019. *Institutional Violence and Disability: Punishing Conditions.* Abingdon, UK: Routledge.

–. 2021. "Catholic Church Residential School Records belong to Survivors and Their Families." *Ricochet,* June 9. https://ricochet.media/en/3685/catholic-church-residential-school-records-belong-to-survivors-and-their-families.

Stauffer, Jill. 2015. *Ethical Loneliness: The Injustice of Not Being Heard.* New York: Columbia University Press.

Vismann, Cornelia. 2008. "The Archive and the Beginning of Law." In *Derrida and Legal Philosophy*, ed. Peter Goodrich, Florian Hoffmann, Michel Rosenfeld, and Cornelia Vismann, 41–54. London: Palgrave Macmillan.

Welch, Robert. 1973. *Community Living for the Mentally Retarded in Ontario: A New Policy Focus.* Ottawa: Provincial Secretary for Social Development.

Willard, Joseph W. 1976. *Inquiry into the Management and Operation of the Huronia Regional Centre.* Orillia, ON: Ministry of Community and Social Services.

Williston, Walter B. 1971. *Present Arrangements for the Care and Supervision of Mentally Retarded Persons in Ontario.* Toronto: Ontario Department of Health.

6

Listening to Peat Island
Planning, Press Coverage, and Deinstitutional Violence at a Potential Site of Conscience

JUSTINE LLOYD and NICOLE MATTHEWS

This chapter considers as a potential site of conscience Peat Island (PI) in Dyarubbin/the Hawkesbury River, near Sydney, Australia, which from 1911 until its closure in 2010 functioned as an institution that provided care and treatment initially for people with mental health conditions and later for those with learning difficulties and intellectual disabilities. Despite the fact that the physical spaces of such institutions contain many traces of the lives lived within them, and often continue to be places invested with meaning by former residents and their families, these lives are largely set aside, unacknowledged, or undiscussed when the spaces left behind after deinstitutionalization are rebranded, gentrified, and sold. Plans for the redevelopment of PI and debates over these plans in the media largely conform to this pattern. We see this lack of recognition as a continuum from institutional violence, which is simultaneously physical and systemic, collective and interpersonal, to a form of principally nonphysical violence, which we term "deinstitutional violence." Thus we suggest that the erasure of the hard evidence of the institutions themselves does not equally erase the inscriptions of institutional power over bodies and identities that disabling practices produce. Following disability scholars influenced by the work of Pierre Bourdieu, we contend that such redevelopment of former institutional sites is a form of symbolic violence, a form of power that works through devaluing the experiences of some groups relative to others (Edwards and Imrie 2003, 250–51). Listening, or a lack of listening, with and to former residents

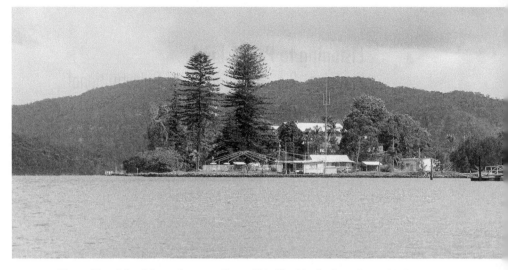

View of Peat Island from the water, Dyarubbin/the Hawkesbury River, 2015.

themselves is a key dimension of the way that this deinstitutionalizing process has played out.

Our analysis uncovers the ways that redevelopment of the site currently excludes the experiences of people with disabilities. Instead, such plans, and their discussion in the media, largely focus on settler-colonial architectural and aesthetic heritage, the visual impacts of development, the needs of the community currently living around the development, and environmental concerns. In this context, deinstitutional violence – the state government's erasure of the historical evidence of the institution itself through the process of closing the institution and determining its future – stands as a barrier to acknowledging the conditions that have allowed institutional violence and harm against people with disabilities to continue. Although the site has been recently handed back to the Darkinjung Local Aboriginal Land Council (DLALC), how the voices of former residents will be heard and recognized within this Indigenous-led redevelopment process is currently unclear ("State Government Transfers" 2022).

A few brief sentences in a 2014 planning report acknowledge the institutional history of the island, explaining that the site forms "an uncommon record of development of the place as a designed mental hospital from the 1900s to the 1980s" (Davies and Heng 2014, 35). However, this report, like the others commissioned by the state government in the multiple and reiterated phases of the redevelopment since 2010, very quickly steps away

from recent history and ignores the role of the state in incarcerating its former residents as part of disability-care policy. In doing so, it prioritizes the aesthetic as a framework in decisions about what parts of the site are preserved, stating that "the more recent buildings" – those associated with the provision of disability services – "are generally of lesser aesthetic significance and have been placed without an overall site plan" (35). Thus far, no opportunities have been given in any of the planning processes, or in the state government's overall vision of the island's future redevelopment, to listen to the lived experience, either directly or in a mediated way, of people with disabilities.[1]

We describe here the frames used in planning processes and media debates around the redevelopment of PI between 2006 and 2022, starting when the Government of New South Wales (NSW) announced the closure of large residential centres such as the Peat Island Centre (PIC), as it had been called since 1989, and concluding when the transfer of PI to the DLALC was announced. These frames obscure the site's history as a place of incarceration of people with disabilities.

We identify how this site could be imagined otherwise, tracing the foundations on which a site of conscience might be integrated into the redevelopments, and we call on decision makers responsible for the guardianship of PI, and for other former sites of institutionalization of people with disabilities, to make space (see also Steele 2022) for reflection on past forms of "violence against, and abuse, neglect and exploitation of, people with disability" in order to prevent such abuses in the future (Government of Australia 2020, 2). If planning processes acknowledged the notion of disability community, as well as the ongoing desire by the local community for the island to remain a publicly accessible space, a fuller acknowledgment of its history could be possible. We mark moments that hint at such possibilities of transformation. In particular, we ask how the notion of "community" might be reconceptualized to allow the experiences of previous inmates to be foregrounded.

In tracing this possibility, we uncover resources available for the development of a site of conscience on the island. Despite the marginalization of people with mental health disorders, cognitive impairment, and learning difficulties, selected voices of the approximately 3,000 former inmates, as well as some of those who worked there, have been extensively documented. Two books, a radio documentary, two official reports – one recommending the closure of the institution and one evaluating the implementation of that closure – and a rich archive of materials in the State Library of New

South Wales offer material documenting these lives. The residents of PI also figure very occasionally in the nearly 200 local, national, and international newspaper articles that mention the island between 2006 and 2022. However, the voices of residents of PIC are never directly heard in these more recent newspaper articles. We focus here on the planning process and on the media coverage leading up to the hand-back of PI to the DLALC. Both the planning process and the media around it have neglected the lived experiences of residents. A key aim of this chapter is to note these absences, the discursive frames that omit residents' voices, and the consequences of these omissions. However, we also argue that, if the experiences embedded in this archival material, as well as traces of residents' experiences present in the site, are listened to in PI's development, visitors will be able to make critical connections to the lives and struggles of disabled people living in Australia today.

History of Peat Island: Institutionalization and Deinstitutionalization

Over 3,000 people lived on Peat and Milson Islands, two adjacent islands in Dyarubbin/the Hawkesbury, over the ninety-nine years that they were in operation as sites of residential care. At their peak in the 1950s, there were over 600 men and boys living on the two islands at any one time, and in 1976, soon after Milson Island ceased being used (Boon 2017), women began living on PI, first in respite and then permanently from 1978 onward (Ellmoos 2010).

An article published in the *Daily Telegraph* in April 1954 exposed inhumane conditions at the "sea-girt Bedlams" (Boys 1954). Because reporters were not given permission to visit, the paper's journalist relied on testimony from the secretary of the NSW Nurses' Association, A.L. Hart, who argued that due to serious overcrowding, understaffing, and a lack of adequate treatment, "Either the N.S.W. Government should legalise euthanasia and put these poor souls out of their misery or they should recognise them as human beings and treat them as such" (Boys 1954). In the mid-1950s, the Labour state government had to respond to a damning report on the Australian mental health system by Dr. Alan Stoller (1955), then senior psychiatrist of the Department of Repatriation, which highlighted that NSW legislation as it was put into practice at sites such as PIC was outdated and directly impacted the treatment of people with disabilities. Families visiting their children at PIC filed complaints about the care and treatment from the late 1950s (Andrews Zucker 2020, 132–33) into the 1980s, including a complaint in 1981 when every one of a seventeen-year-old boy's

fingernails were removed while he was in temporary care on the island (NSW Office of the Ombudsman 1983).

Changes to policy demanded by advocates, policy makers, and practitioners culminated in the 1983 Richmond Report, authored by the secretary of the Department of Health, David T. Richmond (1983), who recommended that large residential mental health hospitals be broken up and that psychiatric services be delivered through integrated community-based networks (NSW Nurses' Association 1983, 5). A series of media reports ("Forgotten Australians" 1981; "Peat Island" 1983) by the Australian Broadcasting Corporation canvassed the perspectives of PIC residents on independent living. Several of the residents interviewed in Jenny Brockie's *Nationwide* documentary "Peat Island" expressed their preference for remaining, as they enjoyed working and living on the island. Brockie interviewed residents who had different perspectives on PIC. Frank Taylor, a resident of fifty years, who was interviewed while working in the garden, said that he would prefer to leave and "live in Gosford, and [then] to go work here [at PIC]." Another resident of four years, Leonie Lawson, had "stronger ideas," according to Brockie's script. When asked what she would do if Peat Island was closed, Leonie replied, "That would be terrible." The nursing and allied staff interviewed were worried about what would happen to the residents when they moved from "the peace and support of Peat Island" ("Peat Island" 1983).

Following these broadcasts, the NSW Nurses' Association (1983, 6) asked whether the Richmond Report represented "real reform or real estate" and suggested that it represented "a poverty model of mental retardation care." The association's general secretary, Jenny Haines, said that the proposal would replace mental heath nurses with less-skilled and worse-paid staff while concentrating "the state's whole population of severely developmentally disabled people ... in groups of five in working class suburbs, with the bulk of funds allocated to teams of social workers trying to persuade parents to keep severely retarded children in their homes ... Some social reform!" (6). The association concluded that the proposal's financing was a "fast buck property developer's dream" (7). These predictions have, in some cases, proven to be prescient, as documented in a 2012 post-implementation review commissioned by the NSW Department of Ageing, Disability and Home Care (Fisher 2013).

By 2010, all residents had been transferred from the island to smaller facilities and group homes on the mainland, and PIC was closed. As noted in the post-implementation review (Fisher et al, 2013), ninety former residents were "transitioned" to new accommodation from 2006 onward, including a

large group moved to a specialist supported living facility for aged people with intellectual disabilities, which was initially publicly run but later privatized ("Casuarina Grove" 2020). A much smaller group was moved to a set of group homes run by a nongovernment provider (Fisher et al. 2013, 6). Most concerningly, residents in the group moved to the facility were found to be the same or worse off as they were before leaving PIC, when measured quantitatively through health and well-being scores, as well as indicators of autonomy (89, 100). During 2010 and 2011, People with Disabilities Australia (PWD) (n.d.) filed a series of court cases over the closure of PIC and relocation of residents, arguing that the residents were worse off in the new facilities, and sought closure of the these and other facilities built for former inmates of large residential centres. Although the cases were ultimately unsuccessful on procedural grounds, PWD argued that these centres violated the objectives and principles of the NSW Disability Services Act and the United Nations Convention on the Rights of Persons with Disabilities.

Commenting on his report more than thirty years later, Richmond (2014) himself reflected that for people with mental health conditions or with disabilities, "a significant exodus from institutional care through bed number reductions had already occurred in the 1960s and 1970s, well before the report, largely to meet budget pressure on the institutions ... [but] rarely had either money or services been channelled into community care." As Richmond acknowledged, the funding required had not materialized, and as PWD argued, the ideals of deinstitutionalization had also not been realized, with outcomes for some former residents the same or even worse than living in a large residential centre.

As has been pointed out by disability scholars, the establishment of networks of asylums for people with mental illness, physical disabilities, and cognitive impairment have deep connections to maintaining boundaries between classes of human beings categorized as normal or defective (Artiles, Dorn, and Bal 2016; Metzel 2004). In this aspect, such visions of the redevelopment of PI can be seen as a step toward covering over a troubling history of institutional violence rather than engaging with this history in a way that might seek to acknowledge the harm done and to repair it on a collective and social level. In the rest of this chapter, we call for this type of problematic redevelopment to be rethought and reimagined. We argue that such a reimagining has the potential to expand notions of community, allowing us to listen differently to the experiences of people with disabilities. We now turn to a discussion of how using a conceptual framework of deinstitutional violence helps us to rethink these ongoing omissions.

Deinstitutional Violence

Kate Rossiter and Jen Rinaldi (2018, 26) define institutional violence as "all practices of humiliation, degradation, neglect and abuse inflicted upon institutional residents, regardless of intention or circumstance." They propose that "while institutional violence is never acceptable, institutions themselves are inherently violent in form" (26). Although the move away from total institutions – such as PI truly was during its medicalization and incarceration phase – and toward deinstitutionalization in group homes and independent living has long been called for by advocates and people with disabilities, we use the term "deinstitutional violence" to highlight that the forms that such processes take are not always entirely beneficial and can create further types of injustice (Ben-Moshe 2020, 34–35). Even if recent policies of care and the assertion of rights for people with disabilities have irreversibly shifted power relations, any narrative of progress actively masks the emergence of more subtle forms of violence. Although there is no evidence that any former residents of PIC entered the criminal justice system as a result of leaving the institution, it is possible to see the deinstitutionalization process as moving residents into a transcarcereal grey zone where the boundaries between state and community actors are fuzzy and where institutional power relationships potentially remain in place (Baldry and Cunneen 2014, 277, 82; Kilty and DeVellis 2010, 137).

In this case, the failure to value and listen to the experiences of residents in the process of moving them to community care creates a secondary trauma by rendering invisible the connections and meanings that former residents and their families have built up over time at the site. This erasure is possible because the residents' absence is naturalized. Devaluing the stories of residents of former sites of institutionalization such as we document here could be considered what Miranda Fricker (2003, 164) has called "epistemic injustice" – where accounts of experience are not listened to, acknowledged, or acted on (see also Carel and Kidd 2014). Epistemic injustice, then, is a key part of what we are calling deinstitutional violence. We designate this process as a violent one – although not physically violent to the bodies of people – because it desubjectifies former residents and dehumanizes the former uses of such spaces. Finally, as is clear from the other chapters in this volume, the devolution of such institutions unleashes uneven and contradictory forces: privatization and socialization, surveillance and invisibility, autonomy and commodification, and more. Although this chapter does not afford us space to fully explore these processes, it is clear from a number of existing accounts that the violence of deinstitutionalization is

deeply implicated in these ongoing changes and challenges (e.g., see Fisher et al. 2013; and PWD n.d.).

Framing Peat Island

Listening – or choosing not to listen – is a key part of the deinstitutionalization process and one of our key concerns here. We now home in on the ways that both the planning documents and the media debates surrounding them manage the institutional history of the island, including the well-documented experiences of residents there. This retelling is evident not simply in the absence or presence of discourses but also in the ways that accounts are structured or framed. Jenny Kitzinger (2007, 137) points to framing as a fundamental building block of the social construction of reality, regarding it as a process that goes beyond notions of journalistic balance and overcoming "bias":

> The notion of framing is also far more radical than the idea of bias because it acknowledges that any account involves a framing of reality. The notion of "bias" suggests that there is an objective and factual way of reporting an issue "correctly," but that some reports distort this. The notion, of "framing," by contrast, suggests that all accounts of reality are shaped in some way or other.

Residents' experiences were rarely discussed in press stories in the period immediately before the closure of the facility and during its redevelopment. Of the 186 press articles referring to PI between 2006 and 2022, only a quarter refer to the experiences of residents at PIC, and only three of these articles include quotations from ex-residents of similar institutions – none of whom had themselves spent time on the island. There was some coverage of the move of PIC residents to their new homes, and PIC featured in a handful of discussions of deinstitutionalization, predominantly in city newspapers and in programs of the Australian Broadcasting Corporation (Hermant and Branley 2013; "Risk" 2019). A few of these articles, like journalist Adele Horin's (2010) reflection on the slow process toward deinstitutionalization in the *Sydney Morning Herald,* explain the threats and limitations of institutional living and feature detailed descriptions of the lives of residents. However, most stories that mention the institutional history of PI refer to the experiences of residents only fleetingly and in passing, or those experiences are turned into a ghoulish, dehumanized spectacle for dark tourism (see Beitiks 2012). Much of the media coverage of the island

foregrounds the views on the redevelopment proposal that have been expressed by current residents of the settlements on Dyarubbin/the Hawkesbury and by local politicians and businesses (see Findlay 2011). Other articles discuss a rumour that the site might be used to house asylum seekers (Cowper 2010) or describe the touristic features of the area (Hennessy 2019).

An editorial in the *Hornsby Advocate* breaks this pattern to make an overt argument for what scholars have referred to as "strategic forgetting" (Joseph, Kearns, and Moon 2013) – a process common in the rehabilitation of psychiatric institutions for private residential developments. The paper's editor, Steve Graham (2011), comments,

> There might still be a few people who are not enamored with the history of Peat Island. People who had mentally ill relatives sent there ... People who were banned, or dissuaded, from visiting those mentally ill relatives for decades. People who knew men working there who were reported to have lived and worked in filth and squalor. Such people might not care one iota about protecting the island, to protect its history.

Here, Graham considers the harms that PI's institutional past caused the relatives of residents and the families of staff working on the island – although significantly not the harms experienced by residents. The point of view of residents seems to be unimaginable – part of the process of failing to listen to or act on lived experience that Fricker views as epistemic injustice. This article's foregrounding of health professionals' and other workers' experiences of the island, in contrast, is common in press accounts. Graham's editorial makes explicit an argument that the violent history of the island should be abjected, rejected, and set aside as part of the river's past that is best forgotten. We describe this process of forgetting, less explicit but present in the framing of much of the media coverage of PI, as "deinstitutional violence."

There are a few moments in the media coverage of PI and its redevelopment when alternative framings are visible. Marion Wood (2009) in an article in the *Newcastle Herald*, notes an absence in official records of the violence and abuse with which many residents were treated, arguing that the fact that "these things happened should be acknowledged and remembered." Although it has been observed that disabled peoples' lives are often viewed as ungrievable (Steele 2022), some of the rare appearances of ex-residents in the media coverage of PI occur in the mention of graves and memorials, such as in stories about the unmarked graves of those who died

Geoffrey Potter, "Patients' Memorial Garden, Peat Island Centre, Mooney Mooney," in Gostalgia: Local History from Gosford Library, Flickr, March 2010, https://www.flickr.com/photos/gostalgia/with/50007101058/. Image reproduced courtesy of Central Coast Library Service under CC BY-NC 2.0.

early in the institution's history (Barnes 2015) or accounts of the discovery of the plaques that had been removed from the former memorial garden on the island (Barnes 2016). As we suggest below, these alternative framings, along with the sentiment commonly expressed in local media that the island should continue to be accessible to the public, are a ground on which proposals for a site of conscience might be built.

Planning proposals and their constituent heritage reports, like media accounts of the redevelopment, sideline the experiences of inmates of PIC. An early community-consultation document illustrates this omission well (Key Insights 2011). A particular account of heritage was "coaxed" (Smith and Watson 2001, 64) from residents through the visual and textual elements of the storyboard that was used as a prompt. Although the storyboard's text referred to "Indigenous and European" heritage, it gave no sense of the Frontier Wars, or of the lives of Indigenous people after colonization, or of the possibility that there might have been Indigenous residents within the institutions on PI. The storyboard's images depicted Frances Peat's grave

and the chapel on the island – elements of European-built heritage. Neither the lives of the inmates nor even the very fact that an institution existed on the island was directly referenced in the storyboard, although it did mention the possibility of "heritage significance (for example, social significance), particularly the buildings and past uses of Peat Island" (Key Insights 2011, 26–27). It is notable that none of the recommendations emerging from this community consultation referred to memorialization of the experiences of the residents of the site or to its history as an institution.

Despite the invisibility of the disability history of PI in this "coaxing" process, one comment highlights the island's labour and institutional history: "Peat Island has historical ties to the local community, having been a source of employment for local people for over a number of decades and is also of interest for its historic role in the provision of health services" (Key Insights 2011, 27). In the same document, a local resident remarks, "It is important to let the community say goodbye to the existing land use" (27). This comment flagging the possibility that community members might have affective connections to the island is the only reference in the planning documents to the emotional responses to PI so amply documented in Karen R. Fisher and colleagues' (2013, 82) post-implementation review of the deinstitutionalization process:

> Residents and family members ... reported that they used to participate in a range of activities when they lived at Peat Island ... arts and crafts, going for walks and picnics, fishing, watching a football game live in a stadium or participating in sports such as football or swimming. One man reported that he used to have a workshop where he repaired small items he collected, he also helped out on a farm in the community.

These moments acknowledging the meanings that PI had for those who worked and lived there offer a brief respite from deinstitutional violence that neglects the lives and perspectives of ex-residents and the wider disability community.

Reframing "Community"

The role that framing plays in producing epistemic injustice is particularly evident in the way that a key concept in the planning process – "community" – is deployed in the planning documents and in the media coverage around them. "Community consultation" is imagined in these documents in terms of consultation with those living in physical proximity to PI. However, the

political construction of "local community" was in fact explicitly discussed in the local press. There were lively debates around the exclusion of Hornsby Shire Council from decision making despite its location immediately south of Dyarubbin/the Hawkesbury in proximity to PI. Decisions about the planning proposals were made instead by Central Coast Council, based some distance from the site. Local press coverage even emphasizes that decisions about the site should not be exclusively the purview of those living nearby. Graham's (2011) editorial in the *Hornsby Advocate* argues that "people who happen to live quite close to PI should have no greater say over the development of the island than anyone else."

Despite this debate over who exactly constituted "the community" to be consulted in the development, neither ex-residents of PI currently living on the Central Coast nor members of the wider disability community were included in planning documents as a community to be consulted. This absence is made all the more visible by the way that the disability community is evoked in the post-implementation review of New South Wales' large institutions for disabled people (Fisher et al. 2013). The failure of planners involved in the project to conceptualize disabled people as constituting a community to be consulted about the redevelopment proposal is visible in the 2016 *Community Facilities Needs Assessment*. This document engages with the *Disability Action Plan 2008–2012*, prepared for Central Coast Council. This plan spells out "acceptance of diversity" and "a sense of place and belonging" as some of its objectives, but the needs assessment of the PI proposal focuses only on questions of access to the site rather than on belonging (Rudland and Roberts 2016, 16). The idea that disabled people visiting PI might be ex-residents or be connected to the site as part of a wider disability community is not imaginable in this document.

This failure to consult ex-residents, disabled peoples' organizations more broadly, or even family members of ex-residents contrasts with the consultation with the Darug, GuriNgai, and Darkinjung communities, traditional custodians of this part of Dyarubbin/the Hawkesbury (see Hoy et al. 2014, 1). Consultation with Indigenous organizations is guaranteed legally as part of the Environment Protection and Biodiversity Conservation Act 1999. Both this consultation process and the separate documents generated in the planning process to respond to the Indigenous-heritage value of the site to be redeveloped are required by law. Nonetheless, even this consultation process did not identify the possibility of Indigenous residents of the institution as part of the carceral archipelago impacting the lives of many

Aboriginal and Torres Strait Islander people. Despite this absence, these planning documents point toward alternative ways of framing community – around a connection to country, a sense of identity, and a shared heritage– rather than current residence. The ways that "community" has come to be understood in relation to the First Nations of Dyarubbin/the Hawkesbury are a model for deploying a wider conception of disability community in the planning process. Conceptualizing the disability community more broadly as a resource for the development of PI would enable adequate consultation on the future of the site, mitigating the deinstitutional violence of abjection and neglect. It would also enable connections to be made between past experiences of violence and present institutions and inequities – a central dimension of sites of conscience. The importance of attending to the intersections between Indigenous and disability history and experience has been brought to the fore with the recent announcement that ownership of the island itself will be transferred from the NSW state government to the DLALC.

Conclusion

In May 2021, following a memorial service dedicating "Peat Island Chapel to the memory of all those who lived and worked at Peat Island," local resident Juno Gemes (2021) asked on a Facebook page that the local campaign resist the development: "Many family members of previous residents have requested a Wall of Remembrance for those who died in this institution. We are bound to honour their request with a wall for plaques and a garden around it. Would all those who support this request consider how to present this to Council?"

These responses by local residents, along with hints in the community-consultation documents, suggest the beginnings of what could be a widening of the concept of the "community" impacted by the development process to include residents of the institutions on the island and the wider disability community. The consequences of the transfer of ownership of PI to the DLALC are as yet uncertain. However, the consultation in the planning process with the Darug, GuriNgai, and Darkinjung communities demonstrates the possibilities of a broader understanding of community and should prompt further attention to the ways that the violence of settler colonialism has intersected with deinstitutional violence at this site. The DLALC's chairperson, Barry ("B.J.") Duncan, has indicated the intent to "create something that showcases and preserves Aboriginal culture and

contemporary Australian history in a way that respects the past use of Peat Island and its former residents" (quoted in Noone 2022). There are opportunities here to address the epistemic injustice of the exclusion of disabled people from earlier rounds of consultation and planning.

We conclude that calls for a memorial at PI could be a starting point for listening differently to the voices of former residents and people with disabilities more generally. Following a site of conscience model, such a memorial might seek to place the lived experiences of people with disabilities in the broader context of historical and current welfare policies in New South Wales and Australia. Many sources are available to be read, and listened to, that can help us to imagine and account for a different future. They include the extensive sets of material in the archives of Margaret Scholtz (n.d.), which were donated to the State Library of New South Wales, Laila Ellmoos's (2010) book on the history of Peat Island, and the oral histories recorded for that book by Sue Andersen (2009), which form an important continuation of the stories of residents recorded in the Australian Broadcasting Corporation's audiovisual archive. The careful research of Gina Andrews Zucker (2020) on the cohort of children admitted to the Watt Street Mental Hospital in the early 1950s, some of whom spent time living on PI, also provides a nuanced starting point. This abundance of evidence stands as a testament to the agency of former residents, despite the ongoing deinstitutional violence that this chapter has argued exists in the wider framings of Peat Island.

NOTES

Acknowledgment: We wish to acknowledge the traditional owners of the waters of Dyarubbin/the Hawkesbury River – the Garigal, GuriNgai, Darug, and Darkinjung peoples – whose deep and unbroken connection to country precedes and overlaps with the events discussed in this chapter. Because we focus only on processes of deinstitutionalization at Peat Island, we are unable to adequately deal with Aboriginal connections to the site in this work, including the possibility that First Nations peoples were incarcerated at the site during its operation. We acknowledge and regret this limitation.

1 Submissions to Central Coast Council regarding the Peat Island Planning Proposal were not made public, but a submission commissioned by the New South Wales Council for Intellectual Disability, and published on its website, argued that "Peat Island has a significant cultural role in representing the transformation of disability policy in NSW and Australia, including through the resistance and activism of people with disability" (Steele and Carnemolla 2021, 17).

REFERENCES

Andersen, Sue. 2009. Interviews with Peat Island residents for the Peat Island History Project, NSW Department of Ageing, Disability and Home Care. In MLOH 620, Mitchell Library, State Library of New South Wales, Sydney.

Andrews Zucker, Gina. 2020. "A Case Study of the Impact of Administrative Frameworks on a Group of Intellectually Disabled Children Admitted to an Australian Mental Hospital in 1952." PhD diss., University of Sydney.

Artiles, Alfredo J., Sherman Dorn, and Aydin Bal. 2016. "Objects of Protection, Enduring Nodes of Difference: Disability Intersections with 'Other' Differences, 1916 to 2016." *Review of Research in Education* 40 (1): 777–820.

Baldry, Eileen, and Chris Cunneen. 2014. "Imprisoned Indigenous Women and the Shadow of Colonial Patriarchy." *Australian and New Zealand Journal of Criminology* 47 (2): 276–98.

Barnes, Denice. 2015. "Island Still Haunted by Its History." *Central Coast Advocate*, August 12.

–. 2016. "Patient History Uncovered." *Hornsby Advocate*, October 13.

Beitiks, Emily Smith. 2012. "The Ghosts of Institutionalization at Pennhurst's Haunted Asylum." *Hastings Center Report* 42 (1): 22–24.

Ben-Moshe, Liat. 2020. *Intersecting Disability, Imprisonment, and Deinstitutionalization*. Minneapolis: University of Minnesota Press.

Boon, Paul I. 2017. *The Hawkesbury River: A Social and Natural History*. Clayton South: CSIRO.

Boys, Larry. 1954. "Disgraceful Conditions on Hawkesbury Islands." *Daily Telegraph*, April 11, 3.

Carel, Havi, and Ian Kidd. 2014. "Epistemic Injustice in Healthcare: A Philosophical Analysis." *Medicine, Health Care and Philosophy* 27 (4): 529–40.

"Casuarina Grove to Be Taken over by a Private Provider." 2020. *Coast Community News*, September 2.

Cowper, Monique. 2010. "No Asylum on Peat for Boat People." *Hornsby and Upper North Shore Advocate*, November 4, 11.

Davies, Stephen, and Joseph Heng. 2014. *Heritage Report: Peat Island, Mooney Mooney*. Sydney: Urbis.

Edwards, Claire, and Rob Imrie. 2003. "Disability and Bodies as Bearers of Value." *Sociology* 37 (2): 239–56.

Ellmoos, Laila. 2010. *Our Island Home: A History of Peat Island*. Ed. Sue Andersen and William Newell. Sydney: NSW Department of Ageing, Disability and Home Care.

Findlay, Tracey. 2011. "Peat Island Pique." *Hornsby and Upper North Shore Advocate*, June 9, 8.

Fisher, Karen R., Sandra Gendera, Friederike Gadow, Deborah Lutz, Rosemary Kayess, Ariella Meltzer, and Sally Robinson. 2013. *Closure of Grosvenor, Peat Island and Lachlan Large Residential Centres – Post Implementation Review*. SPRC Report 17/13. Kensington: UNSW Social Policy Research Centre.

"The Forgotten Australians." 1981. *Four Corners*. Sydney: Australian Broadcasting Corporation.

Fricker, Miranda. 2003. "Epistemic Injustice and a Role for Virtue in the Politics of Knowing." *Metaphilosophy* 34 (1–2): 154–73.

Gemes, Juno. 2021. "Reply to Post: Dedication of Peat Island Chapel to the Memory of All Those Who Lived and Worked at Peat Island: Peat Island Chapel at Mooney Mooney. @peatislandhawkesburyriver." https://www.facebook.com/peatislandhawkesburyriver/.

Government of Australia, Royal Commission into Violence, Abuse, Neglect and Exploitation of People with Disability. 2020. *Interim Report*. Barton: Attorney-General's Department. https://disability.royalcommission.gov.au/publications/interim-report.

Graham, Steve. 2011. "Island Could Become a Beauty." *Hornsby Advocate*, April 14, 26.

Hennessy, Patrick. 2019. "We Cruised the Hawkesbury." *Daily Telegraph*, October 30, 51.

Hermant, Norman, and Alison Branley. 2013. "Group Homes Slammed by Mother after Disabled Daughter Locked in Garage, Forced to Use Bucket as Toilet." *ABC News* (Sydney), December 20.

Horin, Adele. 2010. "Empty Promises of Freedom." *Sydney Morning Herald*, October 9, 4.

Hoy, David, Sarah Horsfield, Norelle Jones, and Skye Playfair Redman. 2014. *Government Property NSW Peat Island and Mooney Mooney Rezoning Proposal*. Urbis/Government Property NSW.

Joseph, Alun, Robin Kearns, and Graham Moon. 2013. "Re-imagining Psychiatric Asylum Spaces through Residential Redevelopment: Strategic Forgetting and Selective Remembrance." *Housing Studies* 28 (1): 135–53.

Key Insights. 2011. *Peat Island and Mooney Mooney Lands Rezoning Consultation Report*. Sydney: NSW State Property Authority.

Kilty, Jennifer M., and Leah DeVellis. 2010. "Transcarceration and the Production of 'Grey Space': How Frontline Workers Exercise Spatial Practices in a Halfway House for Women." In *Droits et Voix/Rights and Voices: La criminologie à l'Université d'Ottawa/Criminology at the University of Ottawa*, ed. Véronique Strimelle and Françoise Vanhamme, 137–58. Ottawa: University of Ottawa Press.

Kitzinger, Jenny. 2007. "Framing and Frame Analysis." In *Media Studies: Key Issues and Debates*, ed. Eoin Devereux, 134–61. Los Angeles: Sage.

Metzel, Deborah S. 2004. "Historical Social Geography." In *Mental Retardation in America: A Historical Reader*, ed. Steven Noll and James W. Trent Jr., 420–44. New York: New York University Press.

New South Wales Nurses' Association. 1983. "Richmond Report: Real Reform or Real Estate?" *The Lamp*, April, 6–9.

New South Wales Office of the Ombudsman. 1983. *Report Concerning Mr R.C. Osborn and the Department of Health, Dated 18 October 1983*. Sydney: Government Printer.

Noone, Richard. 2022. "NSW Govt to Gift Peat Island to Darkinjung." *Central Coast Gosford Express Advocate*, January 21.

"Peat Island." 1983. *Nationwide*. Sydney: Australian Broadcasting Corporation.

People with Disabilities Australia (PWD). n.d. "What We're Doing: New South Wales." https://pwd.org.au/.

Richmond, David T. 1983. *Inquiry into Health Services for the Psychiatrically Ill and Developmentally Disabled [Richmond Report]*. Sydney: Division of Planning and Research, NSW Department of Health. https://www.nswmentalhealthcommission.com.au/content/richmond-report.

—. 2014. "Richmond Report: David Richmond AO, Author of the Report, Talks Briefly about Its History and Its Significance." Mental Health Commission of New South Wales, October 6. https://www.nswmentalhealthcommission.com.au/content/richmond-report.

"Risk in Even Well-Intentioned Reforms." 2019. *Newcastle Herald*, May 11, 29.

Rossiter, Kate, and Jen Rinaldi. 2018. *Institutional Violence and Disability: Punishing Conditions*. Abdingdon, UK: Routledge.

Rudland, Susan, and Sidonie Roberts. 2016. *Mooney Mooney and Peat Island Planning Proposal: Community Facilities Needs Assessment*. Sydney: Urbis. https://www.yourvoiceourcoast.com/sites/default/files/2021-09/appendix_q_-_community_needs_statement1.pdf.

Scholtz, Margaret. n.d. *Papers Regarding Peat Island, Together with Laila Ellmoos' Research Notes on the History of Peat Island 1928, 1958–2010*. MLMSS 8981, box 1, folder 1, Mitchell Library, State Library of New South Wales, Sydney.

Smith, Sidonie, and Julia Watson. 2001, *Reading Autobiography: A Guide for Interpreting Life Narratives*. Minneapolis: University of Minnesota Press.

"State Government Transfers Peat Island Ownership to Darkinjung Land Council." 2022. *Coast Community News*, October 27. https://coastcommunitynews.com.au/central-coast/news/2022/10/state-government-transfers-peat-island-ownership-to-darkinjung-land-council/.

Steele, Linda. 2022. "Sites of Conscience Redressing Disability Institutional Violence." *Incarceration: An International Journal of Imprisonment, Detention and Coercive Confinement* 3 (2): 1–28.

Steele, Linda, and Phillippa Carnemolla. 2021. *Submission to Central Coast Council on Mooney Mooney and Peat Island Planning Proposal on Behalf of Council for Intellectual Disability*. Council for Intellectual Disability. https://cid.org.au/our-campaigns/peat-island/.

Stoller, Alan, with Keith William Arscott. 1955. *Report on Mental Health Facilities and Needs of Australia*. Canberra: Department of Health, Government of Australia.

Wood, Marion. 2009. "Time for Healing." 2009. *Newcastle Herald*, March 7, 7.

"The Old Concept of Asylum Has a Valid Place"
Patient Experiences of Mental Hospitals as Therapeutic

VERUSCA CALABRIA and ROB ELLIS

At the end of the last century, important changes occurred in the care of people experiencing mental distress in the United Kingdom, which mirrored events across the Western world. Although in-patient numbers had been falling since the 1950s, the closure of large-scale mental hospitals in the 1990s represented the final, significant push toward deinstitutionalization (Bartlett and Sandland 2007). People had always been "cared" for in communities, but it was at this point that a somewhat nebulous policy of "community care" became a reality for the remaining patients, many of whom had been in hospital for a long time. Their closure appeared to be a common-sense and humanitarian response to their failings. Dogged by scandal and critique, which focused on primitive treatments and patient abuse (Hilton 2017; Martin 1984), influential studies described them as "total institutions" (Goffman 1961, xiii) that served to control every aspect of their inmates' lives. Rather than being therapeutic environments, these were places that had a negative impact on individuals' mental functions and social identity (Jack 1998).

However, as the processes of deinstitutionalization ramped up, scholars began to look again at the meanings of institutions and their closure. Whereas some focused on the political and economic motivations of policy makers, others placed patients' testimonies at the heart of their analyses. Pauline M. Prior's (1991) longitudinal study of Samuel, a patient in Northern Ireland, for example, revealed a man with a strong sense of personal identity and a

social network that extended beyond the mental hospital, despite his forty years as an in-patient. Empirical studies since that time have likewise shown how psychiatric institutional spaces have been seen as both meaningful and therapeutic by some former patients and staff, who regard them as sites of refuge and respite (Calabria 2022; Calabria, Bailey, and Bowpitt 2021; Gittins 1998; Parr, Philo, and Burns 2003).

In part, these newer, more positive studies have been informed by the "loss" of institutional spaces and, as a corollary, by the failings of the community-care settings that replaced them. The fragmentation of mental health services and their chronic underfunding in the years since deinstitutionalization (Turner et al. 2015) have left some service users unable to access much-needed support (Spandler 2016), whereas others find themselves shunted to facilities hundreds of miles away from home (Campbell 2018). Without denying or undermining the erasures of injustices suffered by people with disabilities in institutions that were supposed to provide "care" for them (Abbas and Voronka 2014), such studies complicate our understanding of mental hospitals as sites of conscience. As Helen Spandler (2016, 7) points out in a special issue of *Asylum* published to commemorate thirty years of the magazine's existence, a new wave of "psychiatric resistance" has emerged in which the survivors' movement and its allies now fight against psychiatric neglect by demanding not only that in-patient units be kept open but also that access to long-term support services be provided in the community.

As researchers turn their attention to sites of conscience (Ashton and Wilson 2019; Brett et al. 2007), they must also consider the systems that replaced mental hospitals. Barbara Taylor (2011, 2015), a historian and a patient of Friern Barnet mental hospital in London, England, in the 1990s, has eloquently made a case for the value of safe spaces in which to recover when caring for oneself is no longer an option, arguing that the choices and personal autonomy born of consumerism can be a form of neglect for people vulnerable to mental health crisis.

How, then, can we balance our duty to remember the difficult pasts of mental hospitals and the right of victims, survivors, and citizens to recall and have their memories recognized (O'Reilly 2020) in this context? We confront this challenge by analyzing an archived in-depth oral testimony of Keith Shires, who encountered life as an in-patient at Shenley Hospital in England during the second half of the twentieth century.[1] Building on the above research and on more recent work that has sought to give a voice to those at the sharp end of policy-making (Ellis, Kendall, and Taylor 2021), we

aim to rectify the enforced amnesia regarding the lived experiences of people with disabilities by documenting memories of psychiatric institutions (Alun, Kearns, and Moon 2011) in order to inform debates on the impact of deinstitutionalization and the ongoing failures of community care. As a former in-patient of Shenley, Keith was well placed to reflect on the consequences of the demise of spatial and social elements of institutional care. Significantly, although he first welcomed the closure program, he later changed his mind, and we seek to unpick the reasons behind his change of heart. Keith's understanding and experience of community care are central to his re-evaluation of the institutional care provided at Shenley, but we also aim to build a view of him as an individual rather than just a former patient or service user.

The first section of this chapter builds on Oisín Wall's (2013) interview with a patient, Adam, to consider the contexts and experiences that shaped Keith's views and, in so doing, to demonstrate the deep experiential, theoretical, and critical thought that he had given to deinstitutionalization. Here, we discuss his institutional experiences as a white male and reflect on whether individuals of other genders and ethnicities negotiated the same treatment paradigms. In the sections that follow, emphasis is placed on the apparent isolation of former mental hospitals, what that meant for some patients, and how connections with the world beyond their grounds were maintained. Rather than presenting deinstitutionalization as a marker or a moment between a dark past and an enlightened present (Altermark 2018; Ellis 2017), the aim is to explore the ongoing challenges faced by someone who transitioned from institutional to community "care" in England in the late twentieth century. As the editors of this volume remind us in the Introduction, institutional care could and can be both dehumanizing and lethal. For instance, Kate Rossiter and Jen Rinaldi (2018) offer an in-depth analysis of how disabled people have endured forms of embodied violation and discipline within institutions designed for their residential "care." At the outset, we want to emphasize that Keith does not present a straightforward, rose-tinted view of mental hospitals, but in amplifying his voice, we aim to highlight the longer-term and ongoing challenges faced by service users in community settings.

Lost Institutional Spaces and Practices in Context

In England, the public funding and public regulation of asylum buildings had peaked between 1845 and 1914 (Rutherford 2005), but Shenley was one

of a handful of English mental hospitals that opened in the interwar period. By this time, the majority of these earlier institutional iterations had grown in size and/or were home to patient populations of around 2,000 to 3,000. The apparently insatiable demand for in-patient provision had pushed the medical profession and policy makers to explore a wider range of options that sought to limit further expansion of patient numbers (Ellis 2020). Shenley was built shortly after the passing of the 1930 Mental Treatment Act. This legislation included provisions for swifter, acute treatments and for the establishment of outpatient clinics (Takabayashi 2017), and Shenley was lauded for its modernism as a result. Its 1,000 patients were accommodated in voguish, smaller villas, and its medical staff employed what were seen, at the time, as pioneering new treatments, including insulin coma therapy (Wall 2013). As with the earlier, institutional paradigms, patients had access to extensive, landscaped grounds (McCrae 2014).

By the 1960s, Shenley was suffering from the fate that had befallen its predecessors. Its patient population had more than doubled, resulting in cramped and overcrowded villas and in poor staff-patient ratios. It seemed to suffer from its reputation as a modern facility, with improvement grants and funds being diverted to older hospitals, which were deemed to have more pressing needs (Wall 2013). Nevertheless, the hospital is perhaps best known for the experimental work of psychiatrist David Cooper, who, like psychiatrist R.D. Laing, was part of a radical anti-psychiatry movement after the Second World War that embraced the principles of "therapeutic community" (Fussinger 2011). At Shenley, Villa 21, a short-lived experiment conducted between 1962 and 1966, Cooper worked with young schizophrenic patients to break down the barriers between staff and patients (Fussinger 2011; Wall 2013). Cooper aimed for equality with the patients, advocating for the validity of their lived experiences. Rather than dismissing them as just symptoms of an illness, he famously believed that mental illness was caused by family relationships, repression, and labelling (Cooper 1967; Crossley and Crossley 2001). Cooper's work was relatively well known as the inspiration for the film *Family Life*, released in 1971, which mirrored the closure of Villa 21 and contrasted its therapeutic and enlightened treatment of schizophrenic patients with the invasive and damaging treatments that had replaced it (Spandler 2006). This longer-term context helps us to understand some of Keith's insights. To reiterate, he does not offer a straightforward and positive view of his time at Shenley, and we need to be attendant to the wider histories of mental hospitals as sites of conscience. Many of

his recollections recall the darker side of institutional treatment, and it is important that we do not ignore these accounts or suggest that his time as an in-patient was uncontroversial.

First admitted to Shenley in 1961 as a seventeen-year-old, just as Cooper's experimental therapeutic community was beginning, Keith was described as "intellectually impaired" and diagnosed with schizophrenia. When he learned that his parents had agreed for him to be given insulin treatment, he ran away to a nearby farm because, in his words, it turned people into "zombies." When he was returned to Shenley, he was brought under the care of Cooper in the adolescent unit, where he described making strong bonds with patients and staff. After his discharge, although no longer under the care of the hospital, he continued to visit Cooper and the patients at the hospital every Saturday for the next three years as his main social support network. He described the sessions that he attended with Cooper as "friendly," "open," and "equal." These sessions could, however, be dominated by verbose people, which sometimes led to tensions and aggression between patients.

Keith spent a year at Shenley and remembered his distress at seeing some patients undergoing electroconvulsive therapy. He spoke of the familiar and distressing themes of fear, control, and restraint. He recalled that staff could be both empathetic and supportive but, as a result, were sometimes seen as being "soft" on the patients. Moreover, others verbally bullied the people in their care, and although this made him angry, the fear of "being injected" helped him to keep his emotions in check. Clearly, there are examples here of nonconsensual psychiatric treatment and detention (Ben-Moshe 2017), but looking back, Keith explained,

> The old concept of asylum has a valid place, which doesn't exist in the modern hospital. It takes one away from the stress of urban society, and one is calmed down by the environment itself, so that it did have a valuable role. I think their philosophy of pushing people into some structure had a practical value, which is looked on [as] a bit of a miss nowadays. It wasn't bullying people, and it was gently urging them back into some form of routine, because if you didn't have the routine, then the problems in the mind could take place.

How could a man who had witnessed bullying and coercion, and had feared invasive treatment, during his time in a mental hospital speak of the

positives of this form of treatment? The answer lies in his experience of both institutional and community-care models.

Blurring the Lines between Treatment Paradigms

After his discharge in 1961, Keith struggled to hold down a job, partly because of his dyslexia and partly because of the stigma that he faced as a former in-patient at a mental hospital. Nevertheless, he kept himself active, volunteering at an Oxfam charity shop and with the Labour Party, a left-of-centre political party, as well as studying and writing plays. Ten years after his first stay at Shenley, he had a breakdown, and an angry and verbally aggressive Keith was returned to Shenley by the police. A medicated Keith, whom he would describe as older and more mature, was discharged within six weeks.

Within this brief overview, it is important to recognize that Keith spent a very small part of his life at Shenley, a little over a year in total. He had a life before and after he was institutionalized, and although the scope of this chapter precludes detailed analysis, there can be little doubt that the in-depth interview with Keith reveals a well-read, intelligent, and articulate man with various interests, including music, sports, politics, and current affairs. His oral history interview was recorded when he was fifty-four; his time as an in-patient did not define who he had become or reflect his broader life story, but his recollections of his time at Shenley must have been affected by the reality of his life as an outpatient.

During his time at Shenley, Keith was prescribed drugs – including Largactil, a brand name for chlorpromazine – and was still taking them at the time of his interview in 1999. According to him, they had both saved him and destroyed his life, not least because they affected his concentration and "his natural intellectual" processes. Significantly, however, Keith recalled that he had not been on drugs when he had been with Cooper, and in this context, it is not surprising that, in retrospect, he saw Shenley as a sanctuary and "a right that people [should] have when they're distressed." With such spaces no longer available in modern in-patient services (Barham 2020, 8), Keith explained the limited options that were available to him in terms of respite from the pressures of everyday life:

> I found it quite a stress-free environment, which to a degree doesn't exist in the modern hospital because the country environment does have something of value in the early stages. I think in a general hospital you're in an

environment that is very competitive, so I feel in the early stages of mental health, the country or the semi-rural environment has a practical purpose.

Keith cited Cooper's (1967) book *Psychiatry and Anti-psychiatry* in the course of the interview and stated very clearly that "social factors [were] the main reasons for mental health," but his portrayal of Shenley is redolent of Wilbert M. Gesler's (1993, 171) concept of "therapeutic landscapes," namely environments that have the capacity to heal physically, mentally, and spiritually. In this case, there is a potential for issues around power and control to remain, but the experiences of the loss of respite and therapy options are often apparent in other studies of deinstitutionalization. For example, by reconstructing the meanings attached to Craig Dunain Hospital in Scotland shortly after the hospital closed in 2000, scholars have shown that for patients and staff the grounds provided a setting where social relations, experiences of mental ill health, and steps toward recovery unfolded and were imbued with discourses of nature as therapy (Parr, Philo, and Burns 2003).

For some, including Keith, respite did not mean isolation but an opportunity to develop close interpersonal relationships. He became well acquainted with staff and the male patients in the adolescent ward, and as both a space and a place, the hospital was central to fostering these relationships. "I had friendly relationships with the staff," he recalled, and "at the same time, there were sort of friendships between staff and patients, which in a busy, urban environment probably couldn't take place." Significantly, the interpersonal relationships that he was able to form in that first period of hospitalization were pivotal in helping him to recover and, according to him, reduced the length of his second hospitalization to six weeks: "If I hadn't been in that privileged position of knowing the nurses from last time, it could have been a very barren experience, so the fact that they knew me, the atmosphere wasn't too stressful." Therapeutic practice has been largely unattainable in acute in-patient settings since the 1990s in the United Kingdom as a result of rising demands for beds, coupled with the reduction in number of beds; more than half of the National Health Service's hospital beds have been cut in the last thirty years (Ewbank, Thompson, and McKenna 2017; Higgins, Hurst, and Wistow 1999). Moreover, the fragmentation of current mental health services has meant that the relationships between staff and patients are typically short-term and veer toward crisis management (Patel 2019).

Keith's experiences can be seen in other places, too. In Nottingham, for example, ex-patients and staff recalled the importance of therapeutic staff-patient relationships in the mental hospitals thirty years after their closure, which were instrumental in recovery and in fostering the long-term nature of some of those relationships (Calabria 2022; Calabria and Bailey 2021; Calabria, Bailey, and Bowpitt 2021). These examples offer additional challenges to the perceptions of the totality of institutions as presented by Goffman (1961) and others, as do some of the ongoing relationships that Keith maintained with the outside world. As he explained, the rural milieu of some mental hospitals did not mean that they were as isolated or as dysfunctional as many people perceived them to be. He recounted his own relative freedom of movement both within and outside Shenley. His recollections also included the time that he feigned a toothache as a way to temporarily escape Shenley's confines with a trip to the dentist, but he further recounted,

> We weren't that isolated because the occupational therapy department arranged trips to concerts and we saw some of the international football matches at Wembley. The patients could walk to the local village, there was no problems in the pub, we were accepted by the villagers. The fact that quite a lot of nurses lived in the village with their families made it a lot easier for us.

Not all patients will have enjoyed the freedom, welcome, or acceptance (Ellis 2013b) that Keith found in these male-dominated activities, but in his trips to the world beyond the hospital site, Keith remembered feeling more accepted by the local community adjacent to the hospital than he did back home. It was these connections that were also central to his understanding of rehabilitation in the old system.

Keith's oral history offers important insights on lost aspects of in-patient care from the old system that are particularly salient in light of the recent review of the Mental Health Act (Wessely 2018). The review of this legislation makes specific recommendations concerning the need to reduce the prison-like environments within in-patient units, including modifications to the built environment so that internal and external spaces can engender informal sociability, such as the ability to move between wards and to access the outdoors, as well as improvements to the atmosphere of the wards by making these environments more welcoming. Importantly, Keith's oral testimony

highlights the limited investment in long-term, therapeutic community-type services and support structures in the mental health system in the early days of community care. These support systems were discontinued with the closure of institutions; as disability rights activists have pointed out, the lack of access to this support persists to this day (Spandler 2020).

Mental Hospitals, Occupational Therapy, and Rehabilitation

Just as sport played a part in maintaining links with the local community, it also had a place in the therapeutic nature of the hospital site. As others have shown, therapy and narratives of recovery can be couched in terms of compliance with psychiatry (Woods, Hart, and Spandler 2022). This context is all-important because there were some obvious things about life as an in-patient that aligned with Keith's broader interests. Peter Nolan (1998) has shown how asylums and mental hospitals could attract individuals to the nursing profession because of the opportunities to play sports using the facilities that were enclosed within their grounds. Although Keith's initial response was to run away from Shenley, he later identified the hospital's provision of sports as a hidden positive of the institutional system that aided his own recovery, noting its absence in post-deinstitutionalization community settings:

> I enjoyed physical activity. It also helped overcome the effects of the medication. The cricket field and the football field were originally part of that estate, whereas at the general hospital, though there's fields round the hospital, they're not used. But at Shenley, one played football. There was cricket and football matches, and that was very satisfactory. It was a valued part of the healing process, interaction was good for everybody, but whether modern hospitals in cities can do that I very much doubt.

In this case, the loss of recreational opportunities presented by the loss of hospital sites was very personal, but it was also gendered. Participation or spectator sport did not suit all patients, and research elsewhere has shown that its therapeutic qualities could also give way to isolating and exclusionary practices (Ellis 2013a). Sporting activities were available only to active and able male patients, and the less able, as well as female patients, did not have the same opportunities to be involved. Nevertheless, for Keith, it was a loss of the space to be able to take part in these practices that framed his experience, a recurring issue throughout his testimony. These examples further undermine the notions of distance and isolation. Keith explained,

The socials were useful, and particularly the trips outside to the football, to the pop concerts. We weren't coerced into it, that was a natural choice on our part, and that was encouraged as well. I think this would be difficult to operate in an urban environment because there'd be too many people in the pub anyway, and there'd also be no relationships established beforehand, so that couldn't be the same [kind] of community if one tried to do the similar sort of thing in an urban environment.

These elements of Keith's testimony focus less on the modernity of Shenley and more on the older conceptions of hospital sites. The loss of "asylum" in its truest form as sites were redeveloped for other purposes has led to dispossession on the one hand and to neglect on the other; the choice to access a place of safety and respite is no longer an option under the current crisis in the provision of mental health in-patient services (Calabria 2022). When Keith was rehospitalized in 1971, he initially felt that he could not go back to the "sympathetic environment" previously experienced, as Cooper had left. However, Keith found attending occupational therapy (OT) beneficial for his recovery, as he felt that it was well developed and provided a better offer than the community-care day services that he attended at the time of his interview in 1999:

OT isn't quite as sophisticated as it was all those years ago. It was far more structured, and they wouldn't allow as they do today, at the day centres, people just sitting around smoking. I think there's a need for some structure to overcome the chaos of mental health. OT gave one a sense of routine, which is often lacking in modern psychiatric care; people are just like a drifting ship. The lack of structure can be very destructive and disorientating.

Keith appreciated the creative activities available in the old system both within and outside the hospital environment, which he felt were not developed in the new system of community care. He pointed to the lack of rehabilitative services as a stepping stone between crisis and recovery in community care by highlighting issues with modern service provision: "It is a transfer from the hospital environment to society where it fails. You're not getting integrated with the sort of social activities of the community in general. There's not a sufficient development to get you integrated into the general cultural scene."

Keith's reflections on care practices in the old system offer important insights into the need for people with long-term mental health conditions

undergoing a mental health crisis to access place-based, structured rehabilitation activities, fostered in an environment removed from everyday life. Despite the imperative of the inclusion agenda in mental health policy, adopted to redesign services as a means to encourage independence from them (Spandler 2007), service users have sought to safeguard opportunities for peer support in safe places (Bryant et al. 2010). Keith's and other former patients' testimonies highlight the shortcomings of care in the current English mental health system, where there is little investment in long-term, therapeutic community-care services (Spandler 2020). Mental health services largely lack integration, which in turn negatively impacts the quality of services available to those in need (Patel 2019). As Keith pointed out, practices such as therapeutic activities and meaningful interaction between patients and staff in acute in-patient settings are largely unattainable due to a shortage of staff and too many demands placed on them, such as dealing with crisis (Csipke et al. 2014; MIND 2004; Wykes et al. 2018). The wards have been reported by patients and staff alike to resemble prison-like environments not conducive to recovery due to the concentration of people who are most unwell and the lack of therapeutic activities and meaningful interaction (Csipke et al. 2014; Wykes et al. 2018).

Keith's and others' experiences of the transition from institutional to community-care practices highlight the conflicts and ambiguities in the project of deinstitutionalization, which became apparent in the early 1990s when the pace of closure of the state mental hospitals outstripped the provision of services in communities (Barham 2020). The renewed effort of the medical model to control symptoms so that people could return to their communities eclipsed the values and ethos of the social model of psychiatry at the expense of communal relationships that existed within the mental hospital environment (Beckman, Nelson, and Labode 2021; Calabria 2016), as signalled by the shift toward an overreliance on psychotropic drugs in community care and away from specialized in-patient and community-type therapeutic environments (Ramon and Williams 2005; Taylor 2015).

Conclusion

Three key themes emerge from Keith's testimony, namely his need for respite at Shenley, how he benefited from structured rehabilitation and recreation, and the sense of community that he recalled. Reflecting on the place of mental hospitals as sites of conscience, we have to be attendant to the voices of those who speak of the dark side of their past, while also recognizing the demand from some disability rights groups and Mad and critical mental health scholars

for adequate in-patient provision in the twenty-first century. There are obvious constraints in the reuse of archived oral testimonies, such as issues of interviewee's consent and the researcher's intent (Bornat 2003). However, Keith's oral testimony and others of its kind provide a valuable resource for understanding the difficult and complex histories of mental hospitals and for recognizing the issues that the loss of these sites created. As a former in-patient and ongoing service user, Keith was well placed to comment on the changes that took place during his lifetime, but as his testimony demonstrated, he thought deeply about the treatment that he received in both cases.

As this chapter has shown, he was critical of elements of both treatment paradigms. His recollections were informed by his own experiences, his politics, and his understanding of psychiatry's past. As authors, we recognize that his views and his experiences were not universal. The strengths of in-patient care as he saw them would not have necessarily been recognizable to women and people of colour. The scope of this chapter precludes more in-depth analysis of these issues, prompting further consideration, but there are still important points to be made. Although Keith first welcomed the closures, the lack of adequate investment in community care meant that he looked backed to see, very clearly, what was missing in his present. Just like accounts of other mental hospitals in the period, Keith's testimony highlights that the hospital could be remembered as a place of rehabilitation, respite, sanctuary, and convalescence. These were the aspects of care that he missed at critical points in his life, which he felt were needed by others during crisis. Keith's experiences evidence the often-chronic underfunding of mental health services moved from one treatment paradigm to another, also mirroring other issues such as stigma, neglect, and even abuse (Ellis 2017). Although not advocating a return to asylums (Ben-Moshe 2017), our chapter has considered some spatial and social aspects of care in the old system that ought to be reflected in the design and planning of modern-day mental health care; it also takes into account a wider range of voices than the one presented here. As historians Alexandra Bacopoulos-Viau and Aude Fauvel (2016) have argued, personal narratives can highlight the multidimensionality of institutions, allowing for a multiplicity of previously hidden experiences to emerge. Keith's narrative offers a nuanced perspective on the range of options for long-term support needed in current mental health provision, one that connects with the perspectives held by disability rights groups in the United Kingdom and elsewhere. Deinstitutionalization has not been a panacea, and the flaws inherent in community care, a shifting and amorphous concept, mean it too can be a site of conscience.

NOTE

1 The total length of Keith's oral history is nine hours. He gave his consent for his name to be used, and in 1999 he was one of fifty contributors to the Mental Health Testimony Project in London, England, now deposited in the British Library National Life Stories Collection (catalogue no. C905, interview identifier C905/01/0109). The archive includes video oral histories not only of people who were long-stay patients in the psychiatric asylums but also of "revolving door" patients and those with a mental illness diagnosis in the second half of the twentieth century in England and Wales.

REFERENCES

Abbas, Jihan, and Jijian Voronka. 2014. "Remembering Institutional Erasures: The Meaning of Histories of Disability Incarceration in Ontario." In *Disability Incarcerated: Imprisonment and Disability in the United States and Canada*, ed. Liat Ben-Moshe, Chris Chapman, and Allison C. Carey, 121–38. New York: Palgrave Macmillan.

Altermark, Niklas. 2018. *Citizenship, Inclusion and Intellectual Disability*. London and New York: Routledge.

Ashton, Paul, and Jacqueline Z. Wilson. 2019. "Remembering Dark Pasts and Horrific Places: Sites of Conscience." In *What Is Public History Globally? Working with the Past*, ed. Paul Ashton and Alex Trapeznik, 281–94. London: Bloomsbury Academic.

Bacopoulos-Viau, Alexandra, and Aude Fauvel. 2016. "The Patient's Turn Roy Porter and Psychiatry's Tales, Thirty Years On." *Medical History* 60 (1): 1–18.

Barham, Peter. 2020. *Closing the Asylum: The Mental Patient in Modern Society*. London: Penguin.

Bartlett, Peter, and Ralph Sandland. 2007. *Mental Health Law, Policy and Practice*. Oxford: Oxford University Press.

Beckman, Emily, Elizabeth Nelson, and Modupe Labode. 2021. "'I Like My Job Because It Will Get Me out Quicker': Work, Independence, and Disability at Indiana's Central State Hospital (1986–1993)." In *Voices in the History of Madness: Personal and Professional Perspectives on Mental Health and Illness*, ed. Rob Ellis, Sarah Kendall, Steve Taylor, 173–90. Cham, UK: Palgrave Macmillan.

Ben-Moshe, Liat. 2017. "Why Prisons Are Not 'The New Asylums.'" *Punishment and Society* 19 (3): 272–29.

Bornat, Joanna. 2003. "A Second Take: Revisiting Interviews with a Different Purpose." *Oral History* 31 (1): 470–53.

Brett, Sebastian, Louis Bickford, Liz Ševčenko, and Marcela Rios. 2007. *Memorialization and Democracy: State Policy and Civic Action*. Sanitago/New York: Latin American School of Social Sciences/International Center for Transitional Justice/International Coalition of Historic Site Museums of Conscience. https://www.ictj.org/sites/default/files/ICTJ-Global-Memorialization-Democracy-2007-English_0.pdf.

Bryant, Wendy, Geraldine Vacher, Peter Beresford, and Elizabeth Anne McKay. 2010. "The Modernization of Mental Health Day Services: Participatory Action Research Exploring Social Networking." *Mental Health Review Journal* 15 (3): 11–21.

Calabria, Verusca. 2016. "Insider Stories from the Asylum: Peer and Staff-Patient Relationships." In *Narrating Illness: Prospects and Constraints*, ed. Joanna Davidson and Yomna Saber, 3–12. Freeland, UK: Inter-Disciplinary Press.

—. 2022. "'With Care in the Community, Everything Goes': Coproducing Oral Histories to Re-examine the Provision of Care in the Mental Hospitals." *Oral History* 50 (1): 93–103.

Calabria, Verusca, and Di Bailey. 2023. "Participatory Action Research and Oral History as Natural Allies in Mental Health Research." *Qualitative Research* 23 (3): 668–85. https://doi.org/10.1177/14687941211039963.

Calabria, Verusca, Di Bailey, and Graham Bowpitt. 2023. "More Than Just Brick and Mortar: Meaningful Care Practices in the Old State Mental Hospitals." In *Voices in the History of Madness: Personal and Professional Perspectives on Mental Health and Illness*, ed. Rob Ellis, Sarah Kendall, and Steve Taylor, 191–208. Cham, UK: Palgrave Macmillan.

Campbell, Denis. 2018. "Mental Health Patients Sent 300 Miles from Home Due to Lack of Beds." *Guardian* (London), September 17.

Cooper, David. 1967. *Psychiatry and Anti-psychiatry*. London: Tavistock.

Crossley, Michele L., and Nick Crossley. 2001. "'Patient' Voices, Social Movements and the Habitus: How Psychiatric Survivors 'Speak Out.'" *Social Science and Medicine* 52 (10): 1477–89.

Csipke, Emese, Clare Flach, Paul McCrone, Diana Rose, Jacqueline Tilley, Till Wykes, and Tom Craig. 2014. "Inpatient Care 50 Years after the Process of Deinstitutionalisation." *Social Psychiatry and Psychiatric Epidemiology* 49 (4): 665–71.

Ellis, Rob. 2013a. "Asylums and Sport: Participation, Isolation and the Role of Cricket in the Treatment of the Insane." *International Journal of the History of Sport* 30 (1): 83–101.

—. 2013b. "'A Constant Irritation to the Townspeople'? Local, Regional and National Politics and London's County Asylums at Epsom." *Social History of Medicine* 26 (4): 653–71.

—. 2017. "Heritage and Stigma: Co-producing and Communicating the Histories of Mental Health and Learning Disability." *Medical Humanities* 43 (2): 92–98.

—. 2020. *London and Its Asylums: Politics and Madness, 1888–1914*. London: Palgrave Macmillan.

Ellis, Rob, Sarah Kendall, and Steven J. Taylor. 2021. *Voices in the History of Madness: Personal and Professional Perspectives on Mental Health and Illness*. London: Palgrave Macmillan.

Ewbank, Leo, James Thompson, and Helen McKenna. 2017. "NHS Hospital Bed Numbers: Past, Present, Future." The King's Fund, London. https://www.kingsfund.org.uk/publications/nhs-hospital-bed-numbers#:~:text=Key%20messages,bed%20numbers%20in%20recent%20years.

Fussinger, Catherine. 2011. "'Therapeutic Community,' Psychiatry's Reformers and Anti-psychiatrists: Reconsidering Changes in the Field of Psychiatry after World War II." *History of Psychiatry* 22 (2): 146–63.

Gesler, Wilbert M. 1993. "Therapeutic Landscapes: Theory and a Case Study of Epidauros, Greece." *Environment and Planning: Society and Space* 11 (2): 171–89.

Gittins, Diana. 1998. *Madness in Its Place: Narratives of Severalls Hospital, 1913–1997.* London and New York: Routledge.

Goffman, Erving. 1961. *Asylums: Essays on the Social Situation of Mental Patients and Other Inmates.* New York: Anchor Books.

Higgins, Ray, Keith Hurst, and Gerald Wistow, 1999. *Psychiatric Nursing Revisited: The Care Provided for Acute Psychiatric Patients.* London: Whurr.

Hilton, Claire. 2017. "Barbara Robb, Amy Gibbs and the 'Diary of a Nobody.'" In *Improving Psychiatric Care for Older People: Barbara Robb's Campaign 1965–1975*, 57–95. New York: Springer.

Jack, Raymond. 1998. "Institutions in Community Care." In *Residential versus Community Care: The Role of Institutions in Welfare Provision*, ed. Raymond Jack, 10–40. London: Palgrave Macmillan.

Joseph, Alun, Robin Kearns, and Graham Moon. 2011. "Re-imagining Psychiatric Asylum Spaces through Residential Redevelopment: Strategic Forgetting and Selective Remembrance." *Housing Studies* 28 (1): 135–53.

Martin, John Powell. 1984. *Hospitals in Trouble.* Oxford: Basil Blackwell.

McCrae, Niall. 2014. "Resilience of Institutional Culture: Mental Nursing in a Decade of Radical Change." *History of Psychiatry* 25 (1): 70–86.

MIND. 2004. *Ward Watch: MIND's Campaign to Improve Hospital Conditions for Mental Health Patients.* London: MIND.

Nolan, Peter. 1998. *A History of Mental Health Nursing.* Cheltenham, UK: Stanley Thornes.

O'Reilly, Gerry. 2020. "Sustainable Development versus Human-Made Atrocities – Never Again." In *Places of Memory and Legacies in an Age of Insecurities and Globalization*, ed. Gerry O'Reilly, 121–48. New York: Springer.

Parr, Hester, Chris Philo, and Nicola Burns. 2003. "'That Awful Place Was Home': Reflections on the Contested Meanings of Craig Dunain Asylum." *Scottish Geographical Journal* 119 (4): 341–60.

Patel, Alisha. 2019. "How the Health and Social Care Act 2012 Has Affected Commissioning of Mental Health in England." *British Journal of General Practice* 69 (suppl. 1). https://doi.org/10.3399/bjgp19X703373.

Prior, Pauline M. 1991. "Surviving Psychiatric Institutionalisation: A Case Study." *Sociology of Health and Illness* 17 (5): 651–67.

Ramon, Shulamit, and Janet E. Williams. 2005. "Towards a Conceptual Framework: The Meanings Attached to the Psychosocial, the Promise and the Problems." In *Mental Health at the Crossroads: The Promise of the Psychosocial Approach*, ed. Janet Williams and Shulamit Ramon. Bodmin, UK: Ashgate.

Rossiter, Kate, and Jen Rinaldi. 2018. *Institutional Violence and Disability: Punishing Conditions.* Abingdon, UK: Routledge.

Rutherford, Sarah. 2005. "Landscapers for the Mind: English Asylum Designers, 1845–1914." *Garden History* 33 (1): 61–86.
Spandler, Helen. 2006. *Asylum to Action: Paddington Day Hospital, Therapeutic Communities and Beyond.* London: Jessica Kingsley.
—. 2007. "From Social Exclusion to Inclusion? A Critique of the Inclusion Imperative in Mental Health." *Medical Sociology Online*, 2 (2): 3-16.
—. 2016. "From Psychiatric Abuse to Psychiatric Neglect." *Asylum* 23 (2): 7–8.
—. 2020. "Asylum: A Magazine for Democratic Psychiatry." In *Basaglia's International Legacy: From Asylum to Community*, ed. Tom Burns and John Foot, 205–25. Oxford: Oxford University Press.
Takabayashi, Akinobu. 2017. "Surviving the Lunacy Act of 1890: English Psychiatrists and Professional Development during the Early Twentieth Century." *Medical History* 6 (2): 246–69.
Taylor, Barbara. 2011. "The Demise of the Asylum in Late Twentieth-Century Britain: A Personal History." *Transactions of the Royal Historical Society* 21: 193–215.
—. 2015. *The Last Asylum: A Memoir of Madness in Our Times.* New York: Penguin.
Turner, John, Rhodri Hayward, Katherine Angel, Bill Fulford, John Hall, Chris Millard, and Mathew Thomson. 2015. "The History of Mental Health Services in Modern England: Practitioner Memories and the Direction of Future Research." *Medical History* 59 (4): 599–624.
Wall, Oisín. 2013. "The Birth and Death of Villa 21." *History of Psychiatry* 24 (3): 326–40.
Wessely, Simon. 2018. *Modernising the Mental Health Act: Increasing Choice, Reducing Compulsion: Final Report of the Independent Review of the Mental Health Act 1983.* London: Department of Health and Social Care.
Woods, Angela, Akiko Hart, and Helen Spandler. 2022. "The Recovery Narrative: Politics and Possibilities of a Genre." *Culture, Medicine and Psychiatry* 46 (2): 221–47. https://doi.org/10.1007/s11013-019-09623-y.
Wykes, Till, Emese Csipke, Diana Rose, Thomas Craig, Paul McCrone, Paul Williams, Leonardo Koeser, and Stephen Nash. 2018. "Patient Involvement in Improving the Evidence Base on Mental Health Inpatient Care: The PERCEIVE Programme." *Programme Grants for Applied Research* 6 (7): 1–211. https://www.ncbi.nlm.nih.gov/books/NBK535233/.

PART 2

Learning from Sites of Conscience Practices

Part 2 explores how engagement with memories and places of former disability and psychiatric institutions can support social justice for disabled people and people experiencing mental distress. Chapters present case studies of current practices of sites of conscience, as well as memorialization and artistic practices. Authors consider the experiences and narratives of former disability and psychiatric institutions by those who have been ignored or silenced during urban renewal and development processes. Authors also consider whom is given the authority to speak "truth" about the history and heritage of disability and psychiatric institutions and surrounding neighbourhoods. Additionally, they propose ways for the voices and experiences of former residents to be centred in the redevelopment and reuse of former disability and psychiatric institutions. Lastly, they examine how alliances can be created among former residents, activists, and scholars and practitioners such as lawyers, clinicians, urban planners, heritage workers, and architects to ensure just re-engagement with former disability and psychiatric institutions.

Benevolent Asylum
Performance Art, Memory, and Decommissioned Psychiatric Institutions

A conversation with BEC DEAN, LILY HIBBERD, and WART

On each of two balmy Saturday evenings in 2011, November 26 and December 3, Lily Hibberd and Wart led a party of twenty or so participants on a tour of twelve sites, or "stations," along the foreshore of Luna Park and Lavender Bay, a harbourside suburb on the lower north shore of Sydney, New South Wales (NSW), Australia. Wart and Lily had devised a promenade-style performance that combined Wart's lived experience of institutionalization and her aesthetic representation of this experience through performance and poetry with Lily's ficto-historical art practice focused on the stories of asylum institutions established in the colonies of Australia. Titled Benevolent Asylum: Just for Fun, the project was initiated by Performance Space curator Bec Dean for the WALK public performance series that took place across Sydney in 2011.

In early 2011, Bec commissioned Lily to deepen her two-year research on places of institutional confinement through site-based research and to work collaboratively with Wart, a contemporary, multi-disciplinary artist based in Sydney. Over several months, Lily studied, mapped, and visited dozens of mental health sites across Greater Sydney, both active and historical. This work resulted in a detailed narrative of confinement across more than twenty urban sites, many of them on the banks of Sydney Harbour or Parramatta River, such as the Parramatta Lunatic Asylum/ Cumberland Hospital (1848–present), Tarban Creek Asylum/Gladesville

Hospital (1838–1997), and Callan Park Hospital for the Insane/Rozelle Hospital (1878–2008).[1] The history also revealed a network of institutions at once entangled with the raw geography of Sydney Harbour and its river systems, as well as the entwinement of different practices of punition, incarceration, welfare, segregation, and care.

One of the important lessons of Benevolent Asylum in its first iteration was the need to give people with a direct experience of institutions a central place in the project. This was an important ethical position to take for Lily, as well as being personal, as the project was prompted by the confinement of her father and two close friends in psychiatric institutions. Conscious of the current gap in such participation, Bec initiated Lily's collaboration with Wart, with whom Bec had already established a curatorial relationship. Wart's work across performance, writing, and painting was renowned for its powerful evocation of her experiences as a person diagnosed with schizoaffective disorder and a patient in the Australian psychiatric system. Over several months, Lily and Wart met up and talked about institutional sites, art, memory, and their ideas for the WALK performance. From these conversations, they developed the concept for a collage of stories, performances, and texts that would be presented along the course of the walk.

The location of the event was also pivotal to the walk. There were many possibilities among Sydney's decommissioned institutional sites at the time, which featured significant colonial architecture and stunning harbourside landscapes, as well as prominent memories, not only personally for Wart but also for Sydney residents, for whom the places resonated with unaddressed grief, mixed with the need to acknowledge and somehow preserve something of these terrible histories. For Wart and Lily, these emotions were fundamental to the performance. For both of them, it was vital that the project resonate with contemporary and intersectional issues of confinement that they believed stemmed from the same predominantly punitive policies. These issues included Australia's crimes against Aboriginal peoples, as well as its inhumane treatment of asylum seekers, children, and marginalized and abused women. The title itself was a direct reference to the paradox of asylum in Australia, where "benevolent asylum" is neoliberal rhetoric for incarceration in the guise of care. Along the walk, Wart performed a poem about Sydney's Villawood Immigration Detention Centre, a place that has predominantly incarcerated people of non-Caucasian backgrounds, mainly from the People's Republic of China, Sri Lanka, Iraq, Afghanistan, Iran, Fiji, and Vietnam (Australia Human Rights Commission 2011, n17).

"Villawood"
by Wart

Villawood ... villawood ...
Ain't no nice hood
Barbed wire ... bare compound
Listless and bland

Illegal immigration ... a liberal saying
Hey these are people of many cultures ...
that add to our multi cultured layered land ...
They are seeking refuge
They have left life threatening places
They need safty.
Wot about the vernacula yeah mate
Bung on the kettle
Now they go to another island
And are put in detention
Becos they came by boat ??????
Not plane.

Lily and Wart's choice to situate the walk at and around Lavender Bay allowed them to include well-known stories about crime, trauma, and their erasure and to give space for people to connect with and generate their own emotions about experiences of psychiatric institutionalization. Not only is Lavender Bay a stunning place, but it also holds an enormously rich trove of stories. The bay is known as Gooweebahree, or Quiberee, in the Dharug language of the Gamaragal/Cammeraygal people of the Eora Nation, who are believed to have inhabited the northern shores of Sydney Harbour for up to 50,000 years. Although Benevolent Asylum did not explicitly relate Aboriginal stories, as they were neither Lily's nor Wart's to tell as non-Aboriginal people, both artists were highly aware that, alongside stories of survival and resistance, traumas reverberated through Lavender Bay's history that originated with the murder, death, and dispossession of the local Gamaragal people at the hands of Europeans in the first 100 years of occupation.

There were two other fascinating histories that drew Lily and Wart to the site. One was the story behind its original name, Hulk Bay, which referred to the only known instance of a prison in the form of a decommissioned

transport ship, or "hulk," which was moored in Lavender Bay with up to 260 prisoners from 1824 to 1837 – long since vanished. The other revolved around Luna Park – still standing on the harbour's edge – where a tragic fire in 1979 had killed six children and a man, the memory of whom occupies a special place even today at the contested memorial in Lavender Green. One site long absent and the other still present, the two structures mirrored each other as ghostly vessels of memory for tragic events and their oblivion either through time or in violent erasure.

The Benevolent Asylum walk was both a history lesson and a group performance that temporarily embodied some of the physical and emotional forms of institutional confinement. It did so through the resonance of Lavender Bay's own struggle to remember as a reflection of Australia's wider culture of forgetting past trauma. Eleven years on, Bec Dean joined Wart and Lily Hibberd in conversation to reflect on their collaboration and its significance for the commemoration of places of psychiatric institutionalization.

Lily: Wart, it's great to talk about our work after all this time. To start, I wanted to ask you what you think about the International Coalition of Sites of Conscience. To me, it seems the organization and its members are focused on empowering the victims of injustice to memorialize the places where things happened to them in an effort to support those who have tried to turn the tables on the way memory has been cast by the state or by perpetrators of injustice.

Wart: Right, I have a lot to say about that.

Lily: I thought you would. That's why I wanted to have this conversation – also because Sydney has so many former institutions that have been turned into "cultural" places already, like Sydney College of the Arts and Parramatta Female Factory, both of which are sited on precincts that reflect the origins of psychiatric institutionalization in the colonial era's punitive welfare model and the porosity/conjunction of lunatic asylum, women's refuge, prison, and workhouse. But what about the sort of artworks that, Bec, you have instigated, as in the case of the performance Benevolent Asylum: Just for Fun? Where do they fit into this fabricated land of cafés and nicely landscaped environs?

Bec: People want to have their weddings in places where other people were incarcerated. I find that incredible.

Wart: Even at Concord Hospital,[2] when the nurses take you for a walk, one of the high points is a house, and they always say, "Well, this is

where they filmed *The Great Gatsby.*" It's a funny contradiction, you know?

Lily: It's the gap between memory and the incongruent narratives overlaid on decommissioned institutions.

Wart: That's the thing about memory. When Bec mentioned that it was ten years ago that we did the Benevolent Asylum walk, I thought to myself, so much has changed since then. I was under a regime of really bad medicine. That began to change about four years ago when I went to what I call the "loopy exercise class." All of us loopies were sitting around and waiting for it to start, and I asked the others: "What drugs are you on?" And it turned out that we were all on the same thing. So I complained, and I said to the doctor, "We're all very different people, but you've just blotted us out."

I was huge, and I was nearly diabetic. My heart was the age of an eighty-five-year-old's. I was crap. So I walked out of there, and I found a new doctor who is just fantastic. And she got me off all the crappy injections. She said, "You just don't need to be on these. I don't know why they put you on them."

When I was leaving the hospital, I told the woman there that I was changing my medicine, and she said, "Well, just you wait, Wart, because next time you're sick, I'm gonna put a CTO [community treatment order][3] on you, and you're going to have to come back in here with the police for these injections." And I couldn't believe what I'd heard, so I said, "You ****** bitch," and I walked out and slammed the door and never went back.

I realized they do really sad, bad medicine. It's done by the pharmaceutical companies, who have to get their quotas. That doctor never thought we'd all get together at an exercise class and just go, "Eh, so you're on Depot, too, and you're on this, and you're on that."[4] And I'm on hardly anything now. My new doctor got me off so much stuff that they had put me on. But I have a permanent shake [i.e., tremor] because of it.

Lily: But I think that to talk about deinstitutionalization, you have to talk about medication because there are these ways of handling people who they think are out of control. And the easiest one is to dose you.

Wart: Oh, they're so lazy.

 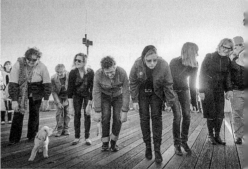

Benevolent Asylum: Just for Fun, Performance Space WALK, 2011. Photos by Alex Wisser.

Lily: In Benevolent Asylum, I think it was the third of the twelve stations on the walk where you stopped and got everyone to do the Largactil shuffle.[5]

Wart: I remember we were walking on the boards. So I said to everyone, "Let's do the boardwalk." Then, the next one was the Largactil shuffle. The instruction was: head down, curvature of the back, hands stiff by your sides, and just little, little steps. Hunched over and shuffling. And you're very stiff-jointed. That's why you can only walk in little steps because the drugs drain your joint fluids.

Lily: Why did you want people to do that?

Wart: It was something that was so real to me. It made you do that; Largactil made you shuffle. And it was to get the audience into it a bit, you know? Because this is what happens. This is a place that your body is taken to through no choice of your own. It just happens. And it made them get into their body and realize how restricted it is. How not only can the drug restrict your mind, but the physicality of yourself disappears as well because it restricts your body movements. I used to call it "Larger-Than-Life Largactil" because it was a drink. I always remember it as a pink syrup. The syrup was the go-to; they always gave it to you. It was quick-acting, and then you became a space cadet. If you were a bit hyper, there was that classic thing of nurses playing doctors, and they'd assume that you really needed the drug. Anyway, that's why I wanted people to do the Largactil shuffle in the walk.

Lily: It was so simple and yet powerful. But what made it so interesting to collaborate with you, Wart, was that you brought a myriad of ways of working and all these art forms into our walk.

Wart: Yeah, I loved it!

Bec: I wonder if we can reach back into the past and remember how we got this together. In 2011, when I was associate director at Performance Space,[6] we were working on a program that took everyone out of the formal institutions of the contemporary-art spaces and the theatre spaces where we normally presented our programs, so that we had these very nimble experiences outside, walking from place to place. This came out of the frustration of working within an institutional art space and the kind of strictures we had around how we had to work, how much it would cost, how much the catering was going to be. All of this was getting in the way of the art. We just wanted to get out of that place.

Wart: Oh, right!

Bec: The Performance Space director at the time, Daniel Brine, basically sent us off to commission a range of walks. And, so, we did a program called WALK. When we started the conversation about this work, it came out of Lily's exploration of the Melbourne Benevolent Asylum, and from there it branched out to tell the stories and histories of asylums and other institutions established as part of the colonization that advanced through Australia's waterways.[7]

Lily: And for the walk, we focused on this history in Sydney.

Bec: So we've established that ten years ago, Wart, you were in a very different place, physically and mentally and in terms of how you were being treated. And at the time, Lily had been doing all of this research, in a very thorough, beautiful, and academic way, and the intention was to bring Wart's lived experience of the institution together with Lily's knowledge of these contexts and how they actually came to be there.

It's profoundly interesting in the case of Lavender Bay, which, as you learned, the Europeans first called Hulk Bay, where the floating prison-asylums were moored. And then it has this other terrible history on top of that, which is the 1979 Luna Park Ghost Train fire,[8] which killed a man and six boys. All of that has literally been paved over and …

Wart: Memorialized and then erased. We are only just coming to terms with how corrupt it was back then.[9] The cover-ups were amazing.

Lily: We appropriated Luna Park's own slogan, "Just for Fun," for this project as a pun. But there was a feeling that Luna Park was not

there by chance. It felt that there was more than meets the eye at Lavender Bay, that something traumatic had happened in that place. I felt it was no coincidence, for instance, when I discovered that Luna Park was sited at Lavender Bay, once Hulk Bay, site of the *Phoenix* hulk – a prison vessel holding colonial convicts, a depot for the chain gangs, a quarantine station, and a mental asylum. In its combination of care and incarceration, the hulk seems to have been a precedent for the contemporary network of state-run mental health and child welfare institutions.

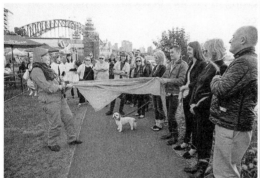
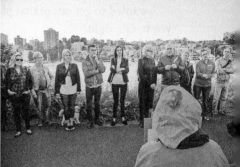

Benevolent Asylum: Just for Fun, Performance Space WALK, 2011. Photos by Alex Wisser.

Lily: Lavender Bay has been a site of constant struggle, starting with the incarceration of people in the prison hulk. But this was different from other projects I'd seen or developed about Australian welfare, penal, and psychiatric institutions because we were not working literally or directly with a site. Lavender Bay offered us something even more powerful because of its twofold colonial past and the metaphoric burden of trauma and memory in Luna Park.

Bec: There was the distance from the site being an institution to its holding no tangible evidence of this history in the space, except for the psychic energy of the space, and you had the cover-up of the space with lavender, which transitioned Hulk Bay to Lavender Bay.[10] I'm thinking of how we use lavender to mask an unpleasant smell. Benevolent Asylum was one of the walks in that program that has settled in me. I remember it very well. I think it was because it combined the things that register with memory. It combined the poems, performance, singing. I remember the "Lavender Blue (Dilly Dilly)"

song. And the smell of lavender. So you had all of these things that pull on our memory registers.

Lily: Yes, the power of lavender was important to us at the time. First, because it's a relaxant and it's in the realm of those plants that help you to let go and forget. Second, because they planted lavender all around the memorial to the Ghost Train fire in Lavender Bay.[11] And, of course, it's poetic to do so because of the name. All the memory and forgetting, and this is part of the psychic presence of the place.

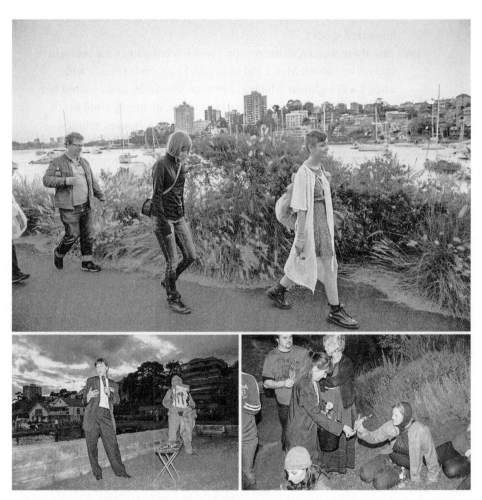

Benevolent Asylum: Just for Fun, Performance Space WALK, 2011.
Photos by Alex Wisser (top and lower right) and Richard Manner (lower left).

Bec: As a historical site, Lavender Bay creeps up on you because it masks its stories. I'm not from Sydney, and I didn't arrive until long after the terrible fire and deaths at Luna Park, so I actually had no knowledge about it. It snuck up on me on our site visits through the beautiful models of children's characters that had been installed there as a memorial by Luna Park artist and local resident Peter Kingston. I remember being taken aback by the presence of that there and recognizing that it had been a site of enormous tragedy for children. I also recognized a lot of stuff that you had been working with, Lily, looking into children being removed – for all intents and purposes, young girls, "wayward girls," being put into institutionalized spaces.

Lily: Yes, there was a specific person I was referring to in the performance. It was about Mel, a girl of fifteen I had made friends with when I was eighteen. Mel was living on the street, and I visited her in lots of places during the year I knew her, including child detention centres, prison remand, hospitals, halfway houses, refuges, mainstream hospitals, and psychiatric wards, like Larundel Hospital in Melbourne, which is incidentally being turned into apartments.

Wart: Is it really?

Lily: Yeah, you can live in rooms where people were hospitalized. But I told this story on one of the stops on the walk. One day, I arrived at Larundel to visit Mel. After passing through the front entrance, I had to step over all these people who were just knocked out, who were asleep in the corridor in the middle of the day and evidently drugged.

Wart: Yeah ...

Lily: It would have been 1992, and Larundel was closed a year later, not that I knew it then. But Mel was fine. Many of these places were being decommissioned at the time. Mel was just a kid who had nowhere to go. She was a ward of the state, removed from her mother at birth, so she never really had a family. A long and sad story. But eventually, I lost her, and that was a tragic thing.

Wart: That's sad.

Lily: So, when Bec and I were starting to talk about Benevolent Asylum as a performance for the WALK series, I had this very strong feeling that I was carrying this person's life with me and that Mel's story

was so important to tell, but she never got to tell it because she was dead at fifteen. Also, it is a story not only about one kind of institution but about how they operate as a network, too, especially when "care" easily turns into punishment when the state fails. One time, for example, Mel had been caught shoplifting, and she was put in a tiny prison cell in a city remand centre.

Wart: She was fifteen! Shocking.

Lily: When we first started talking about the walk, I was at a loss because I felt that it was not my place to talk about these histories on my own. But I had seen the 2006 exhibition you were in Wart, *For Matthew and Others – Journeys with Schizophrenia*, which was such an important example of the power of contemporary art and artists who have "been there" to represent themselves.[12]

Wart: Honouring Mel like that is a really nice thing. And it is interesting that you say that because it's dawned on me that I've done the same thing with another friend of mine. It happened while I was in hospital in April 2021. Angela Berrigan was this gorgeous, wonderful friend from Melbourne who was a puppet maker. I didn't realize – and I kept trying to contact her when I got out of hospital, and eventually I found out – that she had died. But what she was making was this Astroturf chair, and that's why I used Astroturf in my current exhibition, *Eye See Pink, Black and White*, with the neon ibis.[13] Bringing up memory for other people is so important. It's a lovely thing to know that was what Benevolent Asylum: Just for Fun was all about. That Mel's memory was the instigator of it is really good.

Lily: Yes, and it became even more powerful because we remembered the story of the children from the Luna Park fire.

Wart: Exactly!

Lily: By the mid-1970s, Lavender Bay was the focus of commercial development and, with it, corruption and the ferocious fight to expose or prevent it, which artists like Martin Sharp were leading.[14] Long after the fire, people who were trying to remember the dead faced not only opposition but also violence when the first 1995 memorial to the children was destroyed when the devoted tree was ripped out in 2003, apparently by developers. So it's about memories not only being hidden away but also being violently opposed.

Bec: Their erasure.

Wart: Yeah. Knocked out, totally.

Lily: I think that memories of institutions are similar because they involve a complex mix of the fact that these places exist to take care of you and the fact that there has also been abuse or neglect. Publics and governments just wanted to cover that up in the past; and more so, following many inquiries exposing these crimes, they really want to move on.

Bec: For me, Benevolent Asylum: Just for Fun brought the mental health institution into a public space in an embodied form.

Wart: It was not a first, but it was a really good thing to do. Thank you for inviting me to be part of the project because mental health gets slotted in amongst so many other services. But that performance was a high point.

Lily: Yes. The problem is a compound of public denial, underpinned by the emotional and real cost of being sorry (i.e., compensation), and the basic ignorance and marginalization of the lived experience of the institutionalized, yourself among them, Wart, who are burdened with the consequences of nineteenth-century models of psychiatric treatment. This includes the medication model that you talked about, Wart, as well as the impact of physical harm, with people sitting on you, which are basically prison tactics.

Wart: Yeah.

Lily: State welfare has this bad, dark history it must deal with. And the way it has been done in the public arena is to say, "Oh well, we can make these former sites into nice happy places. We can turn them into cultural centres. Or make an apology and put a little statue there." But this is not enough, when there are hundreds of thousands of people implicated, let alone the memories of the people who don't have a voice anymore.

As a performance, Benevolent Asylum brings people into the space of loss without alienating them. It does that by using tactics of truth-telling, undercut by hilarity, riotousness, and excess, and by grating on the conscience, just like Luna Park, in fact. So, Wart, with your poems, people could laugh but also had to confront your experiences. Using this voice is a very powerful way to speak directly.

Wart: The only one I can remember offhand is "I'm a bolt, I want to be your nut." No ... "Have you got a spare nut?" that's how it started. [All laugh.]

Have u a spare nut?
by Wart

Have u a spare nut

4 my blot
for my bolt
4 my rot
for my blot

have you a spare nut for my bolt
I have a nut to screw
But I must tell you
I was never a screw
I was a slut

Didn't we all
Wots yer name
Did u 4get 22
Two
Did you
Did u too
I did
I can't remember bits
I think it's much better
Good to 4 get

I am on your side
I am
Am I
I am
Am I

Do you distort

I have distort
Scratch sniff snuff sniff
Is it
I sit
On it
I am a sitter
Hey I can walk shit larf eat cry do upping
Is it

Lily: Yeah, that's what I mean, it's so visceral!

Wart: Yeah, there was also one called "Beyond the Line." It was specific to Callan Park or Rozelle Hospital. Depending on the ward you were in – I think it was Ward 24 where I used to go – you couldn't go beyond the line of the trees. There was a specific marked area; it was very definite: "Don't go beyond the line!" Or you'll blow up, type of thing.

> ***Beyond the line***
> *by Wart*
>
> No confines
> I am so sick of being told
> Don't go beyond that line
> I have felt many marks ... looked at many lines
> Some poetic and graceful
> Some restrictive and defining
> Some definite and conspiring
> Some delicate some fighting their response
>
> Given lots of restrictions drives me fukt
> Fukt and fact
> Fukt and total fact
>
> I do understand the polites
> I do understand listen
> I do understand a lot
> Some stuff I couldn't give a shit about
> Go fuk
>
> I do understand coagulation
> I do understand moods
> I do understand pain
> I do understand crap and throw it away

Wart: I remember being terrified of going beyond the line. I was very sick at the time, and I thought, "God, I will never go beyond the line." But it is interesting that as an artist I always go beyond the line in drawings. That's why I wrote this poem – the confines of the line. Don't go beyond the line.

Bec: Wart, I am thinking about these resurrections of works from the past and from moments when you were institutionalized and reflecting on that continued relationship with the institution. An example for our readers is The Big Anxiety festival in 2019, where Wart made a beautiful room that was a three-dimensional representation of one of her paintings of the inside of a cell that she'd occupied during a difficult time.[15]

Wart: "The Isolation Room," the painting was called. And then I made a soundscape and read poems over audio I'd made playing piano and all sorts of found instruments. And people listened to it through headphones lying on the bed in the room. The whole work was called *Unravelling Moments from a Torn Mind.* Even though it was quite horrible as a situation back then, people enjoyed lying on the bed because it was so comfortable. And we made it furry instead of horrible stark sheets. One girl, who was really buggered, just fell asleep.

Lily: People wouldn't have a clue that in psychiatric centres all over Sydney there are these isolation cells.

Wart: Yeah, the so-called sensitive, quiet room. [Laughs.] But they've changed. They give you a weighted blanket now. But there's still a room where they jump on you. It's got a big mat on the floor, so that five or six of them jump on you, and they jab a bloody big injection into your bum to calm you down; then you're knocked out for an hour. When they bring you out, you have no memory of what happened, except that you're bruised.

Lily: I remember in the Benevolent Asylum walk there was a powerful sense of the body of institution and how it acted on you Wart. I felt that you brought this very forcefully into being. It was almost as if its body came with you.

Wart: Yeah, the reason I wore those bright orange overalls was as a reference to Guantanamo Bay.

Bec: Most of all, your performance re-enacted the physical actions of mental illness back onto the site of Hulk Bay and brought people into a consciousness of that space by participating in performance (Figure 8.1). And that's why the opposite of the institution is to turn people out onto the street, which is what we were doing in the walk, making the audience embody stuff that was kind of embarrassing, awkward, and uncomfortable. And that very public, very "Sydney-shiny" context contrasted with Wart getting dressed under a

Benevolent Asylum: Just for Fun, Performance Space WALK, 2011. Photos by Richard Manner (left) and Alex Wisser (right).

 tarpaulin on the pavement – literally turning it out onto the street, against the shiny.

Wart: That's the thing about Sydney Harbour, sparkling and shiny.

Lily: And, for me, all this weirdly intersected with Luna Park, as a carnival and a ritual space that effaces loss and exists to deal with mourning on a collective level.

Bec: Yes, yes.

Lily: These are places that serve not only individuals but also whole societies by helping them to cope with a very traumatic thing that they need to control. Sydney's Luna Park has that sense of psychic release. It is loaded with the uncanny. There is something very disruptive about that place and its eight faces that haunt me. I think this rupture and its effects were also reflected in our performance, especially since our stories weren't matching. And it wasn't easy for us either.

Wart: It was good though. It was a great thing to do. I was just thinking now, when I was in art school, one of the exercises I did was a whole range of drawings of the clowns – you know, the ones you see in sideshows where you put a ball down the throat? Well, I did a whole series of laughing clowns. I just had this flashback, just about the carnival, and it is amazing how memories come back at you. That was in the 1970s. [Laughs.]

Lily: There was a set of those in the middle of Luna Park, which I saw when Bec and I went there to suss out the management, to see if they were going to arrest us for walking through. [All laugh.] Bec, you were there at the weird meeting we had with two managers.

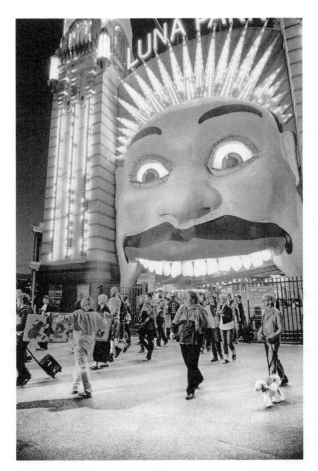

Benevolent Asylum: Just for Fun, Performance Space WALK, 2011. Photo by Alex Wisser.

Bec: Luna Park was the only walk in the whole season where we tried to engage with someone on the permissions level. For all the other projects, we just gathered together and walked.

Lily: We understood that there were all these threatening stories about Luna Park and the fire. I was also there digging, even provoking a little, to be honest.

Bec: They were worried that we were going to bring that narrative back to life in some way.

Lily: And Performance Space director Daniel Brine received a call from the general manager of Luna Park the day before the first performance, asking that no mention be made of the Ghost Train fire.

Wart: Ahhhhhhh.

Bec: I remember that now.

Lily: And now we know more today because of the recent documentary.

Wart: It's so real, yes.

Bec: So the documentary was led by people who were given access to all of Martin Sharp's material on Luna Park. Because he had conducted hundreds of hours of interviews with people about the fire.[16] And they went back through that material and reinterviewed the people from that time.

Lily: So it's Martin Sharp's material that they're using for this …

Bec: It's definitely a part of it.

Wart: He died, didn't he?

Bec: Yes.

Lily: He was one of the artists who remade Luna Park's big face.

Wart: Yeah.

Lily: Once I found out more about Martin Sharp, I thought, "This is the most amazing artist." People know him for his pop artwork but not so much for this activism and what he did to try to expose the underbelly of the site. After some time, he was taken into psychiatric care because he was unwell.[17]

Wart: Was he?

Lily: Yes. He was unwell as a process of doing that project. It rendered him very sick because he got caught up in this kind of psychotic thing about Luna Park and the deaths, conspiracies, and cover-ups – because if you feel that you have found the truth, but nobody believes you, that's exactly what it's like to feel as if you are losing it.

Bec: He was also so invested in preserving the site of Luna Park as a place for fun. It's such a challenging story. But it's also a very Sydney story of the time, isn't it? When you think about other people who got in the way of developers, like Juanita Nielsen going missing, and all that stuff around Sydney and valuable sites for property development.[18] Which then goes to the whole redevelopment of former psychiatric institutions as valuable sites that ought not to be exploited.

Lily: These former sites are very important, but there are so many in the same situation in Sydney. Even Gladesville is up for redevelopment despite resistance from the local community.

Wart: Gladesville was a weird hospital. I was in there for a while when I first got sick. I have this huge memory of grey and white people, who've been so locked up inside that they've gone grey and white. It was really sad. It was a weird, horrible place.

Lily: And it is ongoing at Parramatta Female Factory and at Callan Park.

Bec: Wart, what's happening to that site?

Wart: I don't know. Well, the big organization that's very vocal is the Friends of Callan Park. But it's funny that thing of memory. Do you remember Callan Park Gallery? Well, there was always this old guy who was a patient at Callan Park, and he would always walk past the gallery every morning at ten past eleven with a suitcase and towel, which he would put in the little alcove where I was having a cigarette. And he would just nod his head to me. And it was a ritual, as if his memory was still in the area and he couldn't get away from it. He did what his memory told him to do. I don't even know if he is still alive ...

Lily: It's complicated. It's not only that there was mistreatment but also that people can have a very strong sense of belonging. For a lot of people, those places were a home, maybe the only home they had.

Wart: Well, they were, yeah! At Callan Park, it's the gardens; they're just so beautiful. It is just as I said to the CEO of NSW Mental Health, the only reason that I liked Concord Psychiatric Hospital was just because of the gardens; that's the winning point. But Callan Park, a lot of people love that place, a lot of loopies that I know. And they just can't tolerate the new buildings. The high walls and the fake Astroturf. You can't get out into the world.

Lily: You need nature. You can't just be in clinical isolation.

Wart: Exactly!

Lily: People like the man with the towel, who was possibly at Callan Park for a long time, feel as if it is their home.

Wart: Yeah! I'm sure it was the same for him. He had nothing in his suitcase, but he always carried it as though that was his office space.

Lily: That's the complicated thing because there are acts of care and kindness mixed in with the bad. To erase both histories is not the answer either. Why do that, when all these stories help us to learn what is good for people?

Wart: Exactly.

NOTES

1. Located in Sydney, these sites hosted colonial lunatic asylums at different times. All these institutions changed names many times in tandem with shifting government policies and politics of institutional mental health treatment and care. Callan Park and Parramatta Female Factory Precinct are contested memory sites that still operate outpatient psychiatric services at the time of writing this text, and both have been variously repurposed for arts or community use. They also face the threat of commercial development, as well as activist, survivor, and community resistance to this prospect.
2. Situated in Sydney's western suburbs, Concord Repatriation General Hospital took in Callan Park's remaining psychiatric patients in 2008.
3. Community treatment orders are legal orders under mental health legislation that require individuals to engage in specified treatment while they live in the community. However, if they fail to comply with the order, police are empowered to coercively bring them to their treatment.
4. "Depot" is the term for a slow-release injection formulation for administering a medication to enable less frequent injections.
5. Largactil is a brand name of the drug chlorpromazine, an anti-psychotic and sedative that has been the main medication used by psychiatrists to treat schizophrenia for more than fifty years.
6. Established in 1983, Sydney's Performance Space develops and presents interdisciplinary arts and experimental theatre.
7. Lily Hibberd's 2010 exhibition Benevolent Asylum: An Eclipse of Historical Fiction was inspired by her chance discovery of the traces of the once massive Melbourne Benevolent Asylum in 2008. See https://lilyhibberd.com/Benevolent_Asylum_eclipse_of_historical_fiction.html.
8. Sydney's Luna Park, an amusement park that once featured a ride called the Ghost Train, is an icon of the city prominently located at Milson's Point on the north shore of Sydney Harbour. The Luna Park Precinct was established in 1935, and fifty-seven of its heritage items are listed on the NSW State Heritage Register.
9. In 2021, allegations arose in response to an Australian Broadcasting Corporation television documentary that uncovered corruption associated with development of the area, including the 1979 Luna Park fire, although these accusations have been disputed (Wikipedia 2021).
10. First named Hulk or Phoenix Bay, Lavender Bay was later named after George Lavender, the bosun on the British colonial prison hulk Phoenix, moored there in the 1820s and '30s.
11. Created in 2007, this was the second memorial for the victims of the fire, located in Art Barton Park, named after former Luna Park artist Arthur Barton. See pages 154 to 155 for the story of the first memorial.
12. For Matthew and Others – Journeys with Schizophrenia, Campbelltown Arts Centre, September 1 to October 21, 2006.
13. Eye See Pink, Black and White, solo exhibition by Wart, Rogue Pop-Up Gallery, Sydney, June 12 to July 11, 2021, https://roguepopup.com.au/exhibition/wart-eye-see-pink-black-and-white/.

14 Martin Sharp (1942–2013) was a renowned Australian pop artist, cartoonist, and filmmaker. He created the 1973 version of Luna Park's face, to which he gave a new expression. As the park was increasingly threatened, Sharp joined other Luna Park artists – Garry Shead, Peter Kingston, and Leigh Hobbs – to form the community-action group Friends of Luna Park in order to agitate for the park's restoration and preservation.
15 Unravelling Moments from a Torn Mind, poetry and sound installation by Wart and musician and sound engineer Phil Downing, commissioned for the Empathy Clinic, The Big Anxiety, September 27 to November 16, 2019. See https://www.thebig anxiety.org/events/wart-and-phil-downing/.
16 After the fire, Martin Sharp and others were convinced that it was an act of terrorism to make the site available for redevelopment (see Mulligan 2020).
17 Lily Hibberd read about this hospitalization when researching Martin Sharp but has since lost the reference.
18 Juanita Joan Nielsen was an Australian newspaper owner, journalist, heiress, and Sydney Green Bans anti-development and environmental activist. She disappeared in 1975.

REFERENCES

Australia Human Rights Commission. 2011. "2011 Immigration Detention at Villawood." https://humanrights.gov.au/our-work/publications/2011-immigration-detention-villawood#fn17.

Mulligan, Alvine. 2020. "Martin Sharp, Heritage Activist." *History in the Making* 7: 1–14. https://historyitm.files.wordpress.com/2020/04/martin-sharp-heritage-activist.pdf.

Wikipedia. 2021. "1979 Sydney Ghost Train Fire." https://en.wikipedia.org/wiki/1979_Sydney_Ghost_Train_fire.

Constructing History in the Post-institutional Era
Disability Theatre as a Site of Critique

NIKLAS ALTERMARK and MATILDA SVENSSON CHOWDHURY

Eugenics, institutionalization, and other forms of exclusion and oppression conditioned the lives of disabled people throughout the nineteenth and twentieth centuries in most, if not all, European countries and in North America. Within disability studies and among disability advocates and disabled activists, there is broad support for initiatives to remember this history in order to dignify the victims and to make sure that we learn from history. However, the creation of narratives of the past is a powerful political tool that both highlights and conceals certain aspects of the past. As we shall discuss, it may well be that there are certain ways of constructing the past that obscure how oppression operates in our present era. Hence a key challenge for scholarly and activist work on sites of conscience is to explore and enable modes of learning from the past that offer tools of resistance against the current government of disabled people.

In our previous work, we have discussed how commemorations of past atrocities committed against disabled people come with certain dangers. In popular understandings of disability history, there is a recurring narrative of progression, where a dark past of exclusion gives way to inclusion, rights, and citizenship (see Altermark 2017, 2018). The oppression of disabled people is thereby associated with a bygone era, whereas it is presumed that our own time is morally superior and enlightened. This narrative is reinforced by representations centred on a moment of liberation that functions as a break between historical mistreatments and our own time. Such

breaks invent the past as distanced and distinctively different. As we elaborate below, this narrative structure disguises both how institutionalization lingers and how it has been complemented by new technologies of power. Therefore, to the extent that the history of disability is constructed without the involvement of disabled people, there is a risk that memorials, guided tours, or more traditional and popular forms of documentation of historical treatments constitute a past that both conceals and legitimizes the current government of disabled people.

This risk presents us with a dilemma. Although many see a political and ethical imperative to remember past crimes against disabled people, efforts to document such events can inadvertently support present patterns of domination. A recurrent theme in the emerging literature on sites of conscience is the ambition to challenge linear historiographies and chronologies. Therefore, our ambition is to explore how it is possible to attend to the history of oppression without locating oppression squarely in a past that we presumably have left behind. Learning from history needs to mean something more than just establishing that something horrible has occurred (see Edenheim 2011); we need to remember institutionalization in a way that helps us make sense of current institutions, norms, and practices of power.

The commemoration of sites of conscience is often framed as a collective and community-based learning process, enabling joint critical exploration. In this chapter, we consider alternative starting points of such processes, analyzing two theatre plays – co-performed and co-written by disabled people – in search of resources that facilitate critique of current disability politics. The plays that we analyze were produced in Sweden and Finland respectively, and our analysis of institutionalization and its aftermath focuses on the Scandinavian context. However, we do believe that our analysis of historiography, power, and resistance has broader relevance. Instead of looking backward into history, these plays situate practices associated with institutionalization after deinstitutionalization or outside of the dominating progressive narrative of the history of disability. Thereby, institutionalization is transformed from a past that we have left behind into an ongoing experience that transcends the gap between then and now.

The Post-institutional Era

Before turning to a discussion of theatre and institutionalization, we shall first analyze the popular narrative of deinstitutionalization in Scandinavia. In our previous research, we have conceptualized the present regime of

government policy with respect to intellectually disabled people as "post-institutional" (see Altermark 2017, 2018). This conception draws on how post-colonial studies theorize colonialism and its aftermath. Post-colonial studies can be described as a sustained theoretical effort to complicate the relationship between the perceived past of colonialism and the decolonized present (Morton 2003). Along these lines, Gayatri Chakravorty Spivak (1999) argues that the construction of a narrative break between past and present obscures the production of neocolonial modes of control. In the post-colonial world, patterns of domination between colonial powers and the colonized are reconfigured, operating in new and perhaps less obvious ways. But the reinscription of colonialism as a past crime prevents us from recognizing its new configurations.

There is a parallel narration of the history of disability politics in Scandinavia (see Grunewald 2008; Gustavsson 2004; and Larsson 2008) that presents institutionalization as a historical crime that was eventually replaced with individual rights and humanism. Here, the history of disability politics is figured as a journey toward inclusion in society. This storyline has implications for how we figure the purpose of critique and resistance. Most importantly, the progress narrative seems to imply that the main quest of disability activists and advocates is to guard against a haunting past and that the great danger is that these dark ages will return. At the same time, the spectre of institutionalization is central to how we interpret our present era as its opposite (see Drinkwater 2005). Thus, by analogy to the argument of Spivak (1999), we are not living in deinstitutionalized societies but in a post-institutional era, where the construction of a break between past oppression and contemporary inclusion veils the fact that patterns of domination are reconfigured but persistent.

This is not the place to account for our full analysis of this transformation and how the government of disability has come to operate. Suffice to say, both our own research on Sweden (Altermark 2018; Svensson Chowdhury 2018) and the research of others on other countries that have undergone processes of deinstitutionalization (e.g., Clement and Bigby 2010; Tøssebro 2005) make clear that disabled people are not considered equals and are still subjected to treatments that impede their quality of life. However, although public discussion revolving around disability policy often acknowledges the historical oppression of the group, it is much rarer for it to suggest how the present situation of disabled people can be addressed. This circumstance does not imply that deinstitutionalization was not called for or that it should be aborted at sites where it has yet to take place. Rather, the point that we

want to bring home is that the progress narrative hampers our critical capabilities in important respects. There are at least three significant ways in which that occurs.

First, we become less attentive to historical continuities as a result of a dominating narrative that tells us that everything is much better now. For example, practices of restriction and enforcement are persistent in deinstitutionalized disability services in Sweden today (Altermark 2018), but they may be hard to notice given the dominating idea that current disability policies are the opposite of those that prevailed in the institutional era.

Second, the institutional past comes to represent what power looks like, which makes it harder to see that power can operate in other, less obvious ways (see Altermark and Edenborg 2018). For example, our previous studies suggest that group-home services in Sweden, designed to promote societal participation and self-determination, make use of precisely these ideals to teach disabled people how to behave according to prevailing cultural norms (Altermark 2018). However, technologies of power that target and shape how freedom is exercised (Gilbert 2003), rather than suppressing it, are easily overlooked when the blatant repression that characterizes institutionalization dominates how we understand the government of disabled people.

Third, the progress narrative makes it difficult to recognize the systemic nature of power. The idea of a break between past exclusion and contemporary inclusion makes the current mistreatment of disabled people appear as an anomaly, commonly explained as resulting from failures of implementation (see Bigby 2005; Clement and Bigby 2010; and Drake 1999). After all, countries with deinstitutionalized disability services have committed to human rights and inclusion. We argue that it is more appropriate to understand remnants of institutionalization and the new technologies of inclusion as systematized within the present regime of how disabled people are governed.

Today, the progress narrative is dominant to the extent that policy discussions on the situation of disabled people, as well as cultural representations of disability more generally, tend to take it for granted (see LSS-kommittén 2008). Consequently, historical accounts that teach us about the ills of institutionalization, despite the intentions, are easily inserted into this storyline, leaving us less prepared to make sense of the current government of disability. Our insistence that remembering the oppression of institutionalization supports the oppression of disabled people in the post-institutional era should not discourage us from remembering institutionalization. Rather, it points to a number of problems that we have to navigate while doing so.

Most importantly, we need ways of constructing history that refuse the progress narrative's break between past and present.

Theatre, Sites of Conscience, and Critique

Disability on Stage as a Site of Conscience

As stated, our analysis focuses on two plays that attend to institutionalization in ways that depart from the progress narrative. We approach them primarily as related to the historical treatment of disabled people, paying attention to their narration and how they conceptualize present and past disability politics. However, the form and aesthetics of theatre, particularly theatre of disabled people, are not irrelevant in this respect.

To articulate this significance, it is necessary to say a few things about the intersection of performance studies and disability studies. Kirsty Johnston (2016) notes that the movement of disability arts and culture was closely connected to disability activism, which meant that these cultural expressions came to be figured as tools for social change. Matt Hargrave (2015, 27) – in his book *Theatres of Learning Disability: Good, Bad, or Plain Ugly?* – writes that disability arts are "the cultural vanguard of the social model of disability" due to their role in addressing the social oppression of disabled people, especially in mainstream culture and therapeutically aligned art. Hence theatre made and performed by disabled actors is part of larger movements of disability arts, formulating a critique of dominant modes of representing disability and of putting disability on stage (see Calvert 2017).

David Calvert (2017) offers an approach to theatre performed by intellectually disabled people that aims to investigate "the aesthetic significance and innovations of learning-disabled performance, while also considering cognitive impairment itself as inextricable from the aesthetics, as well as the thematic considerations and making practices of performers" (16). To posit that "disability" is an aesthetic value is to suggest that disability is a constitutive aspect of the artwork in question (see Siebers 2010). From this perspective, the theatre productions that we analyze would have been something else if all the actors had been nondisabled.

Calvert (2017, 16) insists that this approach not only enables a focus on "the ways in which artists with learning disabilities challenge received ideas about performance" but also invites reflections "on the challenges these performances present to the conventional understanding of learning disability in the social field." In particular, the second issue brought up by Calvert, concerning how disability theatre unsettles conventional understandings of

disability as a social phenomenon, is relevant for us since we explore the possibilities of breaking free of a dominant discourse concerning the history of disability. Accordingly, we are interested in how theatre plays that are co-produced and acted by disabled people challenge conventional wisdom about the relationship between past and present with respect to institutionalization, and we believe that the aesthetics of having disabled performers are significant in this regard.

This approach is underpinned by a social understanding of disability. As many critical disability scholars have argued in different yet related ways, disabled subjectivity is produced by societal frames of reference, such as cultural norms and ideals, classifications, and lay understandings (Goodley 2014; McRuer 2005). All of these frames affect how disabled people are seen and made sense of – both on a social level of analysis and when performing on stage. Audiences do not leave their preconceptions about intellectual disability behind them in the lobby when they enter the theatre. In her study on interventionist performances of disabled people, Bree Hadley (2014, 7) argues that an important purpose of disability performances can be to disrupt the process where audience members impose their own "culturally determined codes, categories and labels on the other." Given this perspective, taken-for-granted ideas of disability can be transformed when audiences are confronted with intellectually disabled people as professional actors.

Hence, in our reading, sites of conscience are not necessarily about the meeting between people and place but can appear wherever people are gathered to reconsider history. In the plays that we discuss below, the site of conscience is created through performance and in the process of joint learning that is enabled.

Continuity and Regression in *I, You, We, Together*

The first play that we analyze, *I, You, We, Together*, is a one-hour representation of disability history made by the personal-assistance co-operative JAG. The organization has been advocating for personal assistance for intellectually disabled people since the introduction of the service in 1994, when Sweden committed to deinstitutionalization. This service is based on the philosophy of independent living (Berg 2008) and is often contrasted with group-home living, which is the dominant form of service provided. The actors on stage are disabled, using wheelchairs that they need help driving, and they appear along with their assistants, who take part in the play by doing choreographed dance in a few scenes. According to Swedish classificatory standards, the actors are "severely impaired" and predominantly use

nonverbal communication. There are also two nondisabled actors who appear in most of the scenes and have most of the lines, as well as video montages where the actors appear to be nondisabled.

The plot is made up of a historical review of the evolution of disability services for the group of disabled people organized by JAG. It is centred on four historical periods, the first one dating to 1949. Here, photographs of institutional buildings in black and white frame a short story about a father and mother who are pressured to give away their disabled child to an institution, being assured by a medical official that it will be the best choice for all involved. The attending doctor at the institution has been pre-recorded and is played by a nondisabled actor, and the disabled child is represented by a stroller drifting off the stage and into the wings as the parents struggle to let go. The montage of authentic photos from institutions following directly thereafter illustrates grim living conditions.

The next scene is set in 1985, in a summer house where a family secret is revealed by a brother to his sister; they have a dead sibling, a young boy left at an institution long before they were born. The sister reacts with anger as she realizes their loss. How could their mother make this decision and keep it secret? The sister also stresses that the disabled brother would have been alive today, if not sent away to an institution. Thereafter, there is a swift switch to 1994 and a demonstration for disability rights. Here, seven disabled actors enter and are pushed to the front of the stage by their assistants. They demand equal rights and deinstitutionalization. On a screen that forms the backdrop, the responsible minister at the time declares the introduction of a new law guaranteeing personal assistance for people with severe disabilities. At the end of the declaration, all the people on stage, including the assistants, cheer the victory. Essentially, the play up to this point is a reconstruction of the dominating progress narrative that we discussed above.

The audience is then transferred to 2015 and a scene that is primarily set in a café where disabled people are having coffee together, aided by their assistants. Here, being able to choose to have coffee with friends represents societal participation made possible by personal assistance. However, a few minutes into the scene, the gathering is interrupted by a series of crashing noises, and the background screen shows black fluid spreading. Loud music starts and actual quotations are heard from the government regarding its goal to decrease the costs of personal assistance. This policy led to a dramatic increase of denied applications for personal assistance (Försäkringskassan

2020), and many disabled persons were forced to move back in with their parents or into group homes (Knutsson and Svensson Chowdhury 2018).

From here on, the rest of the play follows a disabled young adult called Kim. We get short glimpses of how personal assistance enables him to go to hard-rock concerts and to follow his favourite football club. However, after the cutbacks on personal assistance, he is forced to move into a group home. The same nondisabled actor who plays the attending doctor at the institution in 1949 now acts as the head of a private group home, appearing on the screen to inform Kim and his parents about the services offered. His efforts to paint a bright picture of the group home nevertheless convey the message that residents are assimilated into a pre-set structure that leaves little room for individual interests, activities, or self-determination. This theme is further emphasized in the succeeding scene when a care-staffer seeks to organize a "cozy Friday," where residents at the group home play bingo and listen to hit-list music. As soon as they get the chance, the disabled residents switch the song – after all, Kim is a hard rocker – and burst out singing along to a Swedish punk anthem about having a home of one's own. At the end of the play, Kim's parents (rather than Kim himself) decide that he is going to move home and that they need to fight together with others to assure the rights of disabled people.

I, You, We, Together relates to the progress narrative of the post-institutional era in several ways. As is evident from the review of the scenes, it follows a linear historical narrative, including the break between past and present marked by the 1994 disability reform. The play reinforces the impression that this reform provided disabled people – at least those granted personal assistance – much better living conditions and much more freedom to live as they wished to. Although we agree with the merits of personal assistance, it is notable that the narrative leaves out that most people with intellectual disabilities moved from institutions to group homes. The latter half of the play departs from the progress narrative by focusing on the effects of cutbacks on personal assistance. Here, the narrative of progression, reinscribed in the first half of the play, is turned into a narrative of regression.

The latter half's depictions of deinstitutionalized services are significant. Most importantly, in the representation of the services provided by the group home that Kim moves to, the play accounts for both continuities and transformations with regard to how disabled people are governed. In contrast to the brutal imagery used to depict institutionalization at the

opening of the play, care-staffers and the head of the group home are depicted as well intentioned and familiar with the vocabulary of inclusion. At the same time, the play exposes that services are based on the idea that residents form a collective, with similar needs and interests, such as the desire to play bingo and listen to dance music. These scenes show how Kim's well-being deteriorates and that his individuality vanishes. In a way, it is a representation of a person being institutionalized by a deinstitutionalized service. In her critique of post-colonialism, Spivak (1999) encourages us to pay careful attention both to continuities and to discontinuities. In this play, group-home services are depicted as a continuation of institutionalization, as they erase individuality and impose a way of living that fits the needs and norms of the institution. Nonetheless, the play also highlights how these services have transformed, as the blatant repression and enforcement of institutionalization have been replaced with affectionate paternalism.

Lastly, the play is performed by actors who are personally affected by this history. The politics highlighted by the play exist on stage, as personal assistance is a service designed to guarantee disabled people the right to use their free time as they wish – such as by joining a theatre group. A central logic of institutionalization was that disabled people were separated from the rest of society, rendered invisible. An effect of group-home services, which do not allow residents to move around in society to the same extent as personal assistance, is that disabled people are isolated. The appearance of disabled people on the theatre stage, which historically has been reserved for nondisabled actors and audiences, counters this logic of separation and invisibility. When the disabled actors are pushed to the front of the stage in the middle of the play, it is a performative insistence on the existence of their group. At the same time, the play's themes expose that this existence is threatened. As a site of conscience, then, the play underlines the importance of the participation of disabled people given that the exclusion of the group is a key aspect of the past that is to be remembered.

Rosemarie Garland-Thomson (2009) has famously argued that vision is a key component of the societal production of disability. Although she analyzes staring as a possible manifestation of dominance, she also argues that the act of looking away is "an active denial of acknowledgment" (83) of people who trigger "our distress of witnessing fellow humans so unusual that we cannot accord them a look" (79). The disabled actors of this play break with norms and ideals of how human bodies are supposed to look and function. Following Garland-Thomson, this unusualness may trigger individuals to look away, in parallel to the societal and historical practice of

keeping disabled people separated from the rest of society. But the setting provided by a theatre play does not permit that. Looking away is not an option unless spectators depart from norms about how to behave when watching stage performances.

The performative challenge to not look away resonates with the topic of the play. Again, institutions were designed and located so that disabled people were not seen. Meanwhile, the mistreatments of disabled people were not recognized. Since deinstitutionalization, the dark and haunting past has facilitated a collective looking away from the current domination of disabled people. Hence, in this play, the disabled actors not only demand that they be seen by the audience but also that the continuity between past and present be recognized.

Appearance and Normativity in *In the Grand Landscape*
The second play that we analyze, *In the Grand Landscape*, was produced in Helsinki, Finland, by the Swedish-speaking professional theatre group Duv-Teatern, where actors have intellectual disabilities, in collaboration with the Swedish-speaking ensemble of the Sveska Teatern. It was performed on the main stage of Svenska Teatern, which is one of the most prestigious stages in Finland, and it received great reviews in national media. DuvTeatern worked with the play for several years, emanating from a project of storytelling with respect to intellectual disability politics and the life stories of the actors.

In the Grand Landscape is a fairy tale set in its own temporal universe. The play tells the story of a king and a queen who are the parents of twins, one of whom is disabled. Although the laws of the fictional country dictate "that everything always needs to be normal," the king and queen negotiate a deal with "the ministers," as they are called, which allows the disabled princess to live with her parents until she is eight years old. However, when her eighth birthday comes, she is sent to a remote institution in the mountains, where she is stripped of her crown and expected to be as normal as possible. After a while, the daughters flee from home and institution to go in search of each other. Before they can succeed, however, a war breaks out between the ministers and some unruly clowns that threatens the order of the kingdom. The disabled princess is killed by accident, as she is mistaken for a clown, but is fortunately restored to life. The play ends with a change of the laws and with the two sisters ruling the country together.

As is evident from this summary, *In the Grand Landscape* is a fairy tale with a happy ending that largely follows the conventions of the genre. Here, the disruption of the progress narrative of post-institutionalization is a

result of the fact that the story operates on a parallel timeline, which means that it cannot be determined whether the events comment on the institutional past or the post-institutional present. When introducing the play, one of the actors declares that the saga takes place in liminal space between fiction and reality as "something that really happens in some way." Furthermore, in the opening scene after the break, one of the actors recounts her story as a disabled woman in contemporary Finland and her sense of injustice in comparison to her nondisabled sister. This scene is not part of the play's overarching storyline but certainly communicates that contemporary treatments of disabled people are related to it. No matter how audiences interpret these aspects, the fact that there is no break between past and present means that the play engages with institutionalization without constructing it as a historical artifact.

Rather, the play brings up a number of rationalities and technologies of government that can be connected to both past and present practices of power. Like in *I, You, We, Together*, there is a scene of giving away a disabled child, perhaps the emblematic representation of kinship in the institutional era. At the same time, the remote institution in the mountains resembles a contemporary group home, where the staffer uses a tone and language that is reminiscent of our current times. Furthermore, the ministers' explicit statement that the function of the law is to preserve "ordinariness" can be seen as a persistent rationality underlying how disabled people are treated. In this sense, *In the Grand Landscape* centres on the dividing line between normalcy and deviancy and on the fear of disruption caused by disabled bodies.

Like in *I, You, We, Together*, the appearance of disabled actors is significant. The disabled princess is played by a nondisabled woman of Svenska Teatern, and the nondisabled sister is played by an actress of DuvTeatern who exhibits the typical features of Down syndrome. Clearly, this is an aesthetic and political choice. Performatively, her skill in acting her role, which requires professionalism and technical competence, refutes the logic that the play exposes: the idea that the deviance of disability is a burden that needs to be removed. In fact, we argue that the appearance on stage by people classified as belonging to a group that would be institutionalized in the fictional kingdom of the play is central to its underlying political message. Disability scholars and critical theorists more generally have often remarked that norms are exposed as they are broken. Thereby, the appearance of disabled people on a grand stage in Finnish cultural life draws attention to the general absence of disabled people in culture more generally. The logic

of the kingdom in this play – that everything that is not ordinary needs to be removed – serves as a general commentary on the place of disabled people in society.

Conclusion

We argue that the theatre productions that we have analyzed can be understood as sites of conscience related to practices of community-based learning. Hence sites of conscience are not isolated to people engaging with specific locations. Rather, the very act of reflecting on the links between past and present is centred in our analysis. Furthermore, we show that theatre can help us to escape narrative traps that are recurrent in the history writing of intellectual disability politics. Thus we are aiming for an expansion of how sites of conscience are conceptualized both with regard to what such a "site'" is and with regard to the preconception that "conscience" refers to a past that we have left behind.

More specifically, we argue that the plays help us to escape the traps set up by the popular progress narrative of intellectual disability politics in at least two ways.

First, the progress narrative prevents us from attending to institutionalization as ongoing since the repressive technologies of power associated with the institutional era linger. With respect to this matter, *I, You, We, Together* uses a regressive narrative that stresses continuity. The political critique presented in the play suggests that we are currently re-enacting institutionalization by scaling down independent-living services. *In the Grand Landscape*, in contrast, places institutionalization in a fictional universe outside of our historical timeline and is not concerned with "how it used to be." Nonetheless, it displays rationalities of rule that can be linked to our current times. Thus, in both cases, the idea that repression of disabled people lies behind us is questioned.

Second, we suggest that the progress narrative depicts power as repressive and tied to institutionalization, which prevents us from appreciating the role of productive technologies of power. Here, it is notable that the continuities highlighted in *I, You, We, Together* depict a contemporary discourse of care and benevolence. The staffer's role in choosing which music to listen to as a way to create a "cozy Friday" evening with bingo is an illustration of how group homes mould disabled people to conform to ideals of what members of this group should be like. Residents are free to listen to music – as long as it is not hard rock. *In the Grand Landscape*, in contrast, takes issue with the underlying logic of such concrete expressions of power.

It explains the government of disability as an effect of the rationality of maintaining order. That is why the disabled princess needs to be sent away from her family. In this way, the play offers a remedy against the third problem of the progress narrative, namely that it fails to account for the systematic function of power. By analyzing the treatment of the disabled princess as an expression of a rationality of state building, it suggests that responses to disability are to be found in the ideology of the kingdom itself.

In addition, again given the common ambition to use sites of conscience as resources for community-based discussions, the plays highlight the importance of representation and participation. In more traditional forms of documenting the histories of marginalized groups, those who have suffered injustices are primarily reduced to being historical victims, as distant as the repression to which they were subjected. Disabled people are rarely involved in the construction of memorials and do not give the guided tours. Thus, paradoxically, efforts to remember the past tend to continue the exclusions of disabled people that were foundational to this past. Indeed, it can be argued that commemoration in the post-institutional era often has very little to do with the needs and wishes of disabled people. Rather, it can be interpreted as representing our current need to assure ourselves that we are not as oppressive as we used to be. The aesthetics of disability in the two plays break the narcissistic cycle of nondisabled people confessing to how other nondisabled people, before deinstitutionalization, mistreated the historical group of disabled people. Instead, the disabled actors insist on a political subjectivity that is located in our own times.

In her discussion of the tendency of activists and critical scholars to locate the repression that they are fighting against in the past, Wendy Brown (1995, 8) states that "freedom premised upon an already vanquished enemy keeps alive, in the manner of a melancholic logic, a threat that works as domination in the form of an absorbing ghostly battle with the past." Brown suggests that certain categories of people are bound up with past injuries and mistreatments, which in turn legitimize their contemporary recognition. Thus we can grant recognition only on the basis of previous oppression. This argument is further developed by Sara Edenheim (2011), who suggests that history writing about marginalized groups also contributes to hegemonic normativity. As stated above, the idea of our own era as inclusive is justified by the narrative of progression. Such history writing is a celebration of the nonmarginalized majority's capacity to include. There is a cultural desire for representations of past crimes, as they serve to uphold a flattering image of our current time.

However, this separation between institutionalization and inclusion is bound to fail. We see this inevitability as soon as we consider that Brown's wider target is the fact that critical intentions are often figured within the same paradigms that once brought about the powers that the critiques set out to contest. Translated to the context of disability politics, the progress narrative and the tendency to locate power in the past are premised on a liberal and humanist tradition, where the ideals of citizenship, autonomy, and freedom are figured as the opposite of oppression of disabled people. These are the ideals of progress that enabled the inclusion of disabled people. However, it can be argued that the very same ideals were involved in the invention of intellectual disability and in the institutionalization of the group in the first place.

The creation of intellectual disability was influenced by the way in which Enlightenment thinkers such as Immanuel Kant (1785) and John Locke (1690) defined human beings as distinguished by their mental faculties. Those who were perceived as deficient in this respect were deemed to be not fully human. Hence a failure to meet the ideals of reason and rationality created the need for sorting instruments that made possible interventions targeting disabled people, such as institutionalization and eugenics (Axelsson 2007; Goodey 2011). In other words, the ideals of citizenship and autonomy that today are mobilized to justify the inclusion of disabled people were also foundational to the era of institutionalization.

As a result, the post-institutional era is marked by the contradiction of seeking to include people who are constituted by a failure to meet the Enlightenment conception of the human. At the same time, people with intellectual disability are both defined as lacking intelligence and adaptive capacity, according to diagnostic criteria, and targeted by policies of inclusion premised on the human as rational and self-sufficient. The lingering nature of institutionalization portrayed in the plays can be seen as resulting from this contradiction. Although there is a need to distance ourselves from the past by reconstructing disabled people as "included," control of disabled people is still with us since members of this group break with cultural and societal presumptions about how human beings ought to function. Although we appear to have left institutionalization behind, we have not left behind the ideals that produce intellectually disabled people as deviant.

In this way, sites of conscience can help us to reveal the architecture of exclusion, founded on norms about how human beings are supposed to function, by troubling received wisdoms about the relationship between past and present. If we wish to resist the oppression of disabled people, we

also need to contest conceptions of the human that are founded on our bodily and mental capacities. A basic premise of this effort is that disabled people should be the central actors in the reconstruction of their own history.

REFERENCES

Altermark, Niklas. 2017. "The Post-institutional Era: Visions of History in Research on Intellectual Disability." *Disability and Society* 32 (9): 1315–32.

—. 2018. *Citizenship Inclusion and Intellectual Disability Biopolitics Post-institutionalisation*. London and New York: Routledge.

Altermark, Niklas, and Emil Edenborg. 2018. "Visualizing the Included Subject: Photography, Progress Narratives and Intellectual Disability." *Subjectivity* 11 (4): 287–302.

Axelsson, Thom. 2007. *Rätt elev i rätt klass: Skola, begåvning och styrning 1910–1950*. Linköping, Sweden: Linköping University.

Berg, Susanne. 2008. *Independent Living i Sverige 25 år*. Stockholm: STIL.

Bigby, Christine. 2005. "The Impact of Policy Tensions and Organizational Demands on the Process of Moving Out of an Institution." In *Deinstitutionalization and People with Intellectual Disabilities In and Out of Institutions*, ed. Kelley Johnson and Rannveig Traustadóttir, 117–29. London: Jessica Kingsley.

Brown, Wendy. 1995. *States of Injury: Power and Freedom in Late Modernity*. Princeton, NJ: Princeton University Press.

Calvert, Dave. 2017. "Performance, Learning Disability and the Priority of the Object: A Study of Dialectics, Dynamism and Performativity in the Work of Learning Disabled Artists." PhD diss., University of Warwick.

Clement, Tim, and Christine Bigby. 2010. *Group Homes for People with Intellectual Disabilities: Encouraging Inclusion and Participation*. London: Jessica Kingsley.

Drake, Robert F. 1999. *Understanding Disability Policies*. London: Macmillan.

Drinkwater, Chris. 2005. "Supported Living and the Production of Individuals." In *Foucault and the Government of Disability*, ed. Shelley Tremain, 229–44. Ann Arbor: University of Michigan Press.

Edenheim, Sara. 2011. *Anakronismen: Mot den historiska manin*. Gothenburg, Sweden: Daidalos.

Försäkringskassan. 2020. "Analys av minskat antal mottagare av assistansersättning." https://www.forsakringskassan.se/download/18.3a5418591814e228e441155/1657122938547/analys-av-minskat-antal-mottagare-av-assistansersattning-svar-pa-regeringsuppdrag-dnr-001381-2020.pdf.

Garland-Thomson, Rosemarie. 2009. *Staring: How We Look*. Oxford: Oxford University Press.

Gilbert, Tony. 2003. "Exploring the Dynamics of Power: a Foucauldian Analysis of Care Planning in Learning Disabilities Services." *Nursing Inquiry* 10 (1): 37–46.

Goodey, C.F. 2011. *A History of Intelligence and "Intellectual Disability": The Shaping of Psychology in Early Modern Europe*. Farnham, UK: Ashgate.

Goodley, Dan. 2014. *Dis/ability Studies: Theorising Disableism and Ableism.* London and New York: Routledge.
Grunewald, Karl. 2008. *Från idiot till medborgare: De utvecklingsstördas historia.* Gothenburg, Sweden: Gothia förlag.
Gustavsson, Anders. 2004. "The Role of Theory in Disability Research – Springboard or Strait-jacket?" *Scandinavian Journal of Disability Research* 6 (1): 55–70.
Hadley, Bree. 2014. *Disability, Public Space Performance and Spectatorship: Unconscious Performers.* London: Palgrave McMillian.
Hargrave, Matt. 2015. *Theatres of Learning Disability: Good, Bad, or Plain Ugly?* London: Palgrave Macmillan.
Johnston, Kirsty. 2016. *Disability Theatre and Modern Drama: Recasting Modernism.* London: Bloomsbury.
Kant, Immanuel. 1785. *Groundwork of the Metaphysic of Morals.* Reprint, London: Yale University Press, 2002.
Knutsson, Hans, and Matilda Svensson Chowdhury. 2018. "Omfattande utökning av barnboenden pågår." *Svenska Dagbladet,* September 4. https://www.svd.se/omfattande-utokning-av-barnboenden-pagar.
Larsson, Monica. 2008. *Att förverkliga rättigheter genom personlig assistans.* Lund, Sweden: Lund University.
Locke, John. 1690. *Two Treatises of Government.* Reprint, Cambridge, UK: Cambridge University Press, 1988.
LSS-kommittén. 2008. *Möjlighet att leva som andra: Ny lag om stöd och service till vissa personer med funktionsnedsättning.* Stockholm: Statens offentliga utredningar.
McRuer, Robert. 2005. *Crip Theory: Cultural Signs of Queerness and Disability.* New York: New York University Press.
Morton, Stephen. 2003. *Gayatri Chakravorty Spivak.* London and New York: Routledge.
Siebers, Tobin. 2010. *Disability Aesthetics.* Ann Arbor: University of Michigan Press.
SO-rummet. 2023. July 20, https://www.so-rummet.se/fakta-artiklar/synen-pa-funktionshinder-i-ett-historiskt-perspektiv#.
Spivak, Gayatri Chakravorty. 1999. *A Critique of Postcolonial Reason: Toward a History of the Vanishing Present.* Cambridge, MA: Harvard University Press.
Svensson Chowdhury, Matilda. 2018. "Människorättsförsvarare: Nya perspektiv på närstående till assistansberättigade." In *Forskning om personlig assistans – En antologi,* ed. Niklas Altermark, Hans Knutsson, and Matilda Svensson Chowdhury, 43–52. Stockholm: KFO.
Tøssebro, Jan. 2005. "Reflections on Living Outside: Continuity and Change in the Life of 'Outsiders.'" In *Deinstitutionalization and People with Intellectual Disabilities In and Out of Institutions,* ed. Kelley Johnson and Rannveig Traustadóttir, 186–202. London: Jessica Kingsley.

10

The Workhouse and Infirmary Southwell
Collaboration with Learning-Disabled Neighbours and Partners

An interview with JANET OVERFIELD-SHAW

Janet Overfield-Shaw is a senior program and partnership officer at the National Trust. In this interview, she discusses the collaborative work that she and others at the National Trust have undertaken at the Workhouse and Infirmary Southwell. The Workhouse and Infirmary is a site of conscience.

Linda Steele: Janet, can you please tell us about the Workhouse and Infirmary?

Janet Overfield-Shaw: The Workhouse and Infirmary in Southwell, England, is part of the small industrial portfolio that the National Trust holds as learning properties. Such properties give curators, staff, and volunteers the opportunity to research and talk about the lived experiences of historical and contemporary welfare systems. In fact, the historic properties form part of the Southwell welfare site, parts of which continue to provide welfare services today.

The Workhouse building is an internationally important, intact model workhouse. It is a Grade II* listed building, although it has been altered both internally and externally and has limited original content. Initially named the Thurgarton Union Workhouse, it was built in 1824 as a place of last resort for the poor and sick, with accommodation for 115 men, women, and children from local rural

parishes of Thurgarton. Its architecture and harsh regime, the creation of the Reverend John Thomas Becher and George Nicholl, became a blueprint for Britain's workhouses and an important step in the development of the welfare system.

There are interesting connections here between the workhouse system in the United Kingdom and the workhouse-apprenticeship system in the Caribbean, the system of indentured labour from India to the Caribbean, and the forced migration of labour from the United Kingdom to the colonies. Becher's family had historical connections to the slave trade, owning slave ships and a plantation in Jamacia. Nicholl had been employed in the East India Company as a ship's captain from 1799 to 1814, and his uncle became the company director in 1800. These influences on Becher's and Nicholl's thinking are something that we aim to investigate further.

In 1871, the Workhouse Board of Guardians was forced by the central authority to provide nursing care for inmates, resulting in the building of the Infirmary. This change in policy by the Poor Law Commission was in response to nursing reformer Florence Nightingale's report on the inadequacies of workhouse nursing care, fears of epidemics, and an increasing awareness of public health. The commissioners insisted that proper care be provided to the poor in the Workhouse. The new Infirmary accommodation consisted of separate male and female sick wards and day rooms for up to thirteen males and fifteen females and included a lying-in ward for four females.

The Infirmary provides rare evidence of all periods of its use for the provision of services: medical poor relief in an infirmary rather than at home, early vaccinations, pre- and post-natal care for local mothers, training and opportunities for the vast majority of the new nursing profession, and most enduringly, care for those with no one to care for them and no hope that a cure would make them self-sufficient again, namely the elderly, the infirm, unmarried mothers, the homeless, those with moderate learning disabilities, and the mentally disabled.

In 1928, a new hospital was built and named Block 1. The Infirmary was renamed Block 2, and later in the 1960s, it became Firbeck House. The hospital continued the care and nursing previously provided by the Infirmary, with provision of both simple medical procedures and more advanced maternity care. In the

1960s, the hospital became a nursing home for elderly men and was used by the Nottinghamshire County Council for a number of functions. In 1990, it became Minster View, a respite and residential home for children under the provision on looked-after children.

The final part of the site is Caudwell House, which was originally named the Children's Home when it was built in 1930. It still functions today as a Nottinghamshire County Council residential home for looked-after children with learning disabilities and complex needs.

So, overall, the Workhouse and Infirmary can be said to exemplify the legislative move from the Poor Law of the nineteenth century to the medical and social welfare of the twentieth century, the long-term identity shift from pauper to patient, and the growing societal awareness of the causal links between mental and physical health and living conditions.

Linda: How was the Workhouse and Infirmary transformed into a site of conscience, and why did this happen?

Janet: The National Trust saved the Workhouse building from redevelopment in 1998 as part of a very conscious new effort to preserve and interpret a more diverse history of people in Britain. The property also joined the International Coalition of Sites of Conscience (ICSC) to further its goal to promote social justice and lasting peace by drawing lessons for life in the present from sites of historical significance around the world.[1] With the National Trust's strategic aim to "move, teach, and inspire," we could not ask for a more powerful site and history. The moral obligation of owning a property such as the Workhouse and Infirmary has also influenced the interpretation of the building and the activities that it has undertaken.

In 2016–21, the site undertook a transformative project of reimagining the visitor experience. This process aimed to reframe the intellectual engagement of staff, volunteers, and visitors through a new approach to interpretation. The ICSC premise of memory to action was essential in creating a convincing intellectual impetus for the reinterpretation of the whole site and for the integration of the Infirmary restoration project. Indeed, ICSC support was key to the National Trust's agreement to cover a large percentage of the £1.3 million that the project cost. Stronger partnerships with local communities and businesses have also ensured a sustainable and inclusive future.

A new role of community and creative program officer was created to engage relevant local communities that have a direct historical or contemporary connection to the site. There was an obvious place to start this communication: Minster View and Caudwell House, the two learning-disabled children's homes housed in historic buildings neighbouring the Workhouse, which were formerly part of the whole site and were run by Nottinghamshire County Council, which looked after children's services.

Developing an exploratory approach required an intellectual underpinning that has taken time to emerge and, I would argue, is still emergent. It was important to explore a variety of points of view and intellectual tools in order to create a position from which to start the process of engagement. Therefore, alongside creating community connections, it was important to engage with academic partners, often through conversations, workshops, and conferences, from a wide range of faculties and universities.

Linda: Sites of conscience are characterized by moving from memory of place to action on contemporary social justice concerns. Can you explain the specific contemporary issues that drive the sites-of-conscience practices at the Workhouse?

Elisabeth Punzi: Yes, and how did the move to a site of conscience approach shift the visitor experience?

Janet: Before 2016, the property focused on bringing to life the poor conditions of inmates in the nineteenth century, but too few of our visitors made the connection between our site's history and their own or other people's contemporary lived experience.

As part of our reimagining, we have increasingly become able to tell a powerful story of how our society has tackled themes of housing, employment, child care, health, care in old age, education, and political representation over a 200-year period. We now also know that the area the Workhouse was built to serve still suffers today from low-paid jobs, pockets of deprivation, and poor services.

We believe that we have reinvented the original role of the Workhouse for the twenty-first century, demonstrating what heritage can do to help local individuals and communities to flourish. We are beginning to present our entire collection of 4,000 objects

and use these to stimulate contemporary conversations rather than just to trigger pity or nostalgia.

Linda: Wow. It is interesting to learn that this site, which was focused on engaging with histories of institutionalization, is situated alongside some still-operating disability institutions. So how have you engaged with the disability community in your work?

Janet: The property itself has inspired several innovative projects that work on the movement from memory to action with relevant communities and individuals. The projects we have co-curated with our partners provide a contemporary commentary that engages the visitor and offers discussion not only on the histories of poverty and social care but also on the contemporary lived experience of people who are still enmeshed in the system.

A cultural-archaeological approach was used, whereby a number of small interventions were created and delivered. Some of these undertakings were part of the public program, which was open to general visitor feedback, whereas others were part of closed and specific groups, were developed with people who had learning disabilities, and were focused on in-depth consultation and collaboration.

One example is a series of programs entitled Do It Different, in which we have co-created exhibition and film work with commissioned artists, National Trust staff and volunteers, the staff and residents of the neighbouring children's homes, and the charity Nottingham Mencap. The title of the project comes from a reference that a Mencap artist-participant made during the filming process to caring and thinking differently about being normal: "We have to do it different; you should do it different."[2]

We also have twenty years of historical research and discovery developed by our volunteers and academic partners that we are using to greater effect. There is significant potential for crossover research here, as inmates of the Workhouse could be transferred to the Asylum and vice versa. Often mental health patients were denied access because treatment at the Asylum was more expensive, and it was cheaper to keep people in the Workhouse. The historical practice of limiting the movement of people with mental health issues and poverty is still evident in mental health services today, and we wanted to ensure we continued work that highlighted the restrictions for those people.

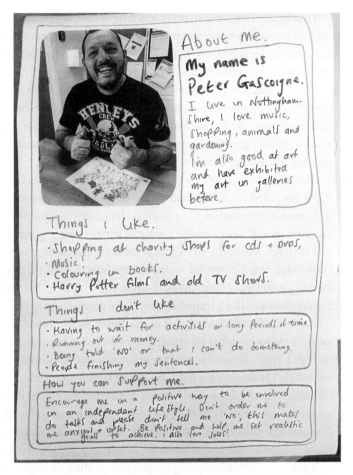

From the exhibition *The Asylum and the Workhouse* at the Workhouse, Southwell, England, 2022. Photograph by Benjamin Rostance. With kind permission of Peter Gascoigne and Backlit.

For example, we have created partnerships with other history agents such as the arts collective Backlit, whose exhibition *The Asylum and the Workhouse* explored the connections between Nottingham General Lunatic Asylum (est. 1812) and the Thurgarton Union Workhouse. Artists Ben Rostance and Peter Gascoigne (a service user who has a long-term mental health condition and lives in a secure setting) created stories using modelling and visual images to engage visitors with current mental health provision and the experience of institutionalization today.

Finally, the Firbeck Infirmary building is now accessible and enables visitors to understand how the workhouse system laid the foundations for the UK welfare state and how the latter acquired much of the bias and stigma it still carries.

Linda: ICSC emphasizes that sites of conscience practices are distinct from heritage preservation. Are you able to elaborate on how these differences manifest at the Workhouse site and if there are any tensions or challenges, on the ground or in terms of regulation, with running a site of conscience on a National Trust site?

Janet: The move from memory to action is the main advocacy tool that ICSC has gifted to us. The main tool that we have developed to foster this move is co-creation. Co-creation challenges the notion of the museum as authority and the visitor as learner and suggests a process through which the strengths of both are the basis of new knowledge. It is a powerful metaphor for how the individualized learning experience combines pre-knowing with new discoveries. Co-creation implies a transition from one narrative to many.

It seems to me that the heart of the Workhouse project is a journey exploring what co-creation could or should mean to the National Trust. Nevertheless, this approach enables us to bend, not break, the rules! I am not sure in any large organization like the National Trust you can really create direct democracy, as it is a long way from the property to the power. Procedures can convolute process and will create barriers to change if they go unchallenged, so eventually you have to choose to be an ally to historical truth.

There were several existing barriers to creating the right atmosphere for bringing vulnerable people into the space. These challenges were mainly due to the infrastructure but more importantly also due to the attitudes of staff and volunteers to people with disability and the work they produce. There was initially a refusal to accept the historical evidence that there had been people with learning disability in the Workhouse and Infirmary; and even when that information proved reliable, there was still resistance to accepting that neurodiverse people could engage with their own history and embrace their personal identity.

This was the first cultural and intellectual hurdle that needed to be confronted, challenged, and overcome. Yet waiting until the ecology at the museum is completely balanced before we involve

vulnerable participants equates, in my view, to a patrician approach. That said, although there has been a purposeful shift by staff and volunteers toward inclusive practice and co-creative engagement for visitors, there is still a long way to go before the work that is produced by people from the community is recognized as legitimate.

Although the National Trust has made great strides in its engagement with inclusion and both staff and volunteers are now expected to complete training on inclusion in order to remain employed in the organization, I would argue that we are still in a process regarding engagement with inclusive practice, and the recent Coronavirus pandemic has not helped our developmental process. I am left with more questions about inclusion and obviously, in particular, about people with learning disability.

It was agreed by the partners that the neurodiverse participants and artists were more likely to change hearts and minds by being present rather than only being talked about. We created a series of small-trench projects, which included people with learning disability being involved in front-facing work areas, arts and creative opportunities, programming, and conversations about their interests and desires. We also widened the partners from the neighbouring institutions' residents to local learning-disabled community groups, both in rural and urban environments.

Elisabeth: Can you perhaps discuss one of these projects?

Janet: The Arts Council–funded project undertaken at The Factory alternative arts school, Do It Different, from 2018 to 2020 was one outcome of this trench approach. Neurodiverse participants were significant members of the project board and were completely involved in the commissioning process, including shortlisting, interviewing, and making the final choice of artists.

The Factory alternative arts school at the Workhouse and Infirmary was co-created by artist Morgan Tipping and the neurodiverse and mobility-diverse children, young people, and adults who attended the school from July 2018 to January 2020. The Factory curriculum foregrounded social relationships, experimental processes, and material encounters. The Factory and the associated Do It Different project drew on diverse educational philosophies and approaches and were informed by social art forms.

Morgan's socially engaged practice explored the challenges presented by ideological and institutional structures that shape and produce marginalization. Drawing on the Foucauldian idea of biopower, The Factory sought to disrupt the way power was encoded in social practices and individual behaviour by the historic workhouse's routines. The Do It Different project also shed light on how these ideological legacies and practices influence social structures in the present.

We also had an external evaluation completed by an independent consultant. The consultation captured the participants, artists, audience, volunteers, and staff.

Elisabeth: Have you encountered any challenges in your work?

Janet: Unfortunately, many of the participation activities of the Do It Different project became impossible with the interruption of the pandemic after 2019. We were unable to fulfill the extended participation activity, which involved an Arts Trail with local businesses, drop-in workshops for visitors run by neurodivergent artists, and Workhouse tours by neurodivergent enablers. These activities were designed to provide vital information about the project's impact and how it might be changing attitudes toward the full integration of people with learning disability in the interpretation of their own history.

Linda: That is so fascinating, particularly the connections to Michel Foucault's approach to biopower. So institutionalization has a very dark and painful past for the disability community, and these practices are continuing in England and elsewhere – for example, in assessment and treatment units, mental health units, and care homes. How did you approach the projects with the disability community in ways that were safe and respectful?

Janet: I would say the projects benefit from both a practical approach to participant safety and respectful engagement and an intellectual understanding of the dark and painful past you mentioned, which is just as important.

I'd like to start with the practical approach and describe the co-creative practice we developed at the Workhouse and Infirmary in the context of the Do It Different project as a three-phase process.

The first stage consisted of building the relationship, including:

- *meeting potential partners* to gain background on the staff and participants (e.g., what services are offered, their commitments in terms of additional projects, their culture/ethics, and their experience of and assumptions around creative projects);
- *running pilot projects* to develop an understanding of the partner organization (e.g., how reliable it is, the limitations of its capacity, and how it manages money) and to help potential partners increase their understanding of the arts so that they are more comfortable taking creative risks;
- *familiarizing partners with the property* (e.g., by bringing staff and participants to the National Trust more than once so that they feel comfortable, designing tasks to communicate that participants' opinions are valued, and asking for their feedback on specific events or changes);
- *discussing possibilities for collaboration* to give partners insights into the artistic process sensitively, without rushing or throwing all the information at them at once, so that any anxieties can be assessed and addressed and people aren't embarrassed dealing with information they can't engage with;
- *ensuring that formal ethics and confidentiality policy are embedded in the process.* As part of any project, the National Trust has an ethics policy that includes consideration for privacy and that ensures people involved in any project are respected and considered and that their views are recognized and attributed to them in public presentations and exhibitions. Formal agreements include a contract for artists and a project agreement with participants that covers media permissions and copyright of the work produced. Conversations about the use of personal information are written into the agreement, but with the potential to be flexible, and such use adheres to the principles of the General Data Protection Regulation.
- *reflecting on the strengths and weaknesses of each partner* and on the roles that would best suit them to identify which one or two partners should be the core of a project and which are best suited to playing a supporting role.

The second stage consisted of building the scaffold, including:

- *building a bid together* while making clear the costs of the creative process so that the partner doesn't envisage the whole budget as coming into its bank account;
- *framing a project around the artistic process* while making clear that the final product will not be known from the beginning since, for example, the participants' work might be included in the artwork or the link between their work and the result might be more indirect and inspirational. You have to avoid the partner limiting the outcome from the beginning because it wants to feel safer. The process needs to be open enough to be of interest to artists.
- *involving the partner and participants in choosing the artists* while allowing the partner and its participants a choice of formats and dates to take part in engagements such as open days and/or interviews where they can ask the candidate artists questions, as well as allowing these questions to be discussed and prepared before the meeting, such as on a poster, if participants are uncomfortable asking the question personally. This step initiates the relationship between the chosen artists and the participants, as well as communicating the sense of individuality among the artists;
- *choosing artists with relevant experience* of both participation and commissioning;
- *designing an evaluation system* to capture the process and outcomes, ideally as independently and anonymously as possible.

The third stage consisted of co-creation, including:

- *briefing the artists* on the needs and expectations of the partner (e.g., recommending that some of the sessions be held on the partner's premises so that participants don't need to travel every time; ensuring that the participants' work is valued even though it might be inspirational rather than a physical object in the final piece; helping the artists to see talent and skill in the group and helping to support participants' involvement in other creative projects; ensuring the artists have enough time for reflection on the quality of the artwork; and supporting the interaction between the artists and participants, considering the needs and vulnerabilities of each person);

- *creating a space* that is conducive to creative activity and may or may not be on-site (but must meet any relevant safeguarding requirements);
- *supporting the artists* to ensure they are reliable, including talking to them before and after sessions to identify and resolve practical problems in real time;
- *debriefing the partner* at key points to check that it is happy with the way the project is progressing;
- *linking the project to the site* so that it is visible, perhaps by identifying any volunteers who want to support the artists or participants;
- *ensuring participants have a central role* in the unveiling of the artwork by inviting them to the launch, getting them to talk to the press, or interviewing them on camera.

In terms of the understanding of historical patterns underlying this approach, I would say that the vehicles of that dark history are connected and still present in public memory. As we identify the historical labels of people with learning disabilities, such as "idiots from birth," "imbecile," and "moral imbecile," we acknowledge the assimilation of these terms into the contemporary culture and their public use as derogatory.

How do we critically consider the archival record of sites of dark history? Most historical accounts of inmates or people in care have been written by institutional staff, by the media, or in judicial records, which may include accounts of potential perpetrators but also of potential advocates and allies. Rarely do we hear the voices of people with learning disability or who are neurodivergent.

How can we show these connections without simplifying history or the contemporary lived experience of excluded groups? The current context of people with learning disability resembles how the historical "poor" or lumpen proletariat constantly moved between places of limited safety: the family, the street, education, care institutions, hospitals, prisons, the workhouse, and the asylum. Public consciousness fails to connect the exclusion of the most vulnerable with the system's inability to support and care for the individual – fails to understand that beyond refuge and food, people with learning disability have needs such as esteem and recognition. They are 2SLGBTQ+, or they are from the poorest

and most deprived backgrounds, or they identify as people of colour, who as children experience unwarranted overidentification with special educational needs. The discrimination and their lived experiences are intersectional.

Linda: It is interesting you raise these questions because I assume the site's history itself in many ways captures this intersectionality, both within the population who lived in the Workhouse (and its subsequent care-home iteration) and in the evolution of the site over time for different institutional uses. How have you captured this intersectionality in your work?

Janet: Foregrounding social relations and the experimental process and reconfiguring the politics of living together are instrumental parts. The Factory and the Do It Different project were shaped by the diverse sensory experiences of the neurodiverse artists involved, and both encompassed visual, sonic, somatic, and movement-based art forms. Throughout the Do It Different project, the artists have demonstrated not only their need for greater creative opportunities but also the immense artistic power that is generated when collaborating with them.

Tyrone Nash was a key artistic collaborator at The Factory and a creative muse for the project's film *Casual Terms.* According to the commissioned lead artist Morgan Tipping, "The title refers to the term 'Casual people,' which was coined by artist Tyrone Nash to describe people without disability. Referring to language and the process of fixing conditions, in *Casual Terms,* the word 'term' takes on multiple meanings. The film asks the viewer to reconsider the language and conditions imposed on people labeled as disabled and meet them on less casual terms."[3]

Tyrone, diagnosed as neurodivergent, is a forty-year-old gay man who lives semi-independently, while also caring for his elderly parents. Morgan made spaces for him to develop as an artist, on and off the project, and the site gave him the opportunity to communicate directly with the visitors. He painted in the Workhouse and Infirmary's historic buildings on weekends and talked with visitors about his paintings and what they represented. Tyrone feels that people do not take him seriously, that he is treated like a child, and he says this makes him act and feel like a child, most often when in organized creative-activity sessions, where he cannot express himself freely.

In terms of the validity of individual experience, the position of neurodiverse people in institutions has not altered considerably in the last 200 years. The areas of intersectionality are evident in the lives of people in the primary sources in our archives, which describe neurodiverse people as objects, nongendered, and asexual, not as autonomous agents in their own lives but as dangerous and unpredictable or vulnerable and unable, just as they are described in public discourse today. Tyrone's work might remind us that, if you are in care or dependant on government services, your experience within the system that purports to support you will continue to segregate you, just as it did under the workhouse system.

NOTES
1 See "What Is a Site of Conscience?" at https://www.sitesofconscience.org/en/who-we-are/faqs/.
2 Mencap artist-participant of The Factory alternative arts school's Do It Different project at the Workhouse and Infirmary, 2019–20.
3 See Morgan Tipping on Casual Terms at https://morgantipping.com/outcomes/casual-terms/.

11

Intellectual Disability in South Africa
Affirmative Stories and Photographs from the Grahamstown Lunatic Asylum, 1890–1920

RORY DU PLESSIS

In South Africa, a deinstitutionalization project that took place in the province of Gauteng from 2015 to 2016 tragically resulted in the country's "most catastrophic care disaster in ... recorded history" (Capri and Swartz 2018, 558). The "genesis of this terrible tale of death and torture" (Moseneke 2018, 18) was the province's decision to embark on the Gauteng Mental Marathon Project (GMMP), which entailed terminating a contract with Life Esidimeni – a long-term care facility for approximately 2,000 mental health care users – and transferring the patients to nongovernmental organizations (NGOs) based in the community. Instead of upholding the country's policy frameworks for deinstitutionalization, the GMMP engaged in numerous depraved decisions and actions that debased the dignity of the patients (75).

For the purposes of this discussion, I outline two factors that contributed to the desecration of the sanctity of patients' lives. First, many of the NGOs "had neither the basic competence and experience ... nor the fitness for purpose" (Moseneke 2018, 25) to provide even a rudimentary standard of care to the patients. Unlike the patients at Life Esidimeni, who were provided with a "structured and non-stop caring environment," the patients at the ill-equipped and poorly funded NGOs were provided with a "sub-standard caring environment" (Makgoba 2017, 1). The conditions at the NGOs were described as "treacherous" (Moseneke 2018, 32), and they operated like "concentration camps" (Makgoba 2017, 6), with the patients starved, dehydrated, and abused. Second, as a consequence of the negligent placement

of patients in substandard facilities, there were a large number of inter-NGO transfers for the patients who required clinical attention that was unavailable at their current site (34). Some patients, before they died, experienced heightened trauma from several inter-NGO transfers (Moseneke 2018, 29). The combination of the above factors turned the NGOs into "sites of death and torture" (25) where 144 patients died and a further 1,418 patients were "exposed to trauma and morbidity" (2).

The GMMP failed as a deinstitutionalization project, as it neither supported nor suitably funded the development of community-based services (Moseneke 2018, 19). Because the GMMP dumped the care of patients into community facilities that were utterly unsuited to supporting and preserving the lives and well-being of the patients, it can be categorized as the execution of a deleterious decision that assaulted, abused, and shortened the lives of the patients. The health ombudsperson's report on the GMMP concluded that "all the patients died under unlawful circumstances" (39) and recommended the establishment of an arbitration process. The appointed arbitrator was Deputy Chief Justice Dikgang Moseneke, who pronounced the GMMP to be the cause of "the death, torture and disappearance of utterly vulnerable mental health care users in the care of an admittedly delinquent provincial government" (2). Rather than focusing solely on compensation, Moseneke described the arbitration proceedings as having the intention "to afford the affected families the space to mourn or grieve" (7).

In providing the affected families with a space to mourn, the arbitration featured photographs of the patients from their families' photo albums. The photographs were contextualized by family members who narrated important facets of the patients' life stories and their individuality. The photographs and the accompanying narratives presented by the family members offered a means to restore the dignity and personhood of the patients. Thus, in contrast to the "inhuman narratives" (Moseneke 2018, 2) of the GMMP, which neglected to value the patients' lives and their rights to full health care provision, dignity, and respect, the narratives offered by families resurrected the humanity of the patients. In this way, the photographs and the narratives tendered by the family members humanized as well as commemorated the lives of their loved ones. Such acts of memorialization are closely aligned with sites of conscience practices, which, in part, are committed to preserving the memory of individuals and to presenting a portrait of their humanity (Steele et al. 2020, 526). In recognizing the significant role that this form of memorialization plays in restoring the sanctity of patients' lives, I seek to adopt this same practice in exploring the lives of South African people with

intellectual disability who were institutionalized in the late nineteenth century. Although the historical photos differ from the contemporary ones, as they were captured in a lunatic asylum for the purposes of identifying the people with intellectual disability as patients of the institution, they remain open to various meanings, as well as to considerations beyond a clinical narrative (Du Plessis 2015). This potentiality is underpinned by Marianne Hirsch and Leo Spitzer's (2020, 13) call for photographs to be read in terms of "liquid time" so that their meaning is not "fixed into static permanence" but rather is dependent on how they "acquire new meanings" by adopting various interpretative routes.

The chapter begins by offering a succinct history of intellectual disability in South Africa during the late nineteenth century, with a focus on the Grahamstown Lunatic Asylum and its medical superintendent, Dr. Thomas Duncan Greenlees. Overwhelmingly, the history of intellectual disability is shown to be dehumanizing and entwined with eugenic discourses. The second half of the chapter seeks to redress this history by presenting affirmative photos and stories from the casebooks of the Grahamstown Lunatic Asylum that honour the lives of people with intellectual disability.

The History of Intellectual Disability in South Africa

In South Africa, the history of intellectual disability is a largely untapped field of scholarship. The few published academic texts within this field are primarily concerned with charting the history of the institutional sites and the legislation governing the care of people with intellectual disability (Du Plessis 2020a, 1). The first facility established for children with intellectual disability was the Institute for Imbecile Children, which opened in 1895 in Grahamstown (now known as Makhanda). Only in 1921, with the opening of Alexandra Hospital in Cape Town, was the country provided with its first dedicated facility for the admission of adults, adolescents, and children with intellectual disability. Owing to the absence of dedicated sites for the care of adults with intellectual disability during the nineteenth century, they were institutionalized along with the mentally ill in the country's lunatic asylums.

In the medical community of South Africa, Dr. Thomas Duncan Greenlees ignominiously inaugurated eugenic discourses with the topic of intellectual disability. He was appointed as the medical superintendent of the Grahamstown Lunatic Asylum from 1890 to 1907 and served as the visiting medical officer of the Institute for Imbecile Children, which he founded, from its inception in 1895 to 1907. Based on his experiences with people

with intellectual disability at these two institutions, Greenlees presented numerous lectures and thereafter published them in medical journals and monographs. In a lecture delivered to the Eastern Province Literary and Scientific Society, Greenlees (1899) described children with intellectual disabilities as an "awful curse" (36) and as "handicapped in every sphere of life" (37). In 1903, in his presidential address to the Grahamstown and Eastern Province Branch of the British Medical Association, Greenlees (1903, 19), as a disciple of eugenics, motioned the government to sanction "the destruction of infants known to be hereditarily tainted with disease." Two years later, speaking to the same branch of the British Medical Association, Greenlees (1905, 222) applauded those who called for people with intellectual disability to receive the "lethal chamber." In 1907, in an article read before the South African Medical Congress, Greenlees (1907, 21) depicted people with intellectual disability as "monstrosities that ultimately become a burden on the State." The solution to the burden included "sterilisation ... and even the lethal chamber" (21). In sum, it becomes comprehensible that in Greenlees's lectures he propagated eugenic discourses and a dehumanized account of people with intellectual disability (Du Plessis 2020a, 2021). Moreover, the publication of some of Greenlees's lectures in the *South African Medical Journal* resulted in his discourses of eugenics bearing a marked influence on the eugenic research published in the journal from 1903 to 1926 (Klausen 1997, 38).

Resoundingly absent in Greenlees's texts is an interest in the life stories and experiences of people with intellectual disability. A possibility to illuminate such an area of interest is available in the casebooks of the Grahamstown Lunatic Asylum. It is imperative to signpost that casebooks are not an uncomplicated and clear-cut resource for pursuing such an investigation. The challenging feature of the casebook medium is that it is composed of multiple narratives that contradict and diverge from one another. The majority of the narratives are concerned with the clinical construction of patients as objects of scientific inquiry. The focus is thus on a patient's physiological anomalies, as well as on illness and disease progression. Nevertheless, there are narratives that present snapshots of patients' life stories and their experiences of institutionalization. Although these snapshots are ambiguous, fragmentary, and disjointed (Du Plessis 2020b), they do aid in bringing into view the humanity of the patients. Thus, although I concede that the casebooks contain juxtaposing narratives, I highlight evidence that paints a humane portrait of the patients. In doing so, I heed Catharine Coleborne's (2020, 6) call for historical evidence that establishes "possibilities for

alternative representations" of patients rather than perpetuating "negative and troubling representations or stereotypes" (emphasis in original). To this end, the investigation of casebooks can be regarded as an invitation for the researcher to intervene by upending the medium's focus on patients as pathological objects and instead shining a spotlight on content that is humanizing.

The process of examining the asylum's casebooks not only allowed me to glimpse the life history and personhood of people with intellectual disability but also provided me with a resource to counter the dominant dehumanizing narrative of Greenlees's published texts. In this regard, the examination of the casebooks is underpinned by the methods of sites of conscience, whose implementation "involves rejecting the idea of a singular official account of these places and instead opens possibilities of new insights, perspectives and responses" (Steele et al. 2020, 526). The adoption of these methods resulted in the recovery of narratives contained in the asylum's casebooks but entirely absent from the official narratives published by Greenlees, while restoring "agency and humanity" (526) to the patients.

In South Africa, although photographs of people with intellectual disability in the nineteenth century are largely missing from the country's public visual culture, it is disturbing that there are numerous photographic records of people with intellectual disability in medical texts where the subjects of the photos are captured as pathological cases (Greenlees and Purvis 1901). Most of the asylum's casebooks contain photographs of the patients. This photographic collection offers us an opportunity to view images of people with intellectual disability that were not captured as pathological cases. To elucidate, in photographing the patients, the asylum made use of a heterogeneous photographic practice wherein some photos resembled portraits, the sitters having a distinctive and personalized sartorial style, pose, and set of gestures (Du Plessis 2015). I am interested in exploring these casebook photographs that are likened to portraits as an aid to the memorialization of people with intellectual disability. To this end, instead of offering a visual analysis of the photographs, I focus on the information garnered from the casebooks. The aim thereof is to equip the reader with the name and biography of each photographed subject. In doing so, the reader is encouraged to grasp the photographed subjects as sacrosanct selves, to appreciate facets of their life stories, and to become sensitized to the complexity of their identities.

To summarize, I aim to redress the public history of people with intellectual disability by presenting affirmative photos and stories that honour their

lives. In the discussion that follows, I pursue this aim by exploring the life stories and experiences of four individuals in order to portray a respectful and compassionate commemoration of their lives. I also draw attention to how elements from an individual's story are shared by patients from the same demographic profile. The asylum's patient population was segregated into categories of race and gender, with each group governed by a distinctive ethos and regimen (Du Plessis 2020b, 11). Not only were patients' experiences of institutionalization circumscribed and shaped by their race and gender, but so too were their portrayals in the casebook entries. The staff framed patients' subjectivity based on their submission to the racial and gendered regimen of the asylum. Consequently, patients who were docile, who were industrious in work duties, and who accepted the colonial hierarchy received the praise of the staff and were portrayed in the casebooks in a complimentary and favourable light. Although these practices can impede efforts to understand the embodied experiences and the unmediated voice of the patients, the casebooks are still valuable for providing us with a "sense of language, images and notes" (Coleborne 2020, 65) about the patients. In the following discussion, I take into account how the patients are marked by the racial and gendered regimen of the asylum but also how we can find glimpses and gestures that point to the "singularity of another being" (Stevenson 2020, 8).

David

David was well known by the local residents of Grahamstown. Even though he was regarded as a "sort of town fool" (HGM 2, 193), he was relatively integrated into the community, whose members demonstrated considerable tolerance and acceptance toward him. From early childhood, David suffered from severe epileptic seizures that caused him to become "violent and excited." Although his relatives were able to ensure his well-being when he was young, they were no longer able to take care of him during the seizures or capable of controlling his violent outbursts when he approached adulthood and gained in strength. Consequently, at the age of twenty-six, David was admitted to the asylum. The willingness of families to provide extended home-based care for their kin with intellectual disability is a recurrent trope in the asylum's casebooks. Significantly, what becomes apparent is that a large portion of parents were committed to caring for their children with intellectual disability, contrary to the proclamations made by Greenlees (1907, 20), who categorized them as "helpless progeny" who would only be a parasite on the family.

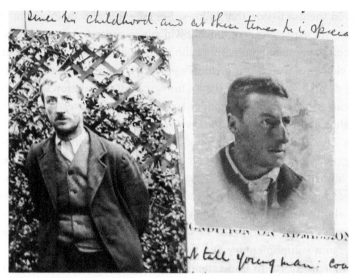

David. Reproduced by permission of the Western Cape Archives and Records Service, Cape Town, South Africa, HGM 2, 193.

From his admission to the asylum in 1890 to approximately 1906, David was assigned numerous duties and was regarded by the asylum staff as a "useful worker." On the one hand, the vast repertoire of duties assigned to David testifies to his ability to master new assignments and to develop several diverse skill sets. On the other hand, the plethora of tasks is indicative of the asylum seeking to reduce running costs by relying on unpaid labour performed by the patients (Du Plessis 2020b). Although some of David's duties were most certainly experienced as depressing and dreary, a few tasks provided him with privileges and rewards. For a period of time, David was the messenger between the asylum and the town. This task offered him frequent visits to the town unaccompanied by staff. The much-desired freedom from the asylum's walls allowed David to remain, to some extent, connected to the townsfolk.

Apart from messenger duties that brought him into town, David would be granted parole from the asylum on Sundays to visit his mother and family. Interestingly, in the asylum's casebooks, there are numerous examples of patients actively maintaining contact and communication with their relatives. Jacobus (HGM 11, 161) would often get the literate patients to write letters to his family on his behalf. In the case of Walter (HGM 9, 9), between visits from his mother, whom he was "always pleased to see," he would ask a fellow patient to write letters to her on his behalf. These examples bring to

the fore the humanness of the patients by revealing the ways that they actively contributed to, nurtured, and maintained their relationships with their families (Bogdan and Taylor 1989, 144).

David was described by the staff as "changeable in disposition and sulks when displeased" (HGM 2, 193). This description highlight's David's acts of agency. Not only would David sulk when he was angered and discontented with the staff and the regimen of the asylum, but he was also quarrelsome and often refused to comply with instructions. To elucidate, David was found by the staff to be "very discontented" and displeased by aspects of the asylum regimen that posed mortifications to his sense of self. Along these lines, David's acts of agency allow us to comprehend that "patients were not simply passive and powerless receptors whose lives were moulded" by the staff (Clarke 2006, 475).

Discussions about the agency of patients should also be tempered by an understanding of how their behaviour was managed by the asylum's disciplinary system of rewards and punishments. David's parole privileges were stopped when he behaved in an improper manner in town – for example, by exhibiting a lack of self-control and by spreading slanderous slurs against the asylum. His privileges were reinstated when his personal appearance, conduct, and behaviour upheld colonial tenets of whiteness and its associations with notions of respectability, as well as maintaining the Victorian idea of manhood as synonymous with self-control and self-restraint (Du Plessis 2019). White male patients who failed to uphold these tenets and this idea were cut off from privileges and were held in negative regard by the staff (Du Plessis 2020b, 205–6). By way of example, Abraham (HGM 10, 42) was extolled on admission for being "clean and tidy" in appearance and dress and for being "quiet, civil and fairly good natured." The staff's praise was followed by preferential treatment and privileges. Once Abraham's conduct began to deteriorate, his privileges were revoked, and the staff labelled him an "untidy rascal" (HGM 10, 42).

The asylum prioritized the admission of patients with acute mental illness who had the prospect of being discharged upon recovery. Upholding this priority resulted in the asylum's doctors transferring patients to poorly resourced institutions if they were intellectually and/or physically disabled, in feeble bodily health, or suffering from incurable forms of mental illness. In general, this practice meant that white patients with intellectual disability spent no more than several years at the asylum before they were earmarked for transfer to another facility. But there were exceptions, as white paying patients, like David, were able to reserve their room at the asylum. In this

way, the white paying patients were likely to live out the remainder of their lives at the asylum.

Hendrik

Under Greenlees's tenure as the superintendent of the asylum, the people of colour with intellectual disability spent a brief time at the asylum before they were transferred to the Port Alfred Asylum and the Fort Beaufort Asylum. Owing to the limited beds available for Black subjects at the Grahamstown Lunatic Asylum (Du Plessis 2020b, 29), the people of colour with intellectual disability experienced a quicker transfer rate to make room for Black subjects suffering from acute forms of mental illness. Despite the limited time that the people of colour with intellectual disability spent at the asylum, the casebooks contain details that aid us in defining them as "distinct, unique individuals with particular and specific characteristics that set them apart from others" (Bogdan and Taylor 1989, 141).

Hendrik was assigned to care for the asylum's herd of cows (HGM 2, 1). This work is emblematic of the asylum's regimen, which allocated outdoor and hard manual labour to Black male patients. Hendrik was lauded by the asylum staff as a "most trustworthy man in every way" for the way that he cared for the herd. He would take the cows out to the grazing fields early in the morning and return to the asylum only for midday meals and in the early evening when he brought them back to the cowshed. In many ways, this labour can be regarded as a form of parole, as he spent the day unsupervised outside of the asylum's grounds. The staff applauded Hendrik for never abusing his liberty from the asylum, and it appears that he enjoyed the solitary time that it afforded, as he disliked being spoken to. Of particular interest is that, although Hendrik was given the standard-issue asylum uniform, he would fashion a self-identity of his own choosing by adorning his hat with an ostrich feather and a vast number of pins. A discernible pattern in Hendrik's casebook entries is thus how it provides evidence of his distinctive personality and confirms his individuality. This patterning is also evident in numerous other casebooks for the male people of colour at the asylum. Masombolo (HGM 4, 15) was fond of dancing and was much admired for being a lively and cheerful character at the asylum. Jonas (HGM 4, 8) is presented in the casebook as an animated and sprightly character who enjoyed singing aloud and lived each day in a "happy contented manner." Hlumbi (HGM 4, 17) was pictured to be "always happy, walks about with a swaggering air and particularly when he has a pipe to smoke … Is a fine and well-mannered fellow."

Intellectual Disability in South Africa

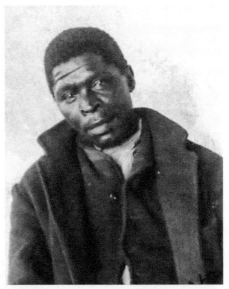

Hendrik. Reproduced by permission of the Western Cape Archives and Records Service, Cape Town, South Africa, HGM 2, 1.

Hendrik and these three men were eventually transferred to the Fort Beaufort Asylum, but a significant portion of others were discharged to their families. Although these discharged individuals were in no way "cured" of intellectual disability, their families were ardently interested in returning them to the fold of the family and were devoted to providing for their well-being with home-based care. Seventeen-year-old Sipongo (HGM 15, 46) was admitted to the asylum in December 1904. At the asylum, Greenlees established that Sipongo's "mental faculties" were "much underdeveloped," noting that he could scarcely speak. After some months, Sipongo's mother requested his discharge. Sipongo required substantial care, as he was "quite unable to look after himself," but this need did not deter his mother from being "anxious to have him home" or from promising to "look after him." He was discharged into her care.

Liza

When Liza was admitted to the asylum in October 1898, no information pertaining to her life history or to the context of her committal was recorded in the casebook. Greenlees described her in November as "cleanly in her habits, and works well" (HGM 18, 103). The following June, he repeated

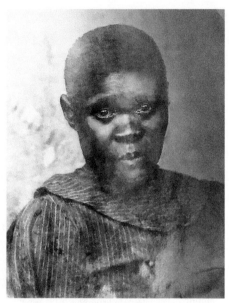

Liza. Reproduced by permission of the Western Cape Archives and Records Service, Cape Town, South Africa, HGM 18, 103.

much of the same information, declaring that Liza "sleeps well – habits clean – works sometimes in laundry." Finally, in August 1899, the focus of the casebook entry was on Liza working "well in the laundry." In October, Liza was transferred to the Fort Beaufort Asylum. Excruciatingly evident in the casebook is a dehumanized and objectified account of Liza, whose subjectivity is omitted in favour of reporting that describes her solely in terms of her bodily functions and the industriousness of her labour. Appallingly, such dehumanized accounts dominate the narratives of the women of colour at the asylum.

The dominance of these accounts in the casebooks of women of colour is an indication that Greenlees prioritized their labour for the laundry room and thus regarded them as an instrumental component in the optimal running of the asylum. Viewed in this way, the women became part of Greenlees's "system of economic exploitation of asylum inmates" (Reaume 2016), where they were valued as a homogenous unpaid workforce. Accordingly, what took centre stage in the casebooks was their ability to perform this labour rather than their experiences of institutionalization. Although the women's experiences of the toilsome labour in the laundry have gone unrecorded in the casebooks, there are aspects of their personalities that shine

brightly. Rodah (HGM 18, 117) was recognized to have a "cheerful disposition," and Hester (HGM 17, 84) was distinguished for being "quick and observant" and for being "happy" and "bright." The casebooks also hold evidence of a "lively subculture" (Clarke 2006, 475) among the patients at the asylum that produced strong bonds of companionship, camaraderie, and support. Such bonds are evocatively evident in the case of Mkhabo (HGM 20, 31), who was suffering from microcephaly. Mkhabo was shy and timid, and she had a profound degree of intellectual disability. Nevertheless, Mkhabo was "well treated by the other patients," who ensured that her health, happiness, and comfort were always met and prioritized. Lastly, to return to Liza, although the casebook is silent on her experiences and subjectivity, her photograph provides us with an "interpretative route" to keep in view her individuality (Du Plessis 2020b, 233). In beholding Liza's photograph, the viewer is called to be conscious of the fact that she witnessed distinctive experiences and extensive encounters in her life – albeit unrecorded in the casebook – that set her apart from any other human who lived or will ever live.

Rosetta

Rosetta was admitted to the asylum for the first time in 1884, when she was twenty-eight years old. Until her death in 1915, she was caught in a merciless merry-go-round of transfers between the asylum, the Chronic Sick Hospital (CSH), and the Port Alfred Asylum (PAA). In the discussion that follows, I draw on Rosetta's case to demonstrate how the institutions in this network were either inhospitable or ill-suited to the care of people with intellectual disability. Frightfully, the casebooks of the asylum are teeming with white female patients who circulated in this network of institutions that were reluctant and averse to being responsible for their care and well-being. The large circulation of white female patients reached its peak in 1905 when the asylum embarked on the "removal" (Greenlees, cited in Cape of Good Hope Official Publications 1906, 75) of Black female patients from its facilities to several other institutions – one of which was the PAA. Making room for them at the PAA necessitated the transfer of the PAA's white female patients to the Grahamstown Lunatic Asylum. Nonetheless, these transferred white female patients were largely unwelcomed there, as they were suffering from chronic mental illness or intellectual disability. Greenlees held that these white women were a "degraded" class of patients (75), and when the PAA had beds available for the admittance of new patients, these women were retransferred to Port Alfred.

Rosetta. Reproduced by permission of the Western Cape Archives and Records Service, Cape Town, South Africa, HGM 21, 78.

In July 1891, Rosetta was readmitted to the asylum from the PAA for the third time. Thus, beginning in 1884, Rosetta's care was tossed between the two institutions. As mentioned earlier, the asylum prioritized the care of patients with acute and curable mental illness and sought to guarantee room for them by selecting people with intellectual disability, like Rosetta, to be transferred to the PAA. However, the PAA was not intended for the care of people with intellectual disability. Instead, it was earmarked to care for docile patients who required minimal supervision and who placed limited demands on the nursing staff. Thus, when Rosetta became excitable, she was transferred to the asylum. When Rosetta had stabilized, she was re-transferred to the PAA.

Rosetta's asylum admission of 1891 ended in November of the same year when she was transferred to the Chronic Sick Hospital (HGM 16, 161). At the CSH, she became so troublesome that the staff "could not deal with her properly" and requested that she be retransferred to the asylum (292). The CSH, in general, opposed the admittance of people with intellectual disability, as it was intended for the care of the aged and infirm. Given that the CSH was loath to care for people with intellectual disability, at the onset of their behaviour becoming troublesome, noisy, or raucous, they were retransferred

to the asylum. A notable feature of Rosetta's casebook is that Greenlees attributes her troublesome behaviour to an "undoubted desire to get back to the Asylum" (292). In this way, Rosetta is portrayed as an individual with a distinct preference for life at the asylum rather than at the CSH. This personal preference is regarded as the defining motivation for the onset of her behaviour. Stated differently, the casebook presents evidence that Rosetta's actions are not "symptomatic of an underlying pathological state" but indicative of an individual expressing "normal motives and feelings" (Bogdan and Taylor 1989, 142). Rosetta's casebook thus provides a vivid comprehension of her individuality and presents a compelling example of her acts of agency as a means to influence her return to the asylum.

The casebook is silent on why Rosetta preferred the asylum. Nevertheless, it is possible to argue that, compared to the CSH and PAA, which were poorly resourced and understaffed, Rosetta enjoyed the asylum's superior provisions in terms of diet, recreations, care facilities, and entertainment (Du Plessis 2020b). In contrast to her troublesome behaviour at the CSH, Rosetta was "civil in her conversation and manner" at the asylum (HGM 16, 292). Despite being "cheerful and active" and "quite happy in the Asylum" (292), she was recommended for transfer to make room for new patients at the asylum. In September 1894, Rosetta was retransferred to the CSH.

Rosetta was retransferred to the asylum in June 1897 owing to her "short-lived attacks of excitement" at the CSH (HGM 18, 10). At the asylum, she made her presence known by interfering with the daily regimen of the institution and abusing the staff. Her behaviour became so intolerable that she was labelled a "firebrand" and was defamed by the staff as the "most troublesome and objectionable of patients" (10). Although the casebook entries do not outline the motivations for Rosetta's behaviour, they could possibly be interpreted as acts of resistance to being imprisoned in a merry-go-round of transfers that mortified her sense of self, as well as exposing her to trauma and anxiety. After only seven months at the asylum, Rosetta was retransferred to the PAA.

Before being returned to the asylum in June 1902, Rosetta had been transferred from the PAA to the CSH. Again, this period at the asylum was remarkably short before she was retransferred to the PAA in March 1903 (HGM 21, 78). At the age of forty-nine, Rosetta returned to the asylum in 1907, after having been retransferred from the PAA to the CSH (HGM 22, 149). After several years at the asylum, where she was described by the doctors as being in a "quiet mental state," Rosetta was retransferred to the CSH in May 1912 (149). However, in November, she "walked away" from the

CSH and returned, at her own choosing, to the asylum, as she "doesn't like" the CSH (149). Until her death in 1915, she remained at the asylum in a quiet and self-possessed state.

The casebooks documenting Rosetta's thirty-one years of institutionalization, spanning from 1884 to 1915, detail her desire for a long-lasting, rather than temporary, place of refuge and sanctuary (Du Plessis 2020b, 191). Motivated by her wish to stay at the asylum, she engaged in acts of agency, namely becoming troublesome at the CSH to secure her transfer to the asylum and later denouncing her stay at the CSH by walking back to the asylum. Furthermore, during the spin cycle of transfers to which Rosetta was subjected in 1897, it is plausible to interpret acts of protest and resistance in her bad behaviour. Enshrined in Rosetta's casebooks is a testimony to her distinct individuality, her acts of resistance to the merry-go-round of transfers she encountered, and the impact of her resolute determination to secure her stay at the asylum.

Conclusion

The methods and practices of sites of conscience (Steele et al. 2020, 524–26) underpin this chapter's focus on rejecting Greenlees's published accounts of people with intellectual disability. To this end, Greenlees's dehumanized narrative of people with intellectual disability is countered by the investigation of the casebooks, as well as by retrieved photos and stories of the patients that encourage us to understand and recognize each one as an "individual with a name and a history" (Stevenson 2020, 7). To elucidate, armed with the stories submitted in this chapter, we can approach the photographed subjects included here as unique individuals. Gazing at their photos, we are reminded of the testimonies that these individuals tender – the vibrancy of their character, the complexity of their motivations and interests, their multifaceted subjectivity, and their life stories, as well as their bonds to family.

The practices of sites of conscience call for us to consider how "historical research into the lives and experiences of people with intellectual disabilities may well further the cause of advocacy movements for the disabled by providing a collective public memory of the injustices of the past, how they happened, and why they must never happen again" (Clarke 2006, 485). In this way, in the act of commemorating the personhood of people with intellectual disability, the chapter not only enumerates their experiences of institutionalization but also establishes an awareness of the injustices that they suffered from a network of sites that were ill-suited and ill-disposed to care

for their well-being. The trauma and anxiety caused by multiple transfers, by a lack of access to equitable care, and by the devaluation and dehumanization of the lives of people with intellectual disability in the nineteenth century are heinously and uncannily echoed in the abominable tragedy of the Gauteng Mental Marathon Project in the twenty-first century. Avoiding future tragedies requires that we think about, theorize, and act on supporting the dispensation of quality care that honours the sanctity of the lives of people with intellectual disability. In this regard, photography can play an integral role in instigating a better future for people with intellectual disability. For Tina Campt (2017, 107), photos of people who are dispossessed, discriminated against, and institutionalized invite viewers to envision and actualize how we can "live the future we want to see now" for them. It is a compelling call for the viewer to take daily actions to bring about, bolster, and buttress a present, and a future, where people with intellectual disability live an enriching and meaningful life that is free of abuse.

ARCHIVE
Hospital Grahamstown Mental (HGM), Grahamstown Lunatic Asylum Casebooks, Western Cape Archives and Records Service, Cape Town, South Africa.

REFERENCES
Bogdan, Robert, and Steven J. Taylor. 1989. "Relationships with Severely Disabled People: The Social Construction of Humanness." *Social Problems* 36 (2): 135–48.
Campt, Tina M. 2017. *Listening to Images*. Durham, NC: Duke University Press.
Cape of Good Hope Official Publications. 1906. *Reports on the Government and Aided Hospitals and Asylums and Report of the Inspector of Asylums*. Cape Town: Government Printers.
Capri, Charlotte, and Leslie Swartz. 2018. "The Right to Be Freepeople: Relational Voluntary-Assisted-Advocacy as a Psychological and Ethical Resource for Decolonizing Intellectual Disability." *Journal of Social and Political Psychology* 6 (2): 556–74. https://doi.org/10.5964/jspp.v6i2.946.
Clarke, Nic. 2006. "Opening Closed Doors and Breaching High Walls: Some Approaches for Studying Intellectual Disability in Canadian History." *Histoire sociale/Social History* 39 (78): 467–85.
Coleborne, Catharine. 2020. *Why Talk about Madness? Bringing History into the Conversation*. London: Palgrave Macmillan.
Du Plessis, Rory. 2015. "Beyond a Clinical Narrative: Casebook Photographs from the Grahamstown Lunatic Asylum, c. 1890s." *Critical Arts* 29 (suppl. 1): 88–103. https://doi.org/10.1080/02560046.2015.1102258.
—. 2019. "Madness, Masturbation and Masculinity in the Casebooks of the Grahamstown Lunatic Asylum, 1890–1907." *Gender Questions* 7 (1): 1–22. https://doi.org/10.25159/2412-8457/4401.

—. 2020a. "The Life Stories and Experiences of the Children Admitted to the Institute for Imbecile Children from 1895 to 1913." *African Journal of Disability* 9: 1–10. https://doi.org/10.4102/ajod.v9i0.669.

—. 2020b. *Pathways of Patients at the Grahamstown Lunatic Asylum, 1890 to 1907.* Pretoria: Pretoria University Law Press.

—. 2021. "The Janus-Faced Public Intellectual: Dr Thomas Duncan Greenlees at the Institute for Imbecile Children, 1895–1907." In *Public Intellectuals in South Africa: Critical Voices from the Past*, ed. Chris Broodryk, 200–21. Johannesburg: Wits University Press.

Greenlees, Thomas Duncan. 1899. *On the Threshold: Studies in Psychology.* Grahamstown: Grahamstown Asylum Press.

—. 1903. *Insanity – Past, Present, and Future.* Grahamstown: Grahamstown Asylum Press.

—. 1905. "Statistics of Insanity in Grahamstown Asylum." *South African Medical Record* 3 (11): 217–24.

—. 1907. "The Etiology, Symptoms and Treatment of Idiocy and Imbecility." *South African Medical Record* 5 (2): 17–21.

Greenlees, Thomas Duncan, and G. Carrington Purvis. 1901. "Friedreich's Paralysis." *Brain* 24 (1): 135–48.

Hirsch, Marianne, and Leo Spitzer. 2020. *School Photos in Liquid Time: Reframing Difference.* Seattle: University of Washington Press.

Klausen, Susanne. 1997. "'For the sake of the race': Eugenic Discourses of Feeblemindedness and Motherhood in the *South African Medical Record*, 1903–1926." *Journal of Southern African Studies* 23 (1): 27–50.

Makgoba, Malegapuru W. 2017. *The Report into the Circumstances Surrounding the Deaths of Mentally Ill Patients: Gauteng Province.* Pretoria: Office of the Health Ombud, Republic of South Africa. https://www.sahrc.org.za/home/21/files/Esidimeni%20full%20report.pdf.

Moseneke, Dikgang. 2018. *In the Arbitration Between: Families of Mental Health Care Users Affected by the Gauteng Mental Marathon Project and the National Minister of Health of the Republic of South Africa, Government of the Province of Gauteng, Premier of the Province of Gauteng, [and] Member of the Executive Council of Health: Province of Gauteng.* https://legalbrief.co.za/media/filestore/2018/03/Life_Esidimeni_Arbitration_Award_19_March_2018.pdf.

Reaume, Geoffrey. 2016. "A Wall's Heritage: Making Mad People's History Public." *Public Disability History*, November 16. https://www.public-disabilityhistory.org/2016/11/a-walls-heritage-making-mad-peoples.html.

Steele, Linda, Bonney Djuric, Lily Hibberd, and Fiona Yeh. 2020. "Parramatta Female Factory Precinct as a Site of Conscience: Using Institutional Pasts to Shape Just Legal Futures." *University of New South Wales Law Journal* 43 (2): 521–51.

Stevenson, Lisa. 2020. "Looking Away." *Cultural Anthropology* 35 (1): 6–13. https://doi.org/10.14506/ca35.1.02.

12

Pathways to Disrupt Eugenics in Higher Education

EVADNE KELLY and CARLA RICE

"Improve Life." That is the present-day slogan and directive of the University of Guelph, where we work. This broad directive applies to university projects with vastly different possibilities and varying effects. As a slogan, it imagines a specific audience and operates as a public relations statement geared toward placing the university on moral high ground. Looking closely at its background, however, reveals conditions of world making (at once humanizing and dehumanizing) shaped by institutional mechanisms of human betterment (Kelly et al. 2021), utility (Ahmed 2019), and active not knowing (Mills 2007).

Recent archival research has revealed the role that Ontario postsecondary institutions played in creating and disseminating oppressive knowledge that benefited primarily white, Anglo-Saxon, heteronormative, nondisabled, propertied settlers at the expense of First Nations and settler peoples who did not fit white-settler, colonial framings of the world. This research, displayed at the Guelph Civic Museum from September 2019 to March 2020 in an award-winning exhibition titled *Into the Light: Eugenics and Education in Southern Ontario*, demonstrates a sustained commitment to not knowing the workings and impacts of oppressive knowledge. Elsewhere, along with several key contributors, we have documented how *Into the Light's* processes of engagement created space for survivors of Ontario's colonial eugenic policies and practices to collaborate with Anishinaabe, Black, disabled, and white-settler anti-racism and disability activists,

scholars, and artists in order to co-construct knowledge shaped by our anti-assimilation solidarity efforts and commitments (Kelly et al. 2021; Kelly, Boye, and Rice 2021; Kelly and Rice 2020; Stonefish et al. 2019). Although *Into the Light* continues to provide us with a powerful model of possibilities for transforming relationships between educational institutions and memorialization, we recognize that the project's success was in part due to its ability to slip between institutions and stay outside of the purview and control of any one organization. Here, we engage with our own institutional history of human-betterment ideas and practices. We pause to linger over questions about the institutionally embedded practices of not knowing this history, analyzing how mechanisms of not knowing currently operate through our university's call to "Improve Life" and how such not knowing functions within higher education in Canada today. Ultimately, as situated scholars, we seek to understand more about engaging in the memorialization of difficult, challenging, and potentially retraumatizing histories in order to move toward more socially just, safer spaces of engagement.

If sites of conscience "remember the past to build a better present and future" by igniting democratic dialogue and engagement with specific narratives of social issues and histories (Brett et al. 2007, 1), we wonder and worry about how processes of (selective) remembering and memorializing might be manipulated actively and unwittingly to better the future for select groups at the expense of others. This chapter aims to push the boundaries of the work being done in this volume. Our intent is to challenge the ideas and assumptions (sometimes inadvertently perpetuated by sites of conscience work) that eugenic ideas and practices are issues that arose elsewhere and belong to the past. We focus on the ongoing ways that eugenics continues today in education and our own educational institution, and we articulate and analyze the ongoing everyday work needed to challenge institutional traditions of practice that perpetuate eugenics. Building on important work done to expose epistemic ignorance (Mills 2007) and epistemic violence (Spivak 1988), especially within the context of British legacies of colonialism, education, and institutionalization in Canada (Bain 2018; Schaefli, Godlewska, and Rose 2018; Tate and Page 2018; Winston 2018, 2020), we explore how oppressive knowledge and ignorance co-constituted themselves in two of the University of Guelph's founding colleges – a home-economics-focused educational institution called the Macdonald Institute (established in 1903) and the Ontario Agricultural College (established with that name in 1880 as an academic extension of the University of Toronto). These sites upheld and instituted social, political, epistemic, and ontological

notions that produced the entitlement of the white, middle-class, non-disabled, heteronormative, propertied settler. Less obvious but potentially just as damaging are how such betterment impulses continue to undergird the university's mandates and strategic priorities, indicating an ongoing refusal to know the oppressive life and afterlife of such mechanisms (Mills 2007). Legacies of abstracted theories and methods of human betterment, including eugenics and euthenics, have proceeded at the university through regimes of ignorance tethered to broader systemic power relations that actively discount the experiential knowledge of situated knowers, especially knowledges connected to marginalized group experiences (Sullivan and Tuana 2007).

Methods to disrupt such not knowing in one's own workplace have the potential to fail. As Sara Ahmed warns (2019, 195), "If we proceed on a path in order to disrupt it, we can end up not disrupting it in order to proceed." This is a problem that we, as white-settler scholars with partial understandings, confront in this chapter. We counter not knowing through "queer use" of the path by "lingering over things, attending to their qualities," in order to "make violence seeable," "stop business as usual," "refuse to use things properly," and activate a "refusal to disappear" (206–10). To subvert the notions of progress, betterment, and utility embedded in academia generally, and in our institution specifically, we linger and loiter around current-day iterations of the "President's Message" as they enact the university's purpose through the logo tagline "Improve Life." This tagline, we argue, comprises one mechanism that carries human-betterment legacies and logics into the present alongside an active refusal to know about their damaging effects. Our method of lingering and loitering puts theories of epistemic ignorance into conversation with twentieth-century human-betterment artifacts – correspondences and course content – from our university's founding colleges, which taught learners how to grade and rank life. Through this process, the university's tagline emerges as making an evaluative comment on life itself – on what "we" in the academy imagine as desirable and not desirable across human and more-than-human life. In our lingering and loitering, we make visible the violence that operated under a directive to improve the future of the so-called Canadian race – a directive hauntingly similar to the university's present-day logo tagline.

By putting iterations of the "President's Message" into conversation with theory, we focus on the macro-institutional and systemic, not individualized, ways that human betterment continues to operate. Susan Burch (2021, 5) shows how white-settler, ableist frameworks, "which individualize

injustices, emphasize the exceptional, and overlook systemic inequities," cannot recognize or address the transinstitutional and systemic violence imposed on First Nations and non-normative settler communities. Although some individuals did push against a eugenic agenda at the University of Guelph, we trace the larger web of ideas that coalesced to produce an educational context that favoured, and continues to favour, some bodies over others. We name individuals only because of the way that the system names them, not to pull them out as singular anomalies or to absolve us from being implicated in the larger webs and systems of uneven power. Believing that sites of learning are also potential sites for resistance through activities that focus on idea making and dissemination in order to engage critically and politically with the colonial academy's pursuit of human betterment, we think through what it means to "Improve Life" differently. In other words, we queer our use of the directive. This process of queering use will, we hope, help to "recover a potential" for transforming relationships within and beyond our educational institution and memorialization.

"Human Betterment": Exposing Active Not Knowing from the Start, in the Past, for the Future

A key philosophical question explored in our lingering has to do with change and the concepts that early naturalists and evolutionary theorists have used to characterize it, including betterment, improvement, efficiency, linear time, and progress. Ideas and methods designed to control human social and biological change have caused immeasurable, long-term, widespread harm. The tradition of understanding usage as a source of human improvement in the early to mid-twentieth century followed from an earlier theory of change. French naturalist Jean-Baptiste Lamarck (1744–1829) proposed that use and disuse changed the biology of organisms and played a key role in organisms' inheritance of acquired traits (Ahmed 2019). Frequent and continuous use created strength, and nonuse created weakness and eventually disappearance (Ahmed 2019). Lamarck also proposed that use and nonuse determined whether acquired traits would be biologically passed on to subsequent generations. In other words, as Ahmed points out, for Lamarck the form of life was shaped by its use, which was further shaped by environment – an enticing theory for the way that it bridges the dichotomous tension between nature (as biology) and nurture (as environment).

Neo-Lamarckians extended Lamarck's idea as "environmentalism" – the notion that environments impact behaviour and then biology – and applied

theories of use and acquired inheritance to effect, shape, and control human biology and behaviour in ways that they believed would improve the human race (López-Durán 2018). Some environmentalists referred to applications of Lamarck's theory as euthenics, which they used to establish and promote the then emerging fields of home economics and domestic science (Dewey 1914; Weigley 1974). Environmentalists targeted First Nations, Black, and other racialized groups as well as poor, immigrant, and disabled peoples for human betterment through residential (i.e., carceral) environments established by the state for the purpose of reform – understood in terms of dominant (i.e., ableist, white, and heteronormative) knowledge, skills, attitudes, behaviours, values, and beliefs.

Values embedded within traditions of use in the history of the University of Guelph's founding colleges show a striving toward improving the future of the so-called "Canadian race."[1] Between 1914 and 1948, the Macdonald Institute and the Ontario Agricultural College engaged in designing and controlling human betterment and progress through eugenics and euthenics theories and methods. At the institute, professors of the college taught eugenics as a stand-alone course and program requirement, and the institute's professors wove eugenics and euthenics ideas throughout other courses, including in psychology, child development, and mothercraft. These courses presented similar patterns and pathways to understanding knowledge about life's betterment and its application by laying out theories and practices in the same ways, year after year, revealing a tradition of use. This tradition approached knowledge about life as utility and progress, expressed as value, worth, and supremacy. Ahmed (2019, 41) reminds us that repetition of knowledge creates an ease of use so that "the more a path is used, the more a path is used." Yet these traditions of mobilizing knowledge to create specific pathways to social mobility and a better life through education were available to some but not to others. This mechanism of human betterment entrenched narrow, reductive habits, traditions, or pathways that aimed to improve the lives of white settlers and the wealth of the nation by "empty[ing] the minds of the colonized as well as empty[ing] the lands" of its First Nations peoples (207). We linger and loiter on where and how habits, traditions, and pathways that shaped and reduced notions of a good, valuable, productive life at the institute and the college continue to operate at the university today.

"Improve Life": Lingering and Loitering over Activations of Ignorance

The University of Guelph enacts a public message: "Improve Life." The message – operating as a slogan, a tagline, and a directive – was altered recently

from the university's previous message, "Changing Lives, Improving Life" (Fisher 2017). Whereas the earlier version of the message orients the activities of the university community toward human lives and life, the current version is not so clearly tethered to human vitality. In both examples, questions remain about whose lives are improved, who will do the improving and how, and why such improvement is needed in the first place. What does it mean to improve life? The impulse to improve life could be widely beneficial, for example, when oriented toward greater social justice. But, as we show, an impulse to improve life can have oppressive effects. How has the university activated its messaging about improving life in the past, and how does the university activate its message today?

As legacies of oppressive human-betterment ideas and practices are still with us, we track the "President's Message" as a performative activation that links past and present productions of knowledge. Iterations of the "President's Message" about "Improving Life" are distributed widely and publicly through the university's official magazine, *Portico*. These periodic messages give us clues as to how the institution activates and uses the logo tagline and directive to "Improve Life" as a mechanism of governance. We view these messages as performative activations of not knowing given that they bring into existence affects and effects that foster inclusion for some (deemed vital) at the expense of others (deemed nonvital). These activations are tethered to the past – a past remembered in ways that support the status quo by at once accomplishing a vanishing act to make the violence disappear and asserting an assimilated group identity formed through the choreography of a partial origin story.

We unravel these messages as they rehearse an origin story that builds a narrative of settler superiority connected to place. Carla Rice and colleagues (2020) note the necessity of unsettling settlers' felt attachments to dominant settler narratives and origin stories, including undoing white-settler assumptions around rights to material benefits and privileges resulting from colonization. They show how processes of knowing and actively not knowing are entwined with felt/sensed perceptions and emotions or with affects such as fear, anxiety, guilt, terror, confusion, anger, sadness, and shame. Iterations of the "President's Message" exemplify how and where settler resistance to knowing is reproduced within processes of subjectivity formation and performativity, activating affects of superiority and entitlement embedded within the notions of excellence and tradition. But as these scholars show, transformative potential lies in interrupting "the narratological and social structures that sustain settler superiority and ignorance" (18). As they

argue, it is necessary that we move beyond exposing violence and oppression and "begin to identify and work through the power/knowing-not-knowing/affect knot of settler resistance in order to act in support of Indigenous people's rights to be self-determined, self-sustaining peoples on these lands" (14). Here, we take the process of exposing and working through the nuanced knot of actively knowing and not knowing and extend it to the underlying settler knots embedded in eugenic and euthenics betterment discourses.

The "President's Message" entitled "Who Are We, and Who Do We Want to Be?" strategically aims to confirm a sense of group identity for the university by evoking a strong, stable connection to the past. As though speaking with an inner circle of friends, the message begins in a relaxed, conversational tone: "As you know, the University has many respected traditions and long-standing areas of strength. Those aspects are as timeless as the values that have sustained us for the past 50 years as a university and the past 150 years since our college beginnings" (Vaccarino 2015). The message asserts an agreed-on understanding of the university that is apparent and knowable as fact. It leaves no cause to question the university's traditions as respected, timeless, and sustaining "us." Although the message does not reveal any more about the values and traditions that create "deep pride in the University's heritage," it does impart an ableist impression when it characterizes the university as strong and full of endurance, as evidenced by the "long-standing areas of strength." The message also notes "an appetite here for change" and a desire to work together to "create a vibrant future" – "a future focused on continued excellence in research and teaching" – and it finishes with an invitation "to join in this conversation to help chart our path to tomorrow." Such statements, which seem on the surface to be open to new ideas, need to be considered in relation to the message's emphasis on joining a conversation about "continued excellence" that is already underway. To what ongoing practice of excellence does the message refer?

Eugenic and euthenics archival documents from the university's founding colleges tell us that the "us" to which this "President's Message" refers is an exclusive group of white settlers that has, at least in the past, sustained itself through traditions of excellence, or superiority, achieved through the oppression, control, and elimination of many people. To describe these traditions and values as timeless flattens them and turns them into essential or universal truths, thereby erasing and not knowing their genesis, the specific ways that the university has mobilized them, and the brutal and specific effects they have had on local communities.

The "President's Message" entitled "Toward a More Sustainable Future" asserts that the university's approach to environmental sustainability is biological, not constructed: "We're also genetically hard-wired at U of G to work across disciplines, a necessary trait for meeting this global challenge" (Vaccarino 2018). The words "genetically hard-wired" operate strategically in activating scientific terminology to anchor the message of "hard" truth, thereby suggesting that there is something essential or biologically inherent about the university's researchers, who share a special "trait" that equips "us" with the ability to solve the world's problems. This message activates, as "hard" truth, the superior abilities of the university's "we" when it asserts that "from our founding colleges to today's campuses, wise resource stewardship has been a constant in our research and teaching." In other words, "we" have been "genetically hard-wired" for successful problem solving since inception, meaning that successful thinking has been passed on through the genetic inheritance of the university – an inheritance that this message enacts as biological, not socially constructed. The message activates the university as a biological body that breeds success thanks to parents – the Macdonald Institute, Ontario Agricultural College, and Ontario Veterinary College – who have passed along superior traits. What is the "hard-wired" pathway to success that we have inherited? How will we know if we are on the right pathway to success? Will success be automatic? Will it feel lucky or natural? What does it feel like to travel on that path of genetically inherited and innate success?

According to this iteration of the "President's Message," "we" apparently use resources wisely. The wisdom, conferred as a sense of use, value, and worth, is tied to a particular mode of conceptualizing the land. If this message, like the others, does the work of connecting the current university ethos to its past, it might be understood as a comment on land-use efficiency and considered for the way that it is tethered to histories of colonial justification for land appropriation and ownership. As Ahmed (2019, 47) points out, colonial notions of land use have justified agricultural and land cultivation as projects of human and land improvement through commodification. The idea that European settlers had a valid claim to land that they deemed uncultivated is connected to notions of terra nullius and the Doctrine of Discovery – which rationalized occupation based on the misleading idea that the land was unoccupied and neglected, a stance that ultimately justified "European sovereignty over Indigenous lands and peoples" (Canada 2015). British colonizers mobilized such notions to claim parts of Turtle Island as their own and eventually to establish Canada as a nation-

state. The message performs a powerful, activating ignorance and, from a presidential position of power and authority, directs others to do the same.

Justified through its use as commodifiable resource, such occupation of land is also situated within a neoliberal orientation toward land and life that maintains white-settler supremacy. This iteration of the "President's Message" goes on to say that "straddling disciplinary borders is a hallmark of our ever-growing Bioproducts Discovery and Development Centre" (Vaccarino 2018). The word "straddling" tells us that the university values the manoeuvrability and flexibility that neoliberalism requires. The message proudly evokes such dynamic capacities as a feature of the university's orientation toward growth through discovery (returning us to the Doctrine of Discovery and terra nullius) and through the development (as entwined with modernist notions of unilinear progress and betterment) of bioproducts (which rest on the capitalization of life). But, as Ahmed (2019) notes, the value conferred to such settler-colonial engagements with the land also has much to do with efficiency and progressive economic growth. Indeed, if the university's wise use of resources is genetically inherited, what can past orientations tell us about the present? Recalling again the claim of the "President's Message" that "wise resource stewardship has been a constant" (Vaccarino 2018), we can see active not knowing, and even perhaps refusing to know, at work as a directive.

Localized Mechanisms: Selective Remembering for Knowing in the Present and Future

Just as the University of Guelph sends high-level messages that activate ignorance, the university's colleges and departments represent sites for performative activations that link past and present productions of knowledge. Active not knowing occurs through department-level recordkeeping, the awards system, and college memorializations and celebrations of legacies.

At the department level, remembering past complicity in eugenics is not a neutral activity. Early in the archival research process for *Into the Light*, a university employee contacted this chapter's co-author Evadne Kelly about eugenic evidence that was meant to disappear. The employee had happened upon two boxes of eugenics materials – photos, correspondences, and slides – in the garbage of the Crop Science Department at the Ontario Agricultural College, brought there from the old horticulture building (now the Geography Department). Studying their contents, Kelly began to find clues about the teaching of eugenics. The official archives later confirmed that one primary eugenics professor was Dr. Oswald Murray McConkey of the Crop

Science Department (then called Field Husbandry). Although active not knowing is very much a part of this story, the active desire to know was also at work in the process of allowing evidence to reappear.

Into the Light sought to prioritize the oral histories of survivors of eugenics over text-based evidence. This approach was, in part, motivated by our awareness of how not knowing operates by diminishing and silencing such experience. Keeping in mind that our primary audience would likely include many who have unwittingly benefited from white supremacy, as bolstered by scientific racism, we knew that we had to expose the history of eugenics in multiple ways. In short, historical artifacts from official archives accompanied oral histories to evidence the effects of eugenics.

Through this research, we found that our university's awards systems comprise another mechanism of not knowing. Here, we linger on the university's tradition of excellence relative to the Ontario Agricultural College's Dr. O.M. McConkey Scholarship, which the institution awards to students deemed to have research potential.[2] By continuing to offer a scholarship in his name, the university upholds his tradition of excellence into the future. McConkey was a professor at the college from 1922 to 1957 and a celebrated grassland researcher ("Oswald McConkey Bequest" 1982). After retirement, he offered to create a scholarship in his name and willed funding for the award (now $10,000) to continue after he and his wife died, to be drawn from the estate's principal (University of Guelph Senate 1965, 29). Although the amount and terms of the award have shifted since 1965, this significant award continues to celebrate a professor of eugenics. Notably, nothing in the award's description mentions eugenics, so it stands as an active memorialization of a white-washed version of the university's institutional history.

Lingering on how the award works within a framework of excellence, we find a fraught and contradictory pathway. What is excellence? Among the many synonyms for "excellence," standard dictionaries list "perfection," "superiority," and "supremacy." Excellence as superiority and supremacy within a Eurocentric university becomes proof of what counts as intellectual talent, skill, ability, and strength. Supremacy and superiority conjure hierarchical images, with fewer and fewer people on each successive tier as you move up the hierarchy. Archived work from one award-winning student of eugenics confirms how excellence was a mechanism of white supremacy for McConkey. This use of excellence becomes clear when we place the student's work next to the images of bodies deemed abnormal (and thus pathological – to be removed or cured) that were represented in McConkey's eugenics slides. Excellence in his formulation did not encompass multiple

bodies and perspectives. More about the concept of excellence is revealed through its antonyms. Standard antonyms for "excellence" include "deficiency," "demerit," and "disvalue." Looking closely at these antonyms exposes the fraught ways that the term operates to apply vitality to some and deny vitality and life to others. As Ahmed (2019) has pointed out, when notions of value, strength, and vitality are applied to use, disuse becomes equated with weakness, decay, death, and nonvitality. She notes that "when something stops being used, the implication is that it ceases to be. This is how use becomes an expression of a commitment to life" (96–97). Improving life through excellence, understood as superiority and supremacy, becomes a powerful drive that confers vitality and life on those who can travel its narrow and reductive path. Disvalued others, deemed not excellent, are of no use to the university and its project to "Improve Life."

The space of excellence was thus organized as a pathway for white supremacy. This history of racism and an active refusal to know about it continues. Instead of being accountable to their own history of white supremacy, and celebration of it, the actions of many have continued along a well-worn pathway directed at the erasure of the history of institutionalized racism. It must be asked: "If a structure of deceptively egalitarian appearances has been erected on top of a racist reality, then how can a person be sure that her vision of the world is untainted by the reigning ideology?" (Sullivan and Tuana 2007, 4). In such a situation, you need proof that something happened and is happening differently because the experience of being a misfit – the affect of misfitting – is not enough to take down white supremacy.

Queering Use: Performing Active Knowing

Given this fraught history of human betterment, how can we propose a rethinking of the call to "Improve Life" without also slipping into the dangerous terrain of directing and controlling human behaviour and biology in ways that reproduce histories and legacies of oppressive ideas and practices by attempting to erase them? We turn now to considering the ways that we might actively expose histories and legacies of oppressive knowledge generation and dissemination, lingering and loitering longer than allowed by colonial mechanisms for not knowing. In doing so, we reflect on our own experiments and experiences of such lingering and loitering.

Queering Not Knowing to Activate New Affects of Knowing

Alumni relations with settler institutions comprise another site that participates in active not knowing. Yet, as a relationship, it offers a threshold space

of tension as people decide what path to take – what knowledge (not) to endorse, what actions (not) to take. The felt space of activated knowing that came with the exhibition's exposure of the University of Guelph's role in generating and disseminating eugenics knowledge was dense with possibility. A few days after the exhibition's opening, the College of Social and Applied Human Sciences Alumni Association invited Kelly to give a thirty-minute tour of the exhibition to twenty-seven alumni. Most had graduated after the 1960s, well after eugenics was officially in the course calendar. For Kelly, the unexpected offer to guide alumni through the history of eugenics at the university immediately raised questions about the affects and intentions underlying the request. Did the alumni want to know about an oppressive history at an institution that they continued to be proud of and to support? Did they want to deny this history? Were they placating their consciences by attending the exhibition? Were they foreclosing the possibility of appearing to deny? Were they absorbing this history to smooth over it, as though the whole idea for the exhibition came from the college to begin with? As Ahmed points out (2019, 196), if projects are "resourced by an institution, it might become harder to confront certain problems as institutional problems, to speak out about the role of the institution in enabling" oppressive ideas and practices. More importantly, how could the history of eugenics and its effects be conveyed sensitively and convincingly within thirty minutes – a limitation that revealed the Alumni Association's preference not to linger in that dense space of transformative possibility. The alumni tourists also likely felt confusion: this was not a safe, comfortable tour of an exhibition for pleasure. These pre-tour reflections and questions represent some of the layers of complexity involved when institutions with white-settler histories undertake to remember the past for the present and future.

Aware of the ways that the alumni (as graduates who remain connected to their alma mater) may have identified their educational experiences with feelings of pride and achievement wrapped in the university's own language of excellence and success, Kelly considered the modes of performance that she might need to activate in order to open her audience to transformative possibilities. Feeling uneasy about the intentions of the group, particularly due to the documented ways that those implicated in oppressive histories tend to deny them (Ahmed 2019; Sullivan and Tuana 2007), Kelly prepared a large, thick binder full of documentation with which to perform evidence excellence. She brought the binder with her for this tour and for the several

Pathways to Disrupt Eugenics in Higher Education

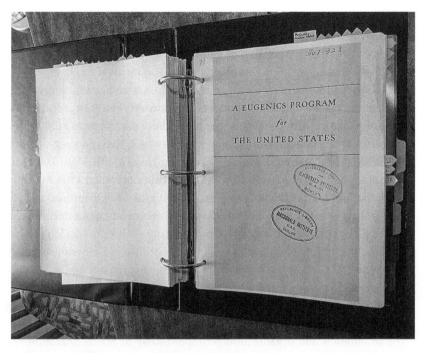

Performing excellence to expose eugenics, Toronto, Ontario, September 2019.

subsequent tours that she guided. She did not design her performance of evidence excellence for actual learning; instead, she developed it to unsettle knowing for those attendees who would rather deny activist-survivor experiences. Although Kelly is critical of the ways that "excellence" narrows the kinds of work that people do in universities, rewards efforts to command and conquer knowing, and urges hyper-productivity, efficiency, and growth (in terms of socio-economic "progress"), she also designed the binder to perform excellence in these ways. She organized the evidence into categories and subcategories – each with its own labelled tabs organized by date and colour-coded by section – and highlighted relevant passages of text. Here, Kelly aimed to subvert eugenic excellence through a grotesque and exaggerated performance of eugenic excellence that exposed the mechanisms and tactics of eugenic excellence in education while operationalizing these same strategies as a form of convincing knowledge production and dissemination with which to bridge past and present. Kelly's performing-excellence binder thus queers use – making familiar forms of knowledge production unfamiliar to generate new affects of knowing.

To Linger and Loiter Longer than Allowed by Settler-Colonial Mechanisms for Not Knowing

In early 2020, the Department of Family Relations and Applied Nutrition, now called Family Relations and Human Development, at the University of Guelph invited Kelly to give a guest lecture on her archival findings to the department's faculty, staff, and students for its weekly research seminar. This is the department with the closest ties to the domestic-sciences mission and curricula of the Macdonald Institute, with which Kelly, a post-doctoral scholar, was affiliated and where she worked closely with Rice. The event took place in a lecture-style room in the institute's original 1903 building. The situation was thick with complexity and dense with meaning, as Kelly was to share some of the materials that McConkey had taught decades earlier in a similar room within the same building. Whereas McConkey had used the materials to build a white supremacist future, Kelly showed them to expose and critique the mechanisms of white supremacy and to advance nonassimilative, more just futures.

The organizer suggested that Kelly structure her research presentation as a twenty-minute talk with fifteen minutes of questions and discussion. The orientation and organization prompted Kelly to realize that although the content might have changed, the style of teaching had not since presenting knowledge in a university setting still followed a method of efficient knowledge dissemination, with the expert telling the learners what they needed to know. Considering pedagogical methods as part of what sustains epistemic ignorance, Kelly designed her presentation to create space for questions, multiple perspectives, and learning something different and more from the artifacts – knowledge that might have an effect in the direction of social justice. To subvert the practice of efficient, hierarchical knowledge dissemination, Kelly decided to start with the image of McConkey lecturing in a Macdonald Institute room. She gave attendees copies of archival documents so that they could take hold of the archives and read the content for themselves, and she invited them to pause, reflect, and write about what they experienced. After showing and providing context for images of the archival documents, she again gave people time to speak and ask questions. As she did with the tours, Kelly organized the time to foster various forms of reflection and to allow attendees to choose their pathway through the ideas; participant-learners told her what captured their attention, and together they explored and discussed.

The questions and comments from participant-learners reveal instances of active not knowing and the damaging effects of the refusal to know. After

Pathways to Disrupt Eugenics in Higher Education 227

Disappearing and reappearing evidence of eugenics. *Left,* Dr. McConkey's eugenics course materials, Guelph, Ontario, 2019. *Right,* Dr. McConkey lecturing on eugenics at the Macdonald Institute, c. 1930s. Ontario Agricultural College, Department of Field Husbandry, Oswald Murray McConkey Papers, RE1OACA0066, Regional History Collection, McLaughlin Library Archival and Special Collections. Courtesy of the University of Guelph.

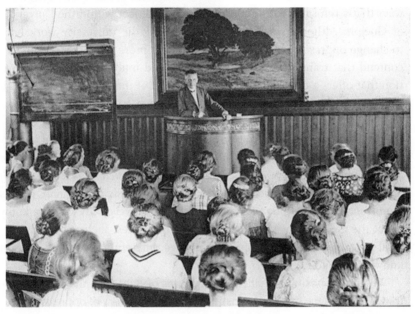

the presentation, one Black student commented that they always felt uneasy in the institute but could not figure out why. There was no obvious evidence that this person was unwelcome in the space. Yet they always felt like they were not supposed to be there and that their presence was unwanted. This comment gave Rice and Kelly pause to linger. What did the hierarchical ordering of chairs and podiums in the institute's lecture halls convey? What about the unidirectional modes of pedagogy still practised by some faculty in the Department of Family Relations and Applied Nutrition? What was communicated by the convent-reminiscent architecture, squeaky-clean floors, oak-panelled hallways, stained-glass windows, and images of

well-dressed and robed white-settler women faculty and students? How about the old posters in a wall-mounted display case with images of blackface minstrelsy performances during past student initiation nights? The walls themselves clearly talked, encoding and carrying something of this institutional history even if the student could not precisely name it.

Conclusion

This chapter exposes institutional conditions, locations, and processes that have fostered oppressive knowledge, practices, and outcomes. In lingering and loitering over contemporary iterations of these conditions, we show the ways that a refusal to know continues to be in effect within the University of Guelph. Although many key individuals at the university work hard to change oppressive impulses and to support more socially just aims, we contend that transparent, nonassimilative, and multi-vocal memorialization that offers a queering of use must be part of that process of redress if we are to fully account for the university's role in establishing and reinforcing such inequities in the first place.

Without such memorialization, this post-secondary educational institution, at many levels of its hierarchical structure, continues to propagate *"an ignorance that is active, dynamic, that refuses to go quietly ... presenting itself unblushingly as knowledge"* (Mills 2007, 13, emphasis in original). Just as importantly, we continue to think and work creatively with what we know about the mechanisms that foster ongoing inequities, such as an active refusal to know – an unwillingness to engage differently in our practices of knowledge building.

We end by posing a challenge in a series of questions that we see as a fraught opening: How can the institution hold its history of oppressive ideas and practices from multiple perspectives in meaningful ways? How can it memorialize this history in its mechanisms, structures, pedagogies, and everyday practices? What thresholds can we enter as members of the university community, and will the institution attend to them?

NOTES

1 Biol.11 – Eugenics, Easter Examinations, 1935–1936, RE1MACA0004, box 3, folder 1935–1936, Courtesy of University of Guelph McLaughlin Library Archival and Special Collections. Question 7 asks: "What steps would you recommend to improve the Canadian race?"
2 University of Guelph, 2020–2021 Graduate Calendar, https://www.uoguelph.ca/registrar/calendars/graduate/2020-2021/pdffiles/calendar.pdf.

REFERENCES

Ahmed, Sara. 2019. *What's the Use? On the Uses of Use*. Durham, NC: Duke University Press.

Bain, Zara. 2018. "Is There Such a Thing as 'White Ignorance' in British Education?" *Ethics and Education* 13 (1): 4–21. https://doi.org/10.1080/17449642.2018.1428716.

Brett, Sebastian, Louis Bickford, Liz Ševčenko, and Marcela Rios. 2007. *Memorialization and Democracy: State Policy and Civic Action*. Santiago/New York: Latin American School of Social Sciences/International Center for Transitional Justice/International Coalition of Historic Site Museums of Conscience. https://www.ictj.org/sites/default/files/ICTJ-Global-Memorialization-Democracy-2007-English_0.pdf.

Burch, Susan. 2021. *Committed: Remembering Native Kinship in and beyond Institutions*. Chapel Hill: University of North Carolina Press.

Canada. 2015. *Truth and Reconciliation Commission of Canada: Calls to Action*. https://nctr.ca/records/reports/.

Dewey, Melvil. 1914. "Euthenics and Its Founder." Proceedings of the first National Conference on Race Betterment, National Conference on Race Betterment, 96–104. Battle Creek, MI: Race Betterment Foundation, Gage Printing. http://archive.org/details/proceedingsoffir14nati.

Fisher, Jack. 2017. "'Improve Life' Slogan Based on Monty Python Song." *Modern Spirit*, November 28. http://modernspirit.ca/u-of-g-improve-life-slogan-based-on-monty-python-song/.

Kelly, Evadne, Seika Boye, and Carla Rice. 2021. "Projecting Eugenics and Performing Knowledges." In *Narrative Art and the Politics of Health*, ed. Neil Brooks and Sarah Blanchette, 37–62. London: Anthem.

Kelly, Evadne, and Carla Rice. 2020. "Universities Must Open Their Archives and Share Their Oppressive Pasts." *The Conversation*, January 17. https://theconversation.com/universities-must-open-their-archives-and-share-their-oppressive-pasts-125539.

Kelly, Evadne, Dolleen Tisawii'ashii Manning, Seika Boye, Carla Rice, Dawn Owen, Sky Stonefish, and Mona Stonefish. 2021. "Elements of a Counter-exhibition: Excavating and Countering a Canadian History and Legacy of Eugenics." *Journal of the History of the Behavioral Sciences* 57 (1): 12–33. https://doi.org/10.1002/jhbs.22081.

López-Durán, Fabiola. 2018. *Eugenics in the Garden: Transatlantic Architecture and the Crafting of Modernity*. Austin: University of Texas Press.

Mills, Charles W. 2007. "White Ignorance." In *Race and Epistemologies of Ignorance*, ed. Shannon Sullivan and Nancy Tuana, 11–38. Albany: State University of New York Press.

"Oswald McConkey Bequest." 1982. *Guelph Alumnus*, 9. https://issuu.com/uofguelph/docs/1982winter.

Rice, Carla, Susan D. Dion, Hannah Fowlie, and Andrea Breen. 2020. "Identifying and Working through Settler Ignorance." *Critical Studies in Education* 63 (1): 15–30. https://doi.org/10.1080/17508487.2020.1830818.

Schaefli, Laura M., Anne M.C. Godlewska, and John Rose. 2018. "Coming to Know Indigeneity: Epistemologies of Ignorance in the 2003–2015 Ontario Canadian and World Studies Curriculum." *Curriculum Inquiry* 48 (4): 475–98. https://doi.org/10.1080/03626784.2018.1518113.

Spivak, Gayatri Chakravorty. 1988. "Can the Subaltern Speak?" In *Marxism and the Interpretation of Culture*, ed. Cary Nelson and Grossberg Lawrence, 271–313. Urbana: University of Illinois Press.

Stonefish, Mona, Carla Rice, Sue Hutton, Evadne Kelly, and Seika Boye. 2019. "Building Solidarity in Celebrating Difference." *ARCH Alert* 20 (3). https://archdisabilitylaw.ca/arch_alert/volume20-issue3/#building-solidarity-in-celebrating-difference.

Sullivan, Shannon, and Nancy Tuana. "Introduction." In *Race and Epistemologies of Ignorance*, ed. Shannon Sullivan and Nancy Tuana, 1–10. Albany: State University of New York Press.

Tate, Shirley Anne, and Damien Page. 2018. "Whiteliness and Institutional Racism: Hiding behind (Un)Conscious Bias." *Ethics and Education* 13 (1): 141–55. https://doi.org/10.1080/17449642.2018.1428718.

University of Guelph Senate. 1965. "Appendix II: Oswald Murray McConkey Scholarship Foundation." Page 29 of 30 at https://uoguelph.civicweb.net/document/13976.

Vaccarino, Franco. 2015. "Who Are We, and Who Do We Want to Be?" *Portico* (University of Guelph), July 8. https://porticomagazine.ca/2015/07/presidents-message-fall-2015/.

–. 2018. "Toward a More Sustainable Future." *Portico* (University of Guelph), October 19. https://porticomagazine.ca/2018/10/toward-a-more-sustainable-future/.

Weigley, Emma Seifrit. 1974. "It Might Have Been Euthenics: The Lake Placid Conferences and the Home Economics Movement." *American Quarterly* 6 (1): 79–96. https://doi.org/10.2307/2711568.

Winston, Andrew S. 2018. "Neoliberalism and IQ: Naturalizing Economic and Racial Inequality." *Theory and Psychology* 28 (5): 600–18. https://doi.org/10.1177/0959354318798160.

–. 2020. "Why Mainstream Research Will Not End Scientific Racism in Psychology." *Theory and Psychology* 30 (3): 425–30. https://doi.org/10.1177/0959354320925176.

13

"You Just Want to Do What's Right"
Staff Collusion in Institutional Abuse of People with Learning Disabilities

NIGEL INGHAM, JAN WALMSLEY,
and LIZ TILLEY

In September 2021, the Norfolk Adults Safeguarding Board in England reported on the avoidable deaths of Joanna, Jon, and Ben, three adults with learning disabilities who lived in Cawston Park Hospital, Norwich, in eastern England (Flynn 2021). The abuse highlighted at this privately run assessment and treatment unit, since closed by the Care Quality Commission, echoes too many similar scandals (Flynn 2018; Halliday 2021; Ryan 2019) in the wake of exposures revealed at Winterbourne View ten years earlier (Flynn 2012). Inquiry reports intimate that a critical factor is staff who witness (and stay silent) or go along with abuse. The report into the 2020 scandal at Cygnet Yew Trees Hospital in Essex noted, "Staff failed to raise concerns about disrespectful, discriminatory and abusive behaviour and attitudes towards patients" (Care Quality Commission 2020, 8).

By doing nothing, staff collude in cruel and inhumane behaviour. The Cawston Park inquest reports CCTV showing that as Jon was choking to death, "the staff are standing there. Nobody appears to be doing anything" (Flynn 2021, 34).

How is it possible that people are still being harmed, even dying, in plain sight, often with no one blowing the whistle? This chapter recognizes former large long-stay institutions as sites of conscience. Staff memories of these places, particularly when juxtaposed with other historical evidence, can be mined for insights into how and why staff continue to collude in institutional abuse, and these findings can contribute to a fuller understanding of

the roots of oppression and suffering, thus helping to end such experiences in the present and in the future. Moreover, the testimonies of institutional staff can provide a critical sites of conscience practice for use in the training of current and future practitioners who work with people with learning disabilities. Primarily, the chapter draws on oral histories of former staff of long-stay institutions in the United Kingdom. It highlights othering discourses, the naming of abuse, pervasive and divisive institutional practices, the challenges and consequences of reporting, and professionals conforming to systemic expectations. We acknowledge the view, although unusual, of two former institutional nurses that "there were always pockets of positive and innovative practice from staff that provided safe and meaningful lives for those who lived in the hospitals" (Bardsley and Henstock 2013, 298). However, we show that rank-and-file nursing staff colluded in dehumanizing practices engendered by hegemonic institutional cultures. Individual acts of compassion offered resistance that was sporadic rather than sustained. The chapter concludes by examining how insider accounts from former staff can play an educational role in the nurturing of reflexive and ethical practitioners – a development intended to disrupt ongoing social injustices and, ultimately, to move closer to social justice.

Insider Accounts

Survivors' testimonies often dominate long-stay institutional histories driven by self-advocacy and human rights agendas (Malacrida 2015; Rinaldi and Rossiter 2021). In our work in the Social History of Learning Disability Group at The Open University in Milton Keynes, these voices have been central, reflecting the slogan of the self-advocacy movement: "Nothing About Us Without Us" (Atkinson and Walmsley 2010). Since its inception in 1994, institutional survivors have contributed oral and life histories, and as co-researchers, they have been at the heart of its international conferences, policy forums, theatrical performances, schools engagement, nurse training, books, online outputs, local authority exhibitions, and archives (Atkinson and Walmsley 2010; Open University n.d.; Tilley et al. 2021). These undertakings can be construed as site of conscience practices that prioritize past and present and are allied with a concern to foster social justice.

Over time, we realized that constructing a more nuanced history of long-stay institutions required us to go beyond a "one-sided history" (Walmsley and Atkinson 2000, 187) by embracing a polyphony of oral and documentary sources (Atkinson and Walmsley 2010). This approach must

not, and need not, compromise the place occupied by people with learning disabilities in their own history. However, to gain insights into how and why staff collude in abusive practices, their viewpoints need to be heard. Hearing staff memories may complicate orthodox assumptions about institutional lives, but in exploring "the grey" (Keilty and Woodley 2013, 24), we may better comprehend why abuse persists. It may be uncomfortable to hear unorthodox narratives (Chapman 2014; Rolph and Walmsley 2006) or "untellable tales" (Andrews 2007, 33–34) and to engage with perspectives judged to be outside the norms of empowerment and disability rights. Nevertheless, as in other controversial oral history research (Blee 1993), we must listen carefully to a range of insider perspectives if we are to understand and so disrupt cycles of oppression.

The chapter looks primarily at the period from the 1960s to the 1980s, drawing on former staff testimonies gleaned from oral histories, public inquiries, and secondary sources. Its main focus is on large long-stay learning disability institutions in England. The bedrock is oral history interviews recorded for a variety of projects (Finding Out Group 2015; Ingham 2011) in which participants shared wide-ranging memories.

Although the chapter draws on published oral history material, lying at its heart are archived interviews. Contributors gave consent to a sensitive, open-ended use of their data. All agreed to have their material placed in a public repository for multiple uses. The interviews were semi-structured in order to enable interviewees to recall their respective varied experiences of institutional life. However, at the time of the interviews, collusion was not discussed. This specific focus emerged as a strong theme when revisiting the testimonies. Does this undermine consent agreements as they were framed at the time of recording? How would interviewees feel about a book chapter that focuses on complicity with abusive institutional practices? What would their response be to our conclusions? Although these issues demanded serious consideration, we ultimately took the view that robust qualitative research depends on freely asking new questions that arise later, including those raised by other researchers (Bornat 2003, 2013; Mauthner, Parry, and Backett-Milburn 1998). As ethical historians, we have attempted to take into account both the social context of the interviews and the institutional environments in which these former staff operated. We acknowledge the ways that, invariably unprompted, the participants themselves signposted their own early career collusion.

Oral histories can contribute details unavailable elsewhere and can both add to and challenge established narratives (Frisch 1979). Oral history is

human and subjective; its peculiarity and strength (Portelli 1981). That makes it ideal for empathizing with predicaments described by former staff. This potential, we assert, is invaluable when trying to understand ongoing collusive staff practices. Common to past and present is the ethical issue of recognizing and responding to abuse (Mee 2013, 2021). This insider perspective is rarely found in current inquiries (Flynn 2021). Interviews reflecting on events far into the past offer a degree of safety. We have selected interview data with individuals who later had careers championing the rights of people with learning disabilities (Ingham 2011) to investigate how even they talked about abuse. Although it is possible to interpret their accounts as redemptive (Ingham 2011), we situate them in an ethical and political "territory of preferred activity" (Chapman 2014, 32). Chris Chapman developed this concept when reflecting on his collusion in abusive institutional practices toward Aboriginal children with disabilities in Canada during his early social work career. This framing enabled him to "inhabit an ethical and political territory that is clear about restraints and locked confinement being wrong, which allows me to explore *how* I was so clear about it being right" (32, emphasis in original). This perspective adds weight to the value of oral history as a way of investigating staff collusion and helps to explain the apparent candour displayed in the accounts discussed below.

The Past: Staff Accounts of Collusion in Institutional Abuse

Permeating the oral testimonies is a sense of the absorption of an institutional discourse. This idea resonates with Michel Foucault's "inspecting gaze" (Foucault and Colin 1980, 155). As a student nurse in the 1970s at Royal Albert Hospital in England, Eric[1] claimed that it was "hard to question," as you were "part of the system" and "quickly fell into a regimented way of thinking" (interview, August 11, 2009).[2] Others at the same institution expressed similar sentiments. Mary Lawrenson, a student in the 1970s, asserted that she was viewed as a "troublemaker." However, despite expressing concerns about institutional practices, she claimed that she "became complicit with the system probably in the first six months ... You soon got indoctrinated into it" (interview, September 9, 2009).

The "gaze" into which young student nurses were "indoctrinated" was underpinned by a discourse that distanced and othered people with learning disabilities. Lawrenson reflected, "We were all given this medical clinical control model ... You weren't taught about people." This approach elided disability with illness and promoted a deficit model of care in which any perceived odd or challenging behaviour was the fault of the individual, not

their context. Eric recalled a curriculum obsessed with "nursey nursey stuff," "medical conditions," and "syndromes." Having been a nursing assistant in the 1970s, Janet Bardsley illustrates how this curriculum translated at ward level. She describes a ward where "some of the occupants sought to smear their faeces in the room ... The interpretation I was given of this behaviour, which I accepted, was that this was another shocking feature of individual pathology, not an outcome of the environmental conditions" (Bardsley and Henstock 2013, 295).

Rights were to many an alien concept. Lawrenson remembered, "I don't think we ever talked about rights." Steve Mee, who became a student nurse in the early 1980s, described an epiphany when a charge nurse told a nurse who had taken a bottle of beer from a resident that she had "no right" to do that. Mee recounted, "It was the first time I had ever heard of an adult with a learning disability being talked about as having rights" (interview, September 9, 2005). This incident, he claimed, had a profound impact on his outlook and practice. Othering had serious consequences. David Jordison, appointed chief executive at the Royal Albert in 1986, recalled deciding to call the police in response to a rape accusation related to a female resident. Approached by a male nurse who worked with "this girl," he was told, "We don't want the police involved, you know. It's not how it's done. We can sort it all out." Jordison replied, "Well, if it was your daughter and she alleged rape, how would you feel?" The nurse objected, "Ah, but that's not the same." Recounting the exchange, Jordison explained, "That was an illustration I think of how some staff didn't regard all the residents as totally equal to them. And that was an eye-opener" (interview, February 15, 2008). Discourses that devalued residents could legitimize abusive practices. Bardsley asserts, "I absorbed that kindness was not necessary as I was not working with real people" (Bardsley and Henstock 2013, 296).

Entwined with a medical discourse was the belief that hospital care was essential for certain people. A "theoretical and practice vacuum" may have existed in which it was almost impossible to question institutional practices without appearing as "naïve and uninformed" (Bardsley and Henstock 2013, 299). Eric reflected that he "had no concept of what it was like for people not to live in an institution." This chimes with a statement by Lawrenson, who suggested that when the Jay Report (see Mitchell 2004) came out in 1979, espousing community care, she and fellow students reflected, "Well, maybe we've not been doing it right all these years." Articulating misgivings was, and is, difficult without appropriate conceptual frameworks or language.

Interiorizing a culture where violence was the norm posed problems when it came to naming behaviour as criminal or abusive. On Mee's first shift as a nursing assistant on an all-male ward, a man escaped. On the man's return,

> the charge nurse kicked him and thumped him from one end of the ward to the other ... "What the fuck's going on here? What's this?" And he said [to me], my first lesson ever in learning disability, he says, "What you've got to realize, lad, is no brain, no pain. Unless you treat them like this, you'll never get 'em to do what you want 'em to do ... He actually won't feel it like you or I would."

Mee recounted how he became aware that violent conduct was the norm for staff and residents. He delayed reporting the senior nurse because "I kept thinking maybe he's right, maybe this is how it needs to be, because I'd never been in anything like that in my life before. Then I went with my first instincts and reported it." He presented his hesitation as resulting from uncertainty about what constituted acceptable practice. The justification given by the charge nurse had a strong persuasive quality. The normalization of violence makes it problematic to recognize and call out as a crime. In 1969, the inquiry into malpractice at Ely Hospital in Cardiff reported a culture similar to that described by Mee. Salient features included a nurse patrolling and threatening patients with a big stick, patients regularly beaten up by nurses, and a patient encouraged by staff to hose down fellow patients with cold water. The inquiry committee responded equivocally to these allegations, claiming that the behaviour was "symptomatic not of malice towards the patient but rather of old fashioned and unsophisticated nursing techniques" (NHS 1969, para. 113). The logic permeating these old-fashioned nursing techniques is illuminated in the report of the Farleigh Hospital inquiry (NHS 1971). Appendix 5, written on behalf of nurses, asserted that they felt defenceless against unfair criticism from people who had no idea what it was like to work with "the severely subnormal aggressive types, the psychotic subnormals, and the disturbed epileptics" (Appendix 5, 38). They argued that "we are extremely susceptible to legal action when restraining violent patients which very frequently becomes our unfortunate duty" (38). An older staff member said, "There are occasions when it is essential and necessary to hit a patient who is attacking a member of staff or another patient." This conduct, he claimed, was part of doing his job properly (122). This taken-for-granted approach made it problematic for young, inexperienced

nurses, like Mee, to believe that they were witnessing cruelty or criminality. The issue of being unable to name abusive practices appears to live on into the present (Fyson and Patterson 2020).

Pressures on staff to conform were shaped by the all-encompassing nature of an abusive institutional culture. Kelley Johnson (1998, 4) provides a vivid illustration of this culture in her ethnography of a locked ward for women in an Australian institution: "Violence was a constant part of life within the unit. Some women were aggressive to each other or to staff; others sought to injure themselves or attacked the building in which they were locked." This threat of violence, she suggests, generated a constant "low level of fear among staff" (4). Johnson describes being shocked at "the speed" with which she – even as a "participant observer," not a nurse – became complicit in institutionalized conduct:

> L. [staff member] was trying to get Brigid to leave the couch and go for a bath. Brigid seized her by the hair and refused to let go. L. tried to remove Brigid's hand. I saw this happening as I came through the door into the day room. I asked L. if she wanted some help and she asked me to hold Brigid's hand while she freed herself. She then asked me to help her lift Brigid off the couch. I started to do so, then realised that I was actually "manhandling" someone. I stopped. (4)

In an email written years later, Johnson (2020) reflected that "my shock at being physically involved in dragging someone I think was greater because I had a base outside the institution. If my whole working life consisting of ten-hour shifts had been in that unit it would have been difficult not to become part of the culture."

Similar observations emphasizing the combined impact of a closed and isolated unit, people with high support needs, and stretched nurses are evident in the report of the Farleigh Hospital inquiry, which stated that the policy was "to concentrate difficult patients in one ward, isolated from other parts of the hospital. It was here that the offences took place. There were times when three nurses were expected to handle over periods as long as 11½ hours at a stretch, a group of 40 disturbed, grossly handicapped and epileptic patients" (NHS 1971, para. 158). The report noted that few patients ever left the ward and that the patients were confined to one large room, without side wards where people could calm down. Violent patients lived alongside profoundly disabled people.

Most reports suggest that physical abuse was not routine in most wards. Nevertheless, in the recollections of former nurses, there is a sense of collusion in everyday routines that degraded the residents (Rinaldi and Rossiter 2021). The memories are infused with a sense of powerlessness to do anything else than conform and are often marked by shame. Short staffing is repeatedly mentioned. Jenny Dunkeld, recalling the Royal Albert in the 1960s, stated that "staffing levels were abysmal" and that "you were limited as to what you could do with people" (interview, August 12, 2009). Eric recalled, "We were that rushed off our feet and knackered we didn't have time to care about anybody." Lawrenson, also a 1970s student nurse, talked of "supporting forty ladies with three staff" and explained that the "wards that I worked on were all similarly understaffed and over occupied ... You basically spent all day toileting and feeding and dressing people and putting them back to bed."

John,[3] a nursing assistant at Brockhall Hospital in Blackburn, recalled that in responding to similar pressures, "You just get on with it" (interview, December 16, 2015). This imperative hints at certain institutions having a tough nursing tradition. In the report of the Farleigh Hospital inquiry, this tradition was highlighted, along with long shifts without a break and without supervision (NHS 1971). Everyday elements of what can at best be regarded as neglectful practice could descend into physical abuse (Malacrida 2015, 59–92).

Critical to towing the line was a willingness to meet the contractual expectations of the job or course. This requirement resulted in dilemmas for young student nurses. June Flynn was on a training placement at Calderstones in Blackburn. She recalled how a member of staff "complained to the charge nurse about me. And when I arrived at work the morning after, 'You're wanted in the office' ... Because you're a student and you just want to do what's right, well what you think's right ... And she'd complained because I kept changing the bath water between people" (interview, May 11, 2016).

Flynn was told "not to hold things up. Because I was holding everybody up." The normal practice, her supervisor explained, was to "change it if it is needed. You don't need to change it if there's nothing floating in it ... So I were like a bit in Dickie's meadow then because you want to do what everybody else is doing, because you want to do it right. But you want to do right what you know's right." From then on, she tried to avoid bath nights "because it became a big stress." Although she talked to others about it, "nobody seemed to think it were that bad."

Doing well during a ward placement as a student featured strongly in the testimony provided by Eric, who reflected that questioning the system was hard when "part of my role was to try to impress the charge nurse so that I got a very good report at the end of the stay." Boris Petrusev started at Gogarburn Hospital in Edinburgh in the late 1960s. In a candid account, he has detailed his "stomach churning" as he colluded with demeaning shaving and haircut routines (quoted in Ingham 2003, 25). Although he feels that his need for money was important, in an impassioned defence of his younger self, he pleads,

> I get very, very angry and frustrated about nowadays when people turn back and criticise how bad it was in the hospitals ... It was the system that was expecting it from us and you had to comply with the system. And now when you look back I resent that somebody would criticise me. That was what was expected. If I didn't do it I wouldn't do my job. (21)

Furthermore, as noted by Dave Spencer, a former nurse at the Royal Albert, individuals at least received a basic level of care:

> You were doing things that you knew weren't right. Because the alternative was that things wouldn't get done at all ... Like lining fifteen blokes up, and they are all sharing the one set of bath water ... If you said, "This is ridiculous. I am not doing it," nobody would have a bath. Well, at least they had got a chance of being semi-clean and a bit more comfortable. (Interview, April 3, 2009)

The evidence points to how easy it was to get caught up in an abusive culture. Occasionally, as identified by Brian Ankers, a young psychiatric nurse, the challenge was to report the misconduct of colleagues you liked and with whom you worked closely: "I've met people and I've liked their company but I didn't like some of their work methods. I felt very compromised by that" (quoted in Beardshaw 1981, 33). However, there could be a more sinister edge to keeping quiet and not rocking the boat. Virginia Beardshaw (1981, 31–38) pinpoints key questions facing any potential complainant: Will I be believed? Will action be taken? What will happen to me? Fears of not being believed, nothing being done, and incurring negative personal and professional consequences are upheld by the findings from the research carried out both by Beardshaw and by us.

As discussed, the dominant institutional gaze differentiated between the staff (or "us") and the people with learning disabilities (or "them"). This hegemonic common-sense perspective extended to staff culture. The sentiment that "people like us don't do that" (Hanley 2016, 45) translated into not reporting colleagues and not questioning the established ways of working. Doing so made oneself, rather than the abuse or the alleged abuser, into the problem. Ultimately, your loyalty was to fellow nurses and the institution, not to those you were supporting. As a former nurse at the Royal Albert observed,[4] "The hospital was run for the staff when I first went there" (interview).

The hegemonic institution was maintained by bullying those who stepped outside it and by using threats if one reported or questioned its ways. Complaints of abuse or malpractice were neither acknowledged nor acted on, and complainants were ostracized. Confronted by this combination of defensive and aggressive responses, choosing to say nothing when witnessing abuse could be sensible.

Beardshaw (1981, 34) concluded that "above all, nurses fear that their complaints will be ignored." The reasons for this dismissal were inept investigations, management complacency, and staff "walls of silence" (34). Other evidence supports these claims. In the report on Ely Hospital, Mr. Pantelides, the whistle-blower, described a culture of cover-up: "The senior staff were very closely knitted together. One was saving the other from anything that might arise against one of them, and nobody had a chance of complaining" (NHS 1969, para. 272).

The inquiry found that the chief male nurse was indifferent to any complaints. Likewise, the report on the Farleigh Hospital asked: "How was it possible for many offences of ill treatment to have taken place over so long a period ... Were these offences known to those in control of Farleigh Hospital?" (NHS 1971, 2). It concluded that complaints, including in relation to the murders of two patients, were never properly investigated. Moreover, staff and other witnesses insisted that no ill-treatment had ever taken place. Oral testimonies paint a similar picture. Dunkeld reported a nurse for hitting a resident with a wet towel: "What action was taken, I don't know." As a student, Lawrenson reported the malpractice of a charge nurse, but "nothing happened." Bob Dewhirst, another Royal Albert nurse, suggested that, regardless of the level of abuse, "it was very difficult to get somebody sacked" (interview, June 9, 2009). Mee recalled that when he reported violence on his first ward at Turner Village in Colchester, he was called to a meeting with the nursing officer:

"It's a very physical environment," he said ... He said, "You'll see me come down onto the ward sometimes and wrestle with the clients" ... I'd never seen that. I could never imagine it ... What he was trying to do was rationalize the physical nature of the care on – care?! – of the abuse on that ward that ... I think he was trying to say it was like a masculine thing. Because it was all men on there.[5]

A culture that belittled and suppressed any perceived threats perpetuated staff collusion with abuse and malpractice. As Beardshaw (1981, 35) observes, "Such failure, however, does not encourage others to complain about bad nursing procedures. Too easily, the apathetic or cynical 'what's the point?' defeats the sense of duty."

Compounding this sense of futility was the well-founded fear that as a complainant you would suffer negative consequences. Colleagues ostracized the nurse whose allegations prompted the inquiry into abuse at South Ockendon Hospital, and other nurses told the investigation that they would never make complaints after what had happened to her (Beardshaw 1981, 36–37). Three-quarters of the student nurses in a survey were afraid to engage in whistle-blowing, citing concerns that ranged from being unpopular to impeding their careers (35). Dunkeld recalled the consequences of having reported a fellow Royal Albert nurse for misconduct, laughing as she said, "I was sent to Coventry by some of the other cadet nurses for quite a few days. But there we go; that's life." Exclusion could extend to threats. After reporting the charge nurse, Mee was transferred to a new ward, where he "was warned off. I had quite a few threats from people [staff], 'Don't you do that again here ... We know what you did on the other ward. You keep quiet.'" Mee's experience resonates with evidence from Princess Marina Hospital in Northampton. A nurse wrote, "As a student nurse, if you raised anything you were seen as a bad student, by the time you got to your next placement your reputation had gone before you" (Finding Out Group 2015, 17). Mee asserted that "troublemakers" would be moved to other wards. Ankers, who raised issues of abuse at a psychiatric hospital, was moved to "a notoriously taxing psychogeriatric ward" (Beardshaw 1981, 36). Others report more visceral outcomes for not behaving as one of "us." Rob Henstock, who as a student nurse was perceived as refusing to participate in the violent culture of a locked men's ward, was tricked into entering a windowless, dark seclusion room. Here, he was shut inside for an interminable length of time and then overcome by ward staff, held down, and injected – with sterile water, as he learned only afterward. It was a veiled warning, he surmised, to conform

with the ward culture of control (Bardsley and Henstock 2013, 296–97). Two whistle-blowers at Farleigh Hospital had the doors of their homes banged in the night ("Mental Patient" 1969). One of the chapter authors met by chance the daughter of a staff member who had blown the whistle at a hospital run by the National Health Service in the early 1970s after witnessing seven patient deaths in two months. Her whistle-blowing resulted in an official inquiry, but she paid a high price. She was unable to get another job locally with the National Health Service, had to move house to escape retribution, and became subject to bouts of depression. Her brave action, well justified according to the subsequent inquiry report, had cast a long shadow. It is not surprising that people hesitate before reporting on colleagues.

Hostility toward complainants could be generated by trade unions (Beardshaw 1981) and might include exclusion from local union membership, colleagues threatening to walk off the ward if the complainant was present, anonymous threatening phone calls, notes left on car windshields, and vandalizing cars and homes. A former senior trade union official charted how this sort of threatening behaviour could escalate:

> The managers make the right kind of noises ... the veil of respectability. Then the word will get around the institution, and then the normal thing is to make the complainant see the error of his ways ... start the process of denying his reality. That's done in a number of subtle ways, over a drink in the social club, on the wards, little chats: "You didn't really mean to do this." It starts off normally friendly – then, if the nurse refuses to budge, it's a case of discredit the complainant. You will find commonly, people who have complained in mental hospitals – there will have been very strenuous attempts to find weaknesses in their own character, and use those weaknesses against them ... And then I've known extremes ... You'll get personal physical abuse, verbal abuse, ridicule. I've seen every trick in the book used against nurses who have blown the whistle. (Quoted in Beardshaw 1981, 36)

Here is a clear depiction of a Gramscian model of a hegemonic culture (Simon 1985), one where consent is created via a mixture of rhetoric ultimately backed up with coercion. Loyalty is to "us," the established institutional staff, not to "them," the patients. It was the whistle-blower who was ostracized and treated as the abusive component. The all-pervasive, powerful institutional culture, enforced by a hostile phalanx of colleagues and management, constituted fertile ground for collusive practices, something seen at Winterbourne View in 2011 (Flynn 2012).

Eric recalled that institutional residents and staff had their place in a pecking order, as did learning disability, which was accorded poor status compared to other forms of nursing overseen by the National Health Service (see also Mitchell 2000). People with learning disabilities, especially those labelled pejoratively as "low-grade," had the least currency in these environments, with potentially abusive outcomes. As Eric said, "We [student nurses] were certainly disapproving of the horrible way some people seemed to slip straight into it and loved, got the power kick of, being in control of another group of people."

Students and other inexperienced nurses often had little opportunity to question these practices. They were encouraged to know their place and to conform. Eric remarked, "I sometimes told some of the other staff that we didn't think they were doing things the right way, but we weren't in a particularly powerful position to be saying that kind of stuff." Lawrenson, after criticizing a senior nurse, soon recognized that this was not the thing to do: "I remember it causing this furor because I'd written this and it had gone into the School of Nursing and that a student nurse was questioning the practice of a charge nurse." The lack of power described here resonates with the Care Quality Commission's (2020, 11) report on Cygnet Yew Trees Hospital, which claims that "staff lacked the confidence and integrity to raise concerns about poor patient care."

Inquiry reports illustrate how the medical hierarchy could engender an abusive climate. Ignorant, all-powerful doctors were identified as barriers to change in three major inquiries of the 1970s: South Ockendon, Farleigh, and Normansfield. The medical gaze was internalized by nurses to mean that doctors knew best (Butler and Drakeford 2005). At South Ockendon, a misplaced respect for clinical autonomy was pinpointed (NHS 1974); and at Farleigh, medical leadership was adjudged lacking, as the chief nursing officer ran the hospital from his office, apparently unaware of pervasive cruelty (NHS 1971).

The Present and Future: Implications for Social Justice

This chapter has explored collusion – how good or well-meaning staff go along with abusive or criminal institutional cultures. We have delved into the memories of those working mainly in the United Kingdom in large long-stay institutions for people with learning disabilities. These accounts illuminate how hegemonic cultural factors and pressures make calling out abuse a huge challenge. As institutional abuse persists, these insights help to explain why workers collude in its infliction.

Testimonies of collusion by former institutional staff connect memories of place to present injustices within the unfinished deinstitutionalization project. They help us to explain how staff simply stand by when the abuse of confined individuals is perpetrated. The testimonies cited here are intimately connected with the specific places where the events took place. Yet we worry that chapters like this one may risk allowing people to absolve themselves by finding excuses for their past failures to stand by their fellow human beings. Despite nagging doubt of this kind, we are confident that without seeking to understand the perspectives of staff who recall their own collusion, we lose an important opportunity to understand the persistence of institutional abuse. Moreover, the chapter offers further evidence for the eradication of institutional environments, showing how they are abusive by their very nature (Rinaldi and Rossiter 2021). As long as institutional settings, not always easily identified by brick and mortar, continue to exist, so too will the potential for abuse. Although there may be multiple avenues to consider, including contributions into official investigations and policy arenas from self-advocates and academic researchers, we propose that staff memories of institutional sites of conscience can constitute a crucial facet in the development of ethical and reflexive practitioners, staff whose code of practice is highly attuned and responsive to signs of abusive behaviour by themselves or others.

Stories from former institutional staff have been used in the education of practitioners working with people with learning disabilities (Chapman 2014; Dennison 2013). Students experienced life at Royal Albert Hospital through a digital archive of the recollections of those who had lived and worked at the institution, visits to the site of conscience, and face-to-face contact with former residents involved as storytellers and educators (Mee 2010). Two senior lecturers who had been nurses at the Royal Albert added their perspectives. Students were encouraged to consider the ethical implications for their own practice. As a former nurse, and now one of the trainers, Mee advocates the use of personal stories as a critical reflective tool in nursing education (Mee 2021; Singleton and Mee 2017). This approach, he argues, is a radical departure from nurse education dominated by evidence-based practice (Mee 2012). Stories can upset hegemonic professional and policy narratives given that they "offer the potential for reflexivity at a deep and nuanced level, in part because they invite an emotional response" (Singleton and Mee 2017, 132). Mee (2013, 16) argues that reflections on present-day practice can be facilitated by empathizing and by teasing out the deeper meanings in historical testimonies through the mechanism of

"theoretical sampling." This approach, positioning past and present examples on a theoretical continuum, unpicks the ways that people with learning disabilities may unconsciously be othered or devalued in an everyday drip-drip manner. For example, June Flynn recalled that staff ascribed nicknames like Snowy to all men with white hair, a historical reference that can be employed to critically appraise the contemporary abuse of humour, as the person with a learning disability often failed to understand the joke (Follows 1996). In such instances, it can be claimed that staff colluded in othering by treating the individual as "an object of ridicule" (Mee 2012, 34–35; see also Wolfensberger 1972). Mee (2022) asserts that "getting students to identify current examples is key to getting them to internalise the learning." Such an educational process can be transformative for practitioners at any career stage, with "action based on deeper understanding ... more likely to lead to a better experience for the person with a learning disability" (Mee 2012, 19). This promise, we assert, underpins the social justice potential of insider stories, including those told by staff of former large long-stay institutions.

NOTES

1 Anonymity at interviewee's request.
2 All interviews cited in this chapter were with Nigel Ingham.
3 Anonymity at interviewee's request.
4 Anonymity at interviewee's request.
5 Just under half a century later, an investigation into Mendip House cited the role of a "laddish culture" in creating an abusive environment (Flynn 2018, 30).

REFERENCES

Andrews, Molly. 2007. *Shaping History: Narratives of Political Change*. Cambridge, UK: Cambridge University Press.

Atkinson, Dorothy, and Jan Walmsley. 2010. "History from the Inside: Towards an Inclusive History of Intellectual Disability." *Scandinavian Journal of Disability Research* 12 (4): 273–86.

Bardsley, Janet, and Rob Henstock. 2013. "The Challenge of Becoming an Ethical Practitioner: Facing the Past." *Ethics and Social Welfare* 7 (3): 293–301.

Beardshaw, Virginia. 1981. *Conscientious Objectors at Work: Mental Hospital Nurses – A Case Study*. London: Social Audit.

Blee, Kathleen, M. 1993. "Evidence, Empathy, and Ethics: Lessons from Oral Histories of the Klan." *Journal of American History* 80 (2): 596–606.

Bornat, Joanna. 2003. "A Second Take: Revisiting Interviews with a Different Purpose." *Oral History* 31 (1): 47–53.

–. 2013. "Secondary Analysis in Reflection: Some Experiences of Re-use from an Oral History Perspective." *Families, Relationships and Societies* 2 (2): 309–17.

Butler, Ian, and Mark Drakeford. 2005. *Scandal, Social Policy and Social Welfare.* Bristol, UK: Palgrave MacMillan.

Care Quality Commission. 2020. *Cygnet Yew Trees Quality Report.* https://api.cqc.org.uk/public/v1/reports/2f3ad8b4-1fa6-4ebf-afa4-3715f11dadab?20210112201155.

Chapman, Chris. 2014. "Becoming Perpetrator: How I Came to Accept Restraining and Confining Disabled Aboriginal Children." In *Psychiatry Disrupted: Theorizing Resistance and Crafting the (R)evolution,* ed. Bonnie Burstow, Brenda A. LeFrançois, and Shaindl Diamond, 16–33. Montreal and Kingston: McGill-Queen's University Press.

Dennison, Tony. 2013. "Unlocking the Past: What Students Can Learn from a Digital Archive." *Learning Disability Practice* 16 (7): 36–37.

Finding Out Group (supported by Jan Walmsley). 2015. *A Modern Hospital: Memories of Princess Marina Hospital, Northampton 1972–1995.* Sheffield: Centre for Welfare Reform. https://www.centreforwelfarereform.org/uploads/attachment/452/a-modern-hospital.pdf.

Flynn, Margaret. 2012. *Winterbourne View Hospital: A Serious Case Review.* Kingswood, UK: South Gloucestershire Council. https://www.learningdisabilitytoday.co.uk/media/16179/report.pdf.

–. 2018. *Safeguarding Adults Review: Mendip House.* Yeovil, UK: Somerset Safeguarding Adults Board. https://ssab.safeguardingsomerset.org.uk/wp-content/uploads/20180206_Mendip-House_SAR_FOR_PUBLICATION.pdf.

–. 2021. *Safeguarding Adults Review: Joanna, Jon and Ben.* Norwich, UK: Norfolk Safeguarding Adults Board. https://www.norfolksafeguardingadultsboard.info/publications-info-resources/safeguarding-adults-reviews/joanna-jon-and-ben-published-september-2021/.

Follows, Richard A. 1996. "Language Use and Its Effects on Empowerment for Adults with Learning Disabilities." PhD diss., Lancaster University.

Foucault, Michel, and Gordon Colin, eds. 1980. *Power/Knowledge: Selected Interviews and Other Writings, 1972–1977.* New York: Pantheon.

Frisch, Michael. 1979. "Oral History and 'Hard Times': A Review Essay." *Oral History Review* 7 (1): 70–79.

Fyson, Rachel, and Anne Patterson. 2020. "Staff Understandings of Abuse and Poor Practice in Residential Settings for Adults with Intellectual Disabilities." *Journal of Applied Research in Intellectual Disabilities* 33 (3): 354–63.

Halliday, Josh. 2021. "Nine Charged with Abuse of Vulnerable Patients in County Durham." *Guardian* (London), October 1. https://www.theguardian.com/uk-news/2021/oct/01/nine-charged-with-abuse-of-vulnerable-patients-in-county-durham.

Hanley, Lynsey. 2016. *Respectable: Crossing the Class Divide.* London: Penguin.

Ingham, Nigel. 2003. "Sweep it back and forward." In *Gogarburn Lives,* ed. Nigel Ingham, 24-31. Edinburgh: Living Memory Association.

–. 2011. "Organisational Change and Resistance: An Oral History of the Rundown of a Long-Stay Institution for People with Learning Difficulties." PhD diss., Open University.

Johnson, Kelley. 1998. *Deinstitutionalising Women: An Ethnographic Study of Institutional Closure.* Cambridge, UK: Cambridge University Press.
—. 2020. Email communication with Jan Walmsley, October 14.
Keilty, Tim, and Kellie Woodley. 2013. *No Going Back: Forgotten Voices from Prudhoe Hospital.* Sheffield, UK: Centre for Welfare Reform.
Malacrida, Claudia. 2015. *A Special Hell: Institutional Life in Alberta's Eugenic Years.* Toronto: University of Toronto Press.
Mauthner, Natasha S., Odette Parry, and Kathryn Backett-Milburn. 1998. "The Data Are Out There, or Are They? Implications for Archiving and Revisiting Qualitative Data." *Sociology* 32 (4): 733–45.
Mee, Steve. 2010. "You're Not to Dance with the Girls: Oral History, Changing Perception and Practice." *Journal of Intellectual Disabilities* 14 (1): 33–42.
—. 2012. *Valuing People with a Learning Disability.* Keswick, UK: M&K.
—. 2013. "Is Workplace Culture an Excuse for Poor Care?" *Nursing Times*, April 5. https://www.nursingtimes.net/roles/nurse-managers/is-workplace-culture-an-excuse-for-poor-care-05-04-2013/.
—. 2021. "'In My Professional Life, a Different Turn of Events Could Have Had a Tragic Outcome.'" *Nursing Times*, May 4. https://www.nursingtimes.net/opinion/in-my-professional-life-a-different-turn-of-events-could-have-had-a-tragic-outcome-04-05-2021/.
—. 2022. Personal communication with Nigel Ingham, October 21.
"Mental Patient Was 'Punchball' Inquest Told." 1969. *Birmingham Post*, August 12.
Mitchell, Duncan. 2000. "Parallel Stigma? Nurses and People with Learning Disabilities." *British Journal of Learning Disabilities* 28 (2): 78–81.
—. 2004. "The Jay Report: 25 Years On." *Learning Disability Practice* 7 (6): 20–23. https://doi.org/10.7748/ldp.7.6.20.s15.
National Health Service (NHS). 1969. *Report of the Committee of Inquiry into Allegations of Ill-Treatment of Patients and Other Irregularities at Ely Hospital, Cardiff.* Cmnd 3975. London: Her Majesty's Stationery Office.
—. 1971. *Report of the Farleigh Hospital Committee of Inquiry.* Cmnd 4557. London: Her Majesty's Stationery Office.
—. 1974. *Report of the Committee of Inquiry into South Ockendon Hospital.* HC124. London: Her Majesty's Stationery Office.
Open University. n.d. "Learning Disability History." https://www.open.ac.uk/health-and-social-care/research/shld/.
Portelli, Alessandro. 1981. "The Peculiarities of Oral History." *History Workshop Journal* 12 (1): 96–107.
Rinaldi, Jen, and Kate Rossiter. 2021. "Huronia's Double Bind: How Institutionalisation Bears Out on the Body." *Somatechnics* 11 (1): 92–111.
Rolph, Sheena, and Jan Walmsley. 2006. "Oral History and New Orthodoxies: Narrative Accounts in the History of Learning Disability." *Oral History* 34 (1): 81–91.
Ryan, Sara. 2019. *Justice for Laughing Boy: Connor Sparrowhawk – A Death by Indifference.* London: Jessica Kingsley.
Simon, Roger. 1985. *Gramsci's Political Thought: An Introduction.* London: Lawrence and Wishart.

Singleton, Vicky, and Steve Mee. 2017. "Critical Compassion: Affect, Discretion and Policy-Care Relations." *Sociological Review* 65 (2): 130–49.

Tilley, Elizabeth, Paul Christian, Sue Ledger, and Jan Walmsley. 2021. "Madhouse: Reclaiming the History of Learning Difficulties through Acting and Activism." *Journal of Literary and Cultural Disability Studies* 15 (3): 347–63.

Walmsley, Jan, and Dorothy Atkinson. 2000. "Oral History and the History of Learning Disability." *Oral History, Health and Welfare*, ed. Joanna Bornat, Robert Perks, Paul Thompson, and Jan Walmsley, 181–204. London and New York: Routledge.

Wolfensberger, Wolf. 1972. *Normalisation: The Principle of Normalisation in Human Services.* Toronto: National Institute on Mental Retardation.

PART 3

Social Justice and Place Making in the Absence of Sites of Conscience

Chapters in Part 3 explore the challenges and possibilities of realizing social justice when places of former disability and psychiatric institutions are used for purposes other than sites of conscience or memorialization. The authors present case studies of current practices of urban planning, heritage management, and reuse/redevelopment in relation to former disability and psychiatric institutions. They consider whether practices of urban planning, heritage management, and reuse/redevelopment can have positive, negative, or even ambivalent connections to social justice for disabled people and people experiencing mental distress. Authors also consider whether these practices are capable of disrupting logics of eugenics and neoliberalism and, in turn, provide a basis for alliances across anti-oppression struggles. Lastly, they reflect on how conventional practices and rules in urban planning, heritage management, and adaptive reuse limit emergence of sites of conscience practices.

14

A Place to Have a Cup of Coffee
Remembering and Returning to a Dismantled Psychiatric Hospital

HELENA LINDBOM and ELISABETH PUNZI

We all have our own ways of working through experiences and hardships and our own ways of remembering. In this process, it can be helpful to have a place to go to when driven by angst, a place that helps you to remember a past, perhaps come to terms with it, or leave it behind. Small things, such as a cup of coffee, often give the necessary support in the meandering and difficult process of remembering painful experiences and abuse.

In this chapter, we offer suggestions on how the remembrance of dismantled psychiatric hospitals can be shaped. We use the case of Lillhagen Hospital, a psychiatric institution in Gothenburg, Sweden, which was established in the 1930s and dismantled by the end of the twentieth century. At Lillhagen, strategic forgetting today exists alongside strivings for remembrance. Our choice of Lillhagen is no coincidence. One of us, Helena Lindbom, has been a patient there, and our thoughts about Lillhagen, and about the importance of small things, brought us together.

We begin this chapter by presenting ourselves and Lillhagen Hospital. Thereafter, Helena shares her narrative about Lillhagen and how she returned to the hospital to recapture her memories. This is followed by Elisabeth presenting a short narrative. We continue with sharing our perspectives on the importance of personal narratives and remembrance. Both of us are fond of informal contexts and relaxed social interactions, and we value small things. A cup of coffee is small, but for us it is of huge importance to our explorations

at the sites and to our dialogues about how Lillhagen and other former psychiatric hospitals can be remembered. Therefore, part of the chapter is devoted to the significance of sharing coffee, and in the final part, we take a site of conscience perspective, providing suggestions on how former psychiatric hospitals can be remembered over a cup of coffee or when we engage in other small things that people feel safe with and even enjoy.

Helena Lindbom

I have worked as a journalist and have been a psychiatric patient at some of the large and now dismantled mental hospitals in Sweden. In our collaboration, Elisabeth helps me to put my story or writing into a greater context and helps me to become active in the process by suggesting literature to read, and I also make suggestions. The archives, too, are an important source in our work. Taking all of this into consideration, I make a sketch, and then Elisabeth continues with the writing, shaping the material into something comprehendible and set within an academic framework. It is amazing to see how she can transform my initial draft, turning it into a fully fledged scholarly article! Next, we exchange new ideas about the final text, making continuous changes and additions. Then it is sent off for further scrutiny.

Elisabeth is careful to stress that I do not have to account for everything, only what I am ready to share. Confidentiality is a cornerstone of our collaboration, not least because our ongoing conversation opens up a lot, and I disclose a lot about my background and experiences in the process.

Elisabeth Punzi

I am a clinical psychologist and a researcher. I write from humanistic and critical perspectives, and the medicalization of human distress makes me sad. To write together with Helena has meant so much to me, both as a researcher and as a person. When Helena writes, multiple ways to examine and understand the heritage of psychiatry and madness, and the human condition, suddenly open up. To me, Helena is perfectly capable of writing and choosing relevant theories and literature without my help. The main difference between us is that I am more trained in the genre of academic writing. Together, we create something unique. Not everything is represented in the text. Our work together is a process. Helena makes me think more deeply about the small things that matter, the beneficial ones, and also about mistakes that I have made when encountering clients. I learn a lot from Helena, and I hope that it is mutual.

Lillhagen Hospital

Lillhagen Hospital was located on the outskirts of Gothenburg, the second largest town in Sweden, with about 500,000 inhabitants. It opened in the early 1930s. In the 1970s, there was room for about 2,000 patients.[1] From the last decades of the twentieth century until the beginning of the twenty-first century, Lillhagen was dismantled (Nordlund 2014; Punzi 2021).

As we write this chapter, buildings are still being demolished. Considerable parts of the hospital are being transformed into a residential area called Lillhagsparken (Lillhagen Park). There are examples of strategic forgetting. Nevertheless, there are also strivings for remembrance. A new street at the site is named Kulvertkonstens väg (meaning "the street of basement art") after the murals that patients made in the basement of the hospital, murals that remain and are reminders of the patients. The patients were paid for decorating the walls. We appreciate that the name of the street is connected to the art itself. This connection avoids sensationalism toward art created by psychiatrized persons. We sense that the naming of the street is a step toward respectful remembrance.

Helena's Narrative

My approach to Lillhagen has been one of circumambulation, or rather semi-circumambulation, for I have passed only on one side, not daring to approach the entrance of the hospital. Then, for some time, it was a kind of three-quarter circumambulation from a distance. This idea of circumambulation dawned on me after some time. My walks in the surroundings of Lillhagen, with my two small dog companions, filled me with a sense of purpose. In retrospect, I can see that it was a small nothing that mattered – a ritual, something that I had to do in order to approach Lillhagen and overcome my sense of fear and the spookiness that I felt when approaching it.

Coffee is another small thing that matters. Elisabeth and I laid the foundation for our collaboration over a cup of coffee, more or less. We spent three to four hours at the site of Lillhagen, but the hours felt like many more, as though we were in a timeless space. One important moment was when we had coffee at Hökälla Green Work and Rehab, a centre for people who are outside the labour market. They had a small café. There, we sat and talked to each other and to the staff and the users.

With the support of Elisabeth's steadfastness and experience, I have found a new way to look at my life and what happened to me. Foremost, she has introduced me to the concept of "narrative threads" – the idea that stories

that first seem disparate and without connection to the greater picture actually make sense. Remembrance supports me in the effort to reconcile and integrate into my life history some of my most painful periods and experiences, which add up to most of my adult life.

For me, remembrance is an integrative process. It "normalizes" my experiences so that they can be understood and fit into my life history. Life narratives, or life histories, can be ways of dealing with contrast and coherence, tensions and unity, fragmentation and wholeness. Anne Harrington (2009) writes that by telling one's narrative, it is possible to live with paradoxes and ambiguities.

If the narrative threads have been overlooked, the life story is incomplete and difficult to comprehend. Comprehension requires being mindful and present in one's own life and paying attention to small things and narrative threads. Personally, I need a psychologist to help me in the work of following up on threads, doing the actual weaving, and going inside myself. But it has to be recognized that the threads and the clues to the threads can come after a walk, or a chat over coffee, with someone who is present with you and supports you to see the threads and to find out how to look for them. By illustrating with threads from her own personal and professional life, Elisabeth inspired me to start to fill in the blanks that have resulted from being shut down by medication for two and a half decades. She has shown me that this is the matter that life consists of. We all have these threads, potential meaning makers, in our minds.

The Importance of Narratives

Existing as a subject is not about opinions, competences, roles, or abilities. Existing as a subject is about being in dialogue, being addressed by someone; we exist when we respond to each other, when we are subjects to each other (Adame 2022). Therefore, we would like to underline that if former psychiatric institutions are to be remembered with conscience and respect, the narratives of persons who experienced what it was like to be a patient there should be listened to. Those persons can contribute a counter-narrative to mainstream presentations of former psychiatric institutions, which tend to prioritize medical perspectives, individual doctors, the architecture, and individual architects. Patients need to be included in research and heritage practices. Their narratives are more than something to add to the narratives of medical staff, researchers, or the heritage sector. Their narratives are fundamental for remembrance and for correcting misunderstandings and injustices.

Opportunities to tell one's narrative are important both for individuals and for groups of individuals who have been exposed to injustice, abuse, and oppression. Through narrative practices, they can explore, nuance, and change their perceptions of themselves. For groups of people who have been exposed to trauma, recognition of the trauma can mitigate the suffering. To know that others know, and that they condemn the injustice and the abuse, is supportive (Gomolin 2019).

Personal narratives, and the strivings to preserve and value the memories of places where trauma occurred, are at the very heart of sites of conscience. One example is the site of conscience at Parramatta Female Factory Precinct in Australia, where narratives of women who were institutionalized as girls and teenagers are fundamental (Steele et al. 2020). Another example is the Pennhurst Memorial and Preservation Alliance, where narratives of former inmates at the Pennhurst State School and Hospital in the United States are central (Downey and Conroy 2020). Together, all of these individual voices create a collective counter-narrative.

We truly enjoy and admire such projects and appreciate the efforts made to establish them and other sites of conscience. At the same time, we sense that it is sometimes important to remember for oneself and to tell one's narrative in more informal contexts. For some, it may be important to write about memories, perhaps without sharing the text with anyone or only sharing parts of it. Sometimes, one's narrative is easier to remember when it is shared with a small group. In such a group, it is possible to support each other, ask questions, and share understandings and memories – good ones and bad ones.

In *Uses of Heritage*, Laurajane Smith (2006) reflects on conducting fieldwork in the Boodjamulla National Park and Riversleigh Heritage Area in Queensland, Australia, far from the nearest town. The research team was there to record sites of importance to the Waanyi people. The work was performed together with Aboriginal women of various ages and from several locations whose people have been exposed to colonial abuse, oppression, and displacement and have endured continuous misrecognition (Lipscombe, Dzidic, and Garvey 2020).

In spare moments during the fieldwork, when the women were not being interviewed about archaeological sites or relating their personal narratives, they often went fishing. One evening, Smith asked them what the fishing was about. It came forth that the fishing activity was multi-layered. It supplied food but was also an opportunity for leisure time in between interviews. Fishing provided joy and appreciation of the site, as well as an

act of communication and meaning making. It was a living heritage practice and thus far removed from the researchers' need to collect data to formally document heritage. While sitting on the banks of the river, the older women shared their knowledge with the younger. It turned out that the work of Smith and her colleagues contributed foremost to securing the women's living cultural heritage by reuniting them with the sacred sites.

The fishing activities of the Aboriginal women encouraged us to reflect on how it is possible to engage in living heritage work at dismantled mental hospitals. Inspired by the women, we sense that narratives as well as meaningful and joyful activities are necessary for remembering sites where injustice, oppression, and abuse have occurred. When narratives, everyday activities, trauma, and meaning making can exist alongside each other, it becomes possible to see oneself more clearly, to discover what resonates with one's deepest sense of self, and to find a material or immaterial place where one is free from other people's defining concepts. In such a place, one can begin to tell one's own story and can connect narrative threads so that the gaps in one's life story may close.

Remembrance

Returning to a place where one has experienced harsh treatment and injustice may be an important step in a healing process (Burger 2011). In line with this approach, buildings where psychiatric oppression and abuse have occurred may be important for patients who strive for recognition and remembrance and who resist psychiatrization (Punzi 2019; Reaume 2010; see also Reaume, this volume).

We appreciate that some patients want to forget and even to demolish former institutions. Yet it is important that we find ways to approach these places of shame and incarceration instead of leaving remembrance as well as forgetting to people who cannot imagine enduring inhuman conditions and treatment year after year or to people who do not even want to imagine it.

But to dare to remember, one needs support and examples to follow. As a person with lived experience of psychiatry, Helena can relate to and be inspired by the experiences of Indigenous people, without appropriating their experiences or trying to mimic their practices and forms of remembrance. Moreover, by understanding how others approach sites that are imbued with conflict and oppression, a helpful distance from one's own experience is created. Furthermore, it is rewarding to learn about how Aboriginal people have handled hardship and found meaning. We took the example of Aboriginal women, but of course there are many more

examples. Due to the efforts of Indigenous and First Nations people around the world, counter-narratives are heard in the context of heritage work today (Smith 2006).

Inspired by the Aboriginal women, and by Smith's work, we sense that it should be mandatory to engage with persons with lived experiences when institutions such as Lillhagen are transformed. Thereby, Mad people's heritage and agency are acknowledged and honoured (Demke forthcoming). Moreover, even though many actors, for financial reasons, want to engage in strategic forgetting when institutions are transformed into residential areas, there are also those who want to engage in remembrance. The naming of the street at Lillhagen is one example. Since so many people have been incarcerated or have been close to incarcerated persons, we believe that a considerable number of citizens reasonably could value thoughtful remembrance of former institutions. For this to occur, however, the experiences and memories of those incarcerated need to be regarded as heritage.

We also argue that one's heritage is a main clue to creating continuous remembrance inside oneself in relation to others, to society as a whole, and in one's life course. Does this contention mean that we are nostalgic? Maybe. And to us, being nostalgic is not a bad thing.

Nostalgia has many definitions depending on who makes the definition and for what purpose (Arnold de Simine 2013, 54). Silke Arnold de Simine stresses that nostalgia combines feelings of sadness and painful longing with joy and warmth. She describes nostalgia as paradoxical since it is a form of obsession with the past that simultaneously involves forgetfulness of some parts. Nostalgia is also a yearning for the dreams and possibilities that never became reality. Nostalgia is generally associated with having rose-coloured glasses when remembering the past, but as Arnold-de-Simine writes, there are also forms of "dark nostalgia" (59), the feeling of being drawn to past times and places because of the tragedies and horrors associated with them. We would like to acknowledge that someone who has been exposed to terrible conditions and treatments at a contested and dissonant heritage site, such as a psychiatric hospital, will experience the site differently from visitors for whom the horrors and hardships can safely be located in the lives of others.

In *Nostalgia: A Psychological Resource,* Clay Routledge (2015) describes how nostalgia may support people's efforts to develop and understand themselves. A body of literature is taking shape that describes how nostalgic memories capture those experiences from our past that are important to us and that provide a sense of authenticity and well-being (Routledge et al. 2011;

Waterton and Smith 2010). Nostalgia keeps us in touch with ourselves and promotes self-continuity (Routledge 2015), just like personal narratives do.

Nostalgia is about things that matter. The sense that sites and buildings are important because of the memories that they embody stands in stark opposition to market-driven transformation processes that turn former institutions into attractive residential areas. According to a market-driven logic, objects, places, and memories matter only if they contribute to financial value. According to a site of conscience logic, however, objects, places, and memories of past oppression and abuse matter in themselves, both for truthful remembrance and for the opportunities to learn from the past and to hinder current and future abuse and oppression.

Coffee

Researchers have described how small things, and even "nothings" – such as pauses, silences, and moments that are crucial for healing but are difficult to capture with words – are fundamental for the recovery and well-being of people with mental health difficulties (Bøe, Larsen, and Topor 2019; Topor, Bøe, and Larsen 2018). Recovery and well-being, they argue, consist not only of "serious stuff" but also of "the nothings that matter," which are however often omitted (Bøe, Larsen, and Topor 2019, 7). These researchers deliberately play with words to acknowledge the importance of everyday experiences that may seem small or invisible and the impossibility of capturing everything in words or numbers. When patients describe what is important for recovery and well-being, spontaneous experiences that are difficult to put into words, which occur in treatment as well as in everyday life, are often emphasized (Bøe, Larsen, and Topor 2019). To share coffee is one such small thing (Topor, Bøe, and Larsen 2018). A cup of coffee is also concrete. It is something to hold in one's hand when haunted by overwhelming emotions or experiences of going to pieces. The warmth of it contributes to one's sensory experiences and to the sense of being present and connected to the moment and the place.

In Sweden, there is a phenomenon called *fika*. "Fika" is old back slang for "coffee." It is both a noun, as in "to have a fika," and a verb, as in "to fika." But as a phenomenon, fika includes more than coffee. It involves coffee accompanied by cookies, cinnamon rolls, or the like, and it is above all social. People visiting Sweden may be surprised that Swedish people often plan to go to a café to drink fika and socialize (Eliasson 2021). Fika is also important at workplaces, where thought exchanges, friendships, and renewed energy may result from the fika break. Few Swedish persons can imagine a meeting

in a voluntary association without fika. To offer a cup of coffee is to show hospitality. Fika is an important, if not the most important, way to connect. And from research, we know how important social connection is. Much of our health depends on it (Haslam et al. 2018). In other cultures, other beverages such as tea probably serve the same function. So even though we emphasize coffee, we hope that people from other cultures can relate to our thoughts.

There are "small things – even 'nothings' – that make it possible 'to stay in the world'" (Bøe, Larsen, and Topor 2019, 1). To us, this sentence stands out in the literature. It is poetic, and it makes us remember both our own experiences and the narratives of others that show how small things make it possible to stay in the world. The authors stress that these small things are not part of a treatment procedure and are not meant to cure difficulties but are interpersonal acts of meaning making and understanding. To further reflect on the importance of small things, like a cup of coffee, we now return to Helena's narrative.

Helena's Narrative Revisited

Cafés and Chinese restaurants were very important places for me for a few years while I was under heavy medication. It was like I could not be confined between four walls with all that was locked up within me. I required places where I could be alone yet in company. I usually went to a Chinese restaurant after the lunch hours were over.

It was like I was invited to fall into a silence that was already there. The cashier behind the counter, often also the waitress, was discreet, and I could sit by myself for a couple of hours or more with a jug of coffee or a pot of Jasmine tea. Sometimes, I ordered a vegetarian dish. I left only when the first guests for the evening started to drop in for chats, beer, and food. Then I gathered together my notebook and put it in my shoulder bag.

I preferred the silence and the slow coming of my thoughts. Sometimes, I wrote. Sometimes, I just stared out the window. There was so much longing in me to be whole again. And that was before I heard Leonard Cohen (1992) sing, "There is a crack, a crack in everything / That's how the light gets in." It might sound like a cliché, but I realize that sometimes I needed clichés that I could lean into for a while and mould into something that meant something personal to me.

I was a cigarette smoker back then. With a cigarette, one always has something to hide behind, something keeping the hands busy, even if they are shaking.

Long ago, before I met Elisabeth, a picture came to mind when I thought of Lillhagen, and I felt a little angst. It was the picture of a wise and empathetic psychiatric aide, sitting at a café table at Lillhagen. She was there so that I could come and speak to her. It was a phantasy picture from when I was institutionalized and longed for someone to talk to. I guess I was too sedated for that, anyway. But what has sprung to mind since I started to work with this chapter is that this woman could be me. The picture has become a narrative thread. Elisabeth and my psychologist have shown me, in a way, that to heal and be completely healed, I have to become that wise and empathetic caregiver myself and embrace those aspects of myself.

Suggestions in Relation to Sites of Conscience

We all have places that are important to us, that we want to remember, return to, and perhaps preserve. If these places are connected to experiences of pain and shame, they become ambiguous; one wants to forget and simultaneously remember (Logan and Reeves 2008). A sense of identity must draw on a sense of history, place, and memory since who we are as individuals, and as communities, is formed by our individual and collective sense of history and places and by the way that memory is understood and remembered (Smith 2006). Accordingly, remembrance of abusive institutions goes beyond oneself; one wants others to know about abusive places and to recognize that oppression occurred.

Defining who you are and establishing a sense of connection are emotionally and politically powerful acts (Smith 2006). If people are connected, and if they listen to each other, they can learn more about the world, others, themselves, and the past. In the case of former psychiatric institutions, strategic forgetting is present when sites are transformed into residential areas, but simultaneous strivings for remembrance, such as the naming of the street at Lillhagsparken, show that there is also interest in and acknowledgment of the past. We sense that degrading presentations of former psychiatric institutions, such as through "ghost walks" (Punzi 2019; Yahm 2014), may capitalize on a genuine interest in understanding and learning about the history of the institutions and the lives of those who were patients there. In 2018, Elisabeth and some of her colleagues arranged a tour in the basement of Lillhagen to show the murals that the patients had created.

Elisabeth recalls that the tour was a success and a disaster – a disaster because sensationalism surrounding psychiatric institutions and Mad people created hype. People lost all decency in order to be included in the tour. She was accused of discriminating against people, and some stated that

they intended to participate no matter what. Guards had to be hired. Notably, no patient behaved in this way. Those who were most clamorous were mental health professionals. Elisabeth was not prepared for this response and sensed that she may have contributed to the sensationalism, although her intention was to facilitate thoughtful remembrance of patients and pay tribute to their heritage. In retrospect, she hopes that she has learned more about how to balance the thin line between remembrance and sensationalism and is happy that she arranged the tour. Many thoughtful former staff members as well as former patients contacted her and related memories and experiences. And the hype contributed to the naming of the street.

From a site of conscience perspective, sites of oppression are useful resources for addressing current wrongdoings and for educating people about the past (Ševčenko 2010). Moreover, sites of conscience emphasize underrepresented narratives and provide dialogues that contribute to recognition, both in the present and in the future (Steele et al. 2020). We propose that processes of remembering need to acknowledge that former inmates may have varying strengths, may be in varying emotional states, and may have varying aims concerning how much they want to share or remember. Therefore, remembrance does not have to be grand or overly professionalized. We prefer places and activities that are small-scale and personal, and we believe that we are not the only ones. If it is apparent that a site of remembrance has been created by amateurs, we do not see this as a failure. With this in mind, we will ponder how the construction of a café at Lillhagsparken might be planned.

We think of a café open for all, not only to patients or staff members – a place where one can come and go incognito, where one is not immediately labelled if one fumbles because of tardive dyskinesia. Where one feels that one does not have to leave one's place when the coffee is finished. Where one can hear voices through the window in spring and early autumn and can sit outside during the summer. Where it is possible for the groups mentioned above to gather for meetings and reunions. It is fruitful to come together, share experiences, and enjoy each other's company, like the Aboriginal women did. Overcoming trauma is not only about remembering what was broken but equally also about remembering ways to survive (Van der Kolk 2014). Therefore, we sense that the core of sites of conscience, while acknowledging abuse, injustice, and oppression, should be accompanied by opportunities for joy and beauty.

Hökälla Green Work and Rehab, which we visited during our first field trip to Lillhagsparken, was such a place. Unfortunately, the Church of

Sweden, which managed Hökälla, could not afford to finance it anymore. The buildings were demolished in 2020. Nowadays, the social work cooperative Multikult, an ecological market garden, is situated in Lillhagsparken. The buildings were part of the greenhouses that provided Lillhagen Hospital with vegetables (Friberg 2010). The patients were sometimes involved in gardening and as caretakers of the park. One dream scenario would be for Multikult to become a co-creator of remembrance in Lillhagsparken. If this could be realized, a café would be a natural link to the heritage of the site. There could also be gatherings two to four times a year, centred on thoughtful remembrance, perhaps in the form of tours at the site, co-created with the Museum of Medical History, the organization Mad Heritage, or the Swedish Partnership for Mental Health, all located in Gothenburg. These are organizations that we in one way or another cooperate with.

It should be acknowledged that visitors may come for nostalgic reasons. They may come because they are in a process of healing or to commemorate relatives who either worked at the hospital or were inmates. A café that welcomed them all, without hiding the heritage of the site, would be a way to respect what Lillhagen has been and represented. This would be heritage work from below.

Thoughtful remembrance of former psychiatric institutions may be both a form of "education" about past wrongdoings and a process of recognition and healing for former patients. For healing to occur, patients need to approach remembrance at their own pace. Tours, exhibitions, a welcoming café, a garden, encounters, and education could be integrated with activities that support recovery. These activities should be adapted to a Mad studies perspective and should be co-created by patients, open-minded architects, staff members, researchers, artists, and the heritage and museum sector (LeFrançois, Menzies, and Reaume 2013). All could contribute their experiences and knowledge to create a welcoming and supportive atmosphere where mental distress and reactions to crisis and trauma could be understood in holistic ways. It should be acknowledged that patients have firsthand knowledge but simultaneously are the farthest away from decision-making processes. Moreover, they may have to concentrate on survival and recovery and therefore may need support to participate in heritage work and remembrance.

Malin Weijmer (2019) notes that, since 1988, Swedish law has presented heritage as a shared responsibility. It proposes that the heritage of those who have been marginalized should be increasingly acknowledged. If heritage

and access to heritage sites truly are considered a shared responsibility, increased focus should be on how the heritage and museum sector could support processes of inclusion and connection. Therefore, when transformations are initiated, it should be mandatory to include those with lived experience. In our own heritage work, we had the opportunity to involve the friends and colleagues with whom we co-operate, as well as Geoffrey Reaume, researcher and co-creator of Mad studies (see Reaume, this volume), who leads struggles for remembrance of former patients, including workshops at the University of Gothenburg and a walk at Lillhagen. His work was crucial for preserving the walls that patients built at the former Toronto Hospital for the Insane (Reaume 2016). He encouraged our work and simultaneously reminded us that remembrance of psychiatric institutions is a long-term process that needs patience and effort. We are happy that the work in which we have participated is interesting to others and that we are able to share it through our writings. We also acknowledge that even though we insist on remembrance, there are others who insist on forgetting. However, one has to keep in mind that forgetting can result in lost opportunities to learn from and flourish in the wake of the past. As stated on the website of the International Coalition of Sites of Conscience (n.d.), "The need to remember often competes with the equally strong pressure to forget. Even with the best of intentions – such as to promote reconciliation after trauma by 'turning the page' – erasing the past can prevent new generations from learning critical lessons and destroy opportunities to establish peace now and well into the future."

Finally, we sense that even though one does not necessarily sit and talk about history or ponder the heritage of Mad people or psychiatry over a cup of coffee, the very fact that coffee is shared supports an encounter that in turn becomes a motivation and an inspiration to delve deeper into the history. In Helena's words, "We, as former inmates, need other people and society. And society, I believe, needs us."

NOTE

1 Many terms are used to describe individuals who seek out, or are forced to receive, psychiatric care. We use the word "patient." It refers to the position of these individuals but has nothing do with medicalization or with the idea that there is something fundamentally wrong or dysfunctional about them.

REFERENCES

Adame, Alexandra. 2022. "Self-in-Relation: Martin Buber and D.W. Winnicott in Dialogue." *Humanistic Psychologist* 50 (3): 376–88.

Arnold-de-Simine, Silke. 2013. *Mediating Memory in the Museum: Trauma, Empathy, Nostalgia*. London: Palgrave MacMillan.

Bøe, Tore, Inger Larsen, and Alain Topor. 2019. "Nothing Matters: The Significance of the Unidentifiable, the Superficial and Nonsense." *International Journal of Qualitative Studies on Health and Well-Being* 14 (1): 1–11.

Burger, Jerry. 2011. *Returning Home: Reconnecting with Our Childhoods*. Lanham, MD: Rowman and Littlefield.

Cohen, Leonard. 1992. "Anthem." *The Future*. Columbia Records.

Demke, Elena. Forthcoming. "Re-assembling the Social in So-Called 'Mental Illness'? Reflections on the Uses of Material Culture in the Historiography of Psychiatry and in Mad Studies." In *Narrating the Heritage of Psychiatry*, ed. Elisabeth Punzi, Christoph Singer, and Cornelia Wächter. Leiden: Brill.

Downey, Dennis B., and James W. Conroy, eds. 2020. *Pennhurst and the Struggle for Disability Rights*. Houston: Keystone Books.

Eliasson, Susanna. 2021. "'Swedish fika': Svenskars matkultur ur internationella studenters perspektiv." In *Matarv: Berättelser om mat som kulturarv*, ed. Anita Synnestvedt and Monica Gustafsson, 112–22. Stockholm: Carlsson.

Friberg, Cajsa. 2010. "Lillhagens växthus: Dokumentation och åtgärdsförslag." MA thesis, University of Gothenburg.

Gomolin, Robin Pollock. 2019. "The Intergenerational Transmission of Holocaust Trauma: A Psychoanalytic Theory Revisited." *Psychoanalytic Quarterly* 88 (3): 461–500.

Harrington, Anne. 2009. *The Cure Within: A History of Mind-Body Medicine*. New York: Norton.

Haslam, Catherine, Jolanda Jetten, Tegan Cruwys, Genevieve A. Dingle, and S. Alexander Haslam. 2018. *The New Psychology of Health: Unlocking the Social Care*. London and New York: Routledge.

International Coalition of Sites of Conscience. n.d. "About Us." https://www.sitesofconscience.org/about-us/about-us-2/.

LeFrançois, Brenda A., Robert Menzies, and Geoffrey Reaume, eds. 2013. *Mad Matters: A Critical Reader in Canadian Mad Studies*. Toronto: Canadian Scholars' Press.

Lipscombe, Tamara., Peta Dzidic, and Darren Garvey. 2020. "Coloniser Control and the Art of Disremembering a 'Dark History': Duality in Australia Day and Australian History." *Journal of Community and Applied Social Psychology* 30 (3): 322–35.

Logan, William, and Keir Reeves. 2008. *Places of Pain and Shame: Dealing with Difficult Heritage*. London and New York: Routledge.

Nordlund, Cecilia. 2014. "Lillhagens sjukhus som immateriellt kulturarv: Bärare av före detta patienters minnen och berättelser." MA thesis, University of Gothenburg.

Punzi, Elisabeth. 2019. "Ghost Walks or Thoughtful Remembrance: How Should the Heritage of Psychiatry Be Approached?" *Journal of Critical Psychology, Counselling and Psychotherapy* 19 (4): 242–51.

–. 2021. "The Art Activities at Lillhagen and Their Relevance for Current Psychiatry." In *Outsider Inpatient: Reflections on Art as Therapy*, ed. Elisabeth Punzi and Vanessa Sinclair, 32–43. Trapart: Stockholm.
Reaume, Geoffrey. 2010. "Psychiatric Patient Built Wall Tours at the Centre for Addiction and Mental Health (CAMH), Toronto, 2000–2010." *Left History* 15 (1): 129–48.
–. 2016. "A Wall's Heritage: Making Mad People's History Public." *Public Disability History*, November 21. https://www.public-disabilityhistory.org/2016/11/a-walls-heritage-making-mad-peoples.html.
Routledge, Clay. 2015. *Nostalgia: A Psychological Resource*. London and New York: Routledge.
Routledge, Clay, Jamie Arndt, Tim Wildschut, Constantine Sedikides, Claire Hart, Jacob Julh, A.J. Vingerhoets, and Wolw Schlotz. 2011. "The Past Makes the Present Meaningful: Nostalgia as an Existential Resource." *Journal of Personality and Social Psychology* 101 (3): 638–52.
Ševčenko, Liz. 2010. "Sites of Conscience: New Approaches to Conflicted Memory." *Museum International* 62 (1–2): 20–25.
Smith, Laurajane. 2006. *Uses of Heritage*. London and New York: Routledge.
Steele, Linda, Bonney Djuric, Lily Hibberd, and Fiona Yeh. 2020. "Parramatta Female Factory Precinct as a Site of Conscience: Using Institutional Pasts to Shape Just Legal Futures." *University of New South Wales Law Journal* 43 (2): 521–51.
Topor, Alain, Tore Bøe, and Inger Larsen. 2018. "Small Things, Micro-affirmations and Helpful Professionals: Everyday Recovery-Oriented Practices According to Persons with Mental Health Problems." *Community Mental Health Journal* 54 (8): 1212–20.
Van der Kolk, Bessel. 2014. *The Body Keeps the Score: Brain, Mind, and Body in the Healing of Trauma*. New York: Penguin Books.
Weijmer, Malin. 2019. "I sökandet efter delaktighet: Praktik, aktörer och kulturmiljöarbete." PhD diss., University of Gothenburg.
Yahm, Sarah. 2014. "Oregon State Hospital Museum of Mental Health." *Journal of American History* 101 (1): 203–8.

15

A Sense of Community within a Site of Amplified Stigma
The Strange Case of Spookers

ROBIN KEARNS, GRAHAM MOON, and GAVIN ANDREWS

In the closing decades of the twentieth century, the delivery of mental health care in New Zealand shifted from the psychiatric hospital to community-based residential and treatment facilities. The convergence of a social policy of deinstitutionalization and the economic imperatives of service-sector restructuring cast public psychiatric hospitals not only as unacceptable but also as inferior to newer, spatially dispersed models of care. Kingseat Hospital, approximately 45 kilometres southwest of Auckland, was one such closure. The hospital opened in 1932 and was operational until 1999, with a peak patient population of over 800. Two decades after closure, at the time of writing, it comprises a mix of dereliction and ephemeral housing in decaying buildings, while also having a reputation for being haunted (Kearns, Joseph, and Moon 2012; Moon, Kearns, and Joseph 2015).

Since 2005, Kingseat has also featured a very specific appropriation of the popular demonology of the psychiatric asylum: Spookers, a horror-themed visitor attraction. This reuse occupies the former nurses' residence and has effectively rescued Kingseat from a "strategic forgetting" (Moon, Kearns, and Joseph 2015) in the public consciousness. Its naming capitalizes on the foreboding character of the disused buildings. Patrons need to drive a circuitous route through the asylum grounds in order to reach its entrance. As a successful entertainment business, Spookers harnesses a potent mix of repulsion and intrigue, offering a packaged opportunity to be frightened by choice. The name Kingseat is still associated with both the locality and the

site of the former hospital, but in the public mind, the site is increasingly associated with its adaptive reuse as a horror-themed park and with the business of Spookers (Joseph, Kearns, and Moon 2009).

In our earlier work, we have explored the tension between the retention of positive memories of the asylum and the simultaneous obscuring of more negative aspects of that past (Moon, Kearns, and Joseph 2015). This tension is anchored in ideas of memory, remembrance, and memorialization (Halbwachs 1992; Nora 1989). Work on these themes in relation to issues of dereliction, especially in urban landscapes, has helped to widen this theoretical lens. Research by Tim Edensor (2005) is particularly relevant, being concerned with ideas that help to reinsert (past) life into locations that are otherwise abandoned. In his investigation of relict industrial sites in northern England, Edensor sees the dereliction as "conjur[ing] up the forgotten ghosts of those who were consigned to the past upon the closure of the factory" (311). This comment draws an analogy with our concern for the potential (re)stigmatizing of a derelict asylum space. Karen E. Till (2005) speaks of the interplay of haunting and nostalgia, and Alistair Bonnett (2009) notes how remnant spaces are potentially unsettling. Bonnett sees them as possessing something akin to what we have termed "spectral" qualities (Moon, Kearns, and Joseph 2015), in the sense that these spaces are presences of the past that are discernible in the present. We have argued that consideration of derelict asylums will unearth remnant presences and shadows of past practices at what can be unsettling sites of abandonment and dereliction (Moon, Kearns, and Joseph 2015). In this regard, former asylums, unless specifically memorialized as such, can stand distinct from sites of conscience. Although former service users – and in a rather different way, former staff – may memorialize an erstwhile asylum site, such locations seldom achieve the wider public standing accorded to sites of conscience, such as concentration camps, even though they may otherwise possess many of the necessary characteristics, being sites where harm was often done to service users.

In this chapter, we examine the case of New Zealand's only haunted-attraction theme park in terms of the book's themes of memory, sites of conscience, and social justice. We take as our vantage point the lens of New Zealander Florian Habicht's 2017 documentary *Spookers*. This film focuses on the sense of community fostered among actors at Spookers, some of whom have their own struggles with mental health and find that their horrific personas offer escape from the challenges of the "real world." We examine scenes and exchanges in the documentary and the affective atmospheres

that they induce. We also consider reactions to this controversial business from people with memories invested in the former hospital. First, we offer further background on Kingseat Hospital before recounting the establishment of Spookers. We then examine emergent themes in Habicht's documentary before reflecting on the case study and the experience of both actors and viewers in light of this book's themes.

Kingseat Hospital

For much of the twentieth century, Kingseat Hospital was one of two large psychiatric hospitals serving the rapidly growing city of Auckland. Situated southwest of the city centre, Kingseat followed the standard asylum model in that it was secluded, rurally located, and institutional – although elements of its activity were innovative by contemporary standards. It comprised a stereotypical mix of an imposing main building and mid-twentieth-century villa provision, alongside a farm enabling occupational therapy and self-sufficiency. Other facilities included a chapel, a swimming pool, and sports fields (Joseph, Kearns, and Moon 2009). Its name recalled another Kingseat in Scotland and signified the colonial legacy underpinning the development of psychiatric care at the time (Kingseat Jubilee Editorial Committee 1981).

The construction of Kingseat began in 1929, and the facility opened in 1932. Separate on-site accommodation for nurses was added in 1939 (Kingseat Jubilee Editorial Committee 1981). By 1947, patient numbers had reached 800, and soon afterward, staff numbered 200. Between the 1950s and the 1970s, the hospital expanded and modified its facilities in accordance with changing emphases in psychiatry. One such development saw the selling-off of the hospital farm as Kingseat sought a more medicalized model of psychiatry and distanced itself from the traditional asylum. Rapid population growth in its Auckland catchment area ensured service demand and meant that the hospital ran at or near full capacity in this period. In the 1980s, however, New Zealand belatedly began to shift away from the asylum model and toward a more community-focused care modality (Kearns, Joseph, and Moon 2012). Throughout the 1980s, Kingseat's patient numbers declined, and its utility within the mental health care system decreased. In 1995, its capacity was just 110 beds, and its closure and imminent sale were announced. The sale was completed in 1996, and the last patients were moved off-site in 1999 (Joseph, Kearns, and Moon 2009).

For the purposes of our arguments in this chapter, two issues arise from this brief history. First, finding a use for a former psychiatric hospital is

never straightforward. In the case of Kingseat, the initial purchaser in 1995 was the Tainui Development Corporation, which intended to establish an educational facility on the site (Joseph, Kearns, and Moon 2009; Kearns, Joseph, and Moon 2012). This possibility appears to have disappeared within a year, and Kingseat was back on the market. It was described as having a diverse potential including "an education or health facility, retirement village, equestrian centre, horticultural centre or rural lifestyle subdivision" (Moon, Kearns, and Joseph 2015). Tainui, the business arm of the regional Māori Tribal Authority, then sold the site to the Prince Corporation, a Korean-based investment group registered in New Zealand. The Prince Corporation attempted to back out of the sale, alleging that the property's condition had been misrepresented (Waikato Raupatu Lands Trust 2002). An alternative redevelopment as a prison was mooted, but eventually the sale to the Prince Corporation was confirmed (Moon, Kearns, and Joseph 2015). Subsequently, the Prince Corporation went into liquidation, and the site was acquired by Pulin Investments (Young 2013), which remains the owner at the time of writing and is seeking to capitalize on the development possibilities as Auckland grows; indeed, Auckland Council has rezoned the area to permit more intense development (Earley n.d.). Throughout this shifting and sometimes confused history, the site has experienced a mixture of dereliction and use as temporary housing (Moon, Kearns, and Joseph 2015). Effectively, it has served as banked land for successive owners awaiting the opportunity to realize their investment through development; in the meantime, options for less permanent reuse have proved an attractive means of generating ongoing income.

The second issue arising from our condensed history of Kingseat is that former psychiatric hospitals carry reputational baggage; they are sites with stigmatized and challenging histories. Kingseat, with its penumbra of hauntings and abuse, is no different from many other hospitals. Several buildings are alleged to be haunted, and the site has long been a target for ghost hunters. One spectre, the grey nurse, has achieved particular notoriety. A more concrete past is provided by cases of historic abuse. Kingseat has featured in the major New Zealand inquiries into abuse at psychiatric hospitals, and news reports have highlighted unexplained deaths and disappearances, alongside beatings, sexual assaults, and the misuse of electroconvulsive therapy and psychotropic drugs (Mitchell 2018). This dark history, documented by heritage listings attached to several of the buildings, has ensured that Kingseat is for some a site of unhappy memory and for others a site of spectral frisson aligned with "dark tourism" (Stone 2013).

Enter Spookers

In some respects, the 2005 opening of Spookers was an inevitable outcome of the presence of developers "sitting on" derelict buildings while seeking an income stream at a site with a dark reputation. This horror-themed visitor attraction, styled as a haunted house and situated in the former nurses' hostel, is essentially modelled on a generic concept. It began as a nonhorrific daytime corn maze on a family farm of the original owners of the Spookers brand, which they sold in 2022. Located in the southern region of Hawke's Bay, the corn maze then metamorphosed into a nighttime attraction in which customers were chased by a chainsaw-wielding farmer. The Kingseat property lent itself to a similar maze within reach of the larger Auckland entertainment market. The corn maze element was retained when Spookers moved into the Kingseat buildings, leasing the former nurses' hostel. Alongside the haunted house and the maze, the attractions include a scary forest, a foggy marsh, cramped spaces with horror perennials, clowns, and a fun run in mud featuring zombies. Diversification is evident not only in the

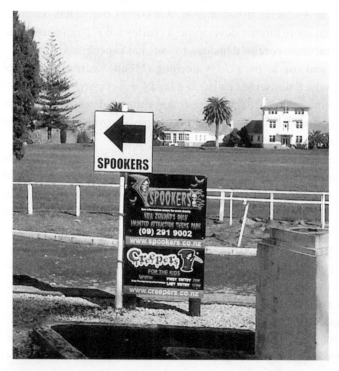

Sign at the entrance to Spookers at the site of the former Kingseat Hospital. Photo by Graham Moon.

complementary provision of school sessions on the business of selling horror and on the creative use of makeup to simulate accidents but also in the use of the site as a video and movie set.

At the time of its opening in October 2005, the *New Zealand Herald* noted, "The company is aware of the potential for accusations of bad taste by choosing a former psychiatric hospital, where many experienced mental suffering and some patients say they were mistreated." Spookers manager Julia Watson told the paper, "That's why we've got it in the nurses' home and not the actual hospital itself ... We also will be having absolutely nothing to do with a mental asylum" (Johnston 2005). Spookers has gone on to win numerous tourism awards and has established itself as a very specific brand of visitor attraction. In 2014, there were plans to franchise the brand in Queensland, Australia, but this possibility appears not to have materialized. Changing circumstances and new ambitions for the proprietors meant that, by 2018, Spookers' owners were seeking to sell the brand. The ambition was to go international while also retaining the Kingseat site. Interest was reported, but the sale was halted and then restarted in April 2020 after the initial wave of the COVID-19 pandemic. Offers of more than $330,000 were being sought for the Kingseat business and the brand (Nadkarni 2020).

In fairness to Spookers, the clear themes of their publicity and their product are stereotypical elements from horror films. There is no specific targeted focus on mental ill-health and no specific mention of the former use of Kingseat. Rather, the emphasis is on terrifying monsters, theatricality, zombies, mutants, and shock. Camped-up nurses carrying dead babies and chainsaw-wielding clowns populate the dark recesses off the corridors of the former nurses' home. Spookers' proprietors have been at pains to clarify that they did not even start out with the idea of a horror park; their initial maze was just "daytime fun" (Howard 2019). They claim that the decision to lease the former nurses' hostel reflected the appearance of the building and the availability of nearby woods, which could be used as the scary forest. They even claim that they realized the building was a former psychiatric hospital only when they inquired about the lease. Spookers cofounder Beth Watson has stated, "We talked about whether it was appropriate and whether we felt that it was disrespectful," and "we just felt more comfortable, because it was the nurses hostel" (Olds 2017). The hidden nature of New Zealand's former asylums and the fact that the proprietors were not local gives some credence to these claims and also to their belief that very few of Spookers' customers know of its former life. Beth Watson does, however, acknowledge that the site "lends horror to the Spookers

experience" (Olds 2017), and visitors often make a link in their encounters with the site. By way of example, in the words of one commentator, "Driving out to the old Kingseat Hospital in the dark and the rain, I can't help but feel like the first victim in a horror film. Making my way across the parking-lot fog, it's silent except for the sound of rain on my umbrella and the distant screams and shouts from inside the former psychiatric hospital" (Yates 2017).

Other views have been aired. In her regular column in *Canvas Magazine*, Daya Willis (2005, 10) writes, "While there are undoubtedly excellent arguments for the old Kingseat Hospital grounds being put to use after all these years, there's also something creepy – something downright disrespectful, methinks – about running a fake scare-athon out of a property that saw so many people live through real horrors." Clearly, as these comments suggest, commercial exploitation of stigma raises important questions about the ease with which selectivity in the collective memory can be fostered. Ironically, it could be argued that this same stigma helped to attract the owners of Spookers to the Kingseat site in the first place. In the newspaper article narrating the arrival of Spookers, Kingseat is described as "one of New Zealand's notorious former psychiatric hospitals" (Johnston 2005). This notoriety was fuelled by the media's close coverage of accusations of abuse and inappropriate treatment at the hospital and of the ongoing litigation associated with those accusations.

Documenting Spookers: Florian Habicht's Film

We now turn to an analysis of the 2017 documentary *Spookers*, by New Zealand filmmaker Florian Habicht, which was distributed, perhaps ironically, by the company Madman Productions. Habicht has made a number of successful documentaries, the most prominent being *Kaikohe Demolition* (2004) and *James and Isey* (2021). Both focus with great empathy on the lives of rural and small-town Māori in Habicht's home region of Northland. Although Spookers is a different story entirely, this award-winning ninety-minute documentary features Habicht's distinctive directorial style of being present in his films as a curious enquirer drawing out people's perspectives. We explore three themes that became evident upon our viewings of the documentary: landscape tropes connecting Spookers to Kinsgseat's past, expressions of unease with the asylum's history, and experiences of community through Spookers in the present.

Although Spookers may not occupy a central place on the former asylum site, it does play on an association between the business and the asylum in

the images pervading its publicity. Both Spookers itself and Habicht's film offer a version of the monster-horror fantasy – a phenomenon that Mikel J. Koven (2007) regards as reflecting a form of social anxiety. In films such as John Carpenter's *Halloween* (1978) and Fred Walton's *When a Stranger Calls* (1979), the monsters are escaped mental patients. To Troy Rondinone (2020), this fear of the patient on the run can be linked to deinstitutionalization and its consequence of people who suffer from mental illnesses finding themselves abandoned with nowhere safe to go. This plight triggered fears of dangerous maniacs on the loose and invading neighbourhoods. Theme parks have controversially embraced this trope, with Cedar Fair Entertainment in Kansas City, Missouri, for instance, having included an attraction called Asylum Island, "where the inmates have taken control of Lakeside Mental Hospital" (Itkowitz 2016).

In terms of our first theme, landscape tropes, the opening scene of the documentary shows a flock of birds rising above grey, dimly lit buildings. Overwritten is the captioning "Kingseat former psychiatric hospital. 45 km south of Auckland." Soon, the past segues into the present, with the filmmakers' voice asking: "What are you doing?" In response, a makeup artist says, "Bloodying up these two-headed babies." Within the first minutes, we are offered connections linking the site to different times: what was once a psychiatric hospital is now a site of contrived horror.

Reviews of the film almost all mention in passing the location on a former asylum site. As one succinctly notes, "The building itself, Kingseat Hospital, is as much a presence in the film as any character ... Today the former psychiatric hospital is thought to be one of New Zealand's 'most haunted locations,' a reputation that presumably does Spookers no harm" ("Spookers" 2017). Soon into the film, another factoid is revealed: "Kingseat is built on 700 acres of farmland. It consisted of fifty-nine buildings, including a maximum-security ward and morgue." Although several buildings could feasibly have been identified, the last word arguably invokes a suggestion of horror and abjection. The strategic positioning of landscape tropes continues intermittently throughout the film, tacitly endorsing a synergy between past and present use. For instance, a scene of a partially obscured moon behind clouds, suggesting a liminal state between illumination and darkness, appears early on and is repeated at the end as the actors are named along with their characters, such as Zombie and Scarecrow.

The second theme that we identify is unease with the asylum's history. Many reviews highlight the equivocal testimonies of former patients concerning Spookers and the documentary (Olds 2017). This unease was

acknowledged by the founding owner's daughter, who in the film says, "When we knew it was the old psychiatric hospital, we did think long and hard about it. A lot of the nurses who used to work here say they just like the fact that something's been done with the old site." Later in the film, Mary, a former psychiatric nurse, expresses her ambivalence: "I was really pleased its being put to some decent use ... But then here we are sticking up these ... killers in an old mental health institution." This trespass into the domain of memory is read as a breach of social justice by former patient Debra Lampshire, who commented in the media that "it's a memorial being defaced" and wished that the owners of Spookers "gave a shit about the real people and their circumstances at the time" (Olds 2017). Debra also appears in the film, where she says, "It scares me ... We're here making fun of [former patients] ... It's upsetting to me people are being mocked ... and the idea that people were violent ... That couldn't be further from the case." She reveals a little of the horror of her own story with the comment that "the doctor said my parents visiting upset me, so they stopped visiting, and I never saw my parents for eighteen years."

Our third theme is the experience of community formation in the context of Spookers. During the documentary, a former patient says, "There are so many lonely people. They just need to meet each other. They could be a tribe." This is in fact what the owners of Spookers have fostered, and this trope of community formation among the workforce is revealed in both the documentary and recent media coverage. Spookers' proprietors are clear on their website that their employees are "a family of 150+ and each member is accepted and celebrated for who they are. Spookers is an incredibly diverse, creative, loving and talented workforce" (Spookers n.d.). It is a place that allows people to be who they want to be. In the words of one actor, David, "The beauty of working with Spookers is you can be whoever the hell you want to be." In other words, actors include people with current mental health issues as well as people who identify as Māori or as various gender identities. It is a site of intersectional acceptance. David tells the filmmaker that he studied biomedicine at university and later worked at the supermarket chain Countdown, but "tonight I'm a zombie bride, and when can you be a zombie bride at your work?" In short, Spookers is not simply a site and set of practices but also a brand and a performed community whose proprietors regard the affective participation of staff as central.

The film's promotional tagline is "a family like no other" ("Spookers" 2017), and IMDb (n.d.) – an online database of information related to films and television programs – provides this plot summary:

As night falls at Spookers, dozens of seemingly ordinary people become freaks, zombies and chainsaw-wielding clowns. Every weekend come rain, hail or shine, this diverse group of amateur performers unite to terrify punters at the southern hemisphere's largest scream park, situated in a former psychiatric hospital. Director Florian Habicht reveals the transformative and paradoxically lifesaving power of belonging to a community that celebrates fear.

Acceptance is a subtheme implicated in community. As one employee tells Habicht, "I'm a Mormon. People think its weird I'm able to combine religion and the Spookers family. I feel comfortable there. I feel wanted there. I feel there is something I can give. I want to put it out there. It's okay to be who you are. It's okay to have whatever ... You're still beautiful." When Habicht asks what character a worker is playing, he is told, "Basically, a psychopath who's being a bit childish." These intimations of "playing" and being "childish" as part of one's employment cast Spookers as a site of ludic practice where the serious business of scaring people is undertaken by staff who are committed to having fun with each other and feeling supported in the course of their horrifying playfulness. Spookers serves as more than a workplace; it could be read as a site of asylum and respite for those dwelling on the edge of their own vulnerabilities and diverse identities in a challenging world.

The Material, Affective, and Moving at Spookers

As we have described, many subjective, conscious processes circulate around Spookers. These processes range from remembrance of, nostalgia for, and ease or unease with the past asylum and its outdated practices to the current attachments, identities, and senses of community associated with Spookers and being Spookers' staff. Yet the conjuncture of the asylum's past and Spookers' present rests, in our view, on more than simple, if often indirect, experiential cross-references. There are also material, affective, and moving dimensions of Spookers that the documentary clearly showcases, each helping to create the aforementioned subjective experiences of ambivalence toward the past use.

In terms of the material, there is evidently a vitality at play at Spookers; materials exceed mere object status by displaying traces of their own intrinsic qualities, agencies, and trajectories. We see this effect in the colours, brightness, and textures of the various materials used at Spookers, which range from aging buildings and their internal decorations to the makeup

and dress worn by the theme-park actors. Indeed, the documentary itself starts with a worker who, mixing blood, describes how the right shade and viscosity are created. The informant says, "It's a long process trying to find different recipes for different sorts of blood." Notions of leaky bodies abound. At one point, the then owner, Andy, discusses Spookers in terms of its generative capacity for fear and anxiety while wearing a T-shirt that says, "I pissed my pants at Spookers." Later, staff and actors discuss procedures when visitors experience a "code brown" – that is, we are told, when they have "crapped their pants." Materials like fake blood and their ritualistic productions, as well as the candid acknowledgment of other bodily fluids, help to build and reinforce the Spookers community. Such is the agency of the sound, vision, and tactile encounter that Spookers can be understood as a more-than-human entity.

In terms of the affective, based on readings of Gilles Deleuze and Félix Guattari (1988) and others (e.g., Massumi 2002), affect has come to describe a process whereby bodies affect and are affected by each other positively or negatively in terms of their capacities. Theories of affect offer insight into how attunements, immersions, and energies emerge in, and are shared between, bodies as pre-conscious feeling states. They lead to an understanding of how intelligence and knowledge of situations and places can exist as a form of whole-body cognition that influences reactions in and in relation to them. Practically, theories of affect lead to a deeper understanding of the common idea of atmospheres – not only of how they are created and experienced but also of their deployments and powers in diverse political, commercial, institutional, and everyday cultural contexts. We see affect clearly at work at Spookers. On one level, there is a palpable energy and enthusiasm among workers feeding off each other as they go about their daily routines. On another level, there is a nervous energy and excitement in the visitors to Spookers. The affects that they seem to experience are not just in the realm of immediate shock and fright; they also experience a baseline affective prehension in their bodies as they anticipate future encounters – prehension about what might suddenly come to be as they enter a new room or a cramped dark space and what the encounter might feel like. To this extent, there is speculatively a parallel to the past use and the treatment and confinement journey of patients. Both past patients and present customers experience their attention turning continually to preparedness for what literally and metaphorically lies around the corner. This behaviour is evident in the documentary's footage of visitors' anticipatory actions, which

include grimacing, tensing, purposefully looking around, talking nervously, and covering up.

In terms of how Spookers is moving, the documentary shows that it is far from being a static space. On the one hand, places move through time. Specific areas within the facility change, sometimes very rapidly, as new characters or environmental stimuli are introduced. At a wider temporal scale, the place has moved in use from its past time as a hospital. On the other hand, people move through space, encountering moving experiences along the way. Visitors navigate their way through the facility – not only its buildings but also its outside spaces, such as the maze, scary forest, and foggy marsh – by day and by night, often talking to each other as they go and encountering surprises along the way. Meanwhile, workers navigate their own way around the same spaces but more purposefully. Through movement on both of these levels, the flow of space and time is created and experienced at Spookers with particular speeds, rhythms, and momentums, all of which are part of a carefully managed production.

Spookers: Competing Narratives and Ambivalent Valences

There are competing narratives at work in our account of Spookers and Habicht's documentary. These narratives speak to the potential coding of the former hospital as a site of conscience. Spookers, we argue, both activates and suppresses memory of past use. When visitors, who might otherwise have no contact with the hospital, drive through its former grounds to reach the horror-themed park, they are either introduced to or reminded of its past use. Yet in arriving at the one-time nurses' hostel, they enter a world of paradoxical forgetting, where the earlier use vanishes but there is amplification of other haunting tropes. Whereas some instances of turning the page, such as new housing developments on old asylum sites, encourage an absolute forgetting by obscuring reminders or lessons of the past (Moon, Kearns, and Joseph 2015), Spookers offers a more ambivalent prospect as a site of conscience by drawing on inflated and stereotypical characterizations of fear that at once speak to the asylum past and distance themselves from it. These fears, however, are specific to the visitor who has chosen to engage with Spookers and are not emblematic of a more general site of conscience.

Spookers at the Kingseat site has been a successful and commercially driven effort that, despite denial, arguably retains at least a parody of the memory of the asylum. This enterprise stands in contrast to former asylum

sites where we have noted a materialization of elements of conscience, reflected in more earnest installations like museums and memorials. At Kingseat, the site of performance is the former nurses' hostel on the edge of the grounds of the former hospital. This positioning is perhaps symbolic. By not occupying the hospital building itself, Spookers manages to partially avoid locating itself at the centre of remembrance of the psychiatric past, a placement that to some might amount to a more acute disrespect for this edgy enterprise. Elsewhere, audiences have been less tolerant of such parody that sails so close to history. In 2013, for instance, the online retailers Asda, Tesco, and Amazon needed to remove two of their fancy-dress costumes from sale, the "Mental Patient" and "Psycho Ward," in the wake of complaints about their "stigmatizing" character, the first of which featured "a blood-stained, ripped white shirt, with machete accessory" (Harpin and Foster 2014, 1). Spookers is replete with emotional valences: the bravado and nervous laughter of customers on entry and the screams of shock and fear as the time within continues. The film dwells on the details of makeup and fake depictions of decay – such as blood oozing from wounds and rotting flesh – and this emphasis, to an extent, mimics the decay in the buildings themselves.

As Chunhui Zheng and colleagues (2020) point out, the emotional turn in geography and tourism studies has called for more research on the mixed emotions of dark tourism to places like closed asylums. Spookers, however, offers more than a walk down a troubled memory lane. It is an ambivalent site of conscience that offers both remembrance and forgetting of its past. With the contrived parody of fake blood, fangs, and characters lunging with chainsaws, it offers a playful veneer and renders the buildings as both a "ludic" (Woodyer 2012) and a memorialized heritage space. Almost two decades after the hospital's closure, the site also unexpectedly offers actors an opportunity to belong, many of whom might otherwise be dwelling at the margins of society due to their intersectional identities. That they find asylum within a horror-themed park situated on the grounds of a closed asylum is, at one level, ironic. It also could be read as an asylum without walls in the sense that people find sanctuary and act out their fantasies as paid employment. To this extent, then, Spookers is – paradoxically and in an unorthodox manner – an ambivalent site of conscience providing sanctuary for its staff and offering the community a sense of inclusion that is so often missing for former asylum residents experiencing isolating, exclusionary, and underfunded community-care programs.

Spookers also plays into a wider discourse of abandoned asylums as haunted places. The journey through the former asylum grounds arguably heightens the anticipation of horror. The anticipation within the visitor experience is escalated by the frisson of entering a building on the former asylum site. Moreover, the haunted-house page on the Spookers (n.d.) website features images of shadows passing over a distant mysterious building on a hill – a stylized composition suggesting an approaching encounter with somewhere other. This image speaks to potential by creating a sense of foreboding that the worst may yet be to come. Thus customers enter first the grounds and then the building with expectations of ghoulishness and the macabre. Being on the otherwise derelict site of a former asylum is central to the experience. Duncan Light (2016) has argued, with respect to the Dracula myth, that visitors do not simply encounter Transylvania; rather, they perform a stereotype of Transylvania. As Habicht's film records so graphically, visitors to Spookers similarly perform and recycle a stereotypical filmic asylum experience prompted by locational associations and surrounding dereliction.

Conclusion

In the face of the ambivalent outcomes of community-care policies, Spookers is an unusual outlier within the afterlives of asylums. Habicht's documentary records a sense of community and accommodation of difference among actors in the midst of producing anxiety among customers. Within the documentary, the idea that the actors constitute a family is clearly a driving theme, but underneath that emphasis the publicity focuses just as clearly on the presence of a former asylum. Paradoxically, a site that until a quarter of a century ago held people within its walls now offers Spookers' actors a sense of freedom and belonging.

In lieu of visiting the attraction and being spooked ourselves, the documentary *Spookers* has offered us a close-up account of the ways that the former asylum site is deployed so as to amplify the darker valences of the public imagination and collective memory. In some ways, the documentary could even be seen as depicting a site of false consciousness. Habicht offers a camped-up and amplified version of the messaging contained in Ken Kesey's 1962 novel *One Flew Over the Cuckoo's Nest,* which is also vividly depicted in Miloš Forman's 1975 film adaptation, namely that institutional spaces are dangerous to healthy minds. Paying customers are offered a real-time encounter with the fears associated with deinstitutionalization

two decades after Kingseat Hospital's closure. Added into the mix are what Rondinone (2020) calls classic horror tropes: isolated fortress-like buildings, superhuman evil forces, and threatened female virtue. All of these elements have rescued Kingseat from a "strategic forgetting" in the public consciousness. Its renaming and rebranding as Spookers capitalize on the foreboding character of the disused buildings (Kearns, Joseph, and Moon 2012). Spookers harnesses a potent mix of repulsion and intrigue in its creation of a packaged opportunity to be frightened by choice. That the frighteners, some of whom may be troubled individuals, apparently form a mutually supportive community at the site of a former hospital building in the midst of asylum memories adds ambivalence to the performance of the post-asylum landscape.

REFERENCES

Bonnett, Alistair. 2009. "The Dilemmas of Radical Nostalgia in British Pyschogeography." *Theory, Culture and Society* 26 (1): 45–70.
Deleuze, Gilles, and Félix Guattari. 1988. *A Thousand Plateaus: Capitalism and Schizophrenia*. London: Bloomsbury.
Earley, Mel. n.d. "Former Kingseat Psychiatric Hospital Prepares to Make Way for New Developments." *Franklin Bugle*. https://melanieearley333.wixsite.com/kingseat-expansion.
Edensor, Tim. 2005. *Industrial Ruins: Spaces, Aesthetics and Materiality*. London: Berg.
Halbwachs, Maurice. 1992. *On Collective Memory*. Chicago: University of Chicago Press.
Harpin, Anna, and Juliet Foster. 2014. *Performance, Madness and Psychiatry: Isolated Acts*. London: Palgrave Macmillan.
Howard, Melissa. 2019. "New Zealand 'Scream Park' Spookers Is Looking for New Owners to Take the Business Global." *Commercial Real Estate*, April 16. https://www.commercialrealestate.com.au/news/new-zealand-scream-park-spookers-is-looking-for-new-owners-57952/.
IMDb. n.d. "Spookers." https://www.imdb.com/title/tt5578538/.
Itkowitz, Colby. 2016. "Halloween Attractions Use Mental Illness to Scare Us: Here's Why Advocates Say It Must Stop." *Washington Post*, October 25. https://www.washingtonpost.com/news/inspired-life/wp/2016/10/25/this-halloween-mental-health-advocates-are-taking-a-powerful-stand-against-attractions-depicting-asylums/.
Johnston, Martin. 2005. "House of Horrors at Former Hospital." *New Zealand Herald*, October 21. https://www.nzherald.co.nz/nz/house-of-horrors-at-former-hospital/DRZTXKF5ABRRJBAGBS7RRS44ZA/.
Joseph, Alun, Robin Kearns, and Graham Moon. 2009. "Recycling Former Psychiatric Hospitals in New Zealand: Echoes of Deinstitutionalisation and Restructuring." *Health and Place* 15 (1): 79–87.

Kearns, Robin, Alun Joseph, and Graham Moon. 2012. "Traces of the New Zealand Psychiatric Hospital: Unpacking the Place of Stigma." *New Zealand Geographer* 68 (3): 175–86.

Kingseat Jubilee Editorial Committee, ed. 1982. *Kingseat Hospital, 50 Years, 1932–1982.* Auckland: Kingseat Hospital.

Koven, Mikel J. 2007. *Film, Folklore and Urban Legends.* Lanham, MD: Scarecrow.

Light, Duncan. 2016. *The Dracula Dilemma: Tourism, Identity and the State in Romania.* London and New York: Routledge.

Massumi, Brian. 2002. *Parables for the Virtual: Movement, Affect, Sensation.* Durham, NC: Duke University Press.

Mitchell, Jim. 2018. "Inside the Haunted History of Spookers' Kingseat Hospital." *SBS*, September 5. https://www.sbs.com.au/guide/article/2018/08/28/inside-haunted-history-spookers-kingseat-hospital.

Moon, Graham, Robin Kearns, and Alun Joseph. 2015. *The Afterlives of the Psychiatric Asylum: Recycling Concepts, Sites and Memories.* Farnham, UK: Ashgate.

Nadkarni, Anuja. 2020. "Spookers' Family Puts Business Up for Sale Again." *Stuff*, March 4. https://www.stuff.co.nz/business/119997690/spookers-family-puts-business-up-for-sale-again.

Nora, Pierre. 1989. "Between Memory and History: Les Lieux de Memoire." *Representations* (26): 7–24.

Olds, Jeremy. 2017. "From Hospital to Haunted House: Former Patients Criticise Spookers." *Stuff*, October 5. https://www.stuff.co.nz/life-style/well-good/97459954/from-hospital-to-haunted-house-former-patients-criticise-spookers.

Rondinone, Troy. 2020. "The Folklore of Deinstitutionalization: Popular Film and the Death of the Asylum, 1973–1979." *Journal of American Studies* 54 (5): 900–25.

Spookers. n.d. "About." https://spookers.co.nz/pages/about.

"Spookers: The Terrifying New Zealand Theme Park with a Cult Following, and a Big Heart." 2017. *Guardian* (London), June 9. https://www.theguardian.com/film/2017/jun/10/spookers-the-terrifying-new-zealand-theme-park-with-a-cult-following-and-a-big-heart.

Stone, Philip R. 2013. "Dark Tourism Scholarship: A Critical Review." *International Journal of Culture, Tourism and Hospitality Research* 7 (3): 307–18.

Till, Karen E. 2005. *The New Berlin: Memory, Politics, Place.* Minneapolis: University of Minnesota Press.

Waikato Raupatu Lands Trust. 2002. *Annual Report, 2001–2002.* Ngaruawahia: Waikato Rapatu Lands Trust.

Willis, Daya. 2005. "Scared Witless? No, Ta." *Canvas Magazine*, October 24.

Woodyer, Tara. 2012. "Ludic Geographies: Not Merely Child's Play." *Geography Compass* 6 (6): 313–26.

Yates, Sienna. 2017. "Inside Spookers: My Night as One of the Living Dead." *New Zealand Herald*, June 21. https://www.nzherald.co.nz/entertainment/inside-spookers-my-night-as-one-of-the-living-dead/5U3IZJ5QPDSZVXR56EJKDITHBA/.

Young, Vivien. 2013. "South Auckland Development Goes to Public Hearing." *National Business Review,* February 12. https://www.nbr.co.nz/south-auckland-development-goes-to-public-hearing/.

Zheng, Chunhui, Jie Zhang, Mengyuan Qiu, Yongrui Guo, and Honglei Zhang. 2020. "From Mixed Emotional Experience to Spiritual Meaning: Learning in Dark Tourism Places." *Tourism Geographies* 22 (1): 105–26.

16

Naming Streets in a Post-asylum Landscape
Cultural Heritage Processes and the Politics of Ableism

CECILIA RODÉHN

In 1988, a letter arrived at the Name Preparation Board (Namnberedningen) of Uppsala Municipality's City Planning Council. Pelle Lundberg and Mikael Nyström, who worked for the supply department of the Uppsala East Hospital District, expressed concerns for the residents at the newly deinstitutionalized Ulleråker psychiatric hospital on the outskirts of the town of Uppsala in southeast Sweden. Since its founding as a hospital in 1811, Ulleråker had always been a residential area for staff members and their families. The address had previously simply been Ulleråker, but after the deinstitutionalization, this address did not work. Lundberg and Nyström wrote in the letter, "We have tried to make the post office deliver the mail to the residences." This undertaking, they added, had proved difficult since "the requirement from the post office is that the streets have names." They pointed out that "a network of streets run through the area, but only one street has a name (Lägerhyddsvägen)" (Lundberg and Nyström 1988). Lundberg and Nyström hoped that the issue would be taken up by the Name Preparation Board as soon as possible so that the residents could receive their mail. Shortly after Lundberg and Nyström's letter arrived at the board, a period of urban development began during the 1990s. At Ulleråker, hospital buildings were repurposed as schools, care facilities, and housing. New apartment complexes were also carefully introduced into the area, and the need for further street names was recognized. This chapter discusses this process of giving

names to the streets in Ulleråker's post-asylum landscape and investigates the role that naming plays in the production of cultural heritage, focusing on the politics of ableism.

Points of Departure

Street naming is a political process where events and people's histories are remembered (Azaryahu 1996, 2012; Light 2004; Palonen 2008; Wanjiru and Matsubara 2017), but these are also processes where some pasts are forgotten in order to create new presents and futures (Gill 2005, 492). Street naming is often discussed in relation to social transformation and/or the decolonization of areas. Scholars explore how old names, reflecting previous political orders, are removed and replaced with new names, reflecting the new political orders and/or previously subjugated groups and their history (Azaryahu 1996, 2012; Duminy 2017; Wanjiru and Matsubara 2017). Therefore, street names can be regarded as discursive products and sites of memory where power, remembrance, language, and space are conflated (Azaryahu 2012, 388). In keeping with research in critical heritage studies and human geography, street naming can be considered a cultural practice and an active performative process, where the past is used in order to create meaning; it is a process of doing heritage (Azaryahu 1996, 2012; Smith 2006, 47). To study the doing of Ulleråker's cultural heritage, I focus on the process of deciding on names. To this end, I explore material from the Uppsala Municipality archives, including minutes from the meetings of both the Name Preparation Board and the City Council. The material is written in Swedish, and I have translated the quotations into English.

The archive material is regarded as articulations – representations or meaning-making practices constituted by discourses. This framing is central in the discussion of street naming as a heritage process because "the discursive construction of heritage is itself part of the cultural and social processes that are heritage" (Smith 2006, 13). In other words, heritage is constructed in discourse, and cultural heritages are both discursive and material as well as in a state of materializing. For this reason, I appropriate a discourse analysis developed within critical heritage studies, where it is acknowledged that "the ways by which we create, discuss, talk about and assess heritage issues do matter" (Waterton, Smith, and Campbell 2006, 342). Thus cultural heritage, including street names, is not a thing or a location but a discourse in which Ulleråker's cultural heritage is "constituted, rehearsed, contested and negotiated and ultimately remade" (Smith 2006, 83). These negotiations becomes visible in the explanations for street names and why the process is

important to study in order to understand how cultural heritage is made in the post-asylum landscape.

In this chapter, I seek to investigate the politics of ableism imbued in the street-naming process, which requires deconstructing normality, ability, and how ableism rejects variations of being (see Wolbring 2008, 253). Ableism can be defined as "a network of beliefs, processes and practices that produce a particular kind of self and body (the corporal standard) that is projected as the perfect, species-typical and therefore essential and fully human" (Campbell 2001, 44n5). The result of the investment in ableism is often that people with disabilities are marginalized and largely made invisible. Ability, in contrast, appears as an unmarked category and unquestioned norm in relation to disability. Ableism, therefore, constructs a binary logic that is "co-relationally constitutive" (Campbell 2008). Questioning the relationality of ability and disability helps to expose the "violence of binarism," where the authority of the "dominant is imagined and maintained through the constant negotiation of the Other" (Goodley 2014, 58).

Previous research into street naming has not discussed how ableism as a political power is upheld and/or taken for granted but has focused predominantly on naming streets in relation to major political transitions in various countries and how power is claimed, maintained, and/or changed in relation to state politics (e.g., Azaryahu 1996, 2012; Duminy 2017; Gill 2005; Light and Young 2014; Palonen 2008; Shoval 2013; Wanjiru and Matsubara 2017). Moreover, street naming in post-asylum landscapes has not received any scholarly attention outside of my own work (Rodéhn 2021, forthcoming), although it should be recognized that naming practices are being discussed in relation to how areas and buildings are renamed. Such research posits that there is a stigma attached to former psychiatric hospitals and that renaming practices provide ways to deal with "the long shadow of past use" (Moon, Kearns, and Joseph 2015, 129). Altering names works so as to create a symbolic break with a troubled past, and urban developers use this as a strategy to cleanse post-asylum landscapes of negative emotions associated with hospitals (Kearns, Joseph, and Moon 2012, 180). New names often make reference to an area's natural environment or to an area's history prior to being a psychiatric hospital, allowing for a selective remembrance of the past (Moon, Kearns, and Joseph 2015, 20). Research about street names in general and renaming practices in post-asylum landscapes in particular deals with how names are changed. The present study adds knowledge to this body of research by exploring not how names are changed but how they are introduced.

In this text, I use "disability" as an overarching term since the hospital at Ulleråker cared not only for people experiencing Madness but also for people with various kinds of neurodiversity as well as for people with somatic variations. I also use the words "Mad" and "Madness," as reclaimed by Mad studies, where "Mad" is an alternative to terms like "mental illness" and "deviant social behaviour" (Menzies, LeFrançois, and Reaume 2013, 10). "Madness" is defined as a term for a range of phenomena connected to experiences of mental ill-health (LeFrançois, Menzies, and Reaume 2013, 337).

Naming the Streets at Ulleråker

Naming streets is an administrative and political process and part of contemporary political culture (Azaryahu 1996; Duminy 2017). In Sweden, this is part of the democratic municipal political culture; however, the process changes over time and varies between municipalities. In Uppsala Municipality during the 1990s, street names were proposed by the Name Preparation Board of the City Planning Council and taken up for decision by the City Council (Namnberedningen 1991). This was also why Pelle Lundberg and Mikael Nyström turned to Uppsala Municipality's City Planning Council with their concerns. The municipality solved the problem by using already established street names when these streets extended into the hospital area. Consequently, Ulleråkersvägen (named in 1932 after the hospital at Ulleråker) and Lägerhyddsvägen (named in 1973 after the huts belonging to the nearby garrison) were introduced (Namnberedningen 1988). Later, in 1991, Kronåsvägen was introduced as a street name. The street was named after the ridge where the hospital existed (Uppsala kommun 1991) but was also the name of an institution at Ulleråker called Kronåsens sjukhus, which had cared for children with neurodiversities.

In 1991, it was also decided that two streets would be named after Gustaf Kjellberg and Frey Svenson (Uppsala kommun 1991). Inspired by this decision, it was determined in 1993 that additional street names should pay tribute to "people who have been active at Ulleråker," which meant people who had worked at the psychiatric hospital at Ulleråker (Uppsala kommun 1991, 1993). Emmy Rappe, Bernhard Jacobowsky, Eva Lagerwall, and Henry Sälde were commemorated with streets. The street names were predominantly memorial names, which is a way to actively honour certain people in the landscape. Memorial street names remind citizens of people who "deserve" to be remembered (Ågren 1999, 49, 63). They point to the kind of history that is perceived as significant, and the names can be regarded as akin to monuments (Azaryahu 1996, 318; Light 2004, 155).

It is therefore necessary to contextualize the names in order to understand how they contribute to furthering the politics of ableism in the post-asylum landscape. In so doing, I begin with Gustaf Kjellbergs väg, named after Gustaf Kjellberg (1827–93). He was an attending physician at Ulleråker's Upsala central hospital starting in 1856, and he became a professor at Uppsala University in 1863. In connection with the hospital's expansion during the mid-1800s, he was one of the first physicians who exclusively worked in psychiatry. Due to this work, he was also a leader in the field (Wahlberg 1994, 256–57). The Name Preparation Board's explanation for why Kjellberg should be commemorated was that he was "the country's first teacher in psychiatry," as well as an "attending physician" and "professor from 1863–1893" (Namnberedningen 1990a, 1990b). Frey Svenssons väg was named after Frey Svenson (1866–1927), an attending physician at Upsala hospital och asylm at Ulleråker. Svenson was also a professor of psychiatry at Uppsala University (Wahlberg 1994, 256). The Name Preparation Board proposed that Svenson should be commemorated because he "was a professor from 1904–1926" and "was Fröding's physician" (Namnberedningen 1990b). Gustaf Fröding was one of Sweden's most cherished poets and also Ulleråker's best-known patient during the turn of the twentieth century.

Emmy Rappe (1835–96) was memorialized with Emmy Rappes väg, in part due to her position as head nurse of the surgical department at Akademiska sjukhuset in Uppsala. She was also the director of the nursing school, which was run by the Swedish Red Cross's predecessor, Föreningen för frivillig vård av sårade och sjuka i fält. In 1877, she became the hospital director of Upsala central hospital at Ulleråker (Wahlberg 1994, 256). The City Council's minutes explained that "as a pioneer in nursing education, Emmy Rappe made a significant contribution" and further stated that "within mental health care, she realized early the value of occupational therapy and introduced weaving and sewing into the daily schedule at Upsala central hospital" (Uppsala kommun 1993; see also Namnberedningen 1992).

Bernhard Jacobowskys väg was named after Bernhard Jacobowsky (1893–1984), a professor of psychiatry at Uppsala University, at Ulleråkers sjukhus in Ulleråker, and at Akademiska sjukhuset in Uppsala (Wahlberg 1994, 256). The explanation for the name reads, "He was a pioneer in new and more humane mental care that emerged during the 1940s and 1950s and intensely participated in the creation of the new psychiatric clinic at Akademiska sjukhuset." The explanation also describes Jacobowsky as an "appreciated author of student spex" (student amateur comedy theatre), "a respected

inspector of the Gothenburg Nation" (a supervising function at a student organization held by a professor), and an "excellent speaker" (Uppsala kommun 1993; see also Namnberedningen 1992). Eva Lagerwalls väg was named after one of the country's foremost forensic psychiatrists, Eva Lagerwall (1898–1960). Lagerwall organized and led the forensic psychiatric ward at Ulleråkers sjukhus. She was also a prison physician at the juvenile detention facility in Uppsala, a scientific expert at the Swedish Medical Board for Forensic Psychiatry, and a lecturer at the Social Institute (Wahlberg 1994, 256). The explanation states, "Eva Lagerwall had a great ability to empathize with her patients and to understand them and a humble respect for their problems. For her employees, she was an inspiring leader and teacher" (Uppsala kommun 1993; see also Namnberedningen 1992).

Henry Sälde (1916–83), another attending physician at Ulleråker sjukhus, was honoured with Henry Säldes väg. In 1964, he became a medical advisor for psychiatry at the National Swedish Board of Health and was later responsible for rehabilitation and long-term care at the National Board of Health and Welfare (Wahlberg 1994, 256–57). The City Council's explanation states that "Sälde was the first person in the country to introduce a functioning division of the hospital" in order to help with interdepartmental communication and that "Sälde had the ability to recruit interested, highly competent employees, who transformed the old, inherently worn-out hospital into a place where people began to come of their own free will in order to receive help and cures" (Uppsala kommun 1993).

The street names commemorate the area and the institution as well as a head nurse and attending physicians. This commemoration occurred at a time when the hospital was deinstitutionalized and when mental health care reforms were being discussed in Sweden (decided on in 1994 and implemented in 1995), resulting in the closure of Swedish psychiatric hospitals. The heritage process at Ulleråker has followed developments similar to those seen with other heritage processes in Sweden, where material culture, traditions, and places have been acknowledged as cultural heritage when drastic social, political, or economic changes have affected people's lives. At Ulleråker, deinstitutionalization not only altered psychiatric care and the lives of service users but also changed the lives of the people who worked and lived at the institution. In addition, the area was physically transformed due to urban development. Maoz Azaryahu (1996, 312) writes that street names not only provide historical references but also create a memory of the past and a situation where history and geography are woven together, which

applies to Ulleråker. Building on this observation, I propose that the street names reinscribed psychiatric care in Ulleråker's post-asylum landscape during this transformation. In so doing, the street names ensured a remembrance of an institutional life and a workplace that were, or were about to be, lost. However, such an inscription is not only a retention of the past but also a way to use history in order to create future relations with, and in, the post-asylum landscape. The street names mark the place as an area for psychiatric care. As a result, the heritage process at Ulleråker exhibits a different kind of development compared to other post-asylum landscapes. Scholars note that in New Zealand, Canada, and Britain, references to psychiatric care and/or mental illness are deliberately removed from names in order to make a symbolic break with the past and thereby create an attractive residential area during urban development (Kearns, Joseph, and Moon 2012, 180; Moon, Kearns, and Joseph 2015, 84–87, 122–26, 162). However, the street names at Ulleråker carry the past into the future and create a cultural heritage constructed around ideas about the staff members as active, the institution as therapeutic, and the work at the institution as progressive – a discussion to which I now turn.

Being Active

The street names commemorate, as described above, "people who have been active at Ulleråker," specified as staff members at the hospital. Being active was furthermore clarified as being about four men and two women. The fact that the street names predominantly commemorate men follows a Swedish gender order where men have been privileged in street-naming processes. For example, in Uppsala, there are 191 memorial street names, 46 of which are named after women, and of these 46 street names, 31 appeared after the year 2000, predominantly following the implementation of a gender equality policy (Wahlberg 2020). The notion of being active at Ulleråker needs to be unpacked and discussed in terms of how gender intersects with ableism and how it furthers politics of exclusion in cultural heritage processes.

The active-passive binary informs the way that masculinity and femininity are relationally constructed in the West. Men and masculinity are associated predominantly with activity, and women and femininity with passivity. Furthermore, being active is associated with a position of power and authority and, consequently, is highly valued. Articulating that the street names commemorate those who were active at Ulleråker and that

this activity was connected predominantly to men places men's activities, contributions, and stories at the centre of Ulleråker's cultural heritage. This placement is problematic given that "masculine bodily performance is primarily and often violently expressed as occupation, control, objectification and subjugation" of others' bodies, which are rendered passive (Whitehead 2002, 190). Masculinity is further connected to rationality, autonomy, mastery, and mental stability, traits that are frequently contrasted with the ideas of a passive, irrational, dependent, and uncivilized disabled body (Campbell 2008; Connell 2005, 3–42, 164). Ironically, any mind or body articulated as being outside of the male norm becomes disabled in this logic (Campbell 2008). For instance, dependency and emotionality are linked to femininity, and throughout history, women have been explained as less rational and less mentally stable and have been considered biologically predisposed for mental illness. Similar ideas were also connected to Indigenous groups, as well as Black and Jewish people (Gilman 1985, 162), and these ideas have been used to describe the other and "the dangerous and inferior" in ableist patriarchal society (Goodley 2014, 12, 118). Being active, in other words, has come to signify masculinity and something positive, whereas passivity is considered negative and is associated with disability (59).

During the name-giving process, the representation of staff members' activity is constructed in relation to that which is not mentioned and not commemorated – the Mad and the disabled, figured as the passive and invisible other. This violence of binarism needs to be questioned for many reasons. First, this framing makes it seem as though patients agreed to submit themselves to care, along with the circumstances of intervention, detention, and medicalization that Mad people often (albeit not always) associate with control, subjugation, and violence. The articulation that staff members were active is therefore an investment in, and a conflation of, patriarchy and ableism. Second, the implicit positioning of patients as passive suggests a disregard for patients' contributions to the institution. It should be acknowledged that throughout the hospital's long history, patients worked in the gardens, in the laundry, and in the kitchen. Patients were also employed in different workshops, making furniture, shoes, or woven gauze bandages. This work was not only regarded as occupational therapy but was also vital for the maintenance of the hospital. Furthermore, during the latter part of the hospital's history, labour was appropriated as a tool for empowerment in order to integrate patients into society. Thus, when activity is associated with an able body and mind, specifically with the ability of a person caring for those with

Madness, name-giving becomes a position of power, an enactment of exclusion, and a normalization of discrimination.

The University Connection

The position of power, as mentioned above, was further strengthened by the description of the commemorated staff members as leaders and, more importantly, as professors, teachers, and educators, one of whom was also the inspector of a student organization called the Gothenburg Nation. These articulations connect Ulleråker to conventional ways of doing cultural heritage in the town of Uppsala. Maths Isacson and Marie Nisser (2007, 63–65) write that Uppsala is closely connected to and officially promoted as the city of learning. This identity can be seen, for instance, in the declaration of Uppsala as a "national interest," a designation reserved for select geographical areas considered to hold important value for Sweden's cultural heritage. The declaration focuses on Uppsala University, founded in 1477, as the oldest university in the Nordic countries but also mentions the historical remains from the Middle Ages and institutions such as hospitals and garrisons, which are interconnected with the university (Beckman-Thoor and Blombäck 2014). Although Uppsala has a long history as an industrial town, the working class is largely marginalized in cultural heritage expressions, as it seems not to match the idea of Uppsala as a university town (Isacson and Nisser 2007, 63–65). Therefore, the commemorations of the attending physicians and the head nurse, as well as the articulations of them as professors or educators, connect Ulleråker to and make the post-asylum landscape intelligible as part of Uppsala University's cultural heritage.

The connection to the university is an investment in the social elite, thus exposing another side of the politics of ableism in cultural heritage. Gregor Wolbring (2008, 253) explains that ableism "rejects the 'variation of being,'" and this rejection has been used to justify discrimination not only in relation to disability but also in relation to other groups. For instance, he proposes that "sexism is particularly driven by a form of ableism" that constructs women as lacking "certain abilities" (253). The notion of lack also comes to define the working class, which is often articulated as lacking in terms of finances and morals. Moreover, there is a long tradition of stereotyping the working class and presenting these people as slow-minded, "dangerous, polluting, threatening, revolutionary, pathological and without respect" (Skeggs 1997, 1). These words have also been used to describe Mad people. In contrast, being able centres on quick thinking and culturally acceptable

behaviours and emotions (Campbell 2012, 213). All of these abilities are implied in occupations such as attending physician, head nurse, professor, director, and educator. These occupations require a "normal" (if not exceptional) mind and someone who is fast-thinking, respectable, rational, and able to distinguish oneself.

Consequently, ableism is associated not just with what the body can do but also with people who, "by way of the bodily configuration and cultural capital they assume, can step into positions of authority and wield the power that grants them" (Garland-Thomson 1997, 8); in other words, ableism lifts those associated with the "power of the bourgeoisie" (Davis 1995, 15). This effect of ableism must further be understood in relation to the long history of Uppsala University as a segregated institution; only during the 1960s did study grants make it possible for working-class students to attend institutions of higher education. In other words, the connection made to the university during the name-giving process can be considered an investment in the elite. Therefore, Dan Goodley's (2014, 27) observation that "ableism clings to economic and ideological conditions" is central in the discussion of street naming at Ulleråker. Evoking the university connection and its masculinized and classed history in the explanations for street names makes a provision for Ulleråker's cultural heritage to be securely positioned in an ablest space, far from any associations with femininity, disability, Madness, or the working class that might also threaten the boundaries of ability. In accounts of Ulleråker's cultural heritage, this ableist focus effectively results both in further marginalizing the patients' contributions and in sidelining the histories of the working-class staff members, who, for instance, worked on the wards, in the kitchen, and in the gardens, holding positions such as hands, gardeners, caretakers, and janitors.

A Success Story

Connecting the street names to the university and to the academic elite positions Ulleråker and its cultural heritage in a positive light. This positioning can be further seen in the articulations focusing on the attending physicians' and the nurse's contribution to the institution. For example, Henry Sälde was said to have "transformed the old, inherently worn-out hospital," Emmy Rappe was regarded as having made "a significant contribution," Bernhard Jacobowsky was hailed as "a pioneer," and Eva Lagerwall was called "an inspiring leader and teacher." Through these articulations, Ulleråker's history was presented as a success story, something that is not uncommon when writing the history of psychiatric hospitals. Anders Åman

(1970, 10) proposes that this history is centred on solutions, advances, and positive changes, whereas failures are seldom or never the focus. A similar situation can be noted in museums of medicine, where the advancements in psychiatric care are often mediated by first explaining the lack of sufficient treatment in the distant past and then subsequently conveying stories about advancements, discoveries, and improvements in psychiatric care. Exhibitions or guided tours are often concluded by focusing on the introduction of psychopharmaceuticals, which are commonly explained as leading to deinstitutionalization and the closure of hospitals (Rodéhn 2020, 205).

Ulleråker's street names are in line with this narrative. The street names represent the hospital's history from its earliest times until the 1980s, and they represent the evolution of medical care from questionable treatments to more compassionate psychiatric care. Frey Svenssons väg and Gustaf Kjellbergs väg represent the earliest period of the hospital, and Gustaf Kjellberg is described as "the country's first teacher in psychiatry." Interestingly, Svenson and Kjellberg are not mentioned in relation to psychiatric care or to medical advancements, probably owing to the fact that they represent a period when no adequate "cure" for mental illness was made available. The explanations for the other street names articulate that Emmy Rappe "realized early the value of occupational therapy," that Bernhard Jacobowsky introduced "more humane mental care," that Eva Lagerwall had the "ability to empathize with her patients and to understand them," and that Henry Sälde "transformed" the hospital. In different ways, the street names are connected to an idea of the hospital as therapeutic and to the positive aspects of care, as well as to improvements made to the institution.

Consequently, the street names convey Ulleråker's success story from its earliest times up until its closure. This is a powerful narrative where a diachronic framework provides a systematic explanation, which in turn produces a sense of stability. The explanatory power of this narrative lies in creating a pattern of medical advancements, which works to reduce any reference to failure. This is a way to uphold ableism. In making this argument, I build on Goodley's (2014, 31) proposal that the idea of success is closely tied to ability, whereas disability is associated with failure. The connection to ableism is further evident in the fact that the dominant understanding of disability not only "confers pain, disease, functional limitation, disadvantage, and social stigma" but also includes limited opportunities and reduced quality of life. The dominant understanding conveys that the world would be a "better place if disability could be eliminated" (Garland-Thomson 2017, 53). Ableism edits out disability (Goodley 2014, 33). Consequently, the focus

on advancements and success in the street-naming process works to eliminate histories and experiences of being treated at the psychiatric hospital.

As much as street names can commemorate histories, they are also effective in hiding the past (Wanjiru and Matsubara 2017, 2). Therefore, I propose that editing out or eliminating associations with Madness during the street-naming process functions as a strategy to reduce any stigma connected to the psychiatric hospital and can be considered an effort to remove any ill feelings connected to the post-asylum landscape during urban development. In removing negative connotations, the street names, in the words of Maoz Azaryahu, "not only celebrate extraordinary moments of history but are also instrumental in their reification" (Azaryahu 1996, 312). Building on this, I propose that the street names at Ulleråker not only celebrate and come to stand as monuments to ableism but also reinstall ableism in the post-asylum landscape. In turn, this works to reduce the complexity of Ulleråker's cultural heritage.

Conclusion

Name-giving is a heritage process where ideologies and politics are acted out, inscribed, and materialized in the post-asylum landscape. The street-naming process at Ulleråker reveals the many different dimensions of the politics of ableism and its subtle workings. As shown, ableism is not only connected to an able mind or body but is also acted out by making reference to masculinity and certain professions and by favouring privileged socio-economic positions. Ableism is further upheld by presenting the history of the psychiatric hospital in a positive light, which reduces any reference to failure and, consequently, to Madness. The street names securely position Ulleråker's cultural heritage in a space far from any association with femininity, disability, Madness, or the working class, all of which might threaten the boundaries of ability. The street-naming process can be said to have been organized around the politics of ableism, with the result that Ulleråker's cultural heritage has become a space where ableism is furthered.

In wider contexts, the study suggests that attention needs to be turned to the subtle ways that ableism as a norm permeates the entire cultural heritage system. Investigations are not only needed in terms of how ableist norms work through suggestions for street names, how the names are explained, and the stories that are told in the urban landscape through these names. It is also vital to further investigate how ableism comes to organize the politics of remembering and forgetting as well as the role that street naming plays during the urban development of deinstitutionalized psychiatric hospitals.

Focusing attention on the role of ableism makes it possible to start addressing future ways of doing a diverse cultural heritage in post-asylum landscapes, where former patients are entitled to redress for their experience at the institution, and where Mad people's stories are allowed to be heard.

NOTE
Acknowledgment: This chapter forms part of the project *From Psychiatric Hospital to Condominium – Urban Development and Cultural Heritage*, funded by Formas, a Swedish research council for sustainable development (project no. 2019–00589).

REFERENCES
Ågren, Henrik. 1999. *Gatunamn och platskänsla i Uppsala.* Uppsala: Ed. Edda.
Åman, Anders. 1970. "Hospital, sinnessjukhus, mentalsjukhus." *Arkitektur* 9 (70): 10–20.
Azaryahu, Maoz. 1996. "The Power of Commemorative Street Names." *Environment and Planning D: Society and Space* 14 (3): 311–30.
–. 2012. "Renaming the Past in Post-Nazi Germany: Insights into the Politics of Street Naming in Mannheim and Potsdam." *Cultural Geographies* 19 (3): 385–400.
Beckman-Thoor, Karin, and Liselott Blombäck. 2014. *Uppsala stad C 40 A: Riksintresseområde för kulturmiljövården: Fördjupat kunskapsunderlag.* Uppsala: Länsstyrelsens Meddelandeserie, Länsstyrelsen i Uppsala län.
Campbell, Fiona Kumari. 2001. "Inciting Legal Fictions: 'Disability's' Date with Ontology and the Ableist Body of the Law." *Griffith Law Review* 10 (1): 42–62.
–. 2008. "Refusing Able(ness): A Preliminary Conversation about Ableism." *M/C Journal* 11 (3). https://doi.org/10.5204/mcj.46.
–. 2012. "Stalking Ableism: Using Disability to Expose 'Abled' Narcissism." In *Disability and Social Theory: New Developments and Directions*, ed. Dan Goodley, Lennard J. Davis, and Bill Hughes, 212–30. London: Palgrave Macmillan.
Connell, R.W. 2005. *Masculinities.* 2nd ed. Cambridge, UK: Polity.
Davis, Lennard. 1995. "Constructing Normalcy: The Bell Curve, the Novel, and the Invention of the Disabled Body in the 19th Century." In *The Disability Studies Reader*, ed. Lennard Davis, 3–16. Abingdon, UK: Routledge.
Duminy, James. 2017. "Street Renaming, Symbolic Capital, and Resistance in Durban, South Africa." In *The Political Life of Urban Streetscapes: Naming, Politics, and Place*, ed. Reuben Rose-Redwood, Derek Alderman, and Maoz Azaryahu, 240–58. London and New York: Routledge.
Garland-Thomson, Rosemary. 1997. *Extraordinary Bodies: Figuring Physical Disability in American Culture and Literature.* New York: Columbia University Press.
–. 2017. "Building a World with Disability in It." In *Culture–Theory–Disability: Encounters between Disability Studies and Cultural Studies*, ed. Annie Waldschmidt, Hanjo Berressem, and Moritz Ingwersen, 51–62. Bielefeld, Germany: transcript.

Gill, Graeme. 2005. "Changing Symbols: The Renovation of Moscow Place Names." *Russian Review* 64 (3): 480–503.
Gilman, Sander L. 1985. *Difference and Pathology: Stereotypes of Sexuality, Race, and Madness.* Ithaca, NY: Cornell University Press.
Goodley, Dan. 2014. *Dis/ability Studies: Theorising Disablism and Ableism.* London and New York: Routledge.
Isacson, Maths, and Maria Nisser. 2007. "Nytt liv i gamla industriområden: Erfarenheter från Uppsala mejeris omvandling." *Bebyggelsehistorisk tidskrift* (53): 59–78.
Kearns, Robert, Alun Joseph, and Graham Moon. 2012. "Traces of the New Zealand Psychiatric Hospital: Unpacking the Place of Stigma." *New Zealand Geographer* 68 (3): 175–86.
LeFrançois, Brenda A., Robert Menzies, and Geoffrey Reaume. 2013. "Glossary of Terms." In *Mad Matters: A Critical Reader in Canadian Mad Studies,* ed. Brenda A. LeFrançois, Robert Menzies, and Geoffrey Reaume, 334–40. Toronto: Canadian Scholars' Press.
Light, Duncan. 2004. "Street Names in Bucharest, 1990–1997: Exploring the Modern Historical Geographies of Post-socialist Change." *Journal of Historical Geography* 30 (1): 154–72.
Light, Duncan, and Craig Young. 2014. "Habit, Memory, and the Persistence of Socialist-Era Street Names in Postsocialist Bucharest, Romania." *Annals of the Association of American Geographers* 104 (3): 668–85.
Lundberg, Pelle, and Mikael Nyström. 1988. *Ang gatu- eller vägnamn inom Ulleråkersområdet: Brev till Kommunens namnberedning, stadsbyggnadskontoret från Pelle Lundberg och Mikael Nyström, försörjningsavdelningen Uppsala östra sjukvårdsdistrikt: Namnberedningen handlingar rörande namnsättning 1983–1988, F1:1.* Uppsala: Uppsala kommunarkiv.
Menzies, Robert, Brenda A. LeFrançois, and Geoffrey Reaume. 2013. "Introducing Mad Studies." In *Mad Matters: A Critical Reader in Canadian Mad Studies,* ed. Brenda A. LeFrançois, Robert Menzies, and Geoffrey Reaume, 1–22. Toronto: Canadian Scholars' Press.
Moon, Graham, Robert Kearns, and Alun Joseph. 2015. *The Afterlives of the Psychiatric Asylum: Recycling Concepts, Sites and Memories.* Farnham, UK: Ashgate.
Namnberedningen. 1988. *Namnberedningen sammanträdesprotokoll 1988–09–14: Namnberedningen protokoll 1971–1989, A1:1.* Uppsala: Uppsala kommunarkiv.
—. 1990a. *Förslag till gatu-, kvarters-, och parknamn med anledning av förlag till detaljplan för Ulleråker, daterad 1990–07–16: Namnberedningens handlingar rörande namnsättning 1989–1991, F1:2.* Uppsala: Uppsala kommunarkiv.
—. 1990b. *Uppsala kommun, namnberedningen: Sammanträdesprotokoll 1990–05–30: Namnberedningen protokoll 1990–1996, A1:2.* Uppsala: Uppsala kommunarkiv.
—. 1991. *Uppsala kommun, namnberedningen: Skrivelse till kommunfullmäktige 1991–01–02: Namnberedningen protokoll 2003–2007, A1:4, skrivelser till kommunfullmäktige 1971–2007, B3.* Uppsala: Uppsala kommunarkiv.

—. 1992. *Uppsala kommun, namnberedningen: Sammanträdesprotokoll 1992– 04–08: Namnberedningen protokoll 1990–1996, A1:2.* Uppsala: Uppsala kommunarkiv.
Palonen, Emilia. 2008. "The City-Text in Post-Communist Budapest: Street Names, Memorials, and the Politics of Commemoration." *GeoJournal* 73 (3): 219–30.
Rodéhn, Cecilia. 2020. "Emotions in the Museum of Medicine: An Investigation of How Museum Educators Employ Emotions and What These Emotions Do." *International Journal of Heritage Studies* 26 (2): 201–13.
—. 2021. "Institutionen, personalen och patienten – Namn och namngivning av gator, kvarter och platser." In *Komplext kulturarv – Från psykiatriskt sjukhus till bostadsområde*, ed. Cecilia Rodéhn and Hedvig Mårdh, 52–89. Stockholm: Riksantikvarieämbetet.
—. Forthcoming. "Street Names and the Narration of Madness in a Post-asylum Landscape." In *Narrating the Heritage of Psychiatry*, ed. Elisabeth Punzi, Christoph Singer, and Cornelia Wächter. Leiden: Brill.
Shoval, Noam. 2013. "Street-Naming, Tourism Development and Cultural Conflict: The Case of the Old City of Acre/Akko/Akka." *Transactions of the Institute of British Geographers* 38 (4): 612–26.
Skeggs, Beverly. 1997. *Formations of Class and Gender: Becoming Respectable.* Thousand Oaks, CA: Sage.
Smith, Laurajane. 2006. *Uses of Heritage.* London and New York: Routledge.
Uppsala kommun. 1991. *Uppsala kommunfullmäktige sammanträdesprotokoll 1991– 03–25: Uppsala kommunfullmäktiges tryck 1991, serie A nr 43–69.* Uppsala: Uppsala stadsarkiv.
—. 1993. *Uppsala kommunfullmäktige sammanträdesprotokoll 1993–01–25: Uppsala kommunfullmäktiges tryck 1993, serie A nr 7.* Uppsala: Uppsala stadsarkiv.
Wahlberg, Mats. 1994. *Ortnamnen i Uppsala län D. 5 Uppsala kommun, 1 Uppsalas gatunamn.* Uppsala: Ortnamnsarkivet.
—. 2020. "Memorialnamn i Uppsala." In *Namn och namnvård: Vänskrift till Annette C. Toresjö på 60-årsdagen den 18 november 2020*, ed. Staffan Nyström, Svante Strandberg, and Mats Wahlberg, 197-214. Uppsala: Institutionen för nordiska språk, Uppsala universitet.
Wanjiru, Melissa Wangui, and Kosuke Matsubara. 2017. "Street Toponymy and the Decolonisation of the Urban Landscape in Post-colonial Nairobi." *Journal of Cultural Geography* 34 (1): 1–23.
Waterton, Emma, Laurajane Smith, and Gary Campbell. 2006. "The Utility of Discourse Analysis to Heritage Studies: The Burra Charter and Social Inclusion." *International Journal of Heritage Studies* 12 (4): 339–55.
Whitehead, Stephen M. 2002. *Men and Masculinities: Key Themes and New Directions.* Cambridge, UK: Polity.
Wolbring, Gregor. 2008. "The Politics of Ableism." *Development* 51 (2): 252–58.

17

"We Bent the Motorway"
Community Action on Exminster Hospital

NICOLE BAUR

Cream tea, fireworks, and an exhibition marked the official closure of Exminster Hospital in England. Set out to commemorate its almost 150-year history, the evening reception on July 17, 1987, saw the hospital flag lowered one last time to the sound of a lone piper as the sun went down (Kemp 1987). Its closure evoked ambivalent feelings, as expressed by long-time hospital staff member Ken Beer, who was chairman of the Exminster Parish Council: "It is a sad day for anybody connected with the hospital, but also a happy day because of the improvements in the mental health service that have brought about its closure" (quoted in Kemp 1987). For others, the negative outweighed the positive. One interview participant said, "I actually locked the door there on the last day. It was horrible" (EHSF03).[1] Another noted that the effects of the closure were felt throughout the local community: "When it closed down, it was a terrible, terrible thing, terrible blight on the community. It wasn't just the patients that were displaced. It was everybody" (EHSF12).

Nowadays, the former hospital is a luxury residential estate. In between these two snapshots lies a time defined by "strategic forgetting" and "selective remembrance," such that the experience and memories of former residents of many psychiatric facilities are neglected following deinstitutionalization (Joseph, Kearns, and Moon 2013; Kearns, Joseph, and Moon 2010; Moon and Kearns 2016; Punzi 2019). To the outsider, Devington Park, as the site of the former Exminster Hospital is now called, appears to be the

result of well-planned heritage preservation. In reality, it is the outcome of intense negotiations between heritage experts, developers, and lay people, all pursuing their own goals, and many others also unwittingly put their stamp on its heritage. This chapter traces the conversion of Exminster Hospital into Devington Park, focusing on how its heritage was both intentionally and unwittingly preserved through the intense discussions between experts and lay people.

From a Public County Lunatic Asylum to a Private Luxury Residential Estate

"Beautiful" – "Majestic" – "Elegant." These words, printed in cursive calligraphy on persuasive photographs of impressive Victorian buildings on the Devington Park (n.d.) website, advertise the "Imposing Residential Estate in Exminster." The website describes the premises as "compris[ing] a handsome range of buildings, formal and informal gardens, surrounded by open parkland," before capitalizing on the hospital's desired history by drawing attention to its construction period of 1842–45 and its renowned architect, Charles Fowler. Information about the premises' wider history, however, is in short supply. Only three words hint at its former function as "Exe Vale Hospital." According to the developer, this framing was intentional, as "99% of people don't want to live in a mental hospital" (quoted in Franklin 2002, 177). This clear attempt to airbrush this building's former life, function, and inhabitants out of its history while emphasizing the more desirable elements has been labelled "strategic forgetting" and "selective remembrance," a process evident in the hospital's material and immaterial heritage. It is by no means a rarity. Heritage activities focusing on a limited set of pre-selected criteria – often guided by the decisions of experts in historical architecture or other people in power – produce a one-sided and oversimplified version of the past, frequently erasing its contested aspects by silencing eyewitnesses and people directly affiliated with the heritage to be preserved (Graves and Dubrow 2019). Consequently, such approaches severely limit the interpretation of heritage by future generations. Intersectionality, a tool to explore the experience of groups often neglected by existing historiography and heritage preservation, shines a light on such deficits. Based on data collected in a participatory project, this chapter seeks to contribute to these efforts. Focusing on how lay people shaped Exminster Hospital's heritage adds a diverse set of previously silenced voices that challenge the dominant "expert" narrative of this heritage. Engaging in dialogue and sharing diverse stories and memories can simultaneously create and confront heritage that is associated with difficult memories. Only by including such

voices and experiences can we ensure the preservation of heritage that would otherwise be lost with the death of the (lay) people directly affiliated with it. "Lay people" in the context of this chapter refers to anyone who is not an expert or gainfully employed in heritage development. This cohort includes villagers, parish councillors, hospital staff, and the members of societies and pressure groups. "Heritage" encompasses material and immaterial heritage.

Data Sources: Remembering the Mental Hospital

Data underpinning this chapter stems from the project Remembering the Mental Hospital (2015–17). Originally designed to create a digital archive of Exminster Hospital through oral histories, archival research, and art workshops, the project became increasingly focused on issues of memorialization, remembrance, and heritage preservation owing to its participatory setting. Attempting to create a legacy of the hospital, numerous people documented the changes to the hospital site in words, photographs, and drawings after the National Health Service vacated the building:

> As a villager and nurse, I observed and recorded the physical change to the hospital as parts of it were demolished to make way for new houses, roads, and layouts, and how other parts were saved and redeveloped. I was aware, too, of the loosening association the village had with the former hospital as the dispersal of staff and patients gathered pace, and increasingly all that remained was the shell of the former hospital, and as the redevelopment gathered momentum, soon the physical structure lost some of its predominance over the landscape. (EHSM10)

In addition to taking part in the oral history and workshop components, many participants contributed their private archives of the hospital, thereby providing the research team with a wealth of photographs, personal scrapbooks, newspaper clippings, and drawings. These artifacts complement archives created by medical experts and historians. More importantly, however, they offer invaluable insights into lay people's input into the process of redevelopment and heritage preservation, illustrating their efforts, frustrations, successes, and failures.

Exminster Hospital's Redevelopment: Torn between Actors and Agendas

In his "The Water Tower Speech," Enoch Powell (1961) labelled the once praised county asylums as both symbols of fear and oppression but simul-

taneously architecturally impressive monuments. Powell clearly advocated their destruction, unless similar uses for them could be found in the future (Kearns, Joseph, and Moon 2010), a fate that would soon affect Exminster Hospital:

> There they stand, isolated, majestic, imperious, brooded over by a gigantic water-tower and chimney combined, rising unmistakable and daunting out of the countryside – the asylums which our forefathers built with such solidity. Do not for a moment underestimate their power of resistance to our assault ... For the great majority of these establishments there is no appropriate future use, and I for my own part will resist any attempt to foist another purpose upon them unless it can be proved to me in each case that, such, or almost such, a building would have had to be erected in that, or some similar, place to serve the other purpose, if the mental hospital had never existed. (Powell 1961)

Until recently, the continued history and heritage of these institutions have attracted little academic interest. In the United Kingdom, former institutions whose heritage and redevelopment have at least been partly researched include Exminster Hospital (Bowden 2012; Franklin 2002), Moorhaven (Franklin 2002), Parkside (Franklin 2002), St. Lawrence's (Cornish 1997), Hanwell (Fitzherbert 1986), and Colney Hatch (Weiner 2004). Interest has since spread to New Zealand (Moon and Kearns 2016; Moon, Kearns, and Joseph 2006) and North America (Hoopes 2015; Reaume 2016; Witty 2015). As with Exminster Hospital, there is often little engagement with past uses. Heritage advocates focus instead on the preservation of the grounds and building facades (Weiner 2004). Even less attention has been paid to the input and role of lay people in this process. Recent attempts to move heritage away from the "authorized heritage discourse" (Smith 2006, 4) offer such opportunities. Heritage is increasingly seen as a process (Andermann and Arnold-de-Simine 2012; Duncan 1995, Gurian 2006; Kirshenblatt-Gimblett 1998; Smith 2006) that opens a platform for non-experts to get involved in decisions about preservation, memorialization, and the remembrance of heritage. In this context, the focus has shifted to people's perception of heritage (Coeterier 2002; Konijnendijk 2010), with studies showing that increased popularity of heritage in society may also influence lay people's stance toward heritage (Ashworth and Graham 1997; Lowenthal 1998). Participatory and co-production projects have emerged (Graham and Vergunst 2019), emphasizing lay people's activities in heritage

preservation. These activities include sites of conscience practices aimed at fostering public dialogue on social issues and stimulating action about a difficult past (Ševčenko 2010). Psychiatry and its institutions are, as particularly contentious areas of historical research, well suited to such heritage-preservation efforts. Applied in the right way, such approaches offer opportunities both for survivors and for heritage preservers to deal with contested memories in ways that do not resort to "strategic forgetting" and "selective remembrance." These approaches also avoid sensationalist practices such as "ghost walks" (Punzi 2019). Achieving this outcome requires that dialogue be integrated into every stage of heritage management (Ševčenko 2010). In small communities like Exminster, community engagement in "heritage preservation" existed long before the term was even coined, a fact from which the research described here benefited greatly.

Exminster Hospital's first upheaval began in the mid-1960s when it was expected to almost halve the number of its beds and was converted into a psychogeriatric unit for people diagnosed with dementia-related illnesses. This conversion brought about a shift in the hospitalized age groups, as younger patients were successively transferred into newly established community care. In line with most other UK psychiatric institutions, Exminster Hospital's final redevelopment was initially left to the health authority, which owned and managed the buildings, and was based on guidance issued in the 1960s and 1970s, when financial returns dominated redevelopment activities (Franklin 2002). Soon, a lack of proper guidance and financial constraints saw more and more of the institutions either razed or in such a state of disrepair that it caused outrage among many who demanded alternative uses for such buildings (Burrell 1985; Spring 1987). This demand was supported by the fact that, during the 1970s and 1980s, heritage organizations and the general public began to take greater interest in their built heritage, resulting in many former county asylums being declared "listed buildings" (Franklin 2002; MIND 1975). Despite their interest in saving the historic buildings, none of these actors took serious issue with their reuse (Weiner 2004), and it would take until 1995 for the National Health Service and English Heritage to co-produce guidelines for the disposal of the National Health Service's buildings. Although these guidelines also outlined the role that hospital buildings should play in the "social heritage of this country" (Binney 1997, 7), critics argue that much of their content has been ignored and that the term "historic preservation" has been too loosely defined (Binney 1997).

Official plans to redevelop the former asylums fell into two categories (Franklin 2002). During the early days of closure, further institutional or – alternatively – commercial use was envisaged. Among the institutions affected by this focus was Exeter's Wonford House Hospital, which originated as the first privately owned asylum in Exeter and continues its existence as the Royal Devon and Exeter Hospital, serving Exeter's population as a general hospital. In this first phase of redevelopment, many buildings were purchased by the private sector and "gentrified" into "therapeutic landscapes" (Moon, Kearns, and Joseph 2006). About twelve of these former county-asylum sites still function as such in the United Kingdom (Green 2017), with sanctuary, security, safety, and the open landscape featured as key promotional elements.

A second line of development, particularly with the revival of the housing market in the 1990s (Joseph, Kearns, and Moon 2013), was a transition of these public institutions into the private-housing sector. Such moves were facilitated by their location on the outskirts of towns whose urban sprawl turned the sites into valuable land. Unsurprisingly, like Exminster Hospital, they were sold to property developers, who turned them into luxury apartments and gated communities, thereby increasing their value in today's security-seeking society. In line with their continued use as health care facilities, "seclusion" and "sanctuary" feature prominently in sales adverts (Joseph, Kearns, and Moon 2009, 82), and like Devington Park, many have been renamed to include the term "Park" in order to associate them with a healthy and aesthetically pleasing environment. Access to amenities and employment was crucial to these redevelopment activities (Joseph, Kearns, and Moon 2009), leading to the building of new roads, educational facilities, and shops in Exminster village – a move that was not necessarily guided by the surroundings (Franklin 2002, 177) but by red tape. Despite fierce community protests, Exminster saw the former nurses' homes destroyed to make way for the new developments. The managing director of the development company acknowledged that it was ridiculous to destroy the houses, but "they stand right in the way of the new road and the road has to be built where it was put down in the plans" – which had already been approved when the company bought the site (quoted in "Anger as Homes" 1989). Housing redevelopments often leave current residents with little freedom in matters such as managing their own gardens, even if the current situation negatively impacts their quality of living. Here, too, as one Exminster resident pointed out, the rules that applied to the Exminster Parish Council differed from those that applied to the residents:

There is only one [tree] now. They cut down the one on the right. Once we moved in, the council slapped a Tree Preservation Order (TPO) on all the trees of the hospital. In our back garden was a huge sycamore tree. It was subject to this [TPO]. I remember when they developed, they had to build a fence around it to stop the diggers going too close to the roots. My house was so overshadowed. Sycamores have vigorous growth. They grow about almost 10 feet a year. It towered over the house, and I ended up spending more than £1,000 on trying to get permission to cut it down. They insisted there was a TPO on it. They wouldn't let me cut it down. So it's still there. But Bovis [the development company] did actually cut down some of these trees. (EHSM17)

The following section of the chapter traces lay people's input on the transformation of Exminster Hospital from a former county asylum into luxury accommodation.

Lay People's Input into Exminster Hospital 1987–2010s

People affiliated with Exminster Hospital put their mark on the site long before its closure. Owing to the hospital's psychogeriatric focus since the mid-1970s, these people included staff and members of the local community but few patients. Their input created a legacy in the form of material and immaterial heritage, undoubtedly facilitated by strong ties between Exminster village and the hospital: "The whole village was the institution at that time" (EHSF03). Children, for instance, used to play on the premises: "Oh, the conker tree was amazing. Every autumn we'd collect the conkers from the chestnut tree. We'd have a little skewer and some string, and you'd get massive conkers. We'd spend hours throwing things at the tree to get the conkers down. We'd then bring them home and have a little chestnut fire. It was kind of comforting" (EHSF03).

The most visible sign of early material heritage is a bend in the M5 motorway. Plans by the Ministry of Transport in the 1970s to build the M5 near the cricket field on the hospital premises, which would have cut off staff houses from the hospital, met with fierce resistance from hospital staff. After collecting statements from hospital physicians regarding concerns about increased noise levels and noxious gasoline fumes from the road (EHSM04), Ken Beer as council chairman mobilized the local member of Parliament, who achieved a rerouting of the M5 so that it bent away from the hospital – at an additional cost of some million pounds. Furthermore,

the fencing on the M5 was heightened for suicide prevention. One of the local driving forces was again Beer, who became known as "the man who helped to put the bend in the M5," a sentence that he himself uttered proudly when participating in our project. The title of this chapter – "we bent the motorway" (EHSM01) – has become synonymous with community action on Exminster Hospital that is fondly remembered by many villagers and passed on as a legacy to younger generations.

The closure of the hospital brought about new freedoms, new tasks, and new responsibilities but also an eerie feeling, and it created some very special memories:

> When it closed, everyone vacated, apart from myself and one of my colleagues. We were doing the gardens, so when the hospital closed, we were the only two on the whole site. We're talking about 50 acres of all the buildings. Everything was empty, locked up, but we had access to it. We had a bit of the run of the hospital. We wouldn't have a lot of plants, so there wasn't a lot to do, but for a time we were just almost security men. That's what it felt like, just guarding. (EHSM04)

Such strong ties undoubtedly helped to preserve the hospital's legacy in people's minds and acted as incentives to have a say in the hospital's fate – even at a time when the once state-of-the-art psychiatric facility had turned into a run-down, cash-strapped shell of its former self. Yet community attempts to come to the hospital's rescue frequently ended in frustration. The following pages are dedicated to the groups that were, at various stages and with varying intensity, involved in preserving the hospital's heritage.

First, there was the community of Exminster village. Even before the closure, villagers viewed the planned developments with suspicion, and Beer recognized early that "the way we play our cards in the next two or three years will have a crucial effect on our life as a community" (quoted in "Village at the Crossroads" 1987). He promised to press for the retention of the buildings (Bradshaw 1985), preferably as a museum (Puttick 1998b). His plans were overruled, to his utmost frustration: "We did put them under considerable pressure about re-using the buildings in some way, but they said it was commercially unviable and there was no future in trying to re-hash buildings. They were so big, on different levels. So we didn't get very far" (quoted in "Homes Plan" 1985). Whereas Beer was comfortable in his dual role as hospital staff and councillor, others began to feel the pressure:

I was on the parish council in the period when the hospital was closing. We used to sit in this room discussing things, and I wasn't allowed to answer any questions because I was on contract at the hospital and I couldn't talk in front of the press unless I got permission from the management. So I came off the council. It was pointless being on there. (EHSM09)

Exminster villagers opposed the redevelopment plans for a number of reasons. For one thing, they felt that the local area's environmental value would suffer with the building of new roads and houses. A further fear was that the rural atmosphere of Exminster village could be "wrecked by a massive development," and the villagers were determined to "do [their] utmost to prevent this" (Tim Beer, quoted in "Village's Fear" 1985). Finally, there were concerns over health and safety during the redevelopment period, as various groups, including vandals, children, and travellers, began to leave unwanted marks on the hospital that created unsavoury legacies: "Thieves took slates from the roof. I had a marble fireplace in my office. They took that" (EHSM02). The most serious of these attacks happened in 1990, when more than 1,000 windows were smashed, suspending ceilings destroyed, and light fittings ripped off the walls – just after some of the buildings had been painstakingly restored earlier that year (Brown 1990). The derelict hospital also attracted other unwelcome visitors, including a group of travellers forced to leave the City of Exeter. Villagers expressed concerns after a previous group of travellers had left rubbish, walked round with air guns, and played loud music during the night (Puttick 1998c). Partly, however, they also feared for the welfare of the travellers' children being so close to the asbestos-infested building ("Travellers Vacate" 1998). Health concerns were not without reason, as children using the derelict hospital site as a playground had come to harm before (Sims 1998a). The council's pleas to parents not to let children access the site were ignored (Puttick 1998a). Such events resulted in renewed calls to make the hospital safe, and the collections of newspaper clippings that now fill many scrapbooks have left a legacy of the hospital. The massive community support for the rescue of the hospital is further evident in letters and articles published in the local newspapers, which served as public outlets for the discussions (Le Roux 1998). Yet achievements were painfully slow to materialize and did not always meet expectations: "I was a councillor and also a mental health manager on panels. Eventually, we got action. Prince Charles was interested in doing something. He runs a heritage group – with money – and he was in the

frame for quite a time until this firm came along and took the derelict hospital" (EHSM02).

The villagers' concerns were pitted against the perspective of the South West Regional Health Authority, which was seeking the best commercial value, whereas the council suggested a development with some open space (Kemp 1985). Selling the land would provide much-needed cash for the health services. Thus Exminster Hospital was to be "mothballed" in case patients needed to be evacuated to Exminster during the rebuilding of the Royal Devon and Exeter Hospital ("Hospital to Be Mothballed?" 1986). Also, further land would ameliorate the local housing crisis ("Objection Outweighed" 1987). Although nobody doubted that the lost income from hospital rates would have to be replaced, villagers feared that financial reasons would dominate and that the hospital might be sold to the highest bidder regardless of the interests of the village (Worrall 1984). Beer's acrimonious comment that it is "difficult to deal with a faceless authority many miles away" (quoted in "Patients Warned" 1985) attests to the tenacious negotiations with the health authorities. Hoping for closer consultation of the health authority with the council, he was joined by neighbouring councillors in criticizing decisions being made about but not with Exminster: "[Whitehall officials are] shirking their responsibilities ... They are sitting in their offices, they don't have to see the hospital, and they don't have to live next to it. It means nothing to them, but it does matter to [our] people" (Connett, quoted in Beer 1998). In 1987, chartered surveyor Christopher Ayres acquired the hospital. Plans to convert it to office space, however, were rendered unviable by the market downturn. Converting it into luxury flats would have cost more than building new ones. Five years later, Ayres considered the building "beyond economic repair for commercial purposes" (Corlett 1995) owing to dry rot and because it had been stripped of tiles and lead by vandals. Ayres withdrew security, as he had run out of money (Corlett 1995), and security guards had disappeared from the site by 1988 ("Gypsies Move" 1996). When, in 1994, the hospital was "bought" for £1 by Heritage Developments (Puttick 1998b), but then left derelict, it was again villagers who fought the deterioration of the hospital by patrolling the premises regularly (Puttick 1998b).

Second, there were the heritage organizations that supported the villagers. A preservation order on the lower part of Exminster Hospital had been giving the health authority early headaches: "Some of the best brains in the country are now trying to find the best possible use for the buildings, which

are considered to be part of our architectural heritage – any good ideas would be welcomed by the authority" (Jackson, quoted in "Hospital to Be Mothballed?" 1986). As demolition plans were leaked, the steering committee of the Devon Buildings Group voiced its concerns over the disappearance of "a major building of national importance" (Cox 1985). The issue attracted national interest, with the Victorian Society of London promising to save the iconic building. Yet, when eventually the Historic Buildings and Monuments Commission issued a Grade II listing for most of the buildings, it rendered redevelopment more difficult. In the meantime, the hospital was left to decay:

> When the hospital closed, the Tiverton-based company bought it, went bust, couldn't afford it. There was a lot of wrangling going on, people stealing everything. So the council ended up putting a big fence around it. I remember seeing a figure of £1,500 at the time to make it secure. They tried to get the money off the building company. The building company virtually gave it for a peppercorn. (EHSM08)

Pressure mounted to identify landmarks in the Exeter area as being under threat and then to put them on the national register of buildings at risk. Exminster Hospital was among 126 buildings added to the register ("At Risk Buildings" 1998), but action remained limited. Owing to the hospital's increasing state of disrepair, the council pursued the rescue mission at the national level, pleading for government intervention in 1996. It achieved a note to protect Center House but not the wings of the building where the patients were housed ("Top-Level Action" 1998). The pressure group Save Britain's Heritage appealed to the Phoenix Trust – a charity set up by Prince Charles – which hoped to put together a rescue package for the hospital (Sims 1998b). The prince's interest is said to have influenced the decision of Virginia Bottomley, the government's national heritage secretary, to issue an order for its immediate repair, which English Heritage would carry out and charge to the owner (O'Neill 1996). Eventually, Devington Homes, under Lawrence Butler, narrowly beat the Phoenix Trust to the post for the renovation project.

Third, there were sports groups and charitable organizations. Exminster Hospital was known for its marvellous, excellently kept premises. During the hospital's existence, sports groups in Exminster and the wider Exeter area used the hospital's sports grounds regularly for tournaments between hospital and local teams and between hospital patients and staff. The closure

of the hospital presented an opportunity to take over excellent facilities. The secretary of the Devon Playing Field Association, which saw the closure as maybe "the only opportunity of more recreational land coming up," urged the association "to sweep aside all obstacles and get hold of these facilities" ("Don't Let Opportunity" 1986). Today, a bowling green and a football ground still remain. The former occupational therapy facilities have been converted into a local community centre with regular activities. The sanatorium, formerly used to house hospital patients with tuberculosis, is now the seat of rehabilitation vocational services. Five different businesses use the premises to prepare people experiencing mental distress to return to paid work. The services are well frequented – not least because the local community is familiar with mental health services being located in these buildings.

Conclusion: Creating a Legacy of the Hospital

On the one hand, Exminster Hospital's journey from nineteenth-century state-of-the-art county asylum to luxury residential estate can be described as "a classic disaster story of what happens to listed hospitals if their future is not properly sorted out by the health authority and no one takes responsibility for the buildings" (Phillips, quoted in Barrie 1996). This chapter has illustrated how the impasse created by red tape designed to protect the nation's heritage stifled efforts to ensure the hospital's timely rescue and how this setback caused frustrations among the local community. On the other hand, considerable parts of the hospital have been preserved – not least through the efforts of lay people – and are now integral parts of Exminster village. The luxury residential estate occupies the former administrative building of the hospital and the six wings that used to house the original wards. Many elements of the former hospital were kept, including the original kitchen, which has become a feature of the enclosed garden. The deconsecrated hospital chapel now serves as a primary school, and as mentioned above, the playing fields and former occupational health units are used by local sports groups and charities. In this context, community input not only helped to save parts of the hospital by turning them into places where the community can come together but also brought money to the area through housing development. Other material heritage has been created, such as by naming some of the newly built roads after people affiliated with the hospital (Baur forthcoming). In September 1987, a remembrance service was conducted at Exminster Parish Church for everybody connected with the hospital, during which a commemorative plaque was unveiled as

"something permanent to commemorate the hospital's life time" ("Salute to Hospital" 1987). Immaterial heritage includes annual staff dinners to keep memories alive as well as the stories that are passed on from one generation to the next about the hospital being haunted. The latter practice has to be seen somewhat critically, as it raises ethical concerns about how we interpret and pass on traumatic experiences and thus treat the feelings of survivors. In recent years, former psychiatric hospitals have sold their "haunted histories" by offering ghost experiences (e.g., Punzi 2019). Such activities have not only polarized local communities but also distracted from the efforts of survivors to expose traumatic experiences, or as Waldron (2020, 585) argues, they "maintain the voice-lessness of the oppressed and ... objectify their experiences for the purview of others." Although Exminster Hospital does not capitalize on these darker stories, they linger in people's memories and therefore perpetuate the stereotypes of danger and violence so often associated with these institutions.

Print of a stone carving depicted in collagraph technique.

Finally, the project Remembering the Mental Hospital supported the creation of a legacy of Exminster Hospital. Through its participatory approach, the project turned lay people's memories and archives into material and immaterial heritage. Material artifacts include items for practical everyday usage, such as cotton bags with prints of hospital buildings, as well as more arty items, such as prints, poems, and handwritten postcards. Among the educational outputs is a lesson kit for Grade 6 pupils that is anticipated to familiarize a future generation with the hospital and to inspire the conservation of its heritage.

One of the artworks created by the author in a workshop jointly organized with an Exeter-based printmaking organization is shown in the image above. Applying the collagraph technique, it displays bricks in the hospital wall, some of which had the words "jam," "biscuit," and "different" carved into them. It is not known who created the carvings, but project participants confirmed that they were there during the existence of the hospital.

NOTE

1 For confidentiality reasons, interview participants are referred to by the codes allocated to them.

REFERENCES

Andermann, Jens, and Silke Arnold-de-Simine. 2012. "Introduction: Memory, Community and the New Museum." *Theory, Culture and Society* 29 (1): 3–13.

"Anger as Homes Demolished." 1989. *Express and Echo*, January 12.

Ashworth, G.J., and Brian Graham. 1997. "Heritage, Identity and Europe." *Tijdschrift voor economische en sociale geografie* 88 (4): 381–88.

"At Risk Buildings 'Must Be Saved.'" 1998. *Express and Echo*, May 19.

Barrie, Patrick. 1996. "Buildings Fan Charles Gives Asylum a Boost." *Express and Echo*, July 5.

Baur, Nicole. Forthcoming. "Unsettling the Past: Creating a Multi-vocal Heritage of the Devon County Mental Hospital through Co-production and Performance." In *Narrating the Heritage of Psychiatry*, ed. Christoph Singer et al. Leiden, Netherlands: Brill.

Beer, Nick. 1998. "Hospital Wrangle in Court." *Express and Echo*, January 19.

Binney, Marcus. 1997. *Hospitals: A Medical Emergency.* London: SAVE.

Bowden, Kirstie. 2012. "Glimpses through the Gates: Gentrification and the Continuing Histories of the Devon County Pauper Lunatic Asylum." *Housing, Theory and Society* 29 (1): 114–39.

Bradshaw, Ben. 1985. "Bulldozer Plan Sparks Red Alert." *Express and Echo*, July 2.

Brown, Mike. 1990. "Track Down the Vandals." *Express and Echo*, July 12.

Burrell, John. 1985. "A Sane Environment." *Building Design* (760): 18–19.

Coeterier, J.F. 2002. "Lay People's Evaluation of Historic Sites." *Landscape and Urban Planning* 59 (2): 111–23.

Corlett. Roy. 1995. "Criticism Rejected by Asylum Owner." *Express and Echo*, July 2.

Cornish, Claire V. 1997. "Behind the Crumbling Walls: The Re-working of a Former Asylum's Geography." *Health and Place* 3 (2): 101–10. https://doi.org/10.1016/S1353-8292(97)00004-X.

Cox, J.H. 1985. "Important Building." *Express and Echo*, July 9.

Devington Park. n.d. https://www.devington.co.uk/.

"Don't Let Opportunity Slip Away." 1986. *Express and Echo*, February 27.

Duncan, Carol. 1995. *Civilizing Rituals: Inside Public Art Museums*. London and New York: Routledge.

Fitzherbert, K. 1986. "Monument to Humanity: Hanwell Lunatic Asylum." *Country Life*, May 22, 1460–61.

Franklin, Bridget. 2002. "Hospital – Heritage – Home." *Housing Theory and Society* 19 (3–4): 170–84.

Graham, Helen, and Jo Vergunst. 2019. *Heritage as Community Research: Legacies of Co-production*. Bristol, UK: Bristol University Press.

Graves, Donna, and Gail Dubrow. 2019. "Taking Intersectionality Seriously: Learning from LGBTQ Heritage Initiatives for Historic Preservation." *Public Historian* 41 (2): 290–316.

Green, Joshua. 2017. "Towards a Conceptual Understanding of the Continuing Presence of the Psychiatric Asylum in Contemporary Urban Britain." PhD diss., University of Southampton.

Gurian, Elaine Heumann. 2006. *Civilizing the Museum: The Collected Writings of Elaine Heumann Gurian*. London and New York: Routledge.

"Gypsies Move on to Hospital Site." 1996. *Express and Echo*, July 30.

"Homes Plan to Replace Most of Hospital." 1985. *Express and Echo*, April 7.

Hoopes, Lauren. 2015. "On the Periphery: A Survey of Nineteenth-Century Asylums in the United States." MA thesis, Clemson University.

"Hospital to Be Mothballed?" 1986. *Express and Echo*, November 29.

Joseph, Alun, Robin Kearns, and Graham Moon. 2009. "Recycling Former Psychiatric Hospitals in New Zealand: Echoes of Deinstitutionalisation and Restructuring." *Health and Place* 15 (1): 79–87.

—. 2013. "Re-imagining Psychiatric Asylum Spaces through Residential Redevelopment: Strategic Forgetting and Selective Remembrance." *Housing Studies* 28 (1): 135–53.

Kearns, Robin, Alun Joseph, and Graham Moon. 2010. "Memorialisation and Remembrance: On Strategic Forgetting and the Metamorphosis of Psychiatric Asylums into Sites for Tertiary Educational Provision." *Social and Cultural Geography* 11 (8): 731–49.

Kemp, Susan. 1985. "'United Front Is the Best Hope.'" *Express and Echo*, July 16.

—. 1987. "Uncertain Future as Hospital Closes." *Express and Echo*, July 17.

Kirshenblatt-Gimblett, Barbara. 1998. *Destination Culture: Tourism, Museums, and Heritage*. Berkeley: University of California Press.

Konijnendijk, Thijs. 2010. "Forget about World Heritage: What Are the Values?" MA thesis, University of Utrecht.
Le Roux, Clare 1998. "Let's Support Old Hospital." *Express and Echo*, April 1.
Lowenthal, David. 1998. *The Heritage Crusade and the Spoils of History*. Cambridge, UK: Cambridge University Press.
MIND. 1975. *Hospital Land: A Resource for the Future?* London: MIND.
Moon, Graham, and Robin Kearns. 2016. *The Afterlives of the Psychiatric Asylum*. London and New York: Routledge.
Moon, Graham, Robin Kearns, and Alun Joseph. 2006. "Selling the Private Asylum." *Transactions of the Institute of British Geographers* 31 (2): 131–49.
"Objection Outweighed by Benefit Claim." 1987. *Dawlish Gazette*, June 25.
O'Neill, Sean. 1996. "Prince Steps In to Save Old Asylum from Ruin." *Daily Telegraph*, July 5.
"Patients Warned by Village Leader." 1985. *Express and Echo*, April 29.
Powell, Enoch. 1961. "The Water Tower Speech." Address to the Annual Conference of the National Association for Mental Health, Brighton, England, March 9.
Punzi, Elisabeth. 2019. "Ghost Walks or Thoughtful Remembrance: How Should the Heritage of Psychiatry Be Approached?" *Journal of Critical Psychology, Counselling and Psychotherapy* 19 (4): 242–51.
Puttick, Helen 1998a. "Children Warned Clear of Hospital." *Express and Echo*, n.d.
–. 1998b. "Time Running Out for a Grand Old Hospital." *Express and Echo*, January 28.
–. 1998c. "'Travellers Must Go' Say Villagers." *Express and Echo*, August 21.
Reaume, Geoffrey. 2016. "A Wall's Heritage: Making Mad People's History Public." *Public Disability History*, November 21. https://www.public-disabilityhistory.org/2016/11/a-walls-heritage-making-mad-peoples.html.
"Salute to Hospital Plaque Unveiling." 1987. *Express and Echo*, September 17.
Ševčenko, Liz. 2010. "Sites of Conscience: New Approaches to Conflicted Memory." *Museum International* 62 (1–2): 20–25.
Sims, Rob. 1998a. "Government Is Urged to Buy Hospital." *Express and Echo*, March 10.
–. 1998b. "New Probe over Cash for Former Hospital." *Express and Echo*, May 28.
Smith, Laurajane. 2006. *Uses of Heritage*. London and New York: Routledge.
Spring, Martin. 1987. "Clearing Mental Blocks." *Building*, May 1, 28–29.
"Top-Level Action over Former Hospital." 1998. *Express and Echo*, March 28.
"Travellers Vacate Hospital Site." 1998. *Express and Echo*, May 27.
"Village at the Crossroads." 1987. *Express and Echo*, April 23.
"Village's Fear." 1985. *Express and Echo*, July 4.
Waldron, David. 2020. "The Legend of Madman's Hill: Incarceration, Madness and Dark Tourism on the Goldfields." In *The Palgrave Handbook of Incarceration in Popular Culture*, ed. Marcus Harmes, Meredith Harmes, and Barbara Harmes, 575–87. Cham, Switzerland: Palgrave Macmillan/Springer Nature.
Weiner, Deborah. 2004. "The Erasure of History: From Victorian Asylum to 'Princess Park Manor.'" In *Architecture as Experience: Radical Change in Spatial*

Practice, ed. Dana Arnold and Andrew Ballantyne, 190–209. London and New York: Routledge.

Witty, Sara. 2015. "Asylum Myth and Material: A History of the St. Peter Regional Treatment Center 1866–Present." PhD diss., University of Wisconsin Madison.

Worrall, Geoff. 1984. "Village Concern at Hospital's Future." *Express and Echo*, February 27.

Contributors

Niklas Altermark is a senior lecturer in the Department of Political Science at Lund University in Sweden. His research is focused on the biopolitics of intellectual disability and welfare-state retrenchment. He is the author of *Citizenship Inclusion and Intellectual Disability: Biopolitics Post-Institutionalisation* (Taylor and Francis, 2017).

Gavin J. Andrews is a professor in the Department of Health, Aging and Society at McMaster University in Canada. A geographer by training, he is interested in the role of space and place in the production of a range of phenomena related to health and aging. Much of his work is theoretical and positional, and it considers the progress and future of health and human geography.

Nicole Baur is a health geographer with a strong interest in heritage studies, particularly mental-health heritage. In 2005, she completed her PhD at the University of Heidelberg in Germany and has since been working at several Russell Group universities in England and Scotland. She has been researching Exminster Hospital since 2007 and has authored and co-authored articles and chapters on her research that appear in international journals and books.

Verusca Calabria is an oral historian and a senior lecturer in health and social care, in the Department of Social Work at Nottingham Trent University in the United Kingdom. Her research sits at the intersection of the history and heritage of mental healthcare. She is the principal investigator of a National Lottery Heritage Fund project entitled "Fifty Years of Middle Street Resource Centre: The Heritage of Wellbeing in the Community." She co-founded and co-convenes the NTU Oral History Network and is a trustee of the Oral History Society.

Matilda Svensson Chowdhury has a PhD in History and is senior lecturer at the Department of Social Work at Malmö University in Sweden. Her research is focused on normative understandings of bodies and brains and their effects on individuals, groups, and societies. She co-edited "Exploring Swedish 'Family Planning': Reproductive Racism and Reproductive Justice" in *Struggles for Reproductive Justice in the Era of Anti-Genderism and Religious Fundamentalism* (Palgrave Macmillan, 2023).

Bec Dean is a curator, writer, educator, and consultant with a background in photo media and performance art. She has worked for multi-disciplinary and interdisciplinary contemporary arts organizations in Australia since 1996 and has been curating interdisciplinary and experimental exhibitions and producing events for two decades. Her recent curatorial projects focus on health and wellbeing, including The Patient, How the City Cares, and The Empathy Clinic (with Jill Bennett). She is currently senior manager of policy and partnerships for the state funding agency Create NSW.

Elena Demke is a historian who has published widely on German memorial culture, visual history, and didacts of history, as well as the history of empirical psychology and Mad history. She is also the initiator of the project Museum Anderer Dinge (MAD) (museumandererdinge.de) and teaches at the University of Luxembourg.

Rory du Plessis is a senior lecturer in visual studies in the School of the Arts at the University of Pretoria in South Africa. He is the co-editor of the academic journal *Image & Text* and author of *Pathways of Patients at the Grahamstown Lunatic Asylum, 1890 to 1907* (PULP, 2020). He has also pioneered the investigation of photographic records from South African psychiatric facilities.

Contributors

Rob Ellis is a reader in history at the University of Huddersfield in the United Kingdom. He has published widely on the histories of mental ill-health and learning disability and has worked in partnership to co-produce projects that have emphasized their contemporary relevance.

Alex Green is an adjunct lecturer in public policy at Harvard Kennedy School in the United States. He is a fellow of the Harvard Law School Project on Disability and a visiting scholar at the Brandeis Heller School Lurie Institute for Disability Policy.

Lily Hibberd is an interdisciplinary artist and writer working on frontiers of time and memory through performance, writing, painting, photography, video, sound, and installation art. Her collaborative and solo projects have been exhibited in museums, festivals, and contemporary art galleries in Europe, Asia, and Australia. She is founding editor of *un Magazine*, co-founder of Parragirls Memory Project, associate researcher at Université Paris Cité, and adjunct lecturer at UNSW Sydney.

Nigel Ingham is a writer and researcher, with particular interests and expertise in the social history of learning disability, community oral history, and participatory research methods. He has been a key member of The Open University's Social History of Learning Disability Research Group since 2000, participating in its co-produced publications and events. Nigel curates an archive and a website of oral histories, photographs, objects and documents relating to the experiences of former residents and staff of former northwest England large long-stay institutions for people with learning difficulties.

Robin Kearns is a professor of geography and head of the School of Environment at the University of Auckland in New Zealand. His PhD thesis at McMaster University in the 1980s focused on the life worlds of chronic psychiatric patients displaced by hospital closures. He co-authored *The Afterlives of the Psychiatric Asylum* (2015, Routledge) and is currently completing a book on islands and health.

Evadne Kelly is an adjunct professor at Re•Vision: The Centre for Art and Social Justice at the University of Guelph in Canada. She is a dance artist, educator, and interdisciplinary scholar who has led and co-created

award-winning projects that expose and counter histories and legacies of eugenics in education. Her arts-based research is focused on collectively creating conditions of knowing for social justice and decolonizing aims.

Helena Lindbom holds a bachelor's degree in social anthropology and is a retired journalist. She has, for periods of her life, experienced overwhelming psychological distress and has been in outpatient and inpatient psychiatric units over several decades. She was a patient during a time when heavy medications that are no longer permitted were administered with devastating effects, which she considers to be a part of the historical record that should not be forgotten or excused. Having worked with creative-writing groups for elderly citizens, she is interested in heritage and history, in literature and reading, and in spending time in nature.

Justine Lloyd is a senior lecturer in sociology at Macquarie University in Australia. Her work broadly investigates the connections between social and spatial justice, and she has a particular interest in contested sites and cultural memory. Her recent publications include "The Non-Sexist City: Then and Now" in the edited collection *Contentious Cities* (Routledge, 2021) and "Social Movements" in *Australian Politics and Policy* (Sydney University Press, 2023).

Nicole Matthews is an associate professor who teaches media and cultural studies at Macquarie University in Australia. Her research explores the nexus between digital media, education, disability, and deaf studies. Her most recent co-authored book is *Digital Storytelling in Health and Social Policy: Listening to Marginalised Voices* (Routledge, 2017). She has published on lived-experience narratives in broadcast, digital, and social media and on their uses in professional education and healthcare contexts.

Graham Moon is Emeritus Professor in the School of Geography and Environmental Science at the University of Southampton in the United Kingdom. He founded the journal *Health and Place* and has played a leading role in the reformulation of health geography. His research focuses on the difference that place makes to health and health care, largely in relation to health-related behaviour and to mental health care.

Janet Overfield Shaw is committed to ensuring that her work is inclusive, creative, and led by excluded voices. Her research interests are concerned with evidencing the impact that female guardians had on the Workhouse system and how this impact instigated a cultural, political, and societal change in this system.

Elisabeth Punzi is a licensed psychologist, specialist in clinical psychology, specialist in neuropsychology, PhD, and associate professor in the Department of Social Work, at University of Gothenburg in Sweden, where she is also director of doctoral studies. In addition, she directs the work with heritage and well-being for the Center for Critical Heritage Studies at University of Gothenburg. She teaches courses in mental health and research methodology and has a research interest in the heritage of psychiatry, Mad studies, and in the meaning of creative expressions and places. She is co-editor of the books *Negotiating Institutional Heritage and Wellbeing* (Brill, 2021) and *Narrating the Heritage of Psychiatry* (Brill, forthcoming) and co-editor of *Narrative and Mental Health: Reimagining Theory and Practice* (Oxford University Press, 2023).

Geoffrey Reaume is an associate professor of critical disability studies in the Faculty of Health at York University in Canada. He earned his PhD in History in 1997 at the University of Toronto and created the first university credit course in Mad People's History, which he has been teaching since 2000.

Carla Rice is Canada Research Chair and professor in the College of Social and Applied Human Sciences and founding director of the Re•Vision Centre for Art and Social Justice at the University of Guelph in Canada. She specializes in disability and embodiment studies and in arts-based research methodologies with a focus on changing systems and fostering social well-being and justice.

Jen Rinaldi is an associate professor of legal studies in the Faculty of Social Science and Humanities at Ontario Tech University in Canada. Her research takes up disability and queer critical theory in service of deinstitutionalization and prison and police abolition.

Cecilia Rodéhn is an associate professor of conservation and works as a senior lecturer at the Centre for Gender Research at Uppsala University in Sweden. She holds a PhD in museum studies from the University of KwaZulu-Natal in South Africa. Her research interest revolves around issues of cultural heritage, post-asylum landscapes, and Mad Studies.

Kate Rossiter is an associate professor in the Department of Health Studies at Wilfrid Laurier University in Canada. Her award-winning research combines critical health and disability studies with participatory and arts-based methodologies.

Linda Steele is an associate professor in the Faculty of Law at the University of Technology in Sydney. Dr. Steele is a socio-legal researcher working at the intersections of disability, law, and social justice, with a particular focus on the law's role in enabling violence, the institutionalization and segregation of disabled people, and, in turn, the possibilities and limits of engaging with legal methods (such as litigation, redress schemes, truth commissions, and law reform) and non-legal methods (such as sites of conscience and community education) to work with disabled people to achieve social justice. She is the author of *Disability, Criminal Justice and Law: Reconsidering Court Diversion* (Routledge, 2020) and co-editor of *Legacies of Institutionalisation: Disability, Law and Policy in the 'Deinstitutionalised' Community* (Hart, 2020) and *Normalcy and Disability: Intersections among Norms, Law, and Culture* (Routledge, 2018).

Liz Tilley is a professor of learning disability studies in the School of Health, Wellbeing and Social Care, at The Open University in the United Kingdom. Her research is focused on reducing health and social inequalities for people with learning disabilities, using inclusive methodologies. Liz co-chairs the international Social History of Learning Disability Research Group and has a long-standing interest in how people with learning disabilities can be supported to access, participate in, and actively shape history, heritage, and archival practices.

Jan Walmsley is an independent consultant, teacher, and researcher with honorary Chairs at The Open University in the United Kingdom and at the University College Cork in Ireland. She is a trustee of Learning Disability England and has been a trustee helper at My Life My Choice, Oxfordshire's

self-advocacy charity since 2012. She is the co-author of *Inclusive Research with People with Learning Disabilities: Past, Present and Futures* (Jessica Kingsley, 2003), regarded as a key text even to this day. Jan was a founding member of the United Kingdom's Open University's Social History of Learning Disability Research Group in 1994, which has used an inclusive approach to furthering the history of intellectual disability through publications and conferences. She now teaches history to people with learning disabilities in a variety of contexts.

Wart (a.k.a., Jen Waterhouse) has worked in the visual and performing arts in Sydney since 1980. She has consistently exhibited and worked as an illustrator, designer, cartoonist, painter, performer, and poet. With her own experiences of institutionalization, Wart has also focused for decades on mental health advocacy and support. From 2010 to 2012, Wart established and ran a working artist's studio for people living with mental illness at Daintree Lodge in the Rozelle Hospital in Sydney, Australia. In 2019, Wart undertook a residency at Bundanon Trust and performed at Cementa19, both in regional New South Wales. That same year, Wart received the inaugural Artist with Disabilities Fellowship from the Australia Council.

Index

Abbas, Asma, 76
ableism: about, 294; and active-passive binary, 290; assumptions, and lack of recognition of Aktion T4 crimes, 51; in cultural heritage, 291, 294–95; defined, 285; disability vs., 293; and forgetting, 294; and invisibility of people with disabilities, 285; medical advancements and, 293; and naming, 284; and remembering vs. forgetting, 294; and sexism, 291; social class and, 291–92; in street naming, 20, 285, 294; and success vs. failure, 293; and truth, 86; and universities, 291–92; in University of Guelph President's Messages, 219
Aboriginal people (Australia), 121; consultation with, 120–21; at Lavender Bay, 147; planning proposals/heritage reports on, 118–19; redevelopment consultation with, 120–21; and remembrance, 256–57; as residents in Peat Island Centre, 120–21; women coming together/sharing, 255–56, 261. *See also* Indigenous peoples
abuses: absence in records, 117; acceptable practice vs., 236; at Cawston Park Hospital, 231; at Cygnet Yew Trees Hospital, 231, 243; dehumanizing practices by staff, 232; at Ely Hospital, 236, 240; family complaints regarding, 112–13; Farleigh Hospital inquiry, 236, 237, 238, 240, 242; of humour, 245; at Huronia, 93, 102; inability to name, 237; of Indigenous children with disabilities, 234; institutional culture and, 242–43, 244; at Kingseat Hospital, 269, 272; legitimization of, 235; medical hierarchy in, 243; neglectful/degrading practices as, 238–39; normalization of, 236–38; patient narratives and, 255; at Peat Island Centre, 112–13; perspective of perpetrators regarding, 103; Princess Marina Hospital, 241; reasons for persistence of, 233, 244; returning to place of, 256; Royal

Index

Albert Hospital, 240, 241; sexual, 99; silence and, 82, 239; at South Ockendon Hospital, 241; of staff, 241–42; staff collusion in, 231, 233, 234, 238–40, 241, 242–43, 244, 245; staff reporting/questioning, 239, 240–43; trade unions vs. staff complainants regarding, 242; Turner Village, 240–41; at Winterbourne View, 231, 242–43. *See also* violence

academic historians: and activists, 31–32, 33, 39–40; heritage profession vs., 40; and Mad studies, 31–32; marginalization by, 15

access: to Aktion T4 memorial sites, 76; belonging to site vs., in redevelopment, 120; and erasure, 76; to heritage sites, 263; to memorial sites, 67–69; to sites of conscience, 14; to Workhouse and Infirmary, 188

activism/activists: academic historians and, 31–32, 33, 39–40; and antipsychiatry, 32, 34, 39, 40; through artistic practice, 12; and critical heritage studies, 30; deinstitutionalization and, 8, 87; on deinstitutionalization and social justice, 7; disability arts/culture and, 170; regarding Aktion T4 murders, 50; and unpaid labour, 30

Adam (Shenley Hospital patient), 128

Ahmed, Sara, 215, 216, 217, 220, 221, 223

Aktion T4, 48–49; 14f13 phase, 77; absence of direct witnesses to, 67, 69–70; archives and, 53; commemoration, 49; commemoration of, 48; compensation for, 49; contemporary psychiatry compared to, 52–53; erasure of, 69; eugenics and, 65; gassing, 46, 48; Holocaust compared, 52–53; lack of memorials for disabled victims, 68; machinery moved to Poland, 64; marginalization of, 68–69; perpetrators' everyday lives, 70; perpetrators' materials, 72–74; perpetrators' trials, 50; process, 49; of psychiatric patients, 64; remembrance of, 15–16, 54; removal of apparatus to Poland, 75; silence regarding, 50; stretchier witnessing to, 66; study of, 66. *See also* Tiergartenstraße 4

Aktion T4 killing centres, 64; art from, 71–72; Bernburg, 64, 69–70, 74, 76; Brandenburg on the Havel, 56–57, 72–73, 74; comparisons/contrasts of, 67; disposal of ashes, 69–70; Grafeneck, 64, 72–73, 74, 75; Hadamar, 64; Hartheim Castle, 64, 69–70, 72, 74–75; material remains from, 74–75; medical files, 70–72, 73; as memorials, 67; numbers of child victims, 71; Pirna-Sonnenstein, 64, 69–70, 72, 73, 74, 75; variable locations of, 69

Aktion T4 memorial sites: accessibility, 76; difficulty in keeping open, HTH, 70; digital records, 73; and disabled vs. non-disabled audience, 76; lack for T4 disabled victims, 68; survivors of Aktion T4 and, 54–57; Tiergartenstraße 4, 52–53, 54; victim biographies, 73–74; victims' names on glass walls, 72–74; website, 73–74

Aktion T4 survivors: activism, 50; compensation for, 50–51; disputed significance of survivorship and, 56; inclusion of, 58; lack of, 66, 69; legal status, 50–51; Manthey, 71; and memorial site, 54–57

Aktion T4 victims: ash/bone remains, 74, 75; biographies, 73–74; lack of testimonies, 72; names on glass walls, 72–74; open listings of names of, 67; personal items, 74–75

Alexandra Hospital (Cape Town), 198

Allen, Jennifer L., 54, 59

Altermark, Niklas, 17–18, 315

Aly, Götz, 53
Åman, Anders, 292–93
Americans with Disabilities Act, 6
amnesia. *See* forgetting
Andersen, Sue, 122
Andrews, Gavin J., 19, 315
Andrews Zucker, Gina, 122
Ankers, Brian, 239
anti-psychiatry, 32; activism/activists and, 34, 39, 40; commemoration as, 35, 36–37, 39; movement, 129; survivor movement in Germany and, 35; voices/memories as, 15
apologies, 13, 41
archives: absences in, 95; and Aktion T4 murders, 53; archons and, 97, 103; behavioural, 98–99; building of digital, 103; Catholic Church and, 104*n*2; contradictions in interpretation, 92; defined, 94; double meaning of, 95; East German secret police, 53; ephemera, 92, 101; eugenics, 221–22; Exminster Hospital, 300, 311; and forgetting, 92, 95; gaps in, 95–96; Huronia Regional Centre, 16, 91–92, 94–96, 98–99, 101–2; interpretations of, 98–99; Lillhagen, 252; and lived experience, 92; and memory, 92, 103; oral histories vs., 222; photographs in, 101–2; postmodern theory, 92, 97, 104*n*3; PSAT and, 32–33; reconstitution of, 100, 103; of residential schools, 104*n*2; truth and reconciliation and, 87, 88; Workhouse and Infirmary, 195
Arnold de Simine, Silke, 257
art: from Aktion T4 killing centres, 71–72; in Benevolent Asylum, 145, 146, 150–51; disability activism through, 12; ficto-historical, 145; at Haus des Eigensinns/Museum of Mad Beauty, 59; at Lillhagen Hospital, 253, 260–61; lived experience in, 159; memories and, 155; performance, 17; Prinzhorn Sammlung, 55–56, 57; and street naming, 253; at Tiergartenstraße 4, 59; at Workhouse and Infirmary, 187, 190, 191–95; workshops regarding Exminster Hospital, 300, 310(f), 311
Art Barton Park, 164*n*11
Asylum, 127
The Asylum and the Workhouse (Backlit), 187, 187(f)
Athanasiou, Athena, 69
Atwood, Margaret, 104*n*4
Australian Broadcasting Corporation: on Luna Park, 164*n*9; on Peat Island Centre, 113, 116, 122
Avery, Scott, 8
Ayres, Christopher, 307
Azaryahu, Maoz, 288–89, 294

Backlit, *The Asylum and the Workhouse*, 187, 187(f)
Bacopoulos-Viau, Alexandra, 31–32, 39–40, 42*n*1, 137
Bardsley, Janet, 235
Barnum, P.T., 90
Barrett, Mike, 85
Barton, Arthur, 164*n*11
Bauman, Zygmunt, 66
Baur, Nicole, 20, 315
Beardshaw, Virginia, 239, 240, 241, 242
Becher, John Thomas, 183
Beer, Ken, 298, 304–5, 307
Ben (Cawston Park Hospital patient), 231
Benevolent Asylum: art in, 145, 146, 150–51; Concord Hospital in, 148–49; devising of, 145; An Eclipse of Historical Fiction (Hibberd), 164*n*7; Just for Fun, 149, 150, 152–53, 152(f), 153(f), 154–55, 156, 159, 160(f); Lavender Bay in, 147–48; location of, 146; Luna Park in, 148; and mental health institution as embodied form, 156; as performance, 156; poetry in, 145, 146–47,

Index

156–58; purpose of, 148; Villawood Immigration Detention Centre in, 146–47
Benevolent Asylum (Melbourne), 151, 164*n*7
Ben-Moshe, Liat, 6
Berlin Irrenoffensive, 54
Bernhard Jacobowskys väg, 287–88
Berlin Philharmonic Orchestra, 51, 59
Berlin Wall, 53, 71
Berliner Ärztekammer (Berlin Medical Association), 53, 58
Berliner Geschichtswerkstatt (Berlin History Workshop), 53, 54
Bernburg (killing centre), 64, 69–70, 74, 76; Euthanasia Memorial Centre, 74
Berrigan, Angela, 155
betterment, human, 18, 213, 214, 217; and change, 216; environmentalism and, 217; and governance, 218; "Improve Life" and, 215; land use and, 220–21; oppression and, 218; refusal to know and, 215; usage and, 216–17
Beyond the Line (Wart), 158
The Big Anxiety festival, 159
Black feminist materialism (BFM), 76–77
Bonnett, Alastair, 267
Boodjamulla National Park, 255–56
Bottomley, Virginia, 308
Bourdieu, Pierre, 109
Brandenburg Euthanasia Memorial Centre, 70–71
Brandenburg on the Havel (killing centre), 56–57, 64, 71, 74
Brandt, Willy, 56
Brine, Daniel, 151, 161
Brockhall Hospital, 238; John (nursing assistant), 238
Brockie, Jenny, "Peat Island," 113
Brown, Wendy, 178, 179
Bruch, Janet, 32
Buck, Dorothea, 47, 50, 54, 55–57, 59; *Der Tragödie der Euthanasie*, 50

Bund der Euthanasie-Geschädigen und Zwangssterilisierten (Association of Victims of Euthanasia and Forced Sterilizations), 54, 55
Bundesverband Psychiatrie-Erfahrener (Federal Association of Psychiatric Survivors), 54, 55
Bunke, Heinrich, 71
Burch, Susan, 215–16
Burstow, Bonnie, 35
Butler, Judith, 64, 65, 66, 69
Butler, Lawrence, 308

Calabria, Verusca, 17, 316
Calderstones, 238
Callan Park Gallery, 163
Callan Park Hospital for the Insane (later Rozelle Hospital), 17, 146, 158, 163, 164*n*1, 164*n*2
Calvert, David, 170–71
Campt, Tina, 211
Canvas Magazine, 272
Care Quality Commission, 231, 243
Carpenter, John, *Halloween*, 273
Casual Terms, 194–95
Catholic Church, 104*n*2
Caudwell House (formerly Children's Home, Southwell), 184, 185
Cawston Park Hospital, 231; Ben (patient), 231; Joanna (patient), 231; Jon (patient), 231
Cedar Fair Entertainment, Asylum Island, 273
cemeteries, 40–41, 83–84, 85. *See also* graves
Central Coast Council (NSW), 120; *Disability Action Plan 2008–2012*, 120; Peat Island Planning Proposal, 122*n*1
Centre for Addiction and Mental Health (formerly Toronto Asylum/Hospital for the Insane). *See* Toronto Asylum/Hospital for the Insane (later Centre for Addiction and Mental Health)

Chamberlin, Judi, 32
"Changing Lives, Improving Life" (University of Guelph), 218
Chapman, Chris, 234
Charles, Prince, 306–7, 308
children: Aktion T4 murders of, 46, 48, 56–57, 66, 70–71; and brain research, 48; and derelict hospital sites, 306; educational materials for, 311; with intellectual disability, 199; at Workhouse and Infirmary, 184, 185
Children's Home, Southwell (later Caudwell House), 184
Chronic Sick Hospital (CSH), 207, 208–10
Church of Sweden, 261–62
Clarke, Charles Kirk, 30
class action lawsuits, 91, 104n5
closures: in Australia, 111; CRPD and, 13; and deinstitutionalization, 6, 126; Exminster Hospital, 20, 298, 305; and ongoing violence, 8; as outstripping community service provision, 136; of Peat Island Centre, 109, 111, 113–14; psychopharmaceuticals and, 293; and social justice, 3, 8; of Swedish psychiatric hospitals, 288; in UK, 126. *See also* deinstitutionalization
co-creation, 18, 188, 192–93
coffee, cups of, 19, 251–52, 253, 258–59
Cohen, Leonard, 259
Coleborne, Catharine, 199–200
College of Social and Applied Human Sciences Alumni Association, University of Guelph, 224
College of Staten Island, 12
Colney Hatch, 301
colonialism: disability and psychiatric institutions and, 7–8; educators and, 18; and erasure, 219; and eugenics, 213–14; and excellence, 219; and Indigenous peoples, 7–8; and institutionalization, 151, 201; and institutions on Indigenous peoples' land, 14; and land use, 220–21; in naming of Kingseat Hospital, 268; neo-, 168; and neoliberalism, 221; past vs. present, 168; postcolonialism and continuities/discontinuities, 174; postcolonialism studies, 168; in redevelopment, 110; and sites of conscience, 5, 14; street naming and decolonization, 284; violence of, 121; white-settler assumptions around rights, 218
commemoration, 148–49; of Aktion T4, 48, 49; as anti-psychiatry, 35, 36–37, 39; in Benevolent Asylum: Just for Fun, 148; deaths of patients and, 41; exclusion of disabled people in, 178; at Huronia, 93; memory and, 29; of personhood of persons with intellectual disability, 210–11; of staff of institutions, 29–30, 287, 288, 291, 292; street naming and, 288; stretchier witnessing and, 66; at Tiergartenstraße 4, 54. *See also* memorialization; remembrance; street naming
common sense, 86–87
community: and acceptance, 275; connection with, 202; deinstitutionalization and, 119; Exminster Hospital and, 20, 305–9; in heritage preservation, 302; listening, and expansion of notions of, 114; and medical vs. social model of psychiatry, 136; mental hospital connections with, 128, 133; Peat Island ties to, 119; reconceptualization, in redevelopment, 111; in redevelopment, 119–20; reframing of, 119–21; sites of conscience practices and, 14; Spookers and, 274–75, 276, 278, 279; *Spookers* and, 279; therapeutic, 129; wider concept of, 121; Workhouse and Infirmary and, 185

community care: in Australia, 113, 114; closures and, 6; deinstitutionalization and, 6; failures of, 17, 127, 128, 196–97; GMMP and, 196–97; institutional care vs., 235; lack of community/support structures in, 133–34; lack of long-term therapeutic services, 136; long-term support in, 127; medical vs. social model of psychiatry in, 136; nebulous policy of, 126; in New Zealand, 268; oral testimony regarding, 128; rehabilitation and, 135–36; safe spaces in, 127; as site of conscience, 137; Spookers and, 279; transfers within, 197; transitioning to, 128, 136; underfunding of, 137, 197
Community Care Act (UK), 183
Concord Hospital, 148–49
Concord Psychiatric Hospital, 163
Concord Repatriation General Hospital, 164*n*2
Contract Division, 42*n*2
Cooper, David, 32, 129, 130, 131, 135; *Psychiatry and Anti-Psychiatry*, 132
COVID-19 pandemic: and Fernald Center, 82; and human rights, 13; and institutionalization, 3–4; and social justice, 3–4; and Workhouse and Infirmary, 189, 190
Craig Dunain Hospital, 132
critical heritage studies, 6, 7, 8, 9, 30, 171, 284
cultural heritage: ableism in, 291, 294–95; active-passive binary and, 290; as discourse, 284–85; street naming and, 20, 284, 289, 294; in Sweden, 288; of Ulleråker, 288, 291; universities and, 291; working class and, 291. See also heritage
Cumberland Hospital (formerly Parramatta Lunatic Asylum), 145
Cygnet Yew Trees Hospital, 231, 243

Dain, Norman, 32
Danvers State Hospital, 83
dark history, 156, 193, 194, 269
dark tourism/thanatourism, 67, 116, 269, 278
Darkinjung community, 120, 121
Darkinjung Local Aboriginal Land Council (DLALC), 110, 111, 112, 121
Darug community, 120, 121
David (Grahamstown patient), 201–4
Dean, Bec, 17, 145, 146, 148, 151, 156, 159–60, 316
deaths: avoidable, 231; of children with intellectual disability, 199; commemoration of, 41; GMMP and, 197; of patients, 242
Deegan, Pat, 83, 85
deinstitutional violence: defined, 115; erasure as, 17, 110; forgetting and, 117; redevelopment as, 109; sites of conscience vs., 17; violence of settler colonialism and, 121
deinstitutionalization, 6; and activism, 8, 87; and changes to lives, 288; and closures, 6, 126; and community, 119; and community NGOs, 196–97; and community-based housing/supports, 6; and disability rights, 6; and drug therapy, 149–50; drug therapy/psychopharmaceuticals and, 293; failure of, 3–4; fears associated with, 273, 279–80; and fragmentation of mental health services, 127; in Gauteng, South Africa, 196; in *I, You, We, Together*, 173–74; institutionalization by, 174; and justice/injustice, 3–4, 6, 7, 8, 115; and legal strategies, 8; listening in, 109–10, 116; and looking away, 175; and loss of respite/therapy options, 132; losses involved in, 137; media on, 16–17, 116–17; memory documentation and, 128; in New Zealand, 266, 268; oral testimonies

regarding, 128; and overlooking of reform, 87; patients' testimonies regarding, 126–27; plays and, 17–18, 167; post-institutionalization vs., 168; in Scandinavia, 167–70; and selective remembrance, 298; and silence, 109–10; and sites of conscience, 4; and strategic forgetting, 298; street naming and, 19–20, 283, 285, 294; as transcarceral grey zone, 115; and transinstitutionalization, 3, 6, 85–86; in UK, 17; of Ulleråker hospital, 283; as unfinished project, 3–4; unrealized ideals regarding, 114; in West Germany, 52. *See also* closures

Deleuze, Gilles, 276

Demke, Elena, 11, 15–16, 35, 60–61, 316

Department of Ageing, Disability and Home Care (NSW), 113

Der Tragödie der Euthanasie (Buck), 50

Deutsche Gesellschaft für Psychiatrie, Psychotherapie under Nervenheilkunde (German Association for Psychiatry, Psychotherapy, and Neurology), 58, 60

Deutsche Gesellschaft für Soziale Psychiatrie (German Society for Social Psychiatry), 58; "Holocaust und die Psychiatry," 52–53

Devington Park (formerly Exminster Hospital), 298–99; buildings at, 299; and word "Park," 303. *See also* Exminster Hospital (later Devington Park)

Devon Buildings Group, 308

Devon Playing Field Association, 309

Dewhirst, Bob, 240

direct witnessing. *See* witnessing: direct witnessing

Disabilities Services Act (NSW), 114

disability: arts, 170; construction of history, 166–67; social understanding of, 171

Disability Action Plan 2008–2012 (Central Coast Council), 120

disability activism/activists. *See* activism/activists

disability community: deinstitutional violence and, 119; Peat Island and, 111, 119, 120, 121; and redevelopment, 111, 120, 121; Workhouse and Infirmary and, 186–87, 190–91

disability and psychiatric institutions: connections between, 7; as "dark past," 8; defined, 5–6; on Indigenous lands, 9–10; interconnections with welfare/penal institutions, 7; power dynamics in, 5; rationalization of wrongdoings at, 10–11; redevelopment of, 9; selective remembrance of, 9; and settler-colonial violence, 7–8; strategic forgetting of, 9. *See also* psychiatric institutions; *and names of individual institutions*

Disability Law Center, 82

disability rights: deinstitutionalization and, 6; in *I, You, We, Together*, 172; legislation, 6; staff testimonies and, 233

disability studies, performance studies and, 170

Disability Support Program (Ontario), 104n4

disability theatre: aesthetics in, 170–71, 178; *In the Grand Landscape*, 175–78; *I, You, We, Together*, 171–75, 177; representation/participation in, 178; as site of conscience, 170–77

Dix, Dorothea, 86

Do It Different, 187, 189, 191–94

Dolmage, Jim, 104n5

Dolmage, Marilyn, 104n5

Dolmage, McKillop and Bechard v Ontario, 105n6

Dolmage v Ontario, 91, 93, 104–5n5

Dorothea Dix Park, 89

Dracula myth, 279

Dragset, Ingar, 67

drug therapy/psychopharmaceuticals, 136, 149–50, 293
du Plessis, Rory, 18, 316
Duncan, Barry ("B.J."), 121–22
Dunkeld, Jenny, 238, 241
DuvTeatern, 176

East German Secret Police, 53
Edenheim, Sara, 178
Edensor, Tim, 267
Edgar Adult Occupational Centre, 105n6
education: colonialism in, 18; memorial sites and, 76; remembrance and, 262; staff stories used in, 244–45
Eisenman, Peter, 67
either/or framework, 15; in historical memory, 31–32, 41–42; Mad activism vs. academic historians, 39–40
Ellis, Rob, 17, 316
Ellmoos, Laila, 122
Elmgreen, Michael, 67
Ely Hospital (Cardiff), 236, 240
Emmy Rappes väg, 287
English Heritage, 302, 308
Environment Protection and Diversity Conservation Act (NSW), 120
environmentalism, 216–17, 220
erasure: accessibility and, 76; of Aktion T4, 69; colonialism and, 219; as deinstitutional violence, 17, 109, 110; of disabled people in memorialization, 69; of histories, 163; of history of racism, 223; of Luna Park fire, 151–52; of physical evidence as deinstitutional violence, 17; redevelopment and, 109, 155–56; street naming and, 294
Ernest C. Drury School for the Deaf, 105n6
eugenics: advocacy regarding legacies of, 89; and Aktion T4, 65; archives, 221–22; colonialism and, 213–14; disbelief regarding, 89; and excellence, 219, 222–23, 224–25; exhibition, 224–25; institutional traditions and, 214; and intellectual disability, 179, 198, 199; photographs and, 18; remembering complicity in, 221; and sites of conscience, 5, 214; truth and reconciliation process and, 89; at University of Guelph, 18, 215, 217; and violence, 215
euthanasia, 15–16, 49, 64. *See also* Aktion T4 murders
Euthanasie im NS Staat (Klee), 50
euthenics, 18, 215, 217, 219
Eva Lagerwalls väg, 288
excellence, 219; awards system at Guelph and, 222–23; eugenics and, 219, 222–23, 224–25; supremacy/superiority and, 222, 223; white supremacy and, 222, 223
exclusion: of Aktion T4 activists, 58; in media discourse regarding PIC, 17; of most vulnerable, 194; in progress narrative, 166; redevelopment and, 110; in remembrance/commemoration, 178; sites of conscience, and architecture of, 179–80. *See also* inclusion
Exe Vale Hospital, 299
Exminster Hospital (later Devington Park), 20, 301; archives, 300, 311; closure, 20, 298, 305; commemorative plaque, 309–10; community ties, 20; as haunted, 310; heritage, 20, 299, 307–8, 309; lay people's input into, 304–9; and M5 motorway bend, 304–5; redevelopment of, 20, 298–99, 302, 304–9; Remembering the Mental Hospital project, 300, 311; sports and, 308–9; village and, 304, 305–9
Exminster Parish Church, 309–10
Eye See Pink, Black and White (Wart), 155

The Factory, 191, 194–95; alternative arts school, 189

families: complaints regarding treatment, 112–13; of people with intellectual disability, 197–98, 201, 202–3, 205, 210; and photographs/life stories of patients, 197–98; as surrogates, 88; in truth and reconciliation process, 88
Family Life (film), 129
Farleigh Hospital, 236, 237, 238, 240, 242, 243
farms: at Grahamstown Lunatic Asylum, 204; at Kingseat Hospital, 268
Fauvel, Aude, 31–32, 39–40, 42*n*1, 137
Federal Association of Psychiatric Survivors (Germany). *See* Bundesverband Psychiatrie-Erfahrener (Federal Association of Psychiatric Survivors)
Ferlinghetti, Lawrence, 90
Fernald, Walter E., 81. *See also* Walter E. Fernald Developmental Center
Firbeck Infirmary (later Minster View), 12, 183–84, 188
First Nations of Dyarubbin/the Hawkesbury, 121
Fischer, Andrea, 57
Fisher, Karen R., 119
Flis, Nathan, 33–39, 40, 41
Flynn, June, 238, 245
For Matthew and Others – Journeys with Schizophrenia (Wart), 155
forgetting: ableism and, 294; archives and, 92, 95; and deinstitutional violence, 117; institutional memory and, 94; interpretation and, 94; Kingseat Hospital and, 266, 277, 280; of lived experiences, 128; memory and forgotten, 29; of personal histories, 15; redevelopment and, 277; silence and, 94; and street naming, 284; unpaid labour, 29–30; as violence, 92
forgetting, strategic, 266, 280, 298, 299, 302; of disability and psychiatric institutions, 9; and Lillhagen Hospital, 251, 253; and Peat Island Centre, 117; in redevelopment, 117, 257, 260
Forman, Miloš, *One Flew Over the Cuckoo's Nest*, 279
Fort Beaufort Asylum, 204, 205, 206
Foucault, Michel, 32, 190, 234
Fowler, Charles, 299
Fox, Mary Ellen, 105*n*6
Frey Svenssons väg, 287, 293
Fricker, Miranda, 115, 117
Friedländer, Henry, 55, 57
Friern Barnet mental hospital, 127
Fröding, Gustaf, 287
Fuchs, Petra, 68

Gamaragal/Cammeraygal people of Eora Nation, 147
Gann Academy, 83
Garballey, Sean, 85
Garland-Thomson, Rosemarie, 174
Gascoigne, Peter, 187
Gauteng Mental Marathon Project (GMMP), 196–98, 211
gaze: in oral testimonies, 234–35; us versus them, 240
Gedenkort-T4.eu, 73–74
Gemes, Juno, 121
gender: and active-passive binary, 289–90; and institutionalization, 201; PSAT and, 41; and street naming, 20, 289
Gesler, Wilbert M., 132
ghost walks, 30–31, 260. *See also* haunting
Gladesville Hospital (formerly Tarban Creek Asylum), 145–46, 162–63
GMMP. *See* Gauteng Mental Marathon Project (GMMP)
Goffman, Erving, 32, 92–93, 133
Gogarburn Hospital, 239
Goodley, Dan, 292, 293
Goodwill Industries, 42*n*2
Gooweebahree, 147
Gothenburg, University of, 263

Index

Gothenburg Nation, 289
Grafeneck (killing centre), 64, 72–73, 74, 75
Grafeneck Sisters of Mercy, 75
Graham, Steve, 117, 120
Grahamstown Lunatic Asylum, 18, 198–200, 210; Abraham (patient), 203; David (patient), 201–4; Hendrik (patient), 204–5; Hester (patient), 207; Hlumbi (patient), 204; Jonas (patient), 204; Liza (patient), 205–7; Masombolo (patient), 204; Mkhabo (patient), 207; Rodah (patient), 207; Rosetta (patient), 207–10; Sipongo (patient), 205; Walter (patient), 202
Gramscian model, 242
graves, 74, 83, 86, 89, 104n2, 117–18. *See also* cemeteries
Green, Alex, 16, 80–90, 317
Greenlees, Thomas Duncan, 198–99, 200, 201, 204, 205–6, 207, 209, 210
grievability of lives, 65, 70–72
group homes, 114, 115, 169, 173, 174, 176
Guantanamo Bay, 159
Guattari, Felix, 276
Guelph, University of: Bioproducts Discovery and Development Centre, 221; "Changing Lives, Improving Life," 218; Department of Family Relations and Applied Nutrition (later Family Relations and Human Development), 226, 227; founding colleges, 214–15; "Improve Life," 18, 213, 215, 216, 217–21; "President's Message," 215, 218, 219, 220; "Toward a More Sustainable Future," 220; "Who Are We, and Who Do We Want to Be?," 219
Guelph Civic Museum, 213
GuriNgai community, 120, 121
Gustaf Kjellbergs väg, 287, 293

Habicht, Florian, *Spookers*, 267–68, 272–75, 276–77, 279
Hadamar (killing centre), 64; Euthanasia Memorial Centre, 70–71
Hadley, Bree, 171
Haines, Jenny, 113
Halloween (Carpenter), 273
Hamm, Margret, 58
Hanwell, 301
Hargrave, Matt, *Theatres of Learning Disability*, 170
Harrington, Anne, 254
Hart, A.L., 112
Hartheim Castle (killing centre), 64, 69–70, 72, 74–75
haunting, 279; of Exminster Hospital, 310; of hospitals, survivors and, 310; Kingseat Hospital and, 19, 266, 269, 270, 271; Spookers and, 19, 270, 279. *See also* ghost walks
Haus des Eigensinns/Museum of Mad Beauty, 53–54, 55, 56, 57, 58, 59
Have U a Spare Nut? (Wart), 157–58
Heidelberg University psychiatry department, 55–56
Hendrik (Grahamstown patient), 204–5
Henry Säldes väg, 288
Henstock, Rob, 241–42
heritage: academic historians vs. heritage profession, 40; access to sites, 263; and architectural/material features, 9; of asylums in UK, 302; community engagement in preservation, 302; counter-narratives and, 257; Devington Park and, 299; and difficult memories, 299–300; of disability and psychiatric institutions, 9; of Exminster Hospital, 20, 299, 300, 309, 310; interpretation of, 299; lay people and, 199, 301–2, 304; lived experiences and, 257; memories and, 311; patients' narratives and, 254; preservation, and redevelopment, 307–8; private archives and preservation of, 300;

and rationalization of institutional wrongdoings, 11; and remembrance, 257; research/preservation in UK, 301; sanism in, 30; selective remembrance in, 9, 199; as shared responsibility, 262–63; and sidelining of inmates' experience, 118–19; sites of conscience and preservation of, 187–88; strategic forgetting in, 9, 199; Workhouse and Infirmary and, 186. *See also* cultural heritage

Heritage Developments, 307

Hester (Grahamstown patient), 207

Heyde, Werner, 49–50

Hiawatha Asylum for Insane Indians, 40–41

Hibberd, Lily, 17, 145–46, 148–63, 317; *Benevolent Asylum: An Eclipse of Historical Fiction*, 164*n*7; and Mel, 154–55

Hierholzer and Rudzinski, 55

Hirsch, Marianne, 198

Hirschfeld, Magnus, 68

Historic Buildings and Monuments Commission, 308

historical memory, 15, 29, 30; either/or framework in, 31–32, 39–40, 41–42

Hitler, Adolf, 48, 65, 72

Hlumbi (Grahamstown patient), 204

Hobbs, Leigh, 165*n*14

Hoffmann, Ute, 74, 76, 77

Hökälla Green Work and Rehab, 253, 261–62

Holocaust, 49, 64; Aktion T4 mass murders compared, 52–53; direct testimony/witnessing to, 66, 72; exploitation and, 38; marginalization of disabled people's murders in commemoration of, 69; survivors of, 66; tourism, 67

"Holocaust und die Psychiatry" (Deutsche Gesellschaft für Soziale Psychiatrie), 52–53

Horin, Adele, 116

Hornsby Advocate, 117, 120

Hornsby Shire Council, 120

Hornstein, Gayle, 36

Howe, Samuel Gridley, 86

Huber, Ellis, 55

Huber, Wolfgang, 55

Hulk Bay (later Lavender Bay), 147–48, 151, 152, 159, 164*n*10

"human" as category, 76–77

human rights: commissions, 85–86; COVID-19 and, 13; Fernald Center survivors and, 81; sites of conscience and, 13; staff and, 235

Huronia Cultural Campus Program, 104*n*4

Huronia Regional Centre, 16; about, 91, 92–94; abuses at, 93; archives, 92, 94; class action lawsuit regarding, 91, 93; closure, 92; commemorative initiatives, 93; history, 92; revitalization of buildings, 104*n*4; as total institution, 92–93

Huronia Regional Centre survivors: Alice, 95–96, 98–99; Anna, 95, 99, 100; class action lawsuit, 91, 93; defined, 104*n*1; Dorothy, 96–97, 98, 101–2; Emmett, 95, 98; interviews with, 91, 94, 98–102; Joseph, 97, 99–100, 102; ownership of history, 91–92; and records, 16, 91–92; and Recounting Huronia Collective, 93–94; residential school survivors compared, 104*n*2; and revitalization of buildings, 104*n*4

I, You, We, Together (play), 171–75, 176, 177

ignorance: experiential knowledge and, 215; as knowledge, 228; pedagogical methods and, 226–27; queering of use and, 215; in University of Guelph's founding institutions, 214–15. *See also* not knowing; refusal to know

"Improve Life" (University of Guelph), 18, 213, 215, 216, 217–21

In the Grand Landscape (play), 175–78
inclusion: of Aktion 4 survivors, 58; heritage/museum sector and, 263; National Trust and, 189; progress narrative and, 166, 168, 178; at Workhouse and Infirmary, 189. *See also* exclusion
independent living, 113, 115
Indian Residential School, 13
Indigenous people (Australia). *See* Aboriginal people (Australia)
Indigenous peoples: cemetery restoration, 40–41; institutions on land belonging to, 14; reconciliation processes, 7–8; redevelopment on lands, 9–10; residential school survivors, 104*n*2; settler-colonial violence and, 7–8
Indigenous peoples (Canada): abusive practices toward children of, 234; land rights, 220–21; PSAT and, 41; residential schools, 104*n*2; rights, 219
Ingham, Nigel, 18–19, 317
injustice(s): epistemic, 11, 115, 117, 119, 122; individualized vs. systemic, 215–16; memories of place, and present, 244; patient narratives and, 255; returning to place of, 256; sites of conscience practices and, 4; sterilizations as, 51; unpaid labour as, 39. *See also* justice
in-patient care: demand for, 127, 136; loss of therapeutic practice in, 132–33
Institute for Imbecile Children, 198
institutional violence: defined, 115; institutions as inherently violent, 115; oral history addressing, 18–19; and redevelopment, 114. *See also* violence
institutionalization: COVID-19 and, 3–4; institutions defined, 5–6; lingering nature of, 167; multi-dimensionality of institutions, 137; and oppression, 3; and overlooking of reform, 87; as past vs. present, 168; plays and, 17–18. *See also* deinstitutionalization
intellectual disability/disabilities, people with: Abraham, 203; agency of, 203, 210; children with, 199; commemoration of personhood of, 210–11; David, 201–4; and disability theatre, 175; Enlightenment and, 179; eugenics and, 198, 199; families of people with, 197–98, 201, 202–3, 205, 210; at Fernald Center, 81; Hendrik, 204–5; Hester, 207; historical research into lives/experiences, 210; Hlumbi, 205; Jonas, 205; as legitimate knowers, 16; life stories/lived experience of, 199; Liza, 205–7; Masombolo, 205; Mkhabo, 207; photographs of, 211; Rodah, 207; Rosetta, 207–10; Sipongo, 205; and sterilization, 199; transfers of, 207–10; Walter, 202. *See also* learning disabilities, people with; neurodivergent people; Walter E. Fernald Developmental Center
intellectualism, 86
International Coalition of Sites of Conscience (ICSC), 18, 148, 184, 188, 263
interpretations: of academic historians vs. Mad activists, 31–32; activist vs. academic historians', 15, 37, 39; cemetery restoration and, 40–41; historical, by academic historians, 29; of past crimes, 47; of photographs, 18; and sites of conscience, 47; survivors' memories vs., 98; Workhouse and Infirmary and, 185, 191
Into the Light: Eugenics and Education in Southern Ontario (exhibition), 213–14, 221–22

invisibility: ableism and, 285; disability theatre vs., 174; in institutionalization, 174
Iron Shield, Harold, 40–41
Isacson, Maths, 291
isolation: gaps in records and, 95–96; group homes and, 174
"The Isolation Room" (Wart), 159

Jackson, Kevin, 41
Jacobowsky, Bernhard, 286, 287–88, 292, 293
JAG, 171, 172
Jay Report, 235
Johnson, Kelley, 237
Johnston, Kirsty, 170
Joinson, Carla, 40–41
Jonas (Grahamstown patient), 204
Jordison, David, 235
justice: deinstitutionalization and, 8; epistemic, 12–13; restorative, 16; transitional, 13, 16. *See also* injustice(s); social justice

Kampe, Norbert, 55
Kant, Immanuel, 179
Kearns, Robin, 19, 317
Keller, Helen, 31
Kelly, Evadne, 18, 221, 224–25, 226–27, 317
Kesey, Ken, *One Flew Over the Cuckoo's Nest*, 279
Kingseat Hospital, 19; about, 268–69; abuses at, 269, 272; and forgetting, 277, 280; former patients, and *Spookers* film, 273–74; as haunted, 19, 266, 269, 270, 271; history, 266, 268–69; later uses of, 268–69; location, 266–67; notoriety of, 272; nurses' hostel, 278; present condition, 266; as site of conscience, 277; Spookers at, 270, 271–72; in *Spookers* film, 273–74. *See also* Spookers
Kingston, Peter, 154, 165*n*14

Kitzinger, Jenny, 116
Kjellberg, Gustaf, 286, 287, 293
Klee, Ernst, *Euthanasie im NS Staat*, 50
Knittel, Susanne C., 69, 73–74
knowing: activation of, 222, 224–25; people with intellectual disability and, 16; queering not knowing, and, 223–25; settler resistance to, 218, 219. *See also* not knowing; refusal to know
knowledge: academic historians vs. heritage profession and, 40; tradition of use and, 217
Koll, Elli, 71
Koven, Mikel J., 273
Kronåsens sjukhus, 286
Kronåsvägen, 286
Kulvertkonstens väg, 253

Lägerhyddsvägen, 283, 286
Lagerwall, Eva, 286, 288, 292, 293
Laing, R.D., 32, 35, 129
Lakeside Mental Hospital, 273
Lamarck, Jean-Baptiste, 216–17
Lampshire, Debra, 274
Landberg, Pelle, 283
Lanzmann, Claude, *Shoah*, 70
Lapon, Lenny, 32
Largactil, 105*n*12, 131, 149, 150
Larundel Hospital, 154
Lavender, George, 164*n*10
Lavender Bay (formerly Hulk Bay), 17, 145, 147–48, 151, 152, 154, 155, 164*n*10
Lavender Green, 148
Lawrenson, Mary, 234, 235, 238, 240
Lawson, Leonie, 113
learning disabilities, people with: abuse of, 236; Caudwell House and, 184; at Cawston Park Hospital, 231; children with, 184; former staff stories and, 244–45; historic labelling, 193; Infirmary and, 183; institutional "gaze" and, 234–35, 240; lack of voices in historical accounts, 194;

omission from T4 sites of conscience, 59; and performance, 170; rights of, 235; sites of conscience practice and, 232; status among other classes of patients, 243; survivors' testimonies, 232–33; *Theatres of Learning Disability* and, 170; "us" vs. "them," 240; in Workhouse and Infirmary, 189–90, 191. *See also* intellectual disability, people with; neurodivergent people
Levi, Primo, 67
Liebermann, Eva, 51
Liebermann, Hans, 51
Life Esidimeni, 196
life histories/narratives: about, 254; comprehension, 254; as counter- vs. mainstream, 254; families and, 197–98; forgetting of, 15; importance of, 251; in informal contexts, 255–56; and multidimensionality of institutions, 137; nostalgia and, 258; of people with intellectual disability, 199, 210; and restoration, 103; and self-advocacy, 232; and sites of conscience, 232, 254, 255, 261; threads, 253–54. *See also* lived experience(s); oral histories
Light, Duncan, 279
light shows, 80, 82, 85
Lillhagen: street name, 257; walk at, 263
Lillhagen Hospital, 19, 251, 252, 253, 257, 260; circumnambulation of, 253; conversion into residences, 253; patient art at, 253, 260–61
Lillhagsparken, 253; café at, 261–62; Hökälla Green Work and Rehab, 261–62; Multikult, 262; street naming at, 260
Lindbom, Helena, 19, 251, 252, 253–54, 256, 259–60, 317–18
lingering, 215, 223, 224, 226–28
Lions Club (Waltham, MA), 81–82

listening: deinstitutionalization and, 109–10, 116; and expansion of notions of community, 114; to lived experience, 111; in redevelopment, 111
little things. *See* small things
lived experience(s), 194; amnesia regarding, 128; archives and, 92; in art, 159; in current policies, 122; ephemera and, 101, 103; and heritage, 257; listening to, 111; marginalization of, 156; media and, 16–17, 112; memorialization of, 119; neglect of, 298; of people with intellectual disability, 199; in performance, 145, 146; planning proposals/ heritage reports on, 118–19; in poetry, 145, 156–58; and psychiatrist-patient equality, 129; in redevelopment, 111, 112, 257; remembrance and, 254; silencing of, 15; Workhouse and Infirmary and, 186. *See also* life histories/ narratives
Liza (Grahamstown patient), 205–7
Lloyd, Justine, 16–17, 318
Locke, John, 179
loitering, 215, 223, 226–28
Lonauer, Rudolf, 70
Luna Park, 145, 148, 160–62, 164n8; Australian Broadcasting Corporation documentary on, 162, 164n9; Friends of, 165n14; Ghost Train fire, 148, 151–52, 153, 154, 155, 156, 161–62, 164nn8–9
Lundberg, Pelle, 286

Macdonald, Sharon, 9
Macdonald Institute, 214, 217, 220, 226
Mad activism/activists. *See* activism/ activists
Mad Heritage, 262
Mad studies, 5, 7, 31–32, 262, 263, 286
Madman Productions, 272

Madness: defined, 286; and disability, 286; street naming and, 294
Magdalene Laundries, 13, 83–84
Mannheimer Kreis (Mannheim Circle), 52
Manthey, Elvira, 56–57, 66, 70–71
Māori Tribal Authority, 269
marginalization: ableism and, 285; by academic historians, 15; environmentalists and marginalized groups, 217; and hegemonic normativity, 178; of lived experience, 156; of mass murder of disabled people, 68–69; of patients' contributions, 292; of working-class staff members, 292
Marx, Karl, 37–38
Mary (former psychiatric nurse), 274
Masombolo (Grahamstown patient), 204
Massachusetts School for the Feeble-Minded. *See* Walter E. Fernald Developmental Center (formerly known as the Massachusetts School for the Feeble-Minded)
Matthews, Nicole, 16–17, 318
McConkey, Oswald Murray, 221–23, 226, 227(f)
McIntyre, Marlene, 105*n*6
McIntyre v Ontario, 105*n*6
McKillop, David, 105*n*6
McRuer, Robert, 66
media: *Daily Telegraph*, on Peat Island Centre, 112; on deinstitutionalization, 16–17; ex-residents lacking in, 117–18; *Hornsby Advocate*, 117, 120; on institutional living vs. deinstitutionalization, 116–17; and lived experiences, 112; *Newcastle Herald* on Peat Island, 117; on patient labour, 35; on Peat Island Centre, 113, 116–17; on PSAT, 34–35; on redevelopment, 117; *Toronto Star* on patient-built walls at Toronto Asylum, 35; *Toronto Star* on "Town Hall on the Wall," 34

Medical History, 42*n*1
medical model, 156; and anti-psychiatry, 32; and Kingseat Hospital, 268; renewal of, 136; social model vs., 136
Mee, Steve, 235, 236, 237, 240, 244, 245
Memorial to Homosexuals Persecuted under National Socialism, 58, 67
Memorial and Information Site for the Victims of the National Socialist "Euthanasia" Murders (Stiftung Denkmal für die Juden Europas), 58
Memorial to the Murdered Jews of Europe, 58, 59, 67
memorial plaques. *See* plaques
Memorial to the Sinti and Roma of Europe Murdered under National Socialism, 58, 68
memorial sites: access to, 67–69; disabled staff at, 67; and disabled vs. non-disabled audience, 76; educational role, 76; in Germany, 53–54, 67–68. *See also* Aktion T4 memorial sites; memorials
memorialization, 15; active not knowing in, 221; of Aktion T4 victims, 16; archaeological, 84; and betterment, 214; and *Denkmal* vs. *Gedenkstätte*, 57, 59; of disabled lives, 65; erasure of disabled, 69; of Exminster Hospital, 300; Gedenkstättenbewegung, 52; in Germany, 67–68; grievability and, 65; higher education institutions and, 214; of histories, and social justice, 214; of lived experiences, 119; of Luna Park fire, 151–52; mainstream, 59; Peat Island Chapel service, 121; photographs/life stories as, 18, 197–98, 200; and removal of shame, 73; by street naming, 286–87; and stretchier witnessing, 66; and victims' vs. perpetrators' points of view, 16, 73. *See also* commemoration
memorials: euthanasia memorial centres, 64; Lavender Green, 148; Luna

Park fire, 155; in media, 117–18; monuments, 57; for Peat Island Centre, 122; at Tiergartenstraße 4, 48, 50, 57–59, 60. *See also* memorial sites; plaques

memory/memories: to action, 18, 185, 186, 188; archaeological, 102; archives and, 92, 103; art and, 155; in Benevolent Asylum, 146; and commemoration, 29; ephemeral traces and, 101–2; evolution over time, 29; and forgotten, 29; heritage and, 299–300, 311; institutional, and forgetting, 94; interpretations vs., 98; neglect of, 298; in performance, 146; reconstitution of, 103; redevelopment vs., 156; regarding Kingseat Hospital, 277; and sense of identity, 260; and social justice, 17; Spookers and, 277; street naming and, 284, 288–89; traumatic, 94, 97, 103. *See also* remembering; remembrance

Mendelssohn, Moses, 68

Mental Health Act (UK), 133

mental health services: fragmentation of, 127, 132; integration of, 136; long-term support in, 137. *See also* community care; psychiatry/psychiatric care

mental hospitals. *See* psychiatric institutions

mental illness: causes of, 129; masculine-feminine/active-passive binary and, 290

Mental Treatment Act (UK), 129

MetFern Cemetery, 82, 83–84

Metropolitan State Hospital, 82, 83

Millett, Kate, 32

Million, Dian (Tanana Athabascan), 7–8

Milson Island, 112

Ministry of Children, Community and Social Services (Ontario), 91, 94

Minster View (formerly Firbeck House), 184, 185

Mitchell, Cameron, 65
Mitchell, David T., 16, 65
Mitchell, Emma, 65
Mkhabo (Grahamstown patient), 207
mobiles Museum (mobile museum), 53, 54
Moon, Graham, 19, 318
Moorhaven, 301
Morrison, Linda, 32
Moseneke, Dikgang, 197
Multikult, 262
Museum der wahnsinnigen Schönheit/Museum of Mad Beauty, 11
Museum of Medical History, 262

Nahwegahbo, Bobbi, 41
narratives. *See* life histories/narratives
Nash, Tyrone, 194
National Health Service (UK), 132, 300, 302
National Trust (UK), 12, 18, 182, 184, 188, 189, 191, 192
neoliberalism: and benevolent asylum, 146; and redevelopment, 9; in University of Guelph President's Messages, 221
neurodivergent people: co-creation with, 18; and Do It Different, 190–93; engagement with own history, 189; history making, 103; Huronia interviews with, 94; lack of voices of, 194; participation of, 194; position in institutions, 195; at Workhouse and Infirmary, 189–90. *See also* intellectual disability/disabilities, people with; learning disabilities, people with
New South Wales Council for Intellectual Disability, 122*n*1
Nicholl, George, 183
Nielsen, Juanita Joan, 162, 165*n*18
Nightingale, Florence, 183
Nisser, Marie, 291
Nolan, Peter, 134
Norfolk Adults Safeguarding Board, 231

Normansfield hospital, 243
nostalgia, 257–58, 262, 275
Nostalgia: A Psychological Resource (Routledge), 257–58
not knowing, 18; activating/active, 221–22, 226–28; alumni and, 223–24; awards system at Guelph and, 222–23; in higher education, 214; and inclusion vs. exclusion, 218; and land use, 221; queering, 223–25; silencing and, 222–23; white-settler assumptions and, 218. *See also* ignorance; knowing; refusal to know
Nottingham General Lunatic Asylum, 187
Nottingham Mencap, 186
Nottinghamshire County Council, 184, 185
Nuremberg Trials, 49, 50
Nurses' Association (NSW), 112, 113
nursing staff: at Exminster, 303; homes, 271, 303; oral histories, 19; on Peat Island Centre closure, 113; replacement at Peat Island, 113; on Richmond Report, 113; and Spookers, 274; and sports, 134; street naming after, 287, 292; and violence, 19; in Workhouse and Infirmary, 183–84. *See also* staff of institutions
Nyström, Mikael, 283, 286

occupational therapy (OT), 133, 135
One on Every Street (video), 105n13
One Flew Over the Cuckoo's Nest (Forman), 279
One Flew Over the Cuckoo's Nest (Kesey), 279
Ontario Agricultural College, 217, 220, 221–22
Ontario Agricultural Institute, 214–15
Ontario Veterinary College, 220
Open University, Social History of Learning Disability Group, 232

oppression: in contemporary psychiatry, 60; historical vs. present, 168–69; and human betterment, 218; institutionalization and, 3; in institutionalization vs. post-institutionalization, 169–70; as ongoing, 166, 167; recognition on basis of previous, 178; staff testimonies and understanding of, 233
oppressive knowledge, 213, 214–15, 223, 224, 228
oral history/histories, 233–34; addressing institutional violence, 18–19; constraints in reuse of, 136–37; established narratives vs., 233–34; gaze in, 234–35; and institutional discourse, 234; nursing staff and, 19; range of, 232–33; regarding deinstitutionalization, 126–27, 128; regarding Exminster Hospital, 300; silencing, and not knowing, 222; staff collusion and, 234; staff testimonies, 232; text-based evidence vs., 222. *See also* life histories/narratives
Orillia Asylum, 41, 92
othering, 235, 245
outpatient clinics, 129, 131
Overfield-Shaw, Janet, 18, 182–95, 318

Pachter, Charles, 104n4
Pantelides, Mr. (of Ely Hospital), 240
Parkside, 301
Parramatta Female Factory, 148, 163, 164n1, 255
Parramatta Lunatic Asylum. *See* Cumberland Hospital (formerly Parramatta Lunatic Asylum)
patients, defined, 263n1
"Patients' Memorial Garden, Peat Island Centre, Mooney Mooney" (Potter), 118(f)
Peat, Frances, 118–19
Peat Island, 109, 110(f); 2014 planning report, 110–11; Chapel, 119, 121;

closure, 109, 111, 113–14; *Community Facilities Needs Assessment*, 120; community ties, 119; conditions, 112–13; court cases over closure/patient relocation, 114; documentation, 111–12; exclusion in media discourse regarding, 17; family complaints against, 112–13; Indigenous people as residents, 120–21; media regarding, 113, 116–17; memorial for, 121, 122; Planning Proposal (Central Coast Council), 122*n*1; population, 112; as potential site of conscience, 109, 111; redevelopment of, 111, 119–21; relocation of patients, 113–14; residents' views on independent living, 113; as site of conscience, 118; strategic forgetting, 117; transfer to DLALC, 111, 112, 121
"Peat Island" (Brockie), 113
Penney, Darby, 60–61
Pennhurst Memorial and Preservation Alliance, 12, 255
Pennhurst State School and Hospital, 12, 255
people of colour: at Grahamstown Lunatic Asylum, 204–7; in-patient care, 137; at Workhouse and Infirmary, 194. *See also* Aboriginal people (Australia); Indigenous peoples; race/racism at
People with Disabilities Australia (PWD), 114
performance: Benevolent Asylum as, 145, 146, 148, 152–53, 154, 156; in engagement with place, 17, 159; of excellence, 224–26; learning-disabled, 170–71; lived experience in, 145, 146; and not looking away, 175; and site of conscience, 171; studies, and disability studies, 170–71; WALK public performance series, 145, 146. *See also* plays; Spookers

Performance Space, 145, 151, 164*n*6
personal histories/narratives. *See* life histories/narratives
Petrusev, Boris, 239
Phoenix (convict ship), 152, 164*n*10
Phoenix Trust, 308
photographs: and eugenics, 18; in Grahamstown files, 18; in Huronia archives, 101–2; interpretations of, 18; of killing centre residents, 70; in medical texts, 200; as memorialization, 18, 200; pathological uses of, 200; of patients, 197–98; of people with intellectual disability, 210, 211
physicians: commemoration of, 29–30; in medical hierarchy, 243; street naming after, 287, 288, 292. *See also* staff of institutions
Pirna-Sonnenstein (killing centre), 64, 69–70, 72, 73, 74, 75
plaques: for buried inmates, 83; to Exminster Hospital, 309–10; media regarding, 35; PSAT and, 40; regarding unpaid labour, 33–34; at Tiergartenstraße, 4, 53, 58
"Plaques, Politics and Preservation" (Reaume), 33
plays, 17–18, 167, 170–77, 232
poetry, 145, 146–47, 156–58
Poor Law, 184
Poor Law Commission, 183
Port Alfred Asylum (PAA), 204, 207, 208, 209–10
Portico, 218
Potter, Geoffrey, "Patients' Memorial Garden, Peat Island Centre, Mooney Mooney," 118(f)
Powell, Enoch, "The Water Tower Speech," 300–1
precarity: of disabled people's lives, 64, 65; grievability and, 65; and violence, 64
Prince Corporation, 269
Princess Marina Hospital, 241
Prinzhorn Sammlung, 55–56, 57

Prior, Pauline M., 126–27
progress narrative, 168–69; about, 166; and construction of history, 169–70; dominance of, 169; in *In the Grand Landscape*, 175–76; and historical continuities, 169; and *I, You, We, Together*, 173–74; inclusivity in, 178; institutionalization as ongoing vs., 177; liberal/humanist tradition and, 179; moment of liberation in, 166–67; and power, 169, 177–78
PSAT. *See* Psychiatric Survivor Archives of Toronto (PSAT)
psychiatric institutions: Aktion T4 murders at, 48; community connections, 128; contrasting views of, 127; general hospitals cf., 131–32; grounds, and nature as therapy, 132; interpersonal relationships in, 132–33; isolation of, 128, 133; loss of therapeutic practice in, 132–33; outside/community relationships, 133; patient populations, 129; as sites of conscience, 127, 129, 136; size, 129; as social support networks, 130
Psychiatric Survivor Archives of Toronto (PSAT), 40, 42n2; commemoration plaques, 40; commemoration of unpaid labour, 41; commemoration work as anti-psychiatry, 35; founding of, 32; and patient-built boundary walls, 33, 34–35, 36, 37; purpose of, 32–33
psychiatrists, street naming after, 287–88, 292
Psychiatry and Anti-Psychiatry (Cooper), 132
psychiatry/psychiatric care: Aktion T4 and, 50, 52–53; as crisis management, 132; deficit model of, 234–35; drug therapy, 131; end to psychiatry, 32; interpersonal relationships, 132–33; medical clinical control model, 234–35; in medical museums, 293; Nazi psychiatry compared, 56; oppression in contemporary, 60; street naming, and reinscription of, 289. *See also* anti-psychiatry; community care
psychopharmaceuticals. *See* drug therapy/psychopharmaceuticals
Pulin Investments, 269
Punzi, Elisabeth, 19, 30–31, 251, 318–19; interview with Green, 82, 83, 87, 88, 90; interview with Overfield-Shaw, 186, 190; and Lindbom, 252, 253–54, 260, 261
Putsky, Ernst, 70–72

queering: and not knowing, 215, 223–25; and redress, 228; of use, 216
Quiberee, 147

race/racism: erasure of history of, 223; institutional arrangements and, 227–28; and institutionalization, 201; people of colour, 137, 194, 204–7; PSAT and, 41; refusal to know about, 223
Rappe, Emmy, 286, 287, 292, 293
Raue, Peter, 55
Reaume, Geoffrey, 14, 32, 42n2, 263, 319; "Plaques, Politics and Preservation," 33
Recounting Huronia Community Archive, 93–95
redevelopment, 9; access vs. belonging to site in, 120; aesthetic in, 110, 111; Callan Park, 163; commercial interests/uses in, 258, 303, 307; community and, 111, 119–20, 306–7; as deinstitutional violence, 109; disability community and, 120, 121; and erasure, 109, 155–56; and exclusion, 110; of Exminster Hospital, 302; and exploitation, 162–63; financial interests in, 302; and forced labour, 11; and forgetting, 277; former residents' lives and, 109; Gladesville hospital, 162–63;

health/safety concerns, 306; heritage preservation and, 307–8; into housing, 303–4, 307; of Huronia's buildings, 104n4; on Indigenous lands, 9–10; institutional violence and, 114; lived experiences in, 112, 257; media on, 117; memories vs., 156; neoliberalism and, 9; of nurses' homes, 271, 303; opposition to, 306–7; and ownership/custodianship of former institutions, 11; of Peat Island Centre, 119–21; private archives and, 300; reflection on violence in, 111; reimagination of, 114; settler-colonial heritage and, 110; and sites of conscience, 111, 258; and strategic forgetting, 117, 257, 260; street naming in, 294; as therapeutic landscapes, 303; in UK, 301; at Uppsala, 283; Workhouse and Infirmary and, 185
refusal to know, 226–28; and human betterment, 215; "Improve Life" and, 215; and knowledge building, 228; racism and, 223. *See also* not knowing
Remembering the Mental Hospital, 20, 300, 311
remembering/remembrance: ableism and, 294; Aboriginal women and, 255–57; of Aktion T4 mass murders, 15–16, 54; cafés as sites of, 261–62; church service for Exminster Hospital, 309–10; claiming of rights to, 11; disability history, 166; and education, 262; and epistemic injustice, 11; exclusion of disabled people in, 178; of Exminster Hospital, 300; and healing, 262; heritage and, 257; as integrative process, 254; of Kingseat Hospital, 19, 278; and Lillhagen Hospital, 253; as long-term process, 263; narrative threads and, 254; patients' narratives and, 254; places of personal importance and, 260; selective, 9, 214, 285, 298, 299, 302; sensationalism and, 261; shaping, 251; small things and, 251–52; small-scale/personal in, 261; Spookers and, 275, 278; street naming and, 20, 253, 257, 260, 285, 289; support for, 256–57 remembrance. *See also* commemoration
residences/residential areas: conversion of Exminster Hospital into, 20; conversion of Lillhagen Hospital into, 253; Devington Park, 298; Larundel Hospital conversion into, 154; psychiatric care/mental illness removed from naming in, 289; redevelopment into, 303–4, 307; strategic forgetting in, 117, 257
residents, defined, 104n1
Rice, Carla, 18, 218–19, 226–27, 319
Richmond, David T., 113, 114
Richmond Report, 113
Rideau Regional Centre, 105n6
Rinaldi, Jen, 16, 115, 128, 319; interviews with Huronia survivors, 94, 95–97, 98–100, 101–2
Riversleigh Heritage Area, 255–56
Rodah (Grahamstown patient), 207
Rodéhn, Cecilia, 19–20, 30, 319
Rondinone, Troy, 273, 280
Rosetta (Grahamstown patient), 207–10
Rossiter, Kate, 16, 115, 128, 319
Rostance, Ben, 187
Routledge, Clay, *Nostalgia: A Psychological Resource,* 257–58
Royal Albert Hospital, 234, 235, 238, 239, 240, 241, 244; Eric (student nurse), 234, 235, 238, 239, 243; Mary Lawrenson (student nurse), 234, 235, 238, 240
Royal Commission into Violence, Abuse, Neglect and Exploitation of People with Disabilities (Australia), 8
Royal Devon and Exeter Hospital (formerly Wonford House Hospital), 303, 307

Rozelle Hospital (formerly Callan Park Hospital for the Insane), 146, 158

S., Petra, 56
Sälde, Henry, 286, 288, 292, 293
sanism, 30, 51
Save Britain's Heritage, 308
Scholtz, Margaret, 122
Seed, Robert, 105*n*6
Seed v Ontario, 105*n*6
sensationalism, 260–61, 302
Seth, Patricia, 93, 104*n*5
settler colonialism. *See* colonialism
Sharp, Martin, 155, 162, 165*n*14, 165*nn*16–17
Shead, Garry, 165*n*14
Shenley Hospital, 17, 127, 128–29; Adam (patient), 128; interpersonal relationships in, 132; Keith Shires (patient), 127, 128, 129–37; modernism of, 129, 135; patient population, 129; recreational opportunities, 134–35; staff, 129, 130; as therapeutic landscape, 132; treatments, 130; Villa 21, 129. *See also* Cooper, David
Shimrat, Irit, 32
Shires, Keith (Shenley Hospital patient), 127, 128, 129–37
Shoah (Lanzmann), 70
Shorter, Edward, 32
silence: and collusion in abuse, 231, 239, 240; deinstitutionalization and, 109–10; forgetting through, 94; and light shows at Fernald Center, 82; of oral histories, 222; regarding Aktion T4 murders, 16, 50; regarding violent incidents, 96–97; of voices/experiences, 15
Sipongo (Grahamstown patient), 205
sites of conscience: about, 4–5; access to, 14; Aktion 4 mass murders, 16; and architecture of exclusion, 179–80; colonialism and, 5, 14; community care as, 137; community gathering places as, 19; and custodianship/control of former institutions, 12; defined, 11; deinstitutionalization and, 4, 17; disability theatre as, 170–77; effect of practices on community, 14; eugenics and, 5, 214; former asylums as distinct from, 267; Grahamstown casebooks as, 200; Haus des Eigensinns as, 59; and heritage preservation, 187–88; and histories/memories of place, 89–90; and human rights, 13; Indigenous disability and psychiatric institutions as, 10; interpretations of past crimes and, 47; Kingseat Hospital as, 277; as means vs. end, 90; mental hospitals as, 127, 129, 136; National Trust and, 187–88; overvaluation of place in, 90; past violence-present institutions/inequities connections, 121; patients' narratives and, 254, 255, 261; Peat Island as, 109, 111, 118, 122; photographs/life stories and, 197–98; practices, 4, 11–14; and public reckoning with injustices, 12; redevelopment and, 111, 258; sites of oppression and, 261; small things and, 252; and social change, 14; and social justice, 12–13, 90; Spookers as, 277, 278; staff testimonies and, 232; survivors' testimonies and, 232; Tiergartenstraße 4 compared, 57; value of comparison among, 89–90; Workhouse and Infirmary (Southwell) and, 184–87. *See also* International Coalition of Sites of Conscience (ICSC)
Slark, Marie, 93, 104*n*5
slavery: unpaid labour compared to, 35–36, 38; and workhouse system, 183
small things, 19; circumnambulation of hospital, 253; and comprehension, 254; cups of coffee, 251–52, 253,

258–59; and healing, 258; and remembering, 251–52; and sites of conscience, 252
Smith, Laurajane, *Uses of Heritage*, 255–56, 257
Snyder, Sharon L., 16, 65
Snyder, Timothy, 66, 75
social class: and ableism, 291–92; PSAT and, 41; and street naming, 20
social justice: closures and, 3, 8; COVID-19 and, 3–4; deinstitutionalization and, 3–4, 6, 7; engagement with cemeteries and, 83–84; insider stories and, 245; memories and, 17; sites of conscience and, 12–13, 90; staff accounts and, 232; truth and, 86–87; Workhouse and Infirmary and, 185. *See also* injustice(s); justice
social model: and comparison of Aktion T4 murders and contemporary psychiatry, 52–53; disability theatre and, 170; medical model vs., 136
South African Medical Journal, 199
South Ockendon Hospital, 241, 243
South West Regional Health Authority, 307
Southwestern Regional Centre, 105n6
Spandler, Helen, 127, 136
Spencer, Dave, 239
Spitzer, Leo, 198
Spivak, Gayatri Chakravorty, 168, 174
Spookers, 19, 266–67, 270–72; acceptance at, 275; actors at, 278; affect at, 276–77; Andy (owner), 276; attractions, 270–71; and community, 274, 276, 278, 279; competing narratives with documentary, 277; David (actor), 274; diversification of, 270–71, 279; at Kingseat Hospital, 270, 271–72; and memory/remembrance, 277, 278; movement, 277; opening of, 270; origin, 270; as past asylum, 271–73, 275, 277, 279; as site of conscience, 277, 278; success of, 271,

277–78; themes, 271; vitality at, 275–76. *See also* Kingseat Hospital
Spookers (Habicht), 267–68, 272–77, 279
sports, 134, 308–9
St. Lawrence's hospital, 301
St. Thomas Psychiatric Hospital, 42n2
staff of institutions: abuse of, 241–42; active-passive binary and, 289–91; collusion in abuse, 231, 233, 234, 238, 241, 242–43, 244, 245; compassion by, 232; and dehumanizing practices, 232; Keith Shires on, 130; institutional culture and, 242–43; job expectations of, 238–39; othering by, 235, 245; patient bonds with, 130; and patient equality, 235; patient interactions with, 136; personal accounts/testimonies, 232, 234–43, 244–45; reporting/questioning regarding abuses, 231, 240–43; and rights of patients, 235; shortages, 136; stereotyping in asylum tours, vs. patients, 30–31; street naming after, 20, 286–91, 293; as surrogates, 88; in truth and reconciliation process, 88; us vs. them perspective, 240, 242; volume of demands upon, 136. *See also* nursing staff; physicians
Starkman, Mel, 32
State Library of New South Wales, 111–12, 122
Steele, Linda, 320; interview with Green, 80, 84–85, 86, 87, 88, 89, 90; interview with Janet Overfield-Shaw, 182, 184, 186, 187, 191, 194
stereotypes: alternative representations vs., 200; horror, 271, 280; of patients vs. staff in asylum tours, 30–31; at Spookers, 277, 280; of violence, 310; of working class, 291
sterilizations, 47, 49, 50, 51, 89, 199
stigma: fancy-dress costumes and, 278; Haus des Eigensinns and, 59; of Kingseat Hospital, Spookers and,

271; re-stigmatization of spaces, 267; street naming and, 285, 294
Stoller, Alan, 112–13
strategic forgetting. *See* forgetting, strategic
Strategic Program Investment Fund, 93
street naming, 284; ableism in, 20, 284, 285, 294; active-passive binary and, 289–90; and artworks, 253; commemoration by, 288; and cultural heritage, 20, 284, 289, 294; deinstitutionalization and, 19–20, 283, 285, 294; forgetting and, 284; gender and, 289; and hiding past, 294; and history, 293–94; and Lillhagen Hospital, 253; memorialization by, 286–87; and memory, 288–89; Name Preparation Board (Namnberedningen), 283, 284, 286, 287; after people affiliated with Exminster Hospital, 309; as performative process, 284; political culture and, 286; and reinscription of psychiatric care, 289; and remembering/remembrance, 20, 253, 257, 260, 285, 289; research, 285; and sites of memory, 284; social class and, 20; after staff members, 20, 286–89, 292, 293; and stigma, 285, 294; success reflected in, 292–94; universities and, 292; in urban development, 294
stretchy witnessing. *See* witnessing: stretchy
survivor stories. *See* life histories/narratives
Svenska Teatern, 175, 176–77
Svenson, Frey, 286, 293
Svensson Chowdhury, Matilda, 17–18, 316
Swedish Partnership for Mental Health, 262
Sydney College of the Arts, 148
Sydney Morning Herald, 116
Szasz, Thomas, 32, 35

Tainui Development Corporation, 269
Talbot, René, 56
Tarban Creek Asylum. *See* Gladesville Hospital (formerly Tarban Creek Asylum)
Taylor, Barbara, 127
Taylor, Frank, 113
thanatourism. *See* dark tourism/thanatourism
theatre plays. *See* plays
Theatres of Learning Disability (Hargrave), 170
therapeutic environments/landscapes: redevelopment as, 303; Shenley Hospital as, 132; total institutions vs., 126
Thurgarton Union Workhouse, 182, 187
Tiergartenstraße 4, 15–16; art at, 59; glass wall, 47, 59; as headquarters of Aktion T4, 48, 49; as learning site, 48, 54, 57, 59, 60; location/site of, 51; memorial at, 48, 50, 57–59, 60; metal plaque at, 53, 58; mobile museum at, 53; as place of memory, 52–53, 54; sites of conscience compared, 57. *See also* Aktion T4
Till, Karen E., 267
Tilley, Liz, 18–19, 320
Tipping, Morgan, 190, 194–95
Topography of Terror museum, 68
Toronto Asylum/Hospital for the Insane (later Centre for Addiction and Mental Health), 12, 29–30, 33, 40, 263
total institutions, 92–93, 115, 126, 133
"Toward a More Sustainable Future" (University of Guelph), 220
transinstitutionalization, 3, 6, 85–86
trauma: GMMP and, 197; institutional transfers and, 211; interpretation of, and survivors' feelings, 310; patient narratives and, 255; transfers within community care and, 197

truth: nondisabled people and, 86; right to, 86–87; and social justice, 86–87; telling, 10, 13, 156
truth and reconciliation, 16; archives in, 88; custodianship of history and, 104*n*2; direct testimony in, 87; and eugenics, 89; family members in, 88; government and, 87; Indigenous peoples and, 7–8; institution staff in, 88; places in, 88–89; regarding Fernald Developmental Center, 84–89; role of people with disability in, 87
Tumarkin, Maria, 11–12
Turner Village, 240–41

Ulleråker, 20, 283; cultural heritage, 284–85, 291, 292
Ulleråker hospital, 283, 288; deinstitutionalization, 283, 288; disability treated at, 286; history as success story, 292–94; repurposing of, 283–84; street naming, and history of, 293–94
Ulleråkersvägen, 286
United Nations Committee on the Rights of Persons with Disabilities, 5–6, 13
United Nations Convention on the Rights of Persons with Disabilities (CRPD), 13, 60, 114
University of Gothenburg. *See* Gothenburg, University of
University of Guelph. *See* Guelph, University
unpaid labour: activists and, 30; as benign therapy, 33; commemoration of, 41; as exploitation, 33, 36, 37; on farms, 204, 268; as forgotten, 29–30; in laundry room, 206–7; media on, 35; memorial plaques regarding, 33–34; redevelopment and, 11; slavery compared to, 35–36, 38; walls of Toronto Asylum, 33, 34–35, 36, 37, 41

Unravelling Moments from a Torn Mind (Wart), 159
Uppsala University, 291, 292
use: and betterment, 216–17; and excellence, 223; queering of, 215, 216, 228; repetition of knowledge and ease of, 217; tradition of, 217
Uses of Heritage (Smith), 255–56, 257
us-them framing, 84, 240, 242

Vergessene Geschichte? Tiergartenstraße 4 - Euthanasie-Aktionen 1939–1945 (Forgotten History? Tiergartenstraße 4 - Euthanasia campaigns, 1939–1945), 53
vicarious witnessing. *See* witnessing: vicarious
Victorian Society of London, 308
Villawood (Wart), 147
Villawood Immigration Detention Centre, 146–47
violence: absence in records, 117; of binarism, 285, 290; and compliance, 99–100; continuities of, 8; deinstitutionalization, 109, 110; eugenics and, 215; forgetting as, 92; against Indigenous peoples, 7–8; normalization of, 236–38; nursing staff and, 19; precariousness and, 64; reflection on, in redevelopment, 111; restraining, in patients, 236–37; silence in records regarding, 96–97; stereotypes of, 310; in survivors' records, 16, 91; symbolic, 109. *See also* abuses; institutional violence

W. Ross MacDonald School for the Blind, 105*n*6
Waanyi people, 255–56
Waldron, David, 310
WALK public performance series, 145, 146, 151
walks, 145, 146, 159, 161–62, 253, 263. *See also* Benevolent Asylum: Just for Fun

Wall, Oisín, 128
Walmsley, Jan, 18–19, 320
Walter (Grahamstown patient), 202–3
Walter E. Fernald Developmental Center (formerly known as the Massachusetts School for the Feeble-Minded), 16, 81–83, 85; abandonment of site, 81–82; light shows at site of, 80, 82, 85; and MetFern Cemetery, 83–84; names/stories of inmates, 83; reform of, 81; subsequent uses of site, 81–82; truth and reconciliation movement regarding, 84–89
Waltham, MA, 80–81, 83
Walton, Fred, *When a Stranger Calls*, 273
Warsaw Ghetto, 56
Wart (Jen Waterhouse), 17, 145, 146, 148–63, 321; *Beyond the Line*, 158; *Eye See Pink, Black and White*, 155; *Have U a Spare Nut?*, 157–58; "The Isolation Room," 159; *For Matthew and Others – Journeys with Schizophrenia*, 155; *Unravelling Moments from a Torn Mind*, 159; *Villawood*, 147
Waßmer, Jorg, 70
"The Water Tower Speech" (Powell), 300–1
Waterman, Emma, 40
Watson, Beth, 271–72
Watson, Julia, 271
Watt Street Mental Hospital, 122
Weheliye, Alexander, 76
Weijmer, Malin, 262–63
Weitz, Don, 32
Welsh, Christopher, 105n6
Welsh v Ontario, 105n6
When a Stranger Calls (Walton), 273
"Who Are We, and Who Do We Want to Be?" (University of Guelph), 219
Willis, Daya, 272
Willowbrook Mile, 12

Willowbrook State School, 12
Winter, Tim, 40
Winterbourne View, 231, 242
witnessing: direct, 16, 66, 67, 69–70, 72; kinds of, 66; vicarious, 67, 73–74, 76
witnessing, stretchy, 16, 76; to Aktion T4, 66; alternative practices of memorialization and, 67; commemoration and, 66; direct witnessing vs., 72; as identification with vs. distancing from victims, 74; memorialization and, 66; vicarious witnessing in, 67, 73–74; and victims' vs. perpetrators' views, 67
Wolbring, Gregor, 291
Wolfe, Patrick, 7
Wonford House Hospital (later Royal Devon and Exeter Hospital), 303
Wood, Marion, 117
Workhouse and Infirmary (Southwell), 12, 182; access to, 189; archives, 195; art at, 187, 189, 191–95; and Backlit, 187; Board of Guardians, 183; Caudwell House, 184, 185; co-creation at, 18, 188, 192–93; community and creative program officer, 185; COVID-19 and, 189, 190; cultural-archaeological approach at, 186–87; and Do It Different project, 187, 189–92, 194; exploratory approach, 185; The Factory and, 189; Firbeck House, 183–84, 188; historical research, 187; history, 182–84; and ICSC, 184; inclusivity at, 189; about Infirmary, 183–84; institutionalization history at, 191, 193–94; and interpretation of site, 184, 191; as learning property, 182; Minster View, 184, 185; National Trust and, 18, 184, 187, 189, 191, 192; and Nottingham Mencap, 186; presence of neurodiverse participants/artists,

189–90; as site of conscience, 184–87; visitor experience, 184, 186; about Workhouse, 182–83
Workman, Joseph, 29–30
World Psychiatric Association Congress, Berlin, 2017, 60–61

Wrentham State School, 85
Wright, David, 33–39, 40, 41
Wynter, Sylvia, 76

Zähringer, Alois, 70
Zheng, Chunhui, 278

Printed and bound in Canada by Friesens

Set in Futura Condensed, Apercu, and Warnock by Artegraphica Design Co. Ltd.

Copy editor: Robert Lewis

Proofreader: Caitlin Gordon-Walker

Indexer: Noeline Bridge

Cover designer: Gabi Proctor

Cover illustration: Painting, "The Great Dream of Excellent Health," by Jeremy Sicile-Kira, 2017